TO DEFEND THIS SUNRISE

TO DEFEND THIS SUNRISE

Black Women's Activism and the Authoritarian Turn in Nicaragua

COURTNEY DESIREE MORRIS

RUTGERS UNIVERSITY PRESS
New Brunswick, Camden, and Newark, New Jersey
London and Oxford, UK

Rutgers University Press is a department of Rutgers, The State University of New Jersey, one of the leading public research universities in the nation. By publishing worldwide, it furthers the University's mission of dedication to excellence in teaching, scholarship, research, and clinical care.

Library of Congress Cataloging-in-Publication Data

Names: Morris, Courtney Desiree, author.
Title: To defend this sunrise : Black women's activism and the authoritarian turn in Nicaragua / Courtney Desiree Morris.
Description: New Brunswick, New Jersey : Rutgers University Press, [2023] | Includes bibliographical references and index.
Identifiers: LCCN 2022009353 | ISBN 9781978804791 (paperback) | ISBN 9781978804807 (hardback) | ISBN 9781978804814 (epub) | ISBN 9781978804838 (pdf)
Subjects: LCSH: Women, Black—Political activity—Nicaragua—Bluefields. | Civil rights—Nicaragua. | Multiculturalism—Nicaragua. | Black people—Nicaragua—Politics and government. | Indigenous peoples—Nicaragua—Politics and government. | Nicaragua—Politics and government—1990-
Classification: LCC HQ1236.5.N5 M67 2023 | DDC 305.80097285—dc23/eng/20220404
LC record available at https://lccn.loc.gov/2022009353

A British Cataloging-in-Publication record for this book is available from the British Library.

References to internet websites (URLs) were accurate at the time of writing. Neither the author nor Rutgers University Press is responsible for URLs that may have expired or changed since the manuscript was prepared.

♾ The paper used in this publication meets the requirements of the American National Standard for Information Sciences—Permanence of Paper for Printed Library Materials, ANSI Z39.48-1992.

www.rutgersuniversitypress.org

Manufactured in the United States of America

For my Bluefields sistren.
Don't give up the fight.

CONTENTS

PREFACE

An Unexpected Uprising?

In April 2018 Nicaragua was shaken by a wave of popular protest against the administration of President Daniel Ortega and his wife and vice president Rosario Murillo. In the weeks and months that followed, hundreds of thousands of Nicaraguans—university students, retirees, environmentalists, feminists, religious leaders, Black and Indigenous communities, journalists, and left-wing and right-wing opposition groups—flooded the nation's streets calling for Ortega's resignation and early elections. The unfolding crisis took many, including the government, by surprise (Semple 2018). Yet the conditions for this uprising had been in the making for more than a decade and revealed a deepening crisis of legitimacy for the Ortega administration (Baltodano 2014; Bendaña 2007; Chamorro 2016; Herrera Vallejos 2018; Jarquín et al. 2016; La Semana 2016; Martí i Puig 2013; Rocha 2016; Ruiz 2016; Salinas Maldonado 2017; Téllez 2012; Velasco 2017).

On April 18, Ortega issued an executive order, bypassing the National Assembly, that instituted a series of reforms to the Nicaraguan Social Security Institute (INSS).[1] The reforms would increase the amount that employees and employers would have to pay into the system while cutting benefits to elderly retirees by 5 percent ("Publican Reformas al INSS en La Gaceta" 2018a; Semple 2018). The public outcry was "swift and furious" (Anderson 2018). Retirees began protesting outside the offices of the INSS. They were quickly joined by university students from the Central American University (UCA) and the Polytechnic University of Nicaragua (UPOLI), many of whom had participated in protests over the government's mishandling of a massive wildfire in the Indio Maíz Biological Reserve on the Caribbean coast earlier that month (Salazar 2018a). The government's reaction rapidly escalated into violent repression. It shut down television stations broadcasting live coverage of the protests, ordered anti-riot police forces to disperse the demonstrations by firing live rounds into crowds of protesters, engineered the mass arrests of student activists, and attacked universities where students were mobilized. Pro-Sandinista gangs, known as *turbas*, and members of the Sandinista Youth also attacked demonstrators with mortars and other arms as the National Police stood by and refused to intervene (Amnesty International 2018; IACHR 2018; Moncada and Chamorro 2018; United Nations 2018a, 2018b). By the end of the first week of protests, the Nicaraguan Center for Human Rights (CENIDH) confirmed forty-three deaths and two people in critical condition. Other groups, relying on official and unofficial reports, estimated as many as sixty deaths ("Organismos Continúan Registro de Víctimas" 2018b). Among the dead was Ángel Gahona, a journalist who was shot and killed while livestreaming

coverage of the protests in the Caribbean coastal city of Bluefields (Miranda Aburto 2018a).

The Ortega administration went on the offensive, claiming that the protests were being infiltrated and manipulated by narco-traffickers, gang members (*pandilleros*), and juvenile delinquents committed to promoting "destruction and destabilization." On April 19, during her daily midday address to the nation, Vice-President Rosario Murillo (2018) decried the protesters as "tiny groups that threaten Peace and Development with selfish, toxic political agendas and interests, full of hate." President Ortega echoed Murillo's comments in a televised speech two days later. The protesters, he claimed, were receiving arms, funding, and tactical support from domestic right-wing elites in collusion with the United States to stage a coup and overthrow the government (Ortega 2018).

If Ortega's comments were intended to restore law and order, they had the opposite effect. He never mentioned the dead protesters or addressed allegations of police abuse but instead stressed the economic impact of the protests on Nicaragua's fragile image as a safe and stable tourist destination. For many, Ortega's response reflected how out of touch he was with the public; even Sandinista supporters, including Bayardo Arce, Ortega's chief economic adviser, admitted that "Ortega made a mistake" in his handling of the protests (Luna 2018).

Protesters retaliated by paralyzing the country with weekly marches, building *tranques* (roadblocks) to keep police and paramilitary forces out of communities sympathetic to the protesters and using social media to counter the administration's narrative (Garth Medina et al. 2018). Shocked by the scale of popular outrage, Ortega rescinded the social security reforms (Robles 2018). But this gesture proved to be too little, too late. The protests had become about something much larger, as more than a decade of accumulated grievances with the administration's abuses of power, manipulation of the democratic process, and co-optation of government institutions exploded.

As the protests continued to escalate, calls for peace and calm came from the powerful Superior Council of Private Enterprise (COSEP) and the Catholic Church.[2] On April 22, Pope Francis, speaking during his Sunday address to thousands gathered in St. Peter's Square, expressed his concern about the crisis, calling "for an end to every form of violence and to avoid the useless shedding of blood" ("Papa Francisco Pide Poner," 2018). The National Conference of Catholic Bishops convened a National Dialogue and served as a mediator between the protest movement and the administration. Representatives of various sectors of Nicaraguan civil society, including labor unions, the feminist and women's movement, national human rights organizations, student activists, the *campesino* movement, *costeño* (coastal residents) representatives, and religious leaders, agreed to participate. But the talks collapsed within days—while members of the Civic Alliance called on the administration to end the repression of the protests, the government insisted on the removal of the *tranques* as a precondition for negotiations. When this failed, the administration simply stopped participating in the dialogue.

In July the Ortega administration launched what it called the "Cleanup Opera-
tion" to forcibly remove the *tranques* and crack down on its political opponents.
FSLN lawmakers then passed sweeping antiterrorism legislation that expanded the
definition of terrorism to include a broad range of activities that result in death,
injury, or property damage when the intent is "to intimidate a population, alter the
constitutional order, or compel a government or an international organization to
perform an act or abstain from doing so." From July to December some 500 people
were arrested under charges of "terrorism" (Amnesty International 2018b; IACHR
2018; United Nations 2018).

The government quickly declared the clean-up operation a success and insisted
that Nicaragua was on the path to "normalization." That effort came at a high
cost. The United Nations, the Organization of American States, and Amnesty Inter-
national reported that the protests left more than 300 confirmed dead (national
human rights organizations placed that number at closer to 500), approximately
2,000 wounded, and more than 400 political prisoners. By year's end an estimated
40,000 Nicaraguans had fled to Costa Rica, fearing reprisal for their participation in
the protests. Although these international organizations reported human rights
abuses on both sides, the evidence suggests that nearly all the violence was perpe-
trated by police officers and pro-government paramilitary forces whose actions
include kidnapping, arson, torture targeted assassination, and sexual violence
against antigovernment protesters (Amnesty International 2018a, 2018b; Inter-
American Commission on Human Rights 2018; Partlow 2018; Salinas Maldonado
2019). After the clean-up operation, the government escalated its repression of civil
society, stripping away the legal status of dissident NGOs, harassing journalists,
and arbitrarily detaining human rights defenders across the country.

A VIEW FROM BLUEFIELDS

But this civic rebellion came as little surprise to Black and Indigenous activists on
the Caribbean Coast, who took a radically different view of the origins and impli-
cations of the protest movement. Bluefields is the capital city of the South Carib-
bean Coast Autonomous Region (RACCS) of Nicaragua and home to a multiracial
population of Afro-descendant Creoles, Afro-Indigenous Garifunas, mestizos,
and Indigenous Miskitu, Rama, and Mayagna peoples. In 1987, Nicaragua formally
approved the creation of the autonomous regions as part of a cluster of multicul-
tural citizenship reforms that formally redefined Nicaragua as a pluri-ethnic, mul-
ticultural nation-state. These reforms recognized the collective rights of Indigenous
and Afro-descendant peoples to govern themselves under their own traditional
forms of customary law, access to bilingual education, communal land title, and
the rights to manage the use and exploitation of the region's natural resources. The
law also established the formation of two autonomous regions with their own
political institutions. The transition from the state's historical embrace of mestizo
nationalism, which defined Nicaraguan national identity as the product of racial

mixing between Spanish colonizers and Indigenous native peoples (Hooker 2005a, 2005b, 2009), was a watershed moment in the struggle for Black and Indigenous rights in Nicaragua and Latin America. The approval of these reforms marked the beginning of the multicultural turn in Latin America and signaled a radical shift in the relationship between the multiracial Caribbean Coast and the mestizo Nicaraguan nation-state.

Despite these reforms, in the years following the approval of regional autonomy, the Nicaraguan state—under multiple administrations whose ideological orientations ranged from revolutionary to reactionary—continued to undermine the political claims of Black and Indigenous people for territory, resources, and political autonomy. Black and Indigenous communities in the RACCS have resisted efforts by the state to grant concessions to national and multinational corporations to the region's fishing, mining, and lumber resources and to construct an interoceanic canal that would cut their communal land claims in half; these communities have also condemned the state for failing to address the mass migration of landless mestizo settlers into the region occupying and trafficking Black and Indigenous communal lands (Amnesty International 2016; Goett 2017; Mendoza 2015; Serra Vázquez 2016). Although these reforms did not radically transform the unequal relationship between Black and Indigenous communities and the state, they did facilitate the emergence of new forms of political subjectivity and new modalities of political mobilization that have transformed racial justice movements throughout Latin America and the Caribbean (Goett 2017; Hooker 2005a, 2005b, 2009; Paschel 2016). Black women in Nicaragua, as in other Latin American countries, have emerged as key leaders in these new political formations, leading struggles against police abuse, gentrification, mega-development schemes, a regional land grab, and territorial displacement.

Since 2004, I have worked with Black women activists in Bluefields who have been at the forefront of regional struggles to defend the communal and territorial rights of Black and Indigenous communities. When the protests erupted in April 2018, they quickly mobilized to organize demonstrations in Bluefields in support of the growing anti-Ortega movement. Costeño participation in the civic rebellion increased dramatically after the National Police arrested two young Black men, Glen Slate and Brandon Lovo, for the murder of Ángel Gahona, despite eyewitness accounts from Gahona's friends and family members that the journalist was murdered by local police (Flores Valle 2018; Salazar 2018b, 2018c; Silva and Romero 2018; Vázquez Larios 2018a, 2018b).[3] In addition to hosting marches, activists discussed the case on local radio, which they livestreamed via Facebook for costeños living outside the country, and circulated memes and social media posts in which they identified these two young men as political prisoners, thereby countering the official government narrative of them as juvenile delinquents (Calero 2018; Navarro 2019; Noticias de Bluefields 2018). Lovo's and Slate's arrests and subsequent convictions powerfully demonstrate the racialized dimensions of Nicaraguan state violence under the authoritarian turn, which were

largely overlooked by the civic movement against the Ortega administration. This exclusion was made evident when the hastily formed Civic Alliance initially neglected to invite Black and Indigenous community leaders to participate in the National Dialogue with the government in May 2018.

Dolene Miller, a longtime Creole land activist and a regional activist and the Creole representative to the National Commission on Demarcation and Titling, argued that, as in previous nationalist movements, the recent civic movement tended to ignore the specific political demands of Black and Indigenous communities on the coast, even though these communities were among the earliest and most vocal critics of the authoritarian turn. She lamented,

> In this social explosion little attention has been given to the problems of the Caribbean coast of Nicaragua; the problem is focused on Managua, in the capital, where the government has wanted to maintain an image of peace and tranquility for those outside and has exercised fierce control over the media in order to avoid the problems of Afro-descendant and Indigenous peoples, that have suffered persecution, the deaths of Indigenous community members, the invasion of settlers on communal lands as well as the irrational exploitation of natural resources, from emerging. (Miller 2018)

The failure of the civic movement to engage with the political concerns of Afro-descendant and Indigenous populations reflects the limited ability of mainstream mestizo nationalist political projects to meaningfully transform the structural conditions that marginalize Black and Indigenous communities. It also reveals, as Shakira Simmons (2018), a Bluefields-based Black feminist activist, argues, the "geo-centric vision" of mestizo nationalisms that historically minimized the place of the coast in broader struggles for state power, nationalist modernization projects, and official development schemes—even though since the nineteenth century the coastal region has historically been the political and military staging ground for these debates. As both Simmons and Miller argue, the civic movement did not prompt the emergence of Black women's regional activism; rather, it was, in many ways, made possible by more than a decade of political mobilization among Black and Indigenous communities—and many other social actors— against the Ortega regime. Whether leading struggles against mega-development projects on collective Black and Indigenous lands; resisting state intervention into traditional, collective governing bodies at the community level; or challenging the Ortega administration's centralized vision of national development, activists struggled "for the vindication of the human, autonomous, civic, political and ancestral rights [of Black and Indigenous communities] in the face of a racist, centralist, and clientelist mestizo state that has destroyed the social, political and economic fabric of Caribbean society" (Simmons 2018, 34).

As protests against the administration grew, it soon became apparent that the only political goal that unified the ideologically fragmented and heterogenous

protest movement was the removal of Daniel Ortega from office. As I argued else-
where, the civic movement was not uniformly progressive but was a complex
assemblage of diverse political actors representing the Right, the Left, and the then-
politically unaffiliated (Morris 2018). The repeated exclusion of Black and Indige-
nous peoples within the Civic Alliance demonstrates that the movement has not
reckoned with crucial questions over what comes after Ortega. Black women activ-
ists in Bluefields consistently argued that a singular political demand—¡que Ortega
se vaya! (Ortega must go!)—would not ensure a more democratic political order
that is attentive to the needs of racial and ethnic minorities, women, LGBT com-
munities, and the poor.

As the political crisis intensified, costeño activists insisted that the region's
problems did not begin with the authoritarian Ortega administration but rather
were the product of the Nicaraguan state's historically exploitative and colonial rela-
tionship with Black and Indigenous costeño communities. Black and Indigenous
activists took the opportunity to reassert a critique of the exclusionary nature of
citizenship in Nicaragua and the racist origins of contemporary state violence. As
Simmons's and Miller's comments illustrate, costeña activists offered a radically
different analysis of the structural nature of state violence and the content of Nica-
raguan democracy. They rejected narratives from both the Right and the Left that
would frame their struggle as an ideological battle against a socialist regime.
Rather, they argued that the state of Nicaragua, under a series of ideologically
divergent political regimes, has historically treated the Caribbean Coast as an inter-
nal colony, "an annexed territory open to exploitation" (Miller 2018). Addressing
this historical legacy of regional exploitation would mean going far beyond replac-
ing an individual political figure—even one as powerful and enduring as Daniel
Ortega—to envision a different kind of political future for Nicaragua.

To Defend This Sunrise: Black Women's Activism and the Authoritarian Turn in
Nicaragua examines the genealogy of Black women's activism in Bluefields and
these women's historic and contemporary struggles against authoritarian state
violence. I demonstrate how Black women have engaged in regional, national, and
transnational modes of activism to reimagine the nation's racial order. I argue that
Black women's contemporary activism is rooted in a genealogy of struggle against
racialized state violence, economic exclusion, territorial dispossession, and politi-
cal repression from the nineteenth century to the present. As the April 2018 pro-
tests illustrate, the authoritarian turn has occasioned widespread reflection on the
crisis of democracy in Nicaragua. For Black women activists on the coast, this cri-
sis has created a space to articulate a more nuanced critique of the racialized nature
of state violence, de-democratization, and the production of unequal citizenship.
Rather than reading the contemporary authoritarian turn as a state of exception,
this book highlights the "tragic continuities" between different racialized regimes
of governance whose collective results have been the ongoing dispossession, dis-
placement, and disappearance of Black communities (Hartman 1997).

The democratic crisis in Nicaragua erupted as I was writing this book. In 2017, after three years of struggling with how to narrate the authoritarian turn and its impact on Black and Indigenous communities, I returned to Bluefields to understand how regional activists were responding to these developments. What I learned led me to rethink my entire project. Residents shared their anxieties about the administration's antidemocratic tendencies and their fears about the erosion of communal property rights as Ortega and his party, the Sandinista National Liberation Front (FSLN), have intervened in regional and communal governments to advance its own centralized development agenda. They pointed with alarm to the wave of mestizo settler-colonial violence against Indigenous Miskitu populations in the neighboring North Caribbean Coast Autonomous Region (RACCN). They shared their concerns about displacement after the administration approved the use of eminent domain under the auspices of the interoceanic canal mega-development project. As I listened to them, I knew I needed to write a different book—one that would help people outside Nicaragua understand the slow process of authoritarian drift that produced the 2018 crisis. One activist told me simply, "You have to tell the truth about what is happening here." This is my attempt to do as she, and many others, asked.

A BLACK FEMINIST READ ON ACTIVIST ANTHROPOLOGY

To Defend This Sunrise is based on fieldwork conducted from 2004–2017, the bulk of which I completed over fourteen months from 2009–2010 in Bluefields, rural Creole communities in the Pearl Lagoon Basin north of Bluefields, Managua, Puerto Cabezas, and the United States. The study combines ethnography, archival research, and oral history to reveal the ways that the racialization of space through state policy, official narratives of mestizo nationalism, cultural representations, and popular discourse have historically marked Black communities on the Caribbean Coast as marginal citizens whose racial difference threatens the project of mestizo nationalism and state formation. Black women's critiques of the geography of race in Nicaragua offer powerful alternatives to existing narratives of citizenship rooted in uneven regional development and racial exclusion. These alternative visions are realized in their struggles for regional autonomy, economic justice, and gender and racial equality.

I have spent more than a decade returning to Bluefields, following the movement of Black women activists in NGOs, regional universities, and community-based organizations for Black land rights; laboring on cruise ships; and navigating the challenges of neoliberal displacement and multicultural dispossession through labor migration to the United States. I went to community gatherings, participated in neighborhood workshops led by regional antiviolence feminist activists, and sat quietly in women's living rooms as I listened to them share their most intimate experiences of violence and trauma. I cohosted an English-language

Black women's radio program with a local Black feminist researcher and community organizer, worked with a multiethnic women's research center at the University of the Autonomous Regions of the Nicaraguan Caribbean Coast (Universidad de las Regiones Autonomas de la Costa Caribe Nicaragüense; URACCAN), taught English classes at the Bluefields Indian and Caribbean University (BICU), and conducted interviews with approximately forty activists and community members. In so doing, my goal has been to provide a rich and varied cartography of Black women's activism in the region that would document these women's political leadership and bring their critiques of state violence to the center of broader debates on the meanings, origins, and long-term implications of the authoritarian turn.

My work in Nicaragua emerged out of a deep commitment to the project of activist anthropology and an attendant conviction that political engagement, rather than objective detachment, produces richer insights and more finely calibrated accounts of how power operates (Hale 2008; Vargas 2006). Since the 1960s, anthropologists—drawing from the insights of feminist, critical race, postcolonial, and decolonial theoretical frameworks—have called for the need to decolonize the discipline by recognizing that "knowledge production and praxis are inseparable" (Harrison 1997, 10). The concept of activist anthropology emerged in the 1990s and early 2000s as a critical methodological response to the call to decolonize the discipline (Allen and Jobson 2016; Hale 2008). Over the last forty years, the critiques formulated by this assemblage of radical anthropologists have been absorbed into the normative workings of the discipline. Anthropologists now seemingly take for granted the need for self-reflexivity, are attentive to the political stakes of their research, and often produce scholarship that is transparently political in its orientation and narration. Nevertheless, Charles Hale (2008, 101) argues that although most anthropologists are willing to engage in what he terms "cultural critique," in which the researcher's political investments are articulated in the written ethnographic product, this model of anthropological inquiry does not fundamentally disrupt "the everyday material relations of the research process." Activist anthropology, in contrast, challenges anthropologists to rethink the very tools and practices through which we produce ethnographic knowledge.

Hale (2008, 97) defines activist anthropology as "a method through which we affirm a political alignment with an organized group of people in struggle and allow dialogue with them to shape each phase of the process, from conception of the research topic to data collection to verification and dissemination of the results." This definition developed organically out of the conviction, as the historian Robin D. G. Kelley (2002, 8) argues, that "social movements generate new knowledge, new theories, new questions." Thus, rather than compromising disciplinary norms of objectivity, detachment, and participant observation, activist anthropology as method suggests that observant participation, ethical engagement, transparency, and accountability produce stronger and more robust accounts of the

violent inequalities that structure the social worlds that we study and inhabit (Vargas 2006).

Although activist anthropology has provided an important strategy for transforming the material relations of knowledge production by centering the voices and insights of marginalized communities, it has been less attentive to the role that the body and subjectivity of the researcher play in the research process. The insights of feminist anthropology and women of color feminist theory suggest that activist anthropology is more than a theoretical exercise or a methodological experiment (Behar 1996; Berry et al. 2017, Kulick and Wilson 1995; Twine and Warren 2000; Visweswaran 1994). It is a political and ethical commitment that carries with it a significant possibility for encountering violence in the field. It entails a bodily risk whose effects are unevenly distributed along relational lines of race, class, gender, nation, and sexual privilege. Women of color researchers are particularly vulnerable in this undertaking. The risks that we take in many ways mirror the forms of violence that the communities with whom we work face in their daily struggles for survival and self-determination. Although exposure to this violence is often mitigated by economic mobility and the dubious privileges of U.S. citizenship, as the accounts of Black feminist ethnographers reveal, those modalities of privilege often fail and are superseded by global racial logics that ascribe low value to Black female bodies and make them illegible in "the field" (Caldwell 2007; Perry 2013).

From the moment I set foot in Nicaragua in 2004, I was immersed in the structure of gendered racial formations that shape Black women's lives. Stumbling off the plane after spending the night in a seedy motel in Miami—without the benefit of my belongings, which had been checked directly to Managua—the only thing I wanted to do was collect my things and figure out how to use my rickety Spanish to get myself to Bluefields and a shower. I did not have to exert much effort, as it turned out, because a young mestiza in a jaunty green uniform suddenly approached me and asked me, "¿va a Bluefields?" Startled by her perceptiveness, I replied that I was, and she proceeded to escort me to the regional airline offices where I promptly purchased a ticket. Within an hour I was on a flight to Bluefields.

If I was surprised that this young woman had been certain that I was headed to Bluefields, the reasons for that confidence soon became apparent. Unwittingly, she had introduced me to the way in which notions of race in Nicaragua are linked not only to particular bodies but also to particular spaces. Over the next decade, I routinely experienced these moments of misidentification in which Creoles and mestizos alike read me as a Creole woman from the coast. People who knew me well, particularly Creole women, often explained my connection to Bluefields and our mutual affinity by pointing out our shared cultural backgrounds as the descendants of Jamaican labor migrants, a few generations removed from the island. These moments of mistaken identity, however, had much broader implications than I realized.

As a researcher, I had not assumed that I would be above the kinds of racial and gendered forms of discrimination that Afro-Nicaraguan women routinely experience, but I was surprised by the degree to which my Black female body obscured my North American privilege, exposing me to particularly gendered forms of anti-Black racism. U.S. citizenship, for example, did not spare me the forms of sexual harassment, criminalization, and mistreatment that Creole women face on a daily basis. These encounters form a catalog of ordinary indignities and humiliations to which I eventually became numb to do my work. There was the night a dear friend and feminist colleague was punched in the face at a bar trying to protect a woman from her drunk, abusive husband. I remember returning home and watching the ugly purple bruise bloom into an angry flower around her eye as I gently pressed ice in a Ziploc bag to her face. Or the time a naval soldier grabbed my ass on the wharf in Corn Island as I disembarked and laughed when I protested. Or the many times I had to endure being pulled aside and having my luggage repeatedly searched for drugs at the airport. Or the taxi driver who insisted I sit in the front seat and tried repeatedly to grope me with one hand as he kept the other precariously on the wheel. Or the school administrator at a rural boarding school who trapped me in a room with him for five minutes, tried to force me to kiss him, and who told me casually before leaving that he would be back later that night. Or the white Brazilian businessman who invited himself to dinner with me when he saw me dining alone in an upscale hotel in Managua and then attempted to proposition me with whiskey and Marlboro cigarettes.

When Creole women shared their experiences of racism with me, they often pointed to humiliating encounters with mestizos in the Pacific,[4] where they were read as sex workers, propositioned by taxi drivers, sexually harassed by their male colleagues, or subjected to strip searches at the nation's airports and wharfs.[5] These experiences reflected the debased status of Black femininity in Nicaraguan racial commonsense (Gordon 1998). This racial logic locates and fixes Blackness in a single place—the coast—and attaches particular meanings to Black bodies and spaces that are linked to larger discourses of Black deviance, hypersexuality, danger, and desire (McDowell 1999; McKittrick 2006).

The fact that I too, was subjected to these forms of misrecognition—an experience with which I was all too familiar in the United States—provided me with a critical entry point into understanding and theorizing Black women's social location in Nicaragua's spatial gender/racial order. Michael Hanchard (2000) suggests that those moments when the researcher is interpellated as an object of knowledge within a larger discursive field of power provide key insights into understanding precisely how power operates in a different diasporic location. Although he does not, nor do I, argue that the lived experience of gendered Blackness is constant across time and space, the global reach of white supremacy and anti-Black racisms produces shared—but not uniform—structures of feeling within and between diasporic communities that can be the basis for fruitful dialogue and exchange in antiracist scholarship and activism. Hanchard argues that these

encounters provide "a basis of experiential knowledge" that allows researchers "to grasp what [is] being offered as sources of information in the stories people . . . tell about themselves" and the social worlds in which they live (167). Similarly, I found that Black women assumed that I would be able to understand and value the stories that they told about themselves, their communities, and the workings of heteropatriarchal racism in Nicaragua precisely because I was a Black woman.

Being a Black woman in Nicaragua is hard work. I came to learn that fact in and through my body and my embodied experiences navigating the complex social terrain of Nicaragua's multiple racial geographies in an era of authoritarianism. It allowed me to become attuned to the many registers through which Black women narrate democracy's failure in Nicaragua, how they are marginalized in the larger political order, and why they have chosen the activist paths that they have taken. Black women taught me to see what matters, to recognize the subtle forms of racial violence that devalue Black personhood and animate structural processes of exclusion and dispossession that make Black life unlivable. They taught me to read the authoritarian turn as the newest iteration of a longer history of slow violence and systematic genocide that undermines juridical recognition of multicultural citizenship rights and criminalizes Black mobilization that refuses the limits of managed democracy in contemporary Nicaraguan politics (Nixon 2011; Smith 2016; Vargas 2008).[6] I had not intended to write a book about the authoritarian turn, but my own embodied experiences and my collaborative relationships with Black women activists demonstrated the need for a deeper analysis of modern authoritarianism as the logical product of the longue durée of racial and regional exclusion that continues to define the place of Blackness in the mestizo nation-state (Whitten 2007).

Black women's struggle to create modes of Black life and sociality that defy the violence of slow genocidal state policies and political dispossession offer the possibility of a different kind of political future. As Robin D. G. Kelley (2002, 10) suggests, it is "in the poetics of struggle and lived experience in the utterances of ordinary folk, in the cultural products of social movements, in the reflections of activists, [that] we discover the many different cognitive maps of the future, of the world not yet born." Activist anthropology, as a method and methodological orientation, provides a means of accessing these "alternative cognitive maps of the future"; it reveals that, even under conditions of pervasive violence, marginalized communities continue to produce alternative spatial imaginaries that enable them to keep fighting for more just political systems and livable human futures.

TO DEFEND THIS SUNRISE

INTRODUCTION

Black Women's Activism in Dangerous Times

On March 8, 2017, while the rest of the world was celebrating International Women's Day, the Nicaraguan national newspaper, *La Prensa,* reported that Lottie Cunningham, a well-known Indigenous human rights attorney and activist in the North Caribbean Coast Autonomous Region (RACCN), had received death threats after criticizing President Daniel Ortega and his party, the Frente Sandinista de Liberación Nacional (FSLN; Sandinista National Liberation Front), of undermining Indigenous communities' political and territorial claims. The threat was sent to her via Facebook Messenger from a man who identified himself as "Nazchi Guirre." It began ominously, "This is not a courtesy call but a warning . . . if you want war, war is what you'll get. War means blood" (Romero 2017c).

In an interview on *Confidencial,* a center-left online magazine and television news program, Cunningham shared that she and her colleagues believed the author was connected to paramilitary groups aligned with the government. "We hold the state of Nicaragua responsible for these threats," she said. "We've been living with these threats for years." The Sandinista government, she argued, had increasingly criminalized Indigenous and Black activists for standing up for their communities' land rights ("Death Threats" 2017). Global Witness (2017) reported that Nicaragua was one of the deadliest countries in the world for land and environmental defenders: they also face arbitrary detention and imprisonment, property seizures, police harassment, and defamation by the state and state-controlled media outlets.

Over the last decade, Black and Indigenous communities residing along the Caribbean coastal region of Nicaragua have lived under what one journalist termed "a reign of terror" as they have struggled to hold onto their communal lands while mestizo *colonos* (settlers) from the central and Pacific region seize control of their territories (Mendoza 2015; see also Mendoza 2016). Between 2008 and 2013 more than one thousand mestizo settlers occupied more than 59,000 square kilometers of communal Indigenous lands in the region—with no response from the state (García 2013; Hobson Herlihy 2016). These settlers have engaged in a series of crimes ranging from illegal lumber trafficking to intimidating, harassing,

and murdering Indigenous community leaders and residents who have resisted these encroachments. This violent process of dispossession has claimed the lives of more than thirty Indigenous community members and local leaders, displaced approximately three thousand Miskito residents, left countless more wounded, and led to the disappearance of community members whose mutilated corpses have often been left lying in the streets as warnings to their families and neighbors (Downs 2015).

Since returning to power in 2007, President Daniel Ortega has espoused a discourse of multicultural recognition and claimed that the FSLN government is committed to meaningfully addressing the land claims of Black and Indigenous communities and restoring the multicultural rights that these communities fought for in the 1980s. Despite this rhetorical support of Black and Indigenous land claims, the administration has largely turned a blind eye to the wave of racial terror unfolding in the region. The state has committed no resources to protecting Indigenous communities from *colonos*, to investigating crimes against these communities, or to prosecuting those responsible for threatening and killing Indigenous activists in the region (Ampie 2017; González 2017; Romero 2017a-f).

Black communities in Bluefields, the capital of the South Caribbean Coast Autonomous Region (RACCS) and home to the nation's largest Afro-descendant population, have observed these developments with growing alarm as they confronted similar challenges in their own territories. Black land rights activists allege that the state has violated their territorial and collective cultural rights by failing to prevent the violent land grab unfolding in the region. They argue that the Ortega administration's indifference to the theft of Afro-descendant and Indigenous lands is part of a longer historical strategy by the Nicaraguan state to dispossess these communities and undermine their claims to territory and political recognition, thereby advancing a national project of economic growth through an extraction-based development model that capitalizes on the region's timber, mining, and marine industries. They point to the state's approval in June 2013—without prior consultation—of Law 840, which granted a concession to the Hong Kong Nicaragua Canal Development Group (HKND) for the construction of an interoceanic canal that would rival the Panama Canal, which would run through Black and Indigenous communities in the Bluefields and Rama and Kriol territory (Amnesty International 2016). They also highlight the state's illegally granting concession for lumber, offshore oil exploration, mining, and fishing operations to national and multinational corporations, as well as the Sandinista state's co-optation of regional politics under a widespread system of corruption, clientelism, and party patronage.

For Black activists, the state's indifference to and encouragement of the territorial dispossession of Black and Indigenous communities continue a long-standing state policy to subjugate and assimilate the Caribbean Coast into the mestizo nation-state. Dolene Miller, a regional activist and the Creole representative to the National Commission on Demarcation and Titling (CONADETI), also calls this

land dispossession a form of "genocide." "Just like the Spaniards came to this land hundreds of years ago and committed genocide against the natives, the mestizos are trying to get rid of us to colonize the land" (Downs 2015). Miller's comment may read as hyperbole to some. But the government's own development agenda reflects these colonial logics (Cupples and Glynn 2018; Gordon 1998; Hooker 2010; Simmons 2019). One government official compared the canal project to the arrival of European settlers to the Americas: "It's like when the Spanish came here, they brought a new culture. The same is coming with the canal. It is very difficult to see what will happen later—just as it was difficult for the Indigenous people to imagine what would happen when they saw the first [European] boats" (Watts 2015).

In response to these colonial logics, Black activists and community members have begun to engage in more radical forms of political critique against the state. In particular, they have begun to deploy the discourse of genocide and dispossession to describe their relationship to the Nicaraguan state. They argue that the experience of Black citizenship in Nicaragua is defined by being marked as disposable, and they identify the state's long policy of benign neglect, internal colonialism, extractive development, and social exclusion as a strategy for producing Black physical, material, and social death. This is not a critique of a single administration; rather, the excesses and violence of the authoritarian Sandinista party-state represent another temporal node in the *longue durée* of anti-Black state formation and regional exclusion (Whitten 2007).

Rather than being incidental to or an aberration from the normative workings of the state, anti-Black racism is a defining feature of the Nicaraguan state and its policy directives on the coast. This foundational anti-Blackness is most clearly reflected in the state's efforts, despite its rhetorical commitment to multicultural recognition, to undermine the legal structures of regional autonomy and constrain the scope of Black and Indigenous peoples' political demands. Black activists argue that the state has done this by disavowing its own juridical norms and policies of multicultural governance. Here the term "multiculturalism" refers to the official recognition by the state of the cultural diversity of the nation and the granting of a narrowly defined set of collective rights based on the performance of particular forms of cultural difference—Indigenous languages, spiritual traditions, customary law, and communal land tenure practices (Van Cott 2000; Goett 2016; Hooker 2005b, 2009; Paschel 2016; Hale 2008; Rahier 2012). Yet it is precisely this system of official recognition that has become the mechanism by which the state enacts Black and Indigenous dispossession (Hale 2008).

In 1987, after nearly a decade of armed conflict with Indigenous and Afro-descendant peoples on the Caribbean Coast, the FSLN approved Law 28, also called the Autonomy Law, which recognized Nicaragua as a multicultural nation-state. The legislation's approval marked a critical turning point in the Nicaraguan state's relationship with Caribbean coastal communities. For the first time, the state acknowledged these communities' long-standing demands for collective land titling, self-determination, and just economic development. It was also a watershed

moment in Latin America, and in the early 1990s, Colombia, Brazil, Ecuador, Honduras, and other states followed suit, integrating a series of multicultural reforms into their constitutions following the end of authoritarian rule throughout the region (Hooker 2005b; Paschel 2016; Rahier 2012).

As Saidiya Hartman (1997) notes, however, the recognition of rights does not assure equality or greater liberty. Rather, scholars must learn to discern the "terror of the mundane and the quotidian" and the "savage encroachments of power" that are enacted under rhetorical performances of "reform, consent and protection" (5). Despite the discourse of multicultural recognition, Black communities on Nicaragua's Caribbean Coast remain politically marginalized and increasingly impoverished as a result of neoliberal reforms implemented by conservative administrations after the end of the revolution in 1990, as well as the Sandinista government's deepening authoritarianism.

This reality stands in stark contrast to the official multicultural discourse articulated by the state. Since returning to power, Ortega has appointed Black *costeños* to several high-profile political posts responsible for overseeing development initiatives and social programs in the Caribbean coastal region and for supporting Black representatives in the National Assembly.[1] These tokenizing gestures, however, have not stopped the Sandinista party-state from pursuing large-scale megadevelopment infrastructure projects on the Caribbean Coast, accelerating extractivist models of economic development, facilitating a widespread regional land grab, and limiting the ability of Black and Indigenous peoples to realize the promises enshrined in the Autonomy Law (Córdoba 2010; González 2014c, 2015, 2016).

What does it mean, at a moment in which Afro-Nicaraguan people are more politically visible than ever before, that they continue to exist on the margins of the political and economic life of the nation? How are we to make sense of ongoing patterns of dispossession and exclusion when official multiculturalism has become the normative frame for political engagement? What are the limits of multicultural recognition, and how do Black communities navigate this fraught political terrain? What does autonomy mean in a political context defined by authoritarianism and growing economic disparity? More importantly, what can Black women's activism reveal about how Black communities are resisting entrenched forms of state violence and political repression that constitute the everyday conditions of Black social life?

Answering these questions requires taking seriously the claims that Black activists have made about the slow violence of the authoritarian turn (Nixon 2011). For if the authoritarian turn has disrupted the process of democratization that began in Nicaragua after the end of the Sandinista Revolution, its policy orientation toward the Caribbean Coast shares clear continuities with previous political administrations. In response to this ongoing marginalization—from both the Right and the nominal Left—Black activists have articulated a definition of genocide that is more directly in keeping with the original framing of the term;

specifically, they highlight the many ways in which the state reproduces social, political, and economic conditions that produce Black marginalization and deprive them of resources, representation, livelihood, and life itself.[2] They propose alternative temporal frameworks that read genocide as an extension of a colonial legacy of racial violence, rather than an aberration from liberal Western democracy. Their arguments suggest that scholars must contend with anti-Black genocide as both a state project and a complex bundle of racial discourses that pathologize Black communities while simultaneously obscuring the structural conditions that produce Black suffering and displacement.

Black and Indigenous women have emerged in this context as the most vocal critics of the Sandinista government's political repression of regional activists and as the strongest defenders of the collective cultural rights of Afro-descendant and Indigenous communities. They have received death threats, been the targets of state-sponsored efforts to impugn their character and delegitimize their political demands, been pushed out of elected government posts, and had their access to international philanthropic funding blocked. They have developed increasingly more sophisticated modes of political engagement—engaging in media activism, grassroots protest, and transnational racial justice advocacy—to challenge state violence at multiple levels and to make their critiques of the racial dimensions of authoritarianism central to current political debates. In the process, they have cultivated a multiscalar struggle for regional and racial justice that radically challenges the foundational premises of multicultural democracy. This movement, which includes Indigenous women, as well as mestizo allies on the coast and in the Pacific, has produced new openings for local, national, and transnational solidarities and coalitional struggles against the authoritarian turn.

PLACING BLACKNESS, RACING THE COAST

Bluefields is a small, multicultural port city seated along the shores of the southeastern Caribbean Coast of Nicaragua; the city faces east toward the sea, its back turned proudly to the mestizo Pacific. It is the capital of the South Caribbean Coast Autonomous Region (RACCS) and home to the country's largest population of Afro-descendant Creole communities. It is also home to mestizos, the Afro-Indigenous Garifuna community, and three Indigenous peoples: the Miskito, the Rama, and the Mayagna. Creoles are the maroon descendants of formerly enslaved Africans who fled the plantation societies of British colonies in the Caribbean and who intermarried with local European settlers and the Indigenous peoples of the region. They have lived in Bluefields, as well as in communities located to the north in the Pearl Lagoon Basin and to the south in Monkey Point and Greytown, since the seventeenth century when Dutch and British pirates began to use the region's complex interior river system to trade in natural resources, rum, contraband, and enslaved Africans (Gordon 1998; Hale 1994; Dozier 1985; Vilas 1989).

During the colonial period, the Caribbean Coast, which has historically been referred to as the Mosquitia, was a critical site in the imperial ambitions of Great Britain, Spain, Nicaragua, and the United States. From the late eighteenth century until 1893, the Mosquitia, for all intents and purposes, operated as a semi-sovereign state whose political allegiance was not to Nicaragua but to the British Empire. The informal alliances that the Miskitu and Creoles brokered with British pirates and merchants were formalized in the eighteenth century, when Great Britain declared the region a British protectorate, a status held for more than two hundred years. Throughout this period, Bluefields' Creole communities were transformed by subsequent waves of labor migration from the Anglophone Caribbean. These communities still speak Mosquito Coast Creole, a regional English dialect that remains a salient category of Black cultural identity in Nicaragua and that reflects the speakers' ancestral ties to the Anglophone Caribbean, particularly Jamaica. Although historically they were the largest minority community in Bluefields, in recent years the Creole population has shrunk to a mere 23 percent of the city's population (INIDE 2005; PNUD 2005).

The divergent and antagonistic colonial formations that produced the Pacific and the coastal regions have historically vexed Nicaraguan nationalist projects. In contrast to the multiracial political formation of the Caribbean Coast, Nicaraguan cultural and political elites have historically articulated a mestizo national identity, emphasizing the nation's origins in the colonial encounter between Spanish *con-quistadores* and Indigenous peoples in the Pacific region—an articulation that tends to obscure the brutal violence of this historical encounter. This understand-ing of what constitutes *lo Nica* is premised on an erasure of slavery and Blackness in the Pacific and of the participation of African and Afro-descended peoples in the construction of Nicaraguan nationhood (Wolfe 2010; Hooker 2010; Ramírez 2007).

Although cultural elites began to tout *mestizaje* as a process of state formation by the end of the nineteenth century, mestizo nationalism was not consolidated for use as a discursive tool of Nicaraguan statecraft until the 1920s and 1930s. Cul-tural and political elites shaped both popular and official narratives of racial differ-ence and national identity to naturalize their right to rule (Gould 1996; Gordon 1998; Hooker 2005a; Ramírez 2007; Ruiz y Ruiz 1925). Their discourses focused on establishing the identity of the nation and closely policing the boundaries of citizenship along racial lines. The Caribbean coast as a multiracial, multilingual, enclave society—with its deep cultural, political, and economic ties to the larger (Black) Anglo-Atlantic world—threatened this project (Gordon 1998; Hooker 2009; Goett 2011). Thus, the Caribbean Coast came to be known as another coun-try within a country. State elites explicitly identified the region's Blackness and Indigeneity as fundamental obstacles to its full integration and assimilation into the mestizo nation-state (Ruiz y Ruiz 1925). Political scientist Juliet Hooker (2010) argues that the racialization of space was central to Nicaraguan state formation in the late nineteenth and early twentieth centuries; this project not only racialized

the coast as Black (and, to a lesser degree, Indigenous) but also enabled mestizo elites to narrate the Pacific region, or western half of the country, as unequivocally non-Black and assert their right to rule as the country's only "civilized" racial group. Thus, Nicaraguan mestizaje is a spatial ideology of racial difference that continues to powerfully shape contemporary official and quotidian discourses of race and nation.

El Azote is a weekly supplement published each Sunday in the conservative national newspaper, *La Prensa.* As suggested by *El Azote*'s name (it means a whip or a lash), the publication critiques and satirizes Nicaraguan national politics and the incessant power struggles of the country's ruling class. In 2003, *El Azote* published "Mapa de Nicaragua (según la clase política)". The political cartoon depicts a map of Nicaragua, according to political class, illustrating the *realpolitik* of power, corruption, and the curious political alliances and concessions made throughout the 1990s and early 2000s between the leaders of the country's two most powerful political parties, the nominally leftist FSLN and the conservative Constitutionalist Liberal Party (PLC).[3] The cartoon focuses largely on the Pacific region and features an image of a *caudillo* (strongman) figure seated on a horse as he smiles and gestures at his poverty-stricken country. The area he occupies belongs entirely to the nation's land-rich elite who control vast tracts of arable land in the central Pacific region. A dilapidated house stands as a painful testament to the impoverished conditions under which nearly all the population lives, while the reader is informed about ongoing border conflicts with Costa Rica and the ecological destruction of the region's major lakes and water sources. Finally, the map sketches out the uneven distribution of wealth in the country by highlighting the Pacific coastline as the preferred vacation spot for the nation's ruling class.

It is the representation of the Caribbean Coast, however, that is most intriguing. The region is entirely separated from the rest of the country. A large sign warns that the coast has been handed over to the international drug trade. The waters of the Caribbean are identified as Colombian waters where traffickers travel freely. A light-skinned man, presumably Colombian, walks throughout the southern region of the coast, a gun raised in one hand and a suitcase overflowing with cash in the other. Like tourist maps of the 1950s and 1960s, this political cartoon contains textual and visual markers that highlight the various products and industries for which the region is known. According to this map, the Caribbean Coast only produces three things: *cocos, coca, y más coca* (coconuts, cocaine, and more cocaine).

At the top of the separated Caribbean Coast, a short description marks it as *una zona de negros,* a Black zone—a designation that seems particularly strange given that the migration of landless mestizo farmers to the coast since the 1990s has made Afro-descendant peoples increasingly a minority in the region. Nevertheless, the characterization of the region as a lawless *zona de negros* continues to persist in the Nicaraguan spatial imagination. Thus, as this political cartoon aptly illustrates, the racialization of space in Nicaragua is not simply a matter of demarcating cultural, regional, and historical differences between the Pacific region and

the Caribbean Coast but is also preoccupied with the containment of counter-national Blackness. Relegating Blackness to the coast not only provides a clear "Other" against whom the nation defines itself but also allows the myth of Nicaraguan mestizaje to persist while simultaneously writing Blackness out of popular and official narratives of shared national history, identity, and citizenship (Hooker 2010; Ramírez 2007). In other words, mestizaje is not simply a social discourse but is also a geographical project that, borrowing from Ruth Wilson Gilmore (2002), actively displaces racial difference through the social construction of space.

The cumulative effect of these spatial representations is to reproduce the idea of Black communities as the nation's domestic "Other" while naturalizing the political and economic exclusion of these communities as a site of criminality and anarchy. This discursive representation illustrates, as Charles Mills argues, how racial states create norms of national space and citizens through a spatial tautology that naturalizes the characterization of racially subjugated groups as counter-national subjects whose Otherness is embedded in the landscapes that they inhabit. Thus, ontology and space enact "a circular indictment: 'You are what you are in part because you originate from a certain kind of space, and that space has those properties in part because it is inhabited by creatures like yourself'" (Mills 1997, 42).

This racial/spatial commonsense is articulated not only in political cartoons and state policy toward the coast but also in general perceptions of the region by mestizos from the Pacific. In a 2005 study by the United Nations Development Program (PNUD in Spanish), researchers asked 900 mestizos from the Pacific a simple question: "What have you heard about the Caribbean coast of Nicaragua?" More than 35 percent held largely negative views of the region as a dangerous area with high levels of drug trafficking and drug abuse, delinquency, and violence, and another 7.7 percent focused on the region's extreme poverty, high unemployment, and economic underdevelopment.

Even more troubling, 33.2 percent of mestizo respondents reported that they did not know anything at all about the coast. As one of the few surveys that systematically tracks mestizo perceptions, the PNUD study provides empirical evidence of how racialized ideas about the coast circulate in Nicaraguan society even among those who have never been to the region. Bluefields is a forty-five-minute plane ride from Managua, and yet it is still common for costeños living in the Pacific to report that their mestizo neighbors, classmates, and colleagues ask them if they need a passport to visit the coast. Many mestizos continue to view the region as a site of radical racial difference, as reflected in the widespread belief that Black and Indigenous costeños practice witchcraft, have looser sexual morals, and are all involved in the growing regional drug trade or otherwise engaged in the kinds of illicit social behaviors that mark one as unfit for citizenship.

Importantly, this negative evaluation of the "costeño Other" contrasts with the positive national valorization of the respondents who recognized "the existence of a diversity of languages and cultures in the autonomous regions as factors that enrich

national society and culture" (PNUD 2005, 7). Seventy-two percent of respondents from the Pacific identified the coast as a region with "pretty cultures, lots of culture and tradition," referring to the region's diverse cultural celebrations, musical and dance traditions, its Afro-Caribbean foodways, and its racial diversity. Although this demonstrates how multicultural discourse has become a normative feature of Nicaraguan racial/spatial commonsense, these newly integrated narratives have done little to challenge racist perceptions of the region. Mestizos' engagement with multiculturalism remains largely in the realm of the folkloric and thus exists alongside entrenched discourses of regional anti-Black racism that mark the coast as outside the national body (Simmons 2018; Hooker 2010; Cunningham 2006; Ramírez 2007).

Furthermore, this articulation of folkloric multiculturalism has not radically transformed the colonial logics that mark the coast as a source of raw materials and natural resources vital for national economic growth. Approximately 78 percent of respondents to the PNUD study, for example, believed that the coast's primary importance to the nation lay in its natural resources—water, lumber, seafood, gold, minerals, biodiversity, and potential oil reserves—whose exploitation could improve the national economy. The study participants tended to imagine the coast as a "'promised land,' an uninhabited territory, or as a repository of riches that belongs to the majority Nicaraguan society by manifest destiny and divine will" (PNUD 2005, 8). The perception that Black and Indigenous communities lack the rational capacities to realize the region's economic potential constitutes a central part of the governing logics that shape the state's approach to the management of multicultural citizenship rights ostensibly designed to give these communities greater control over their lands and natural resources.

The formal adoption of multicultural citizenship reforms failed to alter these perceptions. Moreover, these spatial tropes continue to mark Black communities as subnational citizens. Afro-descendant communities still struggle to assert their collective multicultural rights to land, self-governance, and self-determination and to make their demands legible in the mestizo national public sphere. These struggles are particularly pronounced for Black women, who have emerged in the last twenty years as the most visible defenders of the rights of costeño communities. How does the geography of race inform Black women's political subjectivity, their intimate lives, and their experiences of citizenship and national belonging? How does the gendered racial geography of the country inform these women's political practice and place-based activism in an era of authoritarian resurgence? And finally, what happens when Black women step outside their assigned social location and attempt to rearticulate their place in the national body politic?

BLACK WOMEN IN THE MESTIZO NATION-STATE

On February 27, 2010, Scharllette Allen Moses was crowned Miss Nicaragua in the Ruben Darío Theatre in Managua, making her the first Black woman and costeña

to win the title. Coming from a region that is considered a cultural and economic backwater, her selection carried enormous symbolic weight. The contest result sparked a frenzy in Bluefields, and the entire city poured into the streets to celebrate Allen's victory. The celebration that night was particularly festive in Barrio Beholden, one of the oldest Creole neighborhoods in the city where Allen grew up. Local residents framed her victory as a historic moment for Creoles on the coast who for years had watched a string of promising young Creole women fail to win the crown. For many Creoles, the glass ceiling that Black women persistently encountered in the competition mirrored the region's tenuous relationship to the Pacific and confirmed that the mestizo nation was not prepared to accept a Black woman as the embodiment of Nicaraguan national identity (Castillo 2010; *El Nuevo Diario* 2010a, 2010b; Jarquin 2010a, 2010b; Mendoza 2010).

Beauty contests are contentious sites in which diverse groups struggle over the meanings of national identity, difference, and citizenship (Banet-Weiser 1999; Barnes 1994; Craig 2002; Rahier 1998; Wu 1997). Allen's victory ignited a national debate on race and citizenship in Nicaragua that unfolded in the nation's newspapers and media, particularly in the online editions where readers commented on articles covering the newly crowned costeña. On the one hand, many mestizos saw Allen's victory as a reaffirmation of Nicaraguan multiculturalism and racial progress. To them, Allen was "an emblem of unity between the Pacific and the Caribbean." Criticizing racist attacks on Allen's election, another reader argued, "Our country is mixed where we all coexist and where we have beautiful women of all races and mixtures. The queen from the Caribbean is *Nica*, she drinks *pinol* and is adorable" (*El Nuevo Diario* 2010b). By placing Allen within the hegemonic limits of mestizaje and linking her to cultural markers of Nicaraguan national identity and mestizo culture—for example, by highlighting her consumption of *pinol*, a traditional beverage of sweet cornmeal and cacao—the author attempted to mark Allen as *puro pinolera*, an ideal representative of the mestizo nation.

Allen's detractors, in contrast, questioned her suitability for this role in both racial and spatial terms. Allen's Blackness and place of origin, they argued, placed her outside the boundaries of the mestizo nation, rendering her incapable of representing Nicaragua to the world. In an article in the national daily newspaper, *La Prensa*, one reader stated, "She should represent *costeños* but not Nicaragua in general." Another dismissed Allen by simply stating, "She looks like my maid," and another argued, "This is not a racist comment but a *morena* or Black woman or whatever you want to call her does not represent our country's mestizo culture, Blacks are not a predominant race in our beautiful Nicaragua, or am I mistaken?" (Mendoza 2010). Another reader described Allen in more disparaging terms, as "a bit *quemada* [burnt] but great tits." These comments illustrate that, even though multiculturalism had become the state's hegemonic discursive framework for managing racial difference, mestizos are still asserting themselves as the nation's normative racial subjects while simultaneously disavowing the persistence of anti-Black racism in the project of mestizaje.

The debates over whether a Black woman could represent the mestizo nation-state also spoke to implicit, deeply held ideas about the place of Black women in the body politic. The comments from mestizo Nicaraguans on social media and YouTube video clips revealed a wide range of controlling images of Black femininity that persist in the mestizo racial imagination. If, as a Black woman, Allen was unfit to be a symbol of the mestizo nation-state, mestizo commentators were clear about what she and women like her are fit for: domestic labor, sex work, or performing regional, folkloric cultural difference. These discursive representations of Black women as maids or hypersexual objects of desire—mark Black women as non-national subjects. Although these two narratives are the primary tropes that have historically framed Black women's experience of marginal citizenship, they are part of a broader, more complex bundle of racial tropes that objectify Black women and place them outside the political life of the nation.

In the postrevolutionary period, a new set of discursive representations of Black femininity emerged that continued to characterize Black women as marginal subcitizens. These representations were circulated by news media, NGO reports, popular culture, and literary depictions of Black women as hypersexual objects of desire; long-suffering, hypermoral superwomen; drug traffickers corrupting and destroying society's moral fabric; bad or absentee mothers whose outward labor migration has resulted in the deterioration of the Creole family unit; and, more recently, hysterical feminists whose departure from normative gender roles has left them emotionally confused, sexually "frustrated," and politically dangerous. These tropes are deployed and reproduced in ways that are unpredictable and often contradictory. Nevertheless, they are linked by their function: the marking of Black women as marginal citizens.

Representations matter. These commonsense racial narratives obscure Black women's political subjectivity and make their activism illegible to broader national publics. As Keisha-Khan Perry (2013) notes in her study of Afro-Brazilian women's leadership in an urban land rights struggle in Salvador da Bahia, Black women are rarely recognized as leaders of social movements. This tendency erases their geographies of struggle and how they challenge dominant narratives of citizenship and national identity. This historical erasure has made it difficult to locate Black women in the archives and to document their participation in regional struggles against state violence and authoritarianism. It is the basis for the discourse of invisibility that defines Black women's place in a mestizo nation (Hill Collins 2000). Black women have become the *lingua franca* of racial difference and shape how mestizos understand the spatial boundaries of citizenship, even in the age of multicultural recognition. When Black women challenge these racial norms by inserting themselves into the political life of the nation—whether in symbolic ways like the Miss Nicaragua pageant or as community activists and regional advocates—they not only disrupt these commonsense narratives that normalize Black women's invisibility but also expose the discursive architecture that produces this exclusion.

In so doing, Black women activists are pointing to new kinds of political possibilities whose outcome remains unpredictable. For if the historical experience of Black female subjectivity in the West has been one of persistent pornotroping and misnaming, it also highlights alternative ways of thinking about Black personhood that are not limited to the restrictive and exploitative forms of naming that define Black women as political subjects (Spillers 1987). In other words, what if we read Black women's activism as a demand for national inclusion on terms that refuse the normative logic of slow genocide and racial exclusion enacted by the mestizo state? What kinds of political possibilities might then come into view? And how might these insights be operationalized to counter these long-standing forms of exclusion and create "more livable human" arrangements of power (McKittrick 2006)?

THE *CAUDILLO* RETURNS

In November 2016, President Daniel Ortega, alongside his wife and vice-presidential running mate, Rosario Murillo, won his third consecutive term in an election that was characterized by historically high levels of voter abstention and widespread electoral fraud. For political commentators inside and outside Nicaragua, his victory seemed to confirm the long-held suspicion that the country had returned to the path of authoritarianism. Ortega is an enduring figure who has been a central figure in Nicaraguan politics for more than forty years (Thaler 2017; Medina 2018; Morris 2010). He first came to prominence in 1979 as a leader in the Sandinista revolution, which overthrew the dictatorship of Anastasio Somoza Garcia, ending the longest-lasting family dynasty in the hemisphere. Ortega later served as the president of Nicaragua from 1985 to 1990, when he lost to the conservative opposition leader, Violeta Chamorro. The FSLN made political history when it quickly recognized the election results, marking the first peaceful transfer of power and the beginning of the democratic transition in Nicaraguan politics. As he ceded power to the Chamorro administration, Ortega vowed that the FSLN would continue to "govern from below" and thereby continue the project of social transformation initiated under the Sandinista revolution.

Following this stunning defeat, Ortega began to pivot from the ideals of the revolutionary project toward an increasingly pragmatic, caudillo-style approach to politics. Over the next sixteen years, he tightened his control over the FSLN party structure, driving out internal dissidents and formalizing a system of internal party patronage designed to enforce and reward loyalty to him. Ortega's influence, however, was not confined to manipulating the workings of the party. Throughout the 1990s and early 2000s, the FSLN maintained a strong presence in the National Assembly, which Ortega used to pass legislation that increased his odds of regaining the presidency while systematically weakening both the liberal opposition and former Sandinista militants who founded the leftist option party, the Sandinista Renovation Movement (MRS). This was illustrated most clearly

when Ortega signed what is infamously known as "the pact" with then-president Arnoldo Alemán of the Constitutionalist Liberal Party, which granted Alemán immunity from a slew of corruption charges while allowing him to maintain his influence on electoral politics.[4] In exchange, Ortega negotiated a change in electoral rules that lowered the threshold for a presidential victory from 45 to 40 percent, or 35 percent if the winning candidate led by 5 percent or more (Thaler 2017, 158). For many, the pact demonstrated that Ortega had embraced the same practices of corruption, backroom negotiations, and *caudillismo*, or strongman politics, that have historically stymied democracy-building efforts in Nicaragua (Walker and Wade 2017; Jarquín et al. 2016; Martí i Puig 2010; Morris 2010).

The pact achieved Ortega's aims. In 2006 he won the national election with only 38 percent of the vote, far less than the support he garnered when he ran in 1996 and in 2001. On assuming the presidency in 2007, it quickly became clear that after years of governing from below he had no intention of being placed in that position again. Following his return to the presidency, Ortega and his wife Murillo systematically began to consolidate power. They asserted control over all four government branches: the executive, the National Assembly, the court system, and the Supreme Electoral Council. They then used their influence in the National Assembly to pass laws granting the executive increased authority over the army and the police, giving the president more power to make judicial and civil service appointments, and ending consecutive presidential term limits (Jarquín et al. 2016; Walker and Wade 2017).

Ortega further consolidated his hold on state power by developing strategic alliances with the private sector represented by the Superior Council of Private Enterprise (COSEP) and the Catholic Church. Despite his scorched-earth political rhetoric renouncing economic imperialism, Ortega proved to be a pragmatic neoliberal administrator, quietly upholding free-trade agreements, working with multilateral financial institutions to ensure favorable conditions for foreign investment, and permitting the expansion of free-trade zones. In exchange for support from the Catholic Church, the FSLN helped approve a controversial total abortion ban including in cases of rape, incest, and when the pregnancy endangers the life of the pregnant person (Kampwirth 2008; Lacombe 2013).

The administration formalized the FSLN's practice of clientelism and patronage to ensure voter loyalty. Soon after returning to office, Ortega made public education free and compulsory, established a free lunch program for schoolchildren, and launched a series of infrastructure programs to electrify rural communities, provide farmers with seeds and farm equipment, and distribute aid to poor families. Access to many of these programs, however, was determined by the Citizens' Power Councils (CPCs; later renamed the Life, Community, and Family Cabinets), which exercise discretionary oversight over antipoverty programs. Critics accused Ortega of using the CPCs/Family Cabinets to maintain the appearance of neutrality while ensuring the support of the party's electoral base (Bay-Meyer 2013; Thaler 2017; Walker and Wade 2017).

In June 2013, the FSLN-dominated National Assembly approved Law 840, *Ley Especial para el Desarrollo de Infraestructura y Transporte Nicaragüense atingente a El Canal, Zonas de Libre Comercio e Infraestructuras Asociadas,* which granted a concession for the construction of an interoceanic canal to the Hong Kong Nicaragua Canal Development Co. (HKND), a private Chinese firm. The bill was introduced and passed in three days without public or legislative debate or any comprehensive study of the proposed canal's environmental impact or its impact on communities that would be directly affected by the construction. If completed, the canal, which is projected to be three times the size of the Panama Canal, would be the single largest infrastructure project in modern history. Within days, environmental groups, human rights organizations, and Black and Indigenous activists filed thirty-one constitutional challenges against the Ortega administration, the largest number presented against a single law in the nation's history (Amnesty International 2013; Anderson 2014, 2015; Baltodano 2014; CENIDH 2013; Cupples and Glynn 2017; Ortega Hegg 2013a, 2013b).

Law 840 provides HKND with sovereign control over the canal's infrastructure and property for fifty years with the possibility of a fifty-year extension. It gives the government broad powers to expropriate private property, protected areas, and constitutionally protected Afro-descendant and Indigenous communal lands. At the time of this writing, the state has not made any demonstrable progress on the construction of the canal, apart from a December 2014 ground-breaking ceremony in the Pacific coastal town of Brito (Anderson 2015). Ortega has not spoken publicly about the canal in years, and it appears unlikely that the project will come to fruition. Nevertheless, Law 840 remains on the books, providing the state with the legal means to seize property, thereby compromising the nation's sovereignty and endangering the environmental well-being of the country. Most importantly, for Black and Indigenous communities, Law 840 is a legal loophole that allows the state to circumnavigate the Autonomy Law and Law 445 and "legally" seize their communal lands in the name of economic development (CALPI 2017; Acosta 2014, 2016).

For many domestic critics, this process seemed disturbingly familiar. Once again, a single powerful family has positioned itself at the center of national politics to serve its own ends. In 2013 when I returned to conduct follow-up field work, I observed the phrase, *"Ortega y Somoza son la misma cosa* (Ortega and Somoza are the same thing)" spray-painted onto walls and buildings throughout Managua. Scholars, journalists, and political critics have increasingly argued that the Ortega administration marked the return of dynastic, family rule to Nicaraguan politics and a calculated dismantling of the nation's short-lived democratic experiment (Jarquín et al. 2016; Belli 2016; Martí y Puig 2013; Salinas Maldonado 2017).

What distinguishes this historical moment, however, is the emergence of new political solidarities between diverse political actors that have collectively articulated a broad-based critique of the Sandinista party-state. This new bloc is made up of five key groups: Sandinista dissidents, the women's and feminist movement,

environmentalists, anti-canal campesino activists, and Black and Indigenous activists. The first group includes former Sandinistas who either left or were expelled from the FSLN in the 1990s and early 2000s after they became increasingly critical of Ortega's cult of personality. They include figures such as Dora María Téllez, former vice-president Sergio Ramirez, Carlos Fernando Chamorro, Mónica Baltodano, Sofia Montenegro, and Gioconda Belli; with many others they form the nucleus of a dissident intellectual bloc of journalists, writers, artists, NGO leaders, and academic researchers. In the mid-1990s, several of these figures formed the Sandinista Renovation Movement, a center-left political party committed to upholding the ideals of *Sandinismo* while working to strengthen the democratic process and the nation's political institutions.

Feminist activists have also directly challenged the Ortega administration. In addition to enacting the total abortion ban, the FSLN has attacked the efforts of the feminist movement to end violence against women by imposing a discourse of unity and family values that prioritizes the maintenance of the family unit over the defense of women's human rights. Feminists decried these measures and accused the government of letting women die under the guise of upholding a family values agenda. In response, the government launched a defamation campaign against members of the feminist movement, accusing them of witchcraft, pedophilia, lesbianism, and destruction of the heteronormative nuclear family. Feminist activists were among the first to experience the full brunt of the Ortega family-party-state's assault on civil society and have become its most vocal critics, speaking out about gender and sexual violence, the epidemic of underage pregnancy resulting from rape, and the government's ongoing failure to protect women and children from gender violence (Jubb 2014; Kampwirth 2008a, 2008b; Neumann 2017).

Environmental activists also joined the growing movement against the Sandinista party-state after the passage of Law 840. They developed alliances with mestizo campesinos whose properties and livelihoods are threatened by the canal project; these alliances coalesced in the formation of the Council for the Defense of the Land, Water, and Sovereignty. By 2017, the mestizo farmers' movement had organized nearly ninety marches against the law in rural communities and the nation's capital. The marches drew widespread national and international support from former FSLN militants affiliated with the MRS, environmental groups, and celebrity supporters, including Bianca Jagger (Goett 2016; Ortega Hegg 2013a; Vásquez 2017).

Black and Indigenous activists also emerged as important political actors in the growing movement against the Ortega administration. In the weeks following the passage of the canal law, Black and Indigenous activists and community leaders from the coast filed one of the first suits against the state, alleging that the passage of the law and the granting of the canal concession to HKND violated their communities' rights to free, prior, and informed consent (Nicaragua Hoy 2013; CENIDH 2013). Environmental activists and human rights and legal organizations throughout the country also filed suit against the government. The FSLN-controlled

Supreme Court of Justice dismissed thirty-one of these suits (Alvarez 2013; Complejo Judicial Central Managua 2013). In 2015, Black and Indigenous activists testified before the Inter-American Commission on Human Rights in Washington, DC, that the Ortega administration had violated their collective multicultural rights and undermined regional autonomy by dismantling local governing bodies, a process I discuss more fully in chapter 6.

Yet as Cupples and Glynn (2017, 8) note, these anti-Ortega groups "occupy very different political geographies within Nicaragua and have generally distinct political concerns that converge in their shared opposition to Sandinista authoritarianism, corruption and perpetuation of electoral fraud and in their mutual resistance to the canal project." Thus, although these political actors share a critique of the Sandinista state, their analyses of the origins of the crisis differ. Mestizo political commentators have largely not examined the "racialized dimensions" of the Ortega administration's "strategies of hegemonization" (9). In many ways, this is indicative of a much longer history among the mestizo intelligentsia of ignoring the centrality of race to modern Nicaraguan state formation and nation-building. Indeed, mestizo scholars have often tended to treat the problems of the coast as matters of parochial politics that are tangential to building meaningful representative democracy—despite the fact that, historically, the coast has been the site of many of these national debates over sovereignty, nationalism, nation-building, economic development, and the meanings of democracy. For example, a recent edited volume about the various modes of de-democratization and the rise of authoritarian government under the Ortega administration does not contain a single mention of the coast, the region's struggles over land rights, debates over extractive development projects, or the growing movement to resist the state's unconstitutional dismantling of regional autonomy (Jarquín et al. 2016). This absence illuminates an important reality: from nineteenth-century efforts to consolidate the boundaries of the national territory by "reincorporating" the multiracial coast into the mestizo nation-state as an exercise of sovereignty, to twenty-first-century mega-project development schemes that never seem to materialize, the logic of anti-Black racism and regional difference has underwritten the state's policies toward the region and its inhabitants. As the authoritarian turn deepens, Black activists have become more vocal about the violence that these policies engender and their deadly effects.

AUTHORITARIANISM, GENOCIDE, AND MULTICULTURAL DISPOSSESSION

Since returning to office, Daniel Ortega has deployed the rhetoric of multicultural recognition and antiracism to bolster his administration's narrative of reconciliation, democratic nation-building, socially progressive development, and the restitution of the rights of historically marginalized communities. During a speech in

Masaya in 2016, Ortega took the opportunity to criticize anti-Black state violence in the United States, pointing to the high levels of police abuse and the killing of Black people: "They keep killing young people because they are Black; for them a Black man is a delinquent and they kill him."[5] The irony of Ortega's comments was not lost on Black activists who argued that they had accused the Nicaraguan government of engaging in similar patterns of anti-Black racism, critiques that the state has vigorously denied. In many ways, their struggles making plain the structural underpinnings of anti-Black racism in Nicaragua reflect the contradictions of contemporary official multiculturalism in Latin America.

The challenges that Black activists face in their struggles with the Nicaraguan state mirror similar patterns throughout Latin America and the Caribbean. The multicultural turn that unfolded in the region following the democratic transition in the 1980s and 1990s marked a profound shift in Latin American state discourses of citizenship. Nicaragua was the first Latin American country to approve multicultural citizenship reforms that recognized the rights of Afro-descendant and Indigenous peoples to communal land claims, autonomous governance, multilingual education, and recognition of cultural difference, but several countries have adopted similar constitutional reforms since then. Yet, these reforms, although significant, have not radically altered ongoing patterns of anti-Black racism in Nicaragua. Mirna Cunningham (2006, 5) argues that the "central problem continues to be the form and behavior of the National State: mono-ethnic, exclusionary in its concept of citizenship and in the distribution of goods and services." Additionally, even though the juridical discourse around regional autonomy and communal land rights has been rearticulated under the official narrative of multiculturalism, these reforms have not only been undermined by persistent state corruption and a lack of political will to meaningfully support the autonomy process but also have been diminished by the effects of neoliberal economic reform in the country since the early 1990s.

Despite its seemingly inclusive tenor, the rhetoric of multiculturalism has largely failed to unsettle mestizo hegemony in Nicaraguan nationalist discourse. The political scientist Juliet Hooker (2005a, 16) argues that multicultural discourse has been absorbed into the historical project of mestizo nationalism in ways that reproduce the idea of "Nicaraguan national identity as preeminently mestizo." She claims that, rather than relying on pseudoscientific, biological notions of mestizaje rooted in the romanticized encounter between Indigenous women and Spanish conquistadores, contemporary "mestizo multiculturalism" is premised on the idea that, "when taken as a whole, the entire nation is mestizo because of the different racial and cultural groups that comprise it" (16). Thus, mestizo multiculturalism inhibits the assertion of critical racial subjectivities that challenge the ideological bases of mestizo nationalism.

Black and Indigenous communities in Latin America have not passively accepted state efforts to neutralize the radical political demands for territory, autonomy, and self-determination that lie at the heart of the multicultural turn. Rather they have

used the tools of human rights advocacy to compel their governments to make good on the many promises of multicultural reform. Those efforts have not been well received by their home governments. Following Charles Hale's work on multiculturalism and Indigenous politics in Guatemala, the Afro-Colombian scholar Agustín Lao-Montes (2009, 230) argues that the multicultural and turn has produced a new kind of activist subject—the "*afrodescendiente civilizado*"—that the state and neoliberal institutions tend to favor precisely because they "do not challenge the established order." Neoliberalism is not simply an economic project but a deeply cultural one invested in "the creation of subjects who govern themselves in accordance with the logic of globalized capitalism" (Hale 2008, 17). Hale argues that neoliberalism and state policy converge in the production of "the indio *permitido*," a new political subject who can perform good cultural difference rather than disruptive, transformative, unruly forms of cultural difference. Simply put, states and transnational institutions deploy the discourse of multiculturalism to contain and domesticate the political demands of racial justice movements.

Those political subjects who fail modernity's test and refuse the imposition of neoliberal development projects have become the targets of state-led efforts to discredit, disparage, and delegitimize Black and Indigenous social movements. The consequences for activists who fail to perform the role of the *indio permitido* or the *afrodescendiente civilizado* are often tragic. Since I began working in Nicaragua in 2004, I have seen the phenomenon of repression and state violence intensify in the region and witnessed the growing assault on Black and Indigenous human rights activists—particularly women who emerged as key leaders in popular movements throughout the hemisphere. The names of women murdered for defending the rights of their communities is turning into a mournful roll call of the fallen: Digna Ochoa in Mexico in 2003; Berta Caceres in Honduras in 2016; and in 2017, the Afro-Colombian peace activist, Emilsen Manyoma, who was found decapitated along with her husband, Joe Javier Rodallega, on the outskirts of the city of Buenaventura.

According to the organization Global Witness (2017), at least 185 human rights defenders were assassinated all over the world in 2015; 122 were killed in Latin America. A 2016 report by Oxfam found that women human rights defenders are significantly more likely to be the targets of frequent and intense forms of "stigmatization, hostility, repression, and violence." In short, it is clear that defending the rights of Black and Indigenous communities is dangerous work and that those activists who fail to perform the role of the "*indio permitido*" or the "*afrodescendiente civilizado*" run the risk of losing their lives doing this work. Multicultural inclusion, as Christen Smith (2016, 6) reminds us, comes at a price: "Black inclusion into the national fabric follows a logic of permissibility that allows only those Black bodies and spaces marked as acceptable to participate in the national project, and leaves the Black masses at the margins."

These spectacular forms of state violence, however, can also eclipse the more mundane, systemic, and structural forms of violence that the masses of Black

people encounter in their everyday negotiations with and struggles against the state. Throughout Latin America, Afro-descendant communities are significantly more likely to live in conditions of economic precarity, political repression, and social exclusion. These structurally violent conditions are, as João Vargas (2008) argues, a normalized feature of Black social life throughout the Americas. They are forms of violence that remain unremarkable—even under an official multicultural order. It is precisely these unequal conditions that produce premature social, political, and physical death. Yet, the official multicultural discourse in Nicaragua and throughout Latin America tends to obscure "the economies of Black suffering that sustain it." In Nicaragua, Black activists have responded to this erasure by declaring that the Nicaraguan state is and has historically been engaged in a campaign of genocide against Black communities on the Caribbean Coast. They argue that, under the control of a range of ideologically divergent administrations, the state has conducted a systematic project to dispossess them of their communal lands and deprive them of the resources necessary to ensure their collective survival.

The United Nations defines genocide as "any intent to destroy, in whole or in part, a national, racial, or religious group." It can include but is not limited to "killing members of the group; causing serious bodily or mental harm to members of the group; deliberately inflicting on the group conditions of life calculated to bring about its physical destruction in whole or in part; imposing measures intended to prevent births within the group; forcibly transferring children of the group to another group."[6] Since the approval of the UN Convention on Genocide in 1948, Black activists and scholars throughout the Americas have used the term to describe the various legal, economic, social, and cultural means by which the modern state produces premature Black death, in whole and in part. In 1951, the Civil Rights Congress led a delegation to the United Nations charging the United States with genocide. William Patterson, then the organization's national executive secretary, compiled and edited the group's findings in a collection titled *We Charge Genocide: The Historic Petition to the United Nations for Relief from a Crime of the United States Government against the Negro People*. In the 1970s and 1980s, the Afro-Brazilian scholar and activist, Abdias do Nascimento, argued that the myth of racial democracy obscured a systematic regime of genocidal anti-Black racism that was reflected in the lack of access to housing, employment, and education and to disproportionate levels of police abuse and violence against Black people.

Yet, scholars of genocide studies have largely been reluctant to classify Afro-descendant peoples' historical experiences of state violence as a form of genocide. This stems in part from the tendency to define genocide as a historically specific term rooted in the Holocaust of European Jews during World War II. Genocide scholars have expressed concern that the term is inappropriately applied to social groups who, although they may have experienced brutal forms of discrimination, have not undergone genocide. Yet the definition provided by the UN suggests a much more capacious understanding of genocide than the scholarship suggests.

Anthropologist João Vargas (2008, 7) argues that the concern over banalization "prevents the possibility that the definition of genocide may be applicable, especially to specific, quantifiable, and recurring social processes in the African diaspora whose results are the disproportionate victimization of Black people." Smith (2016, 18) suggests that scholars of anti-Black state violence should theorize genocide not as an "historically determined, location-specific occurrence" but as an assemblage. In so doing, "we not only take into account its gendered/racialized/ sexualized/ classed contours, but also how it is tied to other similar iterations of violence across space and time." Vargas (2008, 10) offers the idea of a "genocidial continuum" as an analytical tool that enables scholars to "link various genocidal phenomena" ranging from the state-sponsored killing of black people to "quotidian acts and representations of discrimination, de-humanization, and ultimate exclusion" to demonstrate how symbolic and material forms of violence are mutually constituted.

Over the last decade, Black anthropologists have taken up the charge of anti-Black genocide and have analyzed its deployment by Black social movements throughout Latin America and the Caribbean (Smith 2016; Vargas 2008). Vargas (2008, 5) argues that the discipline needs to "come to terms with the deadly, often state—and society-sanctioned, yet seldom overt contemporary campaigns against people of African descent" that produce Black death. He claims that the social sciences' lack of attention to the violence and racial terror that Black communities have historically faced as a form of genocide reflects how Black suffering is normalized. Vargas offers the concept of a "genocidal continuum" that allows scholars to "link . . . various genocidal phenomena into a permanent, totalizing, and ubiquitous event . . . but also trace the resulting mass killing of Black people to quotidian acts and representations of discrimination, de-humanization, and ultimate exclusion" (10). That such conditions of anti-Black violence can persist in polities that espouse an official politics of multicultural recognition and national inclusion is not an aberration. Rather, as Smith (2016, 3) suggests in her critique of Brazilian racial democracy, we must analyze the highly "choreographed, theatrical performance between the state's celebration of [depoliticized, commodified, and folkloric] Blackness and the state's routine killing of the Black body." Rather than disrupting this genocidal campaign, multiculturalism as a discursive project and public policy has provided new cover for the violence that Latin American states enact against Black communities.

In November 2017, George Henriquez, a local Creole activist, published an editorial in La Prensa titled "How Is Ethnic Genocide Carried out in Nicaragua?" He describes genocide as a cultural, political, and economic process that systematically deprives minority communities of resources while simultaneously normalizing these forms of dispossession. He begins by stating, "Firstly, we understand genocide as the systematic extermination of a social group motivated by questions of race, ethnicity, politics, or nationality." He argues that, in Nicaragua, genocide against Black and Indigenous peoples has been a slow, gradual process "led by

national political parties towards the peoples of the Caribbean Coast, beginning first with the country's liberal governments and continuing now with the leftist government in power. The method between both parties might be different, but the end has been the same."

As Henriquez's comments illustrate, Black activists on the Caribbean Coast have long criticized the violence and corruption of the Nicaraguan state, arguing that inequalities have been reproduced under multiple administrations across the political spectrum. These activists call into question the traditional distinctions between the Right and the Left in Nicaraguan politics, revealing how ideologically diverse governments shared a disregard for Black life along the coast while remaining invested in a domestic colonial logic that views the region as a wild, unconquered source of raw materials and of racial difference that undermines the project of mestizo nation-building. As Jennifer Goett (2018, 26) argues, their critiques reveal that "traditional ideological and political divisions between the Latin American Left and Right have limited utility" for understanding the relationships that grassroots political actors have to the state.

As a cultural and discursive practice, genocide requires the erasure of a people's social history and the denigration of its cultural traditions and collective identity. In the words of Henriquez (2017), it requires "getting rid of their histories, eliminating signs of their struggles, heroes, and battles so that this way the youth will have no positive images of their ancestors." The next step involves disparaging the community's cultural practices and language to such a degree that the community begins to reject its own language and overvalue the language of the ruling class. The dominant class then imposes its culture, history, and values onto the community, reinforcing its own discursive hegemony.

As a process of political dispossession, Henriquez (2017) argues that the state enacts genocide through its co-optation of local leaders who are "easily bribed with trips, public posts, jobs and other luxuries" at the expense of their communities' well-being. These patterns of co-optation breed conflict and instability within the community, making it difficult for community members to mobilize against the state to defend their collective interests. The co-optation of local leaders, who put a softer, multicultural face on the state's neocolonial policies in the region, is an example of what Joy James (2009) terms "auto-genocide"; that is, the ways in which members of oppressed groups, particularly community elites, can become complicit in the structures and practices that reproduce genocide. In Bluefields, activists and community members are especially critical of the way that the Sandinista party-state has used co-optation as a strategy to weaken and undermine Black political mobilization in the region.

Finally, as an economic process, genocide deprives communities of the resources necessary to reproduce life itself. In this process, the state and the private sector reduce the territories of targeted communities, limiting the space needed for "housing, cultivation, fishing, agriculture." Henriquez observes that the loss of resources and economic opportunity on the coast has led to increased labor

migration by well-educated Creole youth, diminishing the region's human capacity and radically decreasing the community's ability to defend itself politically. The state justifies this dispossession by describing these communities as "ignorant savages for having a *cosmovisión* of conservation and coexistence with nature and utilizes the excuse that they are ignorant and savages for not having an extractive, destructive, looter mentality towards natural resources" (Henriquez 2017). As Henriquez suggests, mestizo political elites and the state have enacted the project of Black genocide through various nationalist schemes across the political spectrum, using a variety of strategies ranging from forcible assimilation and malign neglect to revolutionary nationalism and the violence of neoliberal economic reform.

It is controversial to suggest that the Nicaraguan state is engaged in a campaign of anti-Black genocide. Such claims fly in the face of long-established discourses of Latin American racial exceptionalism and newer narratives of harmonious multiculturalism that states have historically deployed to buffer themselves from critiques of structural racism. Yet this is precisely what Black activists have argued: that the Nicaraguan state in both its democratic and authoritarian iterations has enacted genocide against Black communities through a structured campaign of dispossession, displacement, and exclusion. Following their lead, I argue that since the end of the revolutionary period, the Nicaraguan state—both the neoconservative, free-market liberal administrations and the nominally leftist Sandinista administration—has enacted the long-standing historical project of Black death through what I term "multicultural dispossession." Multicultural dispossession describes the many ways in which state actors and institutions drain multiculturalism of its radical, transformative potential by espousing the rhetoric of democratic recognition and simultaneously supporting illiberal practices and policies that undermine Black political demands and weaken the legal frameworks that support their claims against the state. These forms of dispossession comprise the very heart of the state's genocidal assault on Afro-descendant communities. This violence was not produced solely by the Ortega administration; it is also the product of the violent economic effects of multiple conservative administrations of the 1990s and early 2000s that adopted neoliberal economic reforms that left Black and Indigenous communities increasingly impoverished and hollowed out regional autonomy as a tool for political self-determination.

Henriquez's editorial (2017) also demonstrates that costeño communities have not passively internalized these narratives but have begun to produce their own political counter-discourses. They have done so by drawing from the submerged history of Black-led costeño struggles against the mestizo state. As Henriquez writes, "Although they eliminate our history from the educational system and discriminate against our languages, the oral tradition of our fathers, mothers, grandfathers, and grandmothers creates a spiritual connection with our cultural inheritance and our histories of struggle. We have resisted, we will resist; it is not a question of wanting [to do so]; it is a question of resist or disappear."

Henriquez's article encapsulates a new mode of militant Black politics in Nicaragua, one that draws selectively from historic Black struggles to articulate a sophisticated critique of the racialized contours of twenty-first-century authoritarianism. It is a mode of political engagement that refuses the imposition of respectability politics and legibility to the state and instead espouses a radical diasporic critique of the state's legacy of anti-Black racism and regional exclusion. Black activists are actively refusing the state's efforts to disappear their communities and silence their political demands. In the face of the Sandinista state's co-optation of multicultural discourse and its growing authoritarianism, Black communities have had to recalibrate their activist strategies and modes of critique to resist new forms of multicultural dispossession. The state's persistent efforts to weaken regional autonomy, co-opt local politicians, create internal conflict within Black communities, and expand large-scale extractivist development schemes that will further marginalize and dispossess Black communities have inadvertently produced a new form of Black militancy on the coast that now poses one of the greatest challenges to the Ortega administration's efforts to consolidate its rule.

DIASPORIC LOCALITY AND THE STRUGGLE FOR BLACK LIFE

In October 2015, representatives from Black and Indigenous communal governments in the RACCN and the RACCS provided testimony in a hearing before the Inter-American Commission on Human Rights in Washington, DC. They outlined how the Sandinista party-state has repeatedly violated their collective cultural rights to land and political autonomy through a systematic campaign to discredit, marginalize, and displace local leaders from communal government spaces that have impeded the state's development plans. Dolene Miller and Nora Newball were among the small group of plaintiffs, and they spoke that afternoon on behalf of the Black Indigenous Creole community of Bluefields (Vilchez 2015; Comisión Interamericana de Derechos Humanos 2015b).

Newball shared how she was ousted from her position as president of the Bluefields Black-Creole Indigenous Government, the local governing body that oversees the administration of the territory, resources, and appropriations allocated to the community by the state. She delivered a pointed critique of the state's efforts to manipulate the discourse and mechanisms of official multiculturalism to advance its own political agenda in the region, thereby undermining the Bluefields community's constitutional rights to self-governance, self-determination, and self-representation. At the IACHR hearing, Newball and Cunningham both argued that state intervention in local government processes has become a key strategy of the administration to enact policies that undermine regional autonomy and further marginalize Black and Indigenous communities while maintaining an appearance of democratic order and the rule of law in the region. In her statement, Newball argued, "It is clear that this intervention within the organization of the

Black Creole community of Bluefields seeks to intimidate and repress the defense of our territorial rights."

The Ortega administration's efforts to undermine coastal communal governments and displace local Black leaders revealed the implicit racial logics that inform the enactment of the authoritarian turn. In her final remarks to the commission, Newball said, "It is troubling that during the International Decade for People of African Descent, we continue suffering discrimination and racism on the part of functionaries of the State of Nicaragua." She paused briefly, glaring at the state representatives seated on the other side of the room. "Afro-descendant peoples have ancestral rights on the Caribbean Coast of Nicaragua, and we have always lived in peace and harmony with the [Indigenous] peoples and nature Nevertheless, today we see how the same state that has approved the very laws that restore our rights now promotes the opposite, creating among the Afro-descendant people division, conflict, and confrontation" (IACHR 2015).

Newball and Miller's joint testimony and the state's repeated attacks on the Bluefields Black-Creole Indigenous Government reveal the many insidious ways in which multicultural dispossession operates as a modern tool of Nicaraguan statecraft. They outline in detail how the FSLN has co-opted local Creole leaders and used them as proxies to carry out development agendas dictated from Managua. They also reveal how the government has worked to sideline any political actors who oppose the state's heavy-handed approach to regional politics. But Newball's testimony is also significant because of how it links the struggles taking place in the region to broader political formations. Her scathing closing remarks reframed this domestic racial dispute in a larger discussion of Afro-descendant rights that is unfolding globally: namely, if Black dispossession can continue even under a system of democratic, multicultural recognition, then addressing the challenge of Black genocide requires much more than the simple extension of legal rights; it requires a deeper structural transformation of the state and the social order.

As Newball's testimony suggests, Black activists in Bluefields have developed a global analysis of anti-Black racism that directly informs their critiques of local and national racial formations. The critique of state violence as a form of racial genocide particularly resonates with broader discursive movements in the African diaspora and demonstrates how a global analysis of anti-Black racism directly shapes coastal activists' read on local and national racial formations. But these new modes of activist engagement in the transnational public sphere also reveal how Black women are responding to contemporary state violence by engaging in a politics of what I term *diasporic locality*. Put simply, diasporic locality describes how Black women engage in multiscalar forms of struggle and advocacy that link local struggles to broader racial justice movements currently unfolding throughout the Americas. Activists like Nora and Dolene are offering a radical critique of the excesses and abuses of the authoritarian turn and linking them to a hemispheric legacy of anti-Black racism and discrimination. They critique anti-Black racism as a global racial formation that lies at the foundation of Western liberal democracy.

Diasporic locality illustrates how political ideas, projects, and actors circulate across scales of power and struggle that link local mobilizations to transnational struggles for redress and racial justice. As I demonstrate in this book, Black women have engaged in these multiscalar forms of activism to challenge the state's exclusionary model of citizenship and national belonging. Over the last twenty years, Black women have begun to actively resist their erasure in broader official and popular narratives of Nicaraguan nation-building, producing their own counternarratives that rearticulate their place in the nation. They have done so by cultivating new modes of activist engagement and leadership that have brought Black women's situated knowledges to the center of twenty-first-century national debates over democracy, national sovereignty, the violence of the neoliberal economic project, the enduring legacy of mestizo nationalism, and the resurgence of authoritarian caudillo-style politics.

Although their critique focuses on the racial violence that defines the normative workings of the mestizo state, their activism has taken them from local struggles at the grassroots level to constructing imagined digital communities linked through social media platforms to advocating for the rights of Black and Indigenous communities in transnational human rights spaces. They have done this work using a variety of political strategies that include educating their communities through local radio programs, using social media to circulate information about local political struggles to digital publics around the world, and producing an alternative, unofficial archive that documents the state's systematic violations of Black people's collective rights. Black women have formed community-based organizations and host workshops on Black women's human rights in churches, community centers, and public parks. They have used the national court system to resist government encroachments on their land rights and the state's failure to protect Black women from gender violence. When this strategy has failed, they have taken their grievances to the international human rights legal system, as they did in 2015. They have begun to develop multiracial alliances with new, often unexpected allies in their struggles against the authoritarian state. Black women have also constructed their own hemispheric political networks, building solidarity with Black women's and feminist activists throughout the Americas.

Given the growing visibility of Black women activists as transnational political actors, it is tempting to read this shift as a new phenomenon. But I would argue that it is, to borrow from Audre Lorde (1985), a difference of scale and not of kind. My research on Black women's activism on the Caribbean Coast suggests that these modes of political engagement are not new; rather, they have been expanded by Black women's increased access to digital communication technologies, the development of transnational political networks, and international political institutions including philanthropic organizations, human rights governing agencies, and the international human rights legal system that have allowed Black women to advocate for the rights of their communities to a much larger public audience. But if we look to women's engagement with earlier diasporic political currents, including the

Universal Negro Improvement Association, Rastafari, civil rights, and Black femi-
nist thought of the late twentieth and early twenty-first centuries, the degree to
which transnational diasporic discourses of race, nation, and resistance shape and
are mutually informed by local struggles for racial justice becomes apparent.
Through a careful review of the limited archive of Creole women's historic activ-
ism, I construct a genealogy of these women's struggles against the mestizo
nation-state, which form the foundation of their contemporary struggles against
authoritarian state violence. Yet, even as Black women activists sharpen their cri-
tique of the state's historic and ongoing project of Black genocide, they also nar-
rate their activism as a reproductive politics through which they fight to create the
social, political, and economic conditions to sustain Black life.

A ROAD MAP

The book is divided into three sections that proceed in largely chronological order.
Part I: Genealogies constructs a historical genealogy of Afro-Nicaraguan women's
struggles with the state for regional autonomy, economic opportunity, and politi-
cal representation. It begins by analyzing Creole women's activism against state
violence and political disenfranchisement during the period of state moderniza-
tion and nation-building in the late nineteenth and early twentieth centuries.
I then analyze Black women's engagement with the Sandinista Revolution and the
ways in which Black female activists struggled to fuse their desires for racial and
regional justice with the revolutionary project of the 1980s. *Part II: Multicultural
Dispossession* analyzes how Black women have navigated the conditions of eco-
nomic precarity and political vulnerability that have resulted from austerity mea-
sures imposed during the era of postrevolutionary neoliberal economic restructuring
and the resurgence of state autocracy under the Ortega/Murillo administration.
Finally, *Part III: Resisting State Violence* charts the emergence of new modes of politi-
cal engagement that Black women activists have developed in response to the
intensification of state violence within the region. Specifically, I consider regional
Black women activists' feminist critiques of how the authoritarian state's imposi-
tion of what Elizabeth Dore terms "patriarchy from above" facilitates "patriarchy
from below," in the form of gender and sexual violence against Black women. The
section also examines Black women's leadership in the struggle for communal
land rights and the defense of regional autonomy in the face of systematic state
intervention into local political spaces.

 Chapter 1, "Grand Dames, Garveyites, and Obeah Women: State Violence,
Regional Radicalisms, and Unruly Femininities in the Mosquitia," explores
women's political activism and subjectivity by examining the biographies of women
who played critical roles during the forcible "Reincorporation" of the Caribbean
coast into the Republic of Nicaragua from 1893 through the 1950s. I focus on the
political life of Anna Crowdell, a Creole business woman and Mosquitian national-
ist who played a key role in Creole struggles for regional autonomy, economic

power, and territory. The chapter also examines the lives of less well-known women who make only sporadic appearances in the region's historical archive. Examining these women's lives reveals the complex ways in which gender, race, color, migration, and class shaped Creole women's political subjectivity and their modes of regional activism. Their experiences of labor migration, their encounters with transnational Black social movement, including the UNIA, and their engagement with regional struggles against state expansion and political repression produced new forms of Creole femininity, which fluctuated between what I term "strategic respectability" and "disreputable femininity," both of which served as critical modes of everyday, organized resistance to regional patterns of state violence.

Chapter 2, "*Entre el Rojo y Negro*: Black Women's Social Memory and the Sandinista Revolution," analyzes Afro-Nicaraguan women's participation in the Sandinista Revolution from 1979–1990. The chapter uses oral history and biography to foreground Black women's experiences and analyze their memories of the possibilities and the limits of the revolutionary period. Rather than being passive spectators or counterrevolutionary actors afflicted with false consciousness, Black women entered into the revolutionary process with their own deep political aspirations informed by both a socialist-inspired utopian vision of democratization and national sovereignty and by broader cultural and political currents in African diaspora thought. These Black female combatants, *brigadistas*, artists, and community workers fused a politics of diasporic locality in their revolutionary practice, influenced by the U.S. civil rights movement, Black nationalism, decolonial struggles in Africa and the Caribbean, Rastafari, and Black feminist thought. It also considers the experiences and critiques of Black women who were opposed to the revolutionary project for reasons that are more complex than official revolutionary narratives suggest. The chapter argues that this diasporic nationalist politics played a key role in framing Black women's demands for multicultural democracy, leading to the approval of Law 28, which established one of the earliest multicultural citizenship regimes in Latin America and formalized regional autonomy for Indigenous and Afro-descendant communities on the coast. The chapter concludes with these women's responses to FSLN's return to power in 2007, the legacy of Sandinismo in contemporary politics, and the authoritarian turn currently unfolding in Nicaragua.

Chapter 3, "Cruise Ships, Call Centers, and *Chamba*: Managing Autonomy and Multiculturalism in the Neoliberal Era," examines the political and social impacts on Black women's political subjectivity of free-market economic reforms in the postrevolutionary period. It examines how these economic policies have unfolded on the coast by studying the growing number of Creole women who have left the country to "ship out" and work on cruise ships and in other forms of service work in Central America, the United States, and the Caribbean. Faced with an increasingly precarious regional economy and with structural racism that limits their access to gainful employment, Afro-Nicaraguan women have used their cultural

capital as native English speakers to insert themselves into racialized transnational economies of domestic labor in the global tourist economy. They have also made use of the region's informal economy by "making *chamba*"; that is, inventing work in spaces where transnational capital has largely fled. This chapter draws from the insights of Black activists and Black women working in Nicaragua, the United States, and on cruise ships to consider what coastal communities have lost during the neoliberal period and how the economic pressures imposed by the wholesale adoption of free-market fundamentalism laid the groundwork for the co-optation of local leaders and institutions under the new Sandinista administration.

Chapter 4, "Dangerous Locations: Black Suffering, Mestizo Victimhood, and the Geography of Blame in the Struggle for Land Rights," examines how Creole women activists emerged as key leaders in the struggle for Black communal land rights. The chapter focuses on their involvement in a 2009 land occupation in Bluefields, which illustrates how these women articulated Black people's rights to the city in a politically hostile environment. I demonstrate how these activists strategically deployed the discourse of multicultural inclusion to articulate a politics of multiracial regional solidarity that presaged the political alliances that would later emerge in response to the canal law. Drawing from oral history and participant observation, the article engages Paul Farmer's (1992) concept of the "geography of blame" to address the fraught racial politics of conflicts over the urban Bluefields land claim. I deploy the concept to examine how mestizo encroachment on Afro-descendant and Indigenous communal lands is justified through a discursive strategy of mestizo victimhood that imagines mestizos as marginalized by Creole and Indigenous efforts to secure their communal lands by using the Autonomy Law and Law 445.

Chapter 5, "'See how de blood dey run': Sexual Violence, Silence, and the Politics of Intimate Solidarity," examines the local feminist political frameworks that Black women have produced to respond to the overlapping crises of sexual and gender violence against women and the authoritarian state's indifference to this problem. Over the last thirty years, a vibrant feminist movement has developed in Nicaragua; one of its central goals has been to "break the silence" around the widespread phenomenon of sexual and gender violence against women and girls. Although Nicaraguan women across race and class are subjected to gender violence, race and regionality complicate how that violence is perceived by the nation and addressed by the state. This chapter examines how the politics of race, place, and multiculturalism intersect in ways that make Afro-Nicaraguan women's experiences of sexual violence illegible to broader publics. Drawing from more than a decade of ethnographic research, I argue that examining Black women's complex speech practices suggests a need to complicate mainstream feminist narratives about the imperative to break the silence and instead to consider the structural mechanisms that silence Black women and the shift in material conditions that might enable Black women's speech. Finally, I highlight how Black women activists have begun to cultivate new forms of what I term "intimate solidarity" that

support Black women's ability to name their experiences of sexual violence on their own terms.

Chapter 6, "From Autonomy to Autocracy: Development, Multicultural Dispossession, and the Authoritarian Turn," examines how Black women activists have responded to efforts by the Ortega administration to undermine regional autonomy by stoking conflict between activists and distorting the struggle for communal land rights. Since the passage of the Autonomy Law in 1987, Afro-descendant and Indigenous communities in both the Región Autónoma de la Costa Caribe Norte (North Caribbean Coast Autonomous Region) and the Región Autónoma de la Costa Caribe Sur (South Caribbean Coast Autonomous Region) have insisted that state recognition of their historic claims for land rights lies at the heart of the promise of regional autonomy. By 2016, the Ortega administration had provided legal titles to all the Afro-descendant and Indigenous communities that had submitted their requests for collective title, although some, like the Bluefields territory, had their claims dramatically reduced. Securing these land titles, however, has not led to increased political power or economic self-determination in the region. This situation raises a simple but critical question: What does autonomy mean in the context of an increasingly repressive and authoritarian state ruled by the interests of a single political party and its singular charismatic leadership? In this chapter, I argue that the struggle for territory and the defense of regional autonomy are key sites of struggle for racial justice and democratic governance as Ortega and Murillo continue to consolidate their hold on political power and social control in the country.

PART 1 GENEALOGIES

1 · GRAND DAMES, GARVEYITES, AND OBEAH WOMEN

State Violence, Regional Radicalisms, and Unruly Femininities in the Mosquitia

On February 12, 1944, Doña Anna Crowdell addressed a gathering in Masaya to commemorate the 50th anniversary of the Reincorporation of the Atlantic Coast into the Republic of Nicaragua. At sixty-seven years old, Crowdell was "an eyewitness to [the] historical events" of the Reincorporation and its social and political outcomes.[1] Anna Krause was born on September 7, 1876, in Bluefields, the daughter of Lucy Anna Ingram, a Creole woman, and Robert Krause, a German sea captain. As Anna Crowdell, a respected hotel owner and the wife of a white North American boat captain, she would become one of the most influential political figures of the Caribbean Coast.[2] Yet, as she would illustrate in her speech, costeños, or coastal residents, held a radically different view of the meanings of Reincorporation.

On the morning of February 12, 1894, four hundred Nicaraguan troops under the command of General Rigoberto Cabezas landed in Bluefields and seized control of the city. Cabezas removed the flag of the Mosquito Reserve, the regional government of the Atlantic Coast, a former protectorate of the British Empire, and replaced it with the flag of the Republic of Nicaragua. The town's Black, Indigenous, North American, Caribbean, Chinese, and European residents, who had gone to bed as citizens of a semi-sovereign regional state, awoke that morning to a new, forcibly imposed government (Dozier 1985; Gordon 1998; Hale 1994; Vilas 1989). During her address, Crowdell stated that, contrary to popular belief,

When the government of Nicaragua took possession of the Reserve it did not find, in Bluefields nor in any place in what was called the Mosquito Reserve, groups of semi-savages but towns that, though small and dispersed, enjoyed a certain civilization, ruled by good and healthy systems of government; and with regard to education was based on the same methods of the Anglo-Saxon race. Many foreigners

and natives possessed spacious and good establishments of commerce. Direct steam lines from the United States brought us merchandise and carried bananas and other products from the Litoral such as gold, lumber, coconuts, rubber, and other products.[3]

In December 1894, the then president José Santos Zelaya met with some sixty Indigenous delegates to approve the Mosquito Convention, the treaty that formalized Nicaraguan sovereignty over the region. The treaty also made provisions to protect the political and economic rights of Black and Indigenous communities, exempting them from import and municipal taxation, for example, and ensuring that the state would reinvest tax revenue generated in the region into the coast for the benefit of its inhabitants.

She continued, "It is true that the Reincorporation was a great work, but such delicate matters required the presence of people of high integrity and a spirt of equanimity and justice. . . . Above all humanitarian men."[4] This was not the case. Crowdell lamented, "The ink with which the Mosquito Convention was written was still fresh when [the government] began trying to violate it." Zelaya soon began placing Nicaraguans from the Pacific in key regional government posts, levying heavy duties on imports into the region, and appropriating Black and Indigenous lands, enriching himself and his allies in the process. Although Nicaraguan historians praised Zelaya as the statesmen who modernized Nicaragua and established the nation's first stable political institutions, Black and Indigenous communities experienced this moment as one of profound loss and destruction.

Crowdell assured her listeners that her account was "a real life" portrait of the political and economic situation of the Atlantic Coast: "My brothers are experiencing great suffering and I come here to share this cry of anguish and to ask you all: What have you done for the Atlantic Coast in half a century?"[5] It was a politically charged question made in an equally charged setting. Fifty years after Reincorporation, the coast was no more integrated into Nicaragua than it had been in 1894, and the promise of regional autonomy outlined in the Mosquito Convention remained unfulfilled.

This speech is one of the few historical documents that illustrates Crowdell's political views and that establishes her significance as an "eyewitness to history." But Crowdell was not just a witness; she actively shaped that history through her direct participation in a series of regional struggles following Reincorporation. She was a complex and contradictory figure. U.S. Marine intelligence reports from the 1920s and 1930s describe her as a "disturbing political influence," as well as a "chronic revolutionist and advocate of the Pan-Negro movement."[6] Though her mixed racial ancestry was common knowledge on the coast, she appears to have often passed for white or "English" during her travels to the United States and the Caribbean. And even though by the time she delivered her speech she was widely recognized as a "great supporter of the Liberal Party," thirty-five years earlier she had backed the Conservative Party in a regional rebellion to overthrow the Liberal

dictator, José Santos Zelaya. Sixteen years later she switched sides and backed the Liberals in their bid to depose the unconstitutional government of her former ally, President Adolfo Díaz of the Conservative Party. Her Crowdell Hotel served as an important meeting place for diplomats, politicians, and regional activists, and her membership in the Union Club, a bastion of Creole political mobilization from the 1920s until the 1960s, made Crowdell the "grand dame" of costeño civil society (Hale 1994; Brooks 1998).

In its examination of Creole and Black women's political activism during this tumultuous period between 1894 and 1944, this chapter focuses primarily on the political life of Anna Crowdell. Specifically, it explores the impact of societal changes on Creole women's political subjectivity following Reincorporation by reading against the grain of existing historiography on regional politics. I demonstrate how Creole women negotiated the repressive political conditions that defined the region's relationship to the national government. I argue that the shift to authoritarianism following the period of Reincorporation not only produced new racial formations in the region but also prompted the development of new gender subjectivities that were reflected in Creole women's political activism in the early twentieth century. Examining Creole women's lives reveals how gender, race, skin color, class, political repression, economic exclusion, and labor migration shaped their political subjectivity and modes of regional activism. These women's lives and encounters with transnational Black social movements and their engagement with regional struggles against the mestizo nation-state produced new modes of Creole femininity and political subjectivity that fluctuated between what I term "strategic respectability" and "disreputable femininity," both of which served as critical modes of everyday, organized resistance.

Anna Crowdell perfected the use of strategic respectability as a mode of gendered political engagement. Under the guise of middle-class, elite Creole femininity, she quietly became one of the most politically influential figures on the coast and remained so for more than a half-century. She did so by engaging in a performance of normative femininity that allowed her to participate in unconventional forms of political activism. As a wife, a mother, a devout Catholic, charitable figure, and prominent businesswoman, Crowdell embodied local ideas of ideal Creole respectability that gave her access to forms of political power that most mixed-race Creole and Black women did not have.

Crowdell strategically placed herself in the middle of the most important political debates and movements of her time, quietly exercising her influence through lobbying and networking to support regional struggles for autonomy. She moved through mestizo, Creole, American, and European social spaces, hosting diplomats, national politicians, and local elites at her hotel and leveraging her personal connections on behalf of Black and Indigenous communities. Crowdell's political biography reveals how some women were able to navigate the restrictions imposed on their gender to insert themselves into local and national struggles for regional autonomy.

The chapter also centers the voices and experiences of women whose presence in the archive is not as well documented—labor migrants, church mothers, teachers, grassroots social workers, Garveyites, traditional healers, and bad obeah women: their lives reveal how women played a critical role in building the local and transnational networks that sustained regional struggles against the state. From their involvement in the Universal Negro Improvement Association (UNIA) and Creole social clubs to their support for the Liberal Party that brought Somoza to power, the chapter considers how Creole women on the coast shaped regional political formations in a range of complex and often contradictory ways.

THE MAKING OF THE MOSQUITIA

Prior to sustained European contact, a few thousand Indigenous Miskitu-speaking communities inhabited the northeastern coasts of Honduras and Nicaragua. British buccaneers established political and commercial alliances with Miskitu chieftains for protection from the Spanish, who controlled the western half of Nicaragua; these alliances were so fruitful that the British began to settle in the Caribbean coastal region. Enslaved Africans began to arrive in the area in significant numbers in the mid-1600s. After the Spanish occupation of Providencia in 1629, hundreds of formerly enslaved Africans fled to the Central American mainland. Many of them were reenslaved, but some intermarried with Miskitu families (Offen 2002). This mixing led to the emergence of two geographically and phenotypically distinct Miskitu groups: the Sambo (or Zambo), who were of African and Amerindian origins, and the Tawira, or straight-haired, "pure" Miskitu (Dozier 1985; Gordon 1998; Hale 1994; Offen 2002).

British settlement in the region grew significantly during this time, and these settlers relied heavily on "the good will and assistance of the Indians" to protect their trade and economic interests. The settlers played a central role in the creation of a regional government that would oversee economic relations between the region, the British Crown, and the Caribbean colonies. In 1687, these settlers brought Jeremy, a Sambo chief, to Jamaica, where the colonial governor crowned him "king" of the Mosquitia and formally established the Mosquito Kingdom. Subsequent Mosquito kings were selected by the governor of Jamaica and were educated in Jamaica. Craig Dozier (1985, 15) argues that this was little more than a puppet arrangement in which British settlers controlled the administration of the region through Indigenous proxies who were "flattered by their counterfeit titles" and could be easily manipulated.

Carlos Vilas (1989, 30) claims, however, that "the image of the government of the Mosquito Reserve prevailing in Nicaraguan historiography" and in European and North American scholarship "is that of a kind of fiction, docile to the dictates of foreign economic and political interests." Indeed, Black and Indigenous political leaders on the coast had their own political ambitions. The Miskitu had long resisted Spanish efforts to colonize the region, and the informal alliances that the

Miskitu and Black residents formalized with British pirates and merchants prevented Spain from laying claim to the region. The Miskitu continued to resist colonization even after Nicaragua became an independent republic in 1821. Although the Nicaraguan government tried to gain control over the region, its efforts were unsuccessful (Dozier 1985; Gordon 1998; Vilas 1989).

Great Britain's interests in these informal alliances were largely economic. British settlers wanted to continue trading both with the Spanish mainland and the Caribbean and, later, to secure their country's rights to construct an interoceanic canal in Nicaragua. In 1747, the governor of Jamaica declared the Atlantic Coast a protectorate of Great Britain and sent Robert Hodgson to serve as its superintendent. The regional economy flourished as English settlers and native populations traded sugar, cotton, indigo, sea turtles, and lumber. As British settlement increased and the Afro-descendant population continued to grow, the Mosquitia developed into a multiracial, multicultural society (Gordon 1998; Dozier 1985; Vilas 1989).

The relative freedom that Blacks enjoyed in the Mosquitia, where slavery was not codified into law or as rigidly enforced as it was in the colonies, attracted Afro-descendant people from throughout the Caribbean. Race mixing between the Indigenous, European, and Afro-descendant communities was widespread and produced a Creole elite who distinguished themselves from both Indigenous communities (whom they saw as backward and culturally inferior) and darker-skinned free and enslaved Blacks from the Caribbean (Gordon 1998; Pineda 2006).

From the 1840s through the 1890s, the Mosquitia operated as a semi-sovereign state in the interstices between informal British colonial domination and Spanish colonial neglect. Questions of miscegenation and the unruly racial and sexual politics of Black and Indigenous communities are a recurring theme in the travel accounts produced by North American and European writers, diplomats, scientists, and adventurers in the nineteenth and early twentieth centuries. For these writers, the "exceedingly free and easy" relationships between Black, Indigenous, and European residents on the coast provided evidence of the wildness, savagery, and primitive social order that prevailed there. American archaeologist E. G. Squier (1860, 58) wrote of the region: "Whites, Indians, negroes, mestizos, and sambos—Black, brown, yellow, and fair—all mingle together with the utmost freedom, and in total disregard of those conventionalities which are founded on caste." Although Black women are largely silent in these narratives, they nevertheless are implicated in the region's chaotic racial order by failing to maintain the norms of civilized Western femininity that prohibited wanton race mixing (Squier 1860; de Kalb 1893; Bell 1899 [1989]).

This period of regional independence saw the formation of Creole identity and political ascendancy in the regional government (Gordon 1998). The communities of maroons in Bluefields and Pearl Lagoon, escaped slaves from Corn Island and San Andres, and the established communities of free Blacks and mulattoes "became the foci of Creole ethnogenesis" (37). Even though slavery persisted on the coast, the general isolation and the complex terrain of the region, combined

with the semi-sovereign status of its government, seem to have prevented the development of the system of plantation slavery that characterized Caribbean slave societies. This, in conjunction with the lack of direct colonial rule, allowed people of African descent some latitude to maintain their freedom and led to the consolidation of "Miskitu Coast Creole culture" (39). Freed from direct colonial rule and geographically distant from the wars for independence from Spain unfolding in the Pacific, Black and Indigenous peoples consolidated a regional government. The autonomy that the Mosquitia enjoyed during this period created a space in which Creoles became critical regional power brokers, occupying key positions as political advisers in the administration of the regional government and the regulation of the region's growing economy.

In 1844, the British government reestablished its influence in the region by appointing a new consul-general in Bluefields. By then, a predominantly light-skinned Creole elite was exercising significant political power. The center of this political power shifted to the south after King Robert Charles Frederick relocated to Bluefields from Pearl Lagoon in 1845. Creoles controlled the Mosquitia governmental and military administration, and Miskitu people, who no longer dominated the region, were treated as culturally inferior to Europeans and Anglicized Creoles. Subsequent Mosquito kings would be increasingly separated from Miskitu communities and would assume a Creole cultural identity (Gordon 1998).

Although the regional government was overwhelmingly male dominated, it seems that some women did participate in regional politics. Women in the Mosquitia enjoyed full rights to the franchise—a right that Nicaraguan women did not secure until 1955—and on occasion carried out diplomatic functions for the state. In 1847, Princess Agnes Ana Frederick, the elder sister of King George Augustus Frederick, negotiated a treaty with the Nicaraguan government regarding British claims to San Juan del Norte. "The princess accepted and signed an agreement of friendship and alliance and mutual protection with Nicaragua," though this ultimately did not stop British incursion into the region (Vilas 1989, 27). Her work as a diplomat of the Mosquitian government is particularly remarkable given that women in Nicaragua were almost entirely excluded from politics, particularly in the Pacific, where the traditional gender norms of the ruling Conservative Party curtailed women's access to education, employment, and political participation (Cobo del Arco 2000; González-Rivera 2011).

In 1849, the Moravian Church established its first mission on the coast, concentrating its operations in Pearl Lagoon and Bluefields. The church would come to play a central role in the formation of Creole cultural identity. Moravian missionaries opened the first schools in the region, which resulted in high literacy rates among Creoles. The missionaries were particularly committed to eradicating the "heathen" spiritual traditions of Afro-descendant and Indigenous communities, insisting on heterosexual monogamous marriages, eradicating the practice of obeah and shamanic healing, and stamping out the erotic May Pole celebration. The

Moravian Church also assumed an active role in regional political affairs, housing and educating the Miskitu kings and chiefs and their families. It controlled the financial affairs of the Mosquitia, and as Gordon (1998, 44) points out, the Miskitu "king and all of the state functionaries received their salaries directly" from the Moravian Church. As the most important social institution in the Mosquitia, the Moravian Church played a central role in promoting Anglo culture among Creole and Indigenous communities and encouraging costeños to think of themselves as British colonial subjects.

In 1860, Great Britain signed the Treaty of Managua, which dismantled the protectorate and formalized Nicaraguan authority over the southern Mosquitia. Under this agreement, the territory of the protectorate was radically reduced and renamed the Mosquito Reserve. The treaty allowed the Miskitu to incorporate the region into the Nicaraguan state at any time they wished and to govern themselves in the reserve under a hereditary chief. It also exempted Creoles and Mosquito Indians from national military service and "from all direct taxation on their persons, property, possessions, animals, and means of subsistence. . . . By the terms of the Treaty of Managua in 1860, this territory had autonomous status under Nicaraguan sovereignty" (Dozier 1985, 141).

After Britain's withdrawal under the terms of the Treaty of Managua, U.S. corporations began to establish operations on the coast, transforming the region into "an enclave of U.S. capital" (Gordon 1998, 59). Foreign investors capitalized on the reserve's natural resources, and bananas, gold, rubber, and mahogany became the region's most important export commodities. The *Bluefields Sentinel* reported, "Since the inauguration of the banana trade . . . a new era has dawned on the town, smiling prosperity has gladdened every home."[7] Commercial shipping lines carrying products and passengers traveling to Kingston, New Orleans, Philadelphia, Colón, and New York left Bluefields weekly. By 1894, U.S. investment in the regional banana industry totaled more than US$3.75 million (Dozier 1985; Gordon 1998). As the banana industry grew, local businesses—saloons, dry goods and grocery stores, billiards parlors, print shops, photography studios, newspapers, and hotels—sprang up to accommodate the capital flowing through Bluefields. Black women also capitalized on the boom by opening their own boarding houses and restaurants, providing domestic services and private tutoring lessons to the city's foreign and Creole elite, and offering naturopathic medical services.

Under the terms of the Treaty of Managua, the central government had no rights of taxation in the region and could not levy duties on imports entering the country through Caribbean ports (Vilas 1989). When José Santos Zelaya assumed the presidency in 1893, he immediately set his sights on integrating the region into the national territory. Initially, he sent Carlos Alberto Lacayo, the government's commissioner, to the coast to bribe Mosquitian government officials to "to accept its subordination to Nicaragua" (38). When bribery failed, the state took a more coercive approach.[8]

In February 1894, Nicaraguan troops seized control of Bluefields and disman-
tled the Mosquito Reserve. The Reincorporation forcibly brought the Atlantic
Coast under the jurisdiction of the Nicaraguan state. The Zelaya administration
justified its actions by claiming that the Mosquitia government was in noncompli-
ance with the Treaty of Managua because it was not controlled by the Mosquito
Indians. In a report to Zelaya, Lacayo stated, "The Indians neither govern nor have
any influence on the Reserve. Their name has served only as a pretext to maintain
in that territory the exclusive influence of foreign interests." Instead, a "foreign oli-
garchy" of "Jamaica Negroes" governed the region (Cuadra Chamorro 1944, qtd.
in Vilas 1989, 39). The U.S. government, which by the 1890s had already begun to
develop its own plans to construct an interoceanic canal in the isthmus, was wary
of British claims to the coast and shared the Zelaya administration's view of the
political state of the Mosquito Reserve. U.S. Secretary of State Walter Gresham
claimed that "an alien administration, in other interests than those of the Indians,
notoriously exists, especially at Bluefields. Nobody is deceived by calling this
authority a Mosquito Indian government" (cf. Dozier 1985, 150).

It was true that Creoles dominated the government of the Mosquito Reserve. In
the year before Zelaya's incursion into the coast, more than half of the Mosquito
government's chief's advisers were Creoles who hailed mainly from Bluefields. That
these advisers were consistently decried as a "foreign oligarchy" illustrates how anti-
Black nativist sentiments shaped the incipient nationalist discourse of the Zelaya
administration. Although the Zelaya administration claimed to be concerned about
the political exclusion of the Mosquito Indians, it did not recognize Indigenous
claims to self-governance, a position that seemed to be shared by at least some seg-
ments of Nicaraguan civil society. The editor of one Nicaraguan newspaper wrote,
"It is certain that the Indians alone cannot govern nor govern themselves, the
government which they would establish would be ridiculous and they themselves
would call for an incorporation or that plan with Nicaragua."[9] Thus, Indigenous
peoples were no more fit to rule the region than Black foreigners.

In a direct violation of the Treaty of Managua, Zelaya began displacing Creoles
and Indigenous peoples from their lands, selling and giving away coastal proper-
ties to his political supporters, and appointing mestizos from the Pacific to fill
regional government posts. He imposed martial law on the region and brutally
quelled local uprisings led by Black and Indigenous rebels and backed by the for-
eign business establishment. Following these uprisings, dozens of long-term West
Indian residents either fled or were expelled from the regional government by the
Zelaya administration.[10] Under the Treaty of Managua, the state of Nicaragua
could not legally incorporate the reserve without the consent of the region's Indig-
enous tribes, and so the Zelaya administration quickly moved to sign an agree-
ment with the Miskito Indians.

Ten months after the Nicaraguan incursion, sixty-one delegates representing
Miskito and Creole communities throughout the region attended the Mosquito

Convention on November 20, 1894; they agreed that the reserve would become subject to the Nicaraguan Constitution and enjoy "the protection of the flag of the Republic." The Mosquito Convention extended suffrage to all men and women over the age of eighteen and exempted Mosquitos from military service and direct taxation. Most importantly, the delegates agreed that "all of the revenues that may be produced in the Mosquito Litoral" should "be inverted in its own benefit, thus reserving to us our economic autonomy." Yet, in a particularly humiliating gesture, the Mosquito Reserve was renamed the Department of Zelaya (Dozier 1985; Gordon 1998; Vilas 1989).

The Zelaya administration and subsequent administrations would fail to uphold many portions of the Mosquito Convention, which became a major point of contention between Black and Indigenous communities and the Nicaraguan state. The Zelaya administration soon enacted a series of policies designed not only to integrate the Atlantic Coast into the economic life of the nation but also to assimilate the region's diverse communities into the emergent project of official mestizo nationalism. These reforms included establishing Spanish as the official language of Nicaragua and shutting down schools that failed to provide instruction in Spanish.

Anna Crowdell was seventeen years old when Nicaraguan troops seized Bluefields: the event clearly was a formative moment in her political development. Under Zelaya's rule, she later said, "The coast began to go backwards." The effects were immediate and disastrous. On the fiftieth anniversary of the incursion, she recalled, "Ignorance and complete disrespect for all that was great and good was exalted. Commerce languished and agriculture went into decline. Faith in the integrity of those that governed was lost, and there is nothing that troubles the life of a nation more than when they doubt the purity of their government and its integrity."[11]

Despite being systematically disenfranchised, Creoles continued to resist Nicaraguan national rule well into the twentieth century, refusing Nicaraguan citizenship and pulling their children out of school to protest Spanish-only instruction. From the 1900s to the 1930s, Creoles participated in a series of political rebellions to defend their claims to the region and dismantle the unequal relations of power that excluded them from full citizenship, opportunities for economic prosperity, and access to political power. They formed a variety of "social organizations," including secret societies, lodges, bands, literary societies, athletic clubs, and social clubs that served as bulwarks against mestizo national hegemony in the region. The social clubs became particularly important political spaces for Creoles to protest treatment by the government and, later, to organize full-scale rebellions against the state. The most important social club, the Union Club, would play a critical role in a series of uprisings that would dramatically alter the course of Nicaraguan politics throughout the twentieth century—and Anna Crowdell would be at the center of each one.

RESISTING REINCORPORATION IN THE DEPARTMENT OF ZELAYA

After seizing control of the coast, the Zelaya administration quickly enacted a series of economic policies to increase revenue for the central government. These policies included dramatic increases in tariffs on imports and exports; the approval of monopolies for the import, export, and sale of a range of consumer products; and the granting of exclusive concessions to foreign corporations and Zelaya loyalists to exploit the region's natural resources. Far from "reincorporating" the region into the nation, the Zelaya administration's economic policies on the coast produced a model of internal colonialism. By the turn of the century, the Atlantic Coast, with about only 10 percent of the national population, was contributing approximately 40 percent of all duties collected by the state, a fact that was not lost on costeños who decried the government's unfair and illegal taxation of the region. To add insult to injury, the state did not use any of the revenue generated by these increased tariffs to improve living conditions on the coast. Costeños watched as their tax revenue went to infrastructure and development projects in the Pacific—including the construction of a hospital in Leon and a public park in Managua—while the Atlantic coastal region's infrastructure deteriorated (Dozier 1985).

The region's internal colonial status was also reflected in the departmental government, which was led by Zelaya-appointed mestizos from the Pacific. Gordon (1998, 65) writes that it "chronically operated without funds, and clientelism, nepotism, and bribery were rampant." Government officials routinely levied illegal taxes on Black and Indigenous communities, seized property, and engaged in graft to enrich themselves. Although a small number of the Creole elite obtained political posts at the local and municipal levels, the most important and influential posts were reserved for Nicaraguans.

In their correspondence with British and U.S. consulates, costeños complained about the corruption of the departmental and national governments and the state's exploitive relationship to the region. Consular records of the British Foreign Office also illustrate the state's violent policing of Creole communities. Creoles and West Indian immigrants living in the region filed numerous complaints of abuse at the hands of Nicaraguan authorities. In 1901, Horatio Patterson, a resident of Pearl Lagoon, was arrested, taken to prison, and ordered to pay a fine of $US50 or receive "three hundred stripes from an iron ramrod." The same year, a Jamaican resident, George Campbell, sustained extensive injuries after being severely beaten with a horse whip and then attacked with a machete by two police officers in Bluefields.[12] These incidents of police abuse appear to have been so common that they led at least one Creole resident to write bitterly, "If a Spaniard kills an Indian or one of the mixed people nothing is done to him. He is promoted to high office."[13]

In their correspondence with the British government, Creole and Miskito residents often framed their critiques of the Nicaraguan state in terms of morality and

civilizational progress. Creoles were especially dismayed by the government's repeated attacks on the Moravian Church, which it accused of stoking anti-Nicaraguan sentiment and inculcating loyalty to the British Crown among Black and Indigenous peoples. Creoles were particularly outraged by the closure of the Moravian mission schools and the banning of all English-language instruction on the coast. To many Creoles the Moravian mission had been a civilizing influence in the region. They thus perceived the state's assaults on the Moravian Church as an effort to erode the moral values of their communities. In 1906, a group of Creole and Miskito residents from the Pearl Lagoon Basin, including dozens of local women, sent a letter to the British consul complaining about the deleterious moral effects of Nicaraguan occupation. They wrote, "For our Governors it would be a grand thing if we would go back into our old savage state so they could revel in their pet sin, polygamy, for then our women and girls who they treat with the utmost dis-respect would more easily become their prey. There have been instances among us when we have been beaten, imprisoned and ill-treated, because we refused to give our ten-year-old girls to Government officials for a life of sin and shame."[14]

These sentiments were echoed by Henry Patterson, a Creole from Pearl Lagoon, who in a letter to British consul John Oliver Thomas, decried the immorality of "Spanish" rule. Worry about the moral decay of the region was also linked to anxieties around sexual impropriety, miscegenation, and the specter of prostitution. Creoles especially decried attempts by Nicaraguan police to sexually exploit Black and Indigenous women. Patterson lamented, "If you have a young girl, and you correct her to let her walk [in] a honourable direction, the authorities interfair [sic], puts you into prison. After that he begin to work around the girl to seduce and make her a prostitute. So by this you can see how we are treated by the Sovereign Government. I could write you fifty sheets of such doings."[15]

Thus, local critiques of Nicaraguan state violence engaged in a moral discourse that criticized the state's repressive policing while simultaneously policing Black women's sexuality in the public sphere. It is unclear to what extent sex work increased in the region after Reincorporation.[16] Thus, it is difficult to ascertain from Patterson's letter how much his critique reflected the full dynamics at play in this situation. Although it seems likely that some women were "seduced" into sex work by unscrupulous state actors, it is also possible that some engaged in sex work or maintained long-term relationships with Nicaraguan law enforcement officers much in the same way that some Creole women had previously done with British and American foreigners. Nevertheless, Patterson's letter reveals how concerns over sexual morality and state repression converged in costeños' critiques of the Zelaya administration and its regional representatives.

Sexual violence and harassment by police officers appear to have been normative features of state repression. This pattern is reflected in a story that Patterson recounted in his letter to the British consul:

On the 16th inst. at night, about 7 o'clock, a boat came down from Tasba Powni, having as crew and passengers three females and one man. The police met them on the wharf, took the man to prison from the wharf. The police went and molested the females the whole night, trying to lay with them. But the women was good, the three kept them off and reported them the next morning. But nothing was done or said to the police as it is a habit amongst the Nicaraguans that whenever a Spaniard does an Indian or a negro, as we are called, any harm, nothing is done or said.[17]

Patterson's brief description of the sexual politics of Nicaraguan occupation on the coast illustrates the complex moral logic at work in these critiques. Here, he juxtaposes the virtue of the "good" female passengers with the moral depravity of the local police. But he leaves out some important information, particularly the vexing question of how these women "kept them off" the whole night and how the community would have responded if they had been unable to do so. There do not appear to be any accounts in the consular records of women who were unable to keep police officers at bay. Nor are there any accounts of Creole or Indigenous women who experienced sexual violence from men in their own communities. Rather, sexual violence emerges as a serious point of contention only when it was articulated as a form of collective racial and regional injury that offended the dignity of the community, rather than an assault on Black women's bodily integrity (Goett 2016b).

The North American business elite had initially opposed Zelaya's dissolution of the Mosquito Reserve government but eventually reached a mutually beneficial, if uneasy, alliance with the Nicaraguan government. Yet Creoles were excluded from these new economic arrangements and bristled at the granting of monopolistic concessions on consumer goods that left them vulnerable to corporate exploitation. These monopolies included exclusive concessions on the sale of alcohol, gunpowder, domestic and foreign tobacco products, butchering rights, control of the region's meat supply and pricing, and lumber and mining rights. The government even granted monopolies for offshore fishing rights, India rubber, and the right to gather and sell coconuts (Dozier 1985). Anna Crowdell recalled bitterly, "The only thing that was not monopolized in Bluefields was pure air because it came to us from the sea."[18]

But the monopoly that Creoles found most destructive was related to the region's vibrant banana economy. In 1904, the Zelaya administration granted an exclusive concession to the Bluefields Steamship Company, owned by Jacob Weinberger, to operate on the Escondido River. Small-scale Creole planters, many of whom maintained their banana plantations along the Escondido, were prohibited from using another transport service to ship their products. They found themselves at the mercy of the Bluefields Steamship Company, which imposed exorbitant prices for transportation while paying the lowest prices for high-quality fruit (Dozier 1985). While the Bluefields Steamship Company profited by offering the lowest possible prices to small-scale Creole and Nicaraguan planters, it simultaneously offered higher, more competitive prices to select American-owned plantations

(Gordon 1998). Costeño planters who refused to sell to the company watched their products rot on their farms.

Creoles immediately mobilized in response to these exclusionary policies. In 1904, they formed the Planters Association to break the Bluefields Steamship Company's monopoly. Association members agreed not to sell to the company and purchased transportation equipment from a rival fruit company to transport their products for export. Despite the support of the department's governor General Juan José Estrada, the Zelaya administration "enforced the monopoly by seizing Planters Association shipments, destroying their bananas, and sinking their barges" (Gordon 1998, 72). The following year, the Planters Association led a delegation to Managua to present their grievances to the Zelaya administration, but their demands went unanswered. Regional resentment grew as the state continued to approve monopoly concessions that marginalized small planters while at the same time subjecting costeños to disproportionately high tariffs.

In May 1909, the Planters Association began another strike. In addition to refusing to sell to the Bluefields Steamship Company, its members destroyed fruit on the company's plantations and on those belonging to planters who worked for the company. The Zelaya administration's response was swift and brutal; it declared martial law and arrested some 500 planters and their family members. Costeños were outraged by this draconian response, which deepened their resentment of the Zelaya administration and the Bluefields Steamship Company. Thus, the stage was set for a larger, more violent confrontation with the state (Gordon 1998; Dozier 1985; Vilas 1989).

In October 1909, Jose Estrada, the Liberal department governor—with a coalition of disaffected members of the Liberal and Conservative Parties, U.S. businessmen, and Black and Indigenous rebels—launched a revolutionary movement based in Bluefields to overthrow the Zelaya administration. Estrada seized control of the department and immediately abolished the monopoly concessions (excluding those granted to North American businessmen who supported the movement against Zelaya) and "called for the establishment of an independent republic on the Atlantic Coast" (Gordon 1998, 73). Most of the Creole community actively supported the separatist movement, engaging in combat against Nicaraguan forces and providing funds and logistical support to the revolutionary forces. What began as a regional rebellion against Zelaya soon escalated into a national struggle to gain control of the state. Estrada established an alliance with the Conservative *caudillo*, or political strongman Emiliano Chamorro, to overthrow Zelaya. Chamorro apparently had no interest in the separatist demands of Black and Indigenous communities, and as the struggle against Zelaya spread throughout the country, the contributions and concerns of costeños were excluded.

Officially, the United States remained neutral in the conflict, but it sent Marines to protect U.S. lives and property. The U.S. government was worried about Zelaya's attempts to broker an agreement with several European nations to construct an interoceanic canal.[19] In December 1909, Zelaya, under increased pressure from

the U.S. State Department and the Taft administration, resigned from office and went into exile. Estrada later assumed control of the presidency, but his promises to his costeño supporters were soon forgotten; Creoles found their former ally to be as unresponsive to their political aspirations as his predecessor. The Conservative Party would remain in power for sixteen years, employing the same semi-colonial governing strategy that the Zelaya administration had followed. Successive Conservative administrations levied steep duties and taxes on the region to pay off foreign creditors and rebuild the Pacific. Almost none of this revenue was invested in the region.

Anna Crowdell joined other Creoles in supporting the movement against Zelaya, a fact she did not mention in her 1944 address. By the early 1900s, she had become increasingly involved in regional politics as a local organizer and advocate for Black and Indigenous communities. She was an unofficial member of the Union Club, which was the hub of Creole politics for more than sixty years. Its members included regional and national politicians, professionals, business owners, journalists, and planters, and it was widely considered to be the center of elite Creole social life. But its social function masked its deeper political purpose. As Gordon (1998, 71) writes, "For all intents and purposes, it functioned as a political party" where "strikes were planned and implemented, political organizations spawned, protest letters written, and political candidates launched or endorsed." The Union Club played a key role in the 1904 and 1909 planters' strikes, and its members also supported the 1909 revolt that brought the Conservative Party to power.

By this time, Crowdell was widely regarded as "a very respected Creole woman" in Bluefields and an influential figure whose social and political networks extended far beyond the coast.[20] Her hotel was a social and political hub for the Creole elite, the U.S. merchant class, diplomats, and local politicians. Black and Indigenous communities routinely called on her to represent their concerns to the British and U.S. consulates, and she was widely known to have the ear of government officials and the region's most prominent businessmen. Her colleague R. H. Hooker, a Creole builder/contractor and a long-time Union Club member, described her as "the greatest feminine figure in Nicaragua." Nevertheless, despite Crowdell's regional influence, personal relationships with both national and regional politicians, and her key role in the 1909 rebellion, once they were victorious her Conservative allies forgot about the region and their Creole allies, including Crowdell, who had made their election victory possible. The speed with which costeños' Conservative allies turned their backs on the coast taught Creole rebels a bitter lesson.

Although the 1909 revolution did not restore regional autonomy on the coast, it did mark an important turning point in Creole politics. For one, it was the first time that Creoles began to engage in national party politics. For another, the failure of the Conservative alliance shaped costeños' struggles against the state in the 1920s. Just as Creole and Indigenous leaders attempted to capitalize on the competing political and economic interests of more powerful colonial actors, these communities

would make use of the perpetual power struggles among Nicaragua's elite class to make their own demands on the government. In their struggles with the Nicaraguan state, Creoles would also turn their sights to the Black Atlantic and draw inspiration from the first modern transnational Black social movement.

MESTIZO NATIONALISM AND BLACK MILITANCY

On the morning of May 12, 1912, Maymie Leona Turpeau de Mena boarded the SS *Dictator* in Bluefields heading for New Orleans. She was twenty-nine years old, married, and listed her occupation as "wife." She was planning to visit her sister in Jennings, Louisiana. She reported that her husband, Francis H. Mena, had paid for her passage. She stated that she had been born in St. Martinville, Louisiana, but that her nationality was "Nicaraguan by marriage."[21]

Madame Maymie Turpeau de Mena would become internationally known as an organizer with the Universal Negro Improvement Association (UNIA), who worked her way up from serving as a translator for the Black Star Line, a shipping line incorporated by Marcus Garvey, to serving as his official representative in the United States by the 1930s. Born Leonie Turpeau in St. Martinville, Louisiana, in 1879, she grew up in a working-class family of mixed-race *gens de couleur*.[22] Although there is limited documentation from this period of her life, it seems that the rise of Jim Crow in the post-Reconstruction Era led de Mena and her siblings to leave the rural South. Whereas her brothers and sisters looked to move to the U.S. Northeast and Midwest, de Mena initially set her sights east on New Orleans and then south toward Bluefields.

By the 1900s, Bluefields had transitioned from a British protectorate to an "enclave of U.S. capital" (Gordon 1998). As the economy prospered, West Indian laborers migrated to the coast in growing numbers, along with Chinese, South Asian, Middle Eastern, and European migrants; a number of Chinese immigrants established successful commercial enterprises in the city. Additionally, African Americans from the U.S. South immigrated to Bluefields at this time; Maymie Leona Turpeau de Mena was one of them. They, along with their Caribbean counterparts, would slowly transform the contours of Creole identity as they became absorbed into the community. Nevertheless, as Gordon (1998, 66) notes, well into the twentieth century, distinctions of color, class, and religion would continue to produce salient divisions within the cultural/racial category of Creole.

Bluefields became a cosmopolitan port city whose identity was constructed through its economic, cultural, and social connections to the Black Atlantic world. But this multicultural cosmopolitanism was based on a social hierarchy that was deeply racialized: white North Americans occupied the highest position of power and privilege in the region, followed by Mestizos and Creole elites; darker-skinned Caribbean labor migrants, Chinese immigrants, and Indigenous peoples occupied a significantly lower status. Moreover, Creoles and Blacks found themselves subjected to intense forms of racial subordination as white U.S. residents imported

their Jim Crow sensibilities to the region. Nevertheless, the multiracial milieu of Bluefields created a social order that was radically different from that of the Mestizo nation. Indeed, the Nicaraguan state continued to view the cultural and racial diversity of the Atlantic Coast as a central threat to the construction of a homogeneous national identity.

In 1925, President Carlos Solórzano commissioned Frutos Ruiz y Ruiz, a naturalized Nicaraguan citizen from Spain, to conduct a study of the economy, geography, and inhabitants of the coast; his findings were largely unfavorable. Given its racially diverse communities, unregulated racial mixing, and large, mobile foreign-born population, Ruiz y Ruiz argued that the region posed a critical threat to the Nicaraguan nation-state, undermining the project of building a racially homogeneous, culturally coherent, and uniform national identity. The region's cultural and racial heterogeneity represented the "seeds of discord . . . the typical antipatriotic ferment: different races, languages, religion and customs" (Ruiz y Ruiz 1925, 6). He was disturbed by what he perceived as the coast's cultural and racial chaos and insisted that the state needed to restrict the immigration of Black and Chinese laborers to the region or risk becoming another version of Colón, where large numbers of West Indian labor migrants had settled during the construction of the Panama Canal: "Nicaragua is still a people in formation, without racial homogeneity, and therefore is not prepared to impose its national seal on such diverse peoples, in a region so uninhabited and so hardly Nicaraguan as the Atlantic Coast; that is why it must select who will immigrate and reject unassimilable races" (7). To secure its national identity, Nicaragua would need to exercise greater control over the region and bring coastal racial formations into alignment with the vision of mestizo nationalism that had already taken root in official nationalist discourse. The solution was clear: "the coast must be strictly hispano-nicaragüense" (114).

In the face of this narrative of mestizo cultural nationalism, Creoles continued to cultivate their own regional counter-nationalisms. Local Creole struggles for regional autonomy and political redress drew inspiration from the UNIA, which was founded in New York City in 1917 by Marcus Garvey. Born in St. Ann's Bay, Jamaica, in 1887 to a family of modest means, Garvey apprenticed as a young man with a printer. In 1910, he migrated to Costa Rica where he found work as a timekeeper on a banana plantation. He also worked as an editor of a local newspaper, La Nación. He later traveled to Colón, Panama, where he witnessed firsthand the discriminatory social and labor conditions experienced by Black labor migrants building the Panama Canal. Garvey's experiences in Central America shaped his understanding of white supremacy and anti-Black racism as global racial formations. Based on the ethos of Black self-determination, racial uplift, cultural pride, and the redemption of the African continent, the UNIA was enormously popular in Central America, where approximately one-third of all UNIA chapters were located (Harpelle 2003).

There were five UNIA chapters on the Nicaraguan Caribbean Coast, two of which operated in Bluefields from 1921 until about 1933 (Gordon 1998, 75; Harpelle 2003, 46; Wunderich 1986, 33–35).[23] It is estimated that, at their peak, the

Bluefields chapters had 500 to 1,000 active members, nearly one-quarter of the city's Black population (Harpelle 2003). On August 31, 1922, the two chapters came together to celebrate the national Negro holiday convened by the UNIA. All the town's stores closed as the two chapters led a march through the city followed by services at both the Anglican and Baptist churches.[24] Despite the UNIA's popularity, the two UNIA chapters in Bluefields were sharply stratified along lines of color and class. The chapter based in the Union Club comprised mostly light-skinned Creole elites, whereas the Liberty Hall's membership, based in the Beholden neighborhood, were largely poor, dark-skinned Blacks and a handful of Creoles (Gordon 1998, 76; Harpelle 2003, 63). Rivalries between the two factions would continue until 1930 when the two chapters merged.[25]

But these intragroup tensions did little to diminish the popularity of this transnational movement, leading one Moravian missionary to write disapprovingly that it was "a danger to our people." He lamented, "It is a new form of Ethiopianism; Back to Africa is on their banner, Africa to the Africans. I do not think that anything during my stay has taken the people so quickly as this new movement. The majority of our male church members and a goodly number of the female as well are active members of the Black Star Line, and I am sorry to say, not with advantage for their inner life. The movement is also 'Anti-White.'"[26]

Although women participated in the region's UNIA chapters, for the most part, they tended to play traditional roles, serving as Black Cross nurses and providing logistical support for events while men dominated in public speaking, communicating the division's activities to the parent body in New York, and overseeing local programs. Female members in the two Bluefields chapters seem to have had more opportunities for leadership than women who were involved in the ones in Puerto Cabezas, Great River Bar, and Greytown; in those rural areas, women are almost never mentioned and rarely spoke at chapter gatherings except to deliver dramatic recitations or sing UNIA and religious hymns.[27] Black female Garveyites in Bluefields, in contrast, gave public lectures, facilitated chapter meetings, and hosted their own gender-specific events.[28]

There is little documentation of the extent to which Maymie Leona Turpeau was involved in the Bluefields UNIA divisions. Nevertheless, her marriage to Francis H. Mena, a Creole planter, made her a member of the city's small, politically active Creole elite. Francis Mena was the vice president of the Union Club in the 1920s and later became an administrator for the English-language newspaper, *The Bluefields Weekly*. It is possible that de Mena knew Anna Crowdell and attended the social gatherings that Crowdell held at her hotel. Although it is unclear whether Crowdell was a member of the UNIA, U.S. Marine intelligence reports described her as a "an advocate of the Pan-Negro movement." Her brother, Alfred E. Krause, appears to have been a supporter of the UNIA and donated money to the organization's 1924 convention fund.

It is difficult to determine precisely what influence these encounters had on de Mena's political formation. It is possible that she observed Crowdell's performance

of strategic respectability. De Mena may have taken cues from Crowdell of how women of their class might navigate the complex social and political landscape of Bluefields. Poor Creole women and female labor migrants were limited to either domestic forms of labor or in the illicit economy as sex workers, whereas women from more privileged backgrounds were able to participate in gender-normative forms of female entrepreneurship, as Crowdell did with her hotel. This exposure to Crowdell's powerful political and economic presence in costeño civil society, and the highly visible forms of political engagement of Creole women involved in the UNIA, may have provided a model of the proto-feminist politics that de Mena would later espouse in her work with the UNIA in the United States.

On June 22, 1922, de Mena boarded the SS *Managua* heading home to Louisiana. She would not be returning to Bluefields. The immigration official who processed her ticket put "D" under her marital status: divorced.[29] For reasons unknown, her marriage to Francis Mena had come to an end, and de Mena never looked back; existing travel records suggest that she never returned to Bluefields despite her extensive travel throughout Central America and the Caribbean on behalf of the UNIA.

Nevertheless, the multiracial environment of Bluefields and the rise of the UNIA on the coast proved to be formative experiences in de Mena's political development. That she embraced a Nicaraguan Creole identity demonstrates how significantly this experience shaped her political sensibilities. Witnessing the contours of anti-Black racism on the coast helped de Mena draw connections between local expressions of racial subordination and white supremacy as a transnational system of domination and exclusion. She had arrived as Leonie Turpeau, a young Creole woman from the backwoods sugar country of Louisiana, and left as Señora Maymie Leona Turpeau de Mena, a politicized Creole activist who for the rest of her life would claim Nicaragua as home.

De Mena left the coast at a particularly volatile moment in which "the heightened racial consciousness and organizational experience gained from participation in the Garvey movement prepared Creoles for the pivotal role they were to play in the political upheavals" of the 1920s (Gordon 1998, 76). The impact of Garveyism and the political goal of Black self-determination resonated powerfully with deepening local resentment over the state's ongoing exploitation of the region. Less than four years after de Mena's departure, the long-simmering frustrations of the region would explode in a violent conflict that would shake the country to its core and lay the foundations for the nation's transition to dictatorship.

REGIONAL RADICALISMS AND DISRUPTIVE FEMININITIES

After more than a decade of Conservative rule, the coast was in a state of political neglect. On the one hand, it remained one of the most economically productive areas in the country. It received large amounts of foreign investment and was home to a lucrative international banana trade and a thriving regional economy.

With the exception of exclusionary concessions, however, the Conservatives maintained many policies of the preceding Liberal government. Despite routinely raising taxes in the region to support the national budget, the state did not invest in public works projects, education, health, sanitation, or infrastructure development in the region (Dozier 1985; Vilas 1989). Frustrated by the Conservatives' exploitation of the region, Creoles began to consider political alternatives.

In October 1925, General Emiliano Chamorro, leading a rival Conservative faction, overthrew Conservative president Carlos Solórzano and installed himself as president. In January 1926, Bartolomé Viquez, Senior Political Chief and Commander at Arms in Bluefields, contacted Anna Crowdell asking for her support for Chamorro's power grab. Her response illustrates the disillusionment that many costeños felt toward the Conservatives by this point:

> In 1910 General Chamorro had the hearts and hopes of the humble inhabitants of this region in the palm of his hands. They believed in him and in the promises of the REVOLUTION, but sadly, little, there was little concern or memory of the poor soldiers and unhappy coastal inhabitants who suffered so much, who endured so much to bring him to such heights. Today the scene has changed, and the people see with sad eyes and broken hearts the fall, decadence and complete ruin of the Coast: THEY DO NOT BELIEVE IN PROMISES ANYMORE.

She concluded, "In my humble opinion, there exists only one path that carries the promise of saving the sad situation, which is to put into full force the SACRED PACTS of the MOSQUITO CONVENTION."[30]

The United States refused to recognize Chamorro's administration. Appreciating the futility of his power grab, Chamorro agreed to step down and ceded the presidency to Adolfo Díaz, the Conservative politician who had collaborated with Creole rebels against José Santos Zelaya in 1909. Liberals, especially on the Atlantic Coast, refused to recognize Díaz's presidency (Dozier 1985; Gordon 1998). This conflict marked the beginning of what would come to be known as the Constitutionalist War, a civil war between the country's Liberal and Conservative Parties that would engulf the entire country (Dozier 1985; Gordon 1998).

Creoles saw the Liberal uprising against the Conservatives as an opportunity to articulate their own political grievances and to make their own bid for regional autonomy. Spurned by the Conservative Party, they brokered a tenuous alliance with their former political enemy, the Liberal Party. On May 2, 1926, General George M. Hodgson led a group of Creole combatants known as the "Twenty-Five Brave" in an assault on the military barracks in Bluefields.[31] In December 1926, Dr. Juan Bautista Sacasa, a Liberal university professor and Zelaya supporter who had returned from exile in Mexico, established a Constitutional Government in Puerto Cabezas. A multiracial coalition of Black, Indigenous, and mestizo forces led by José María Moncada began an assault on the state and nearly took control of the country. Creoles participated in the Liberal Revolution but to

achieve their own aims: restoration of their political claims to the Mosquitia and recognition of their rights to self-governance.

Two days after Creole forces captured the military barracks in Bluefields, a group of thirty-three prominent Creole leaders requested that the U.S. military intervene to reestablish the Mosquito Reserve. Anna Crowdell was among the signatories and appears to have been the only woman in the group. In June 1926, the leaders of the revolution placed Crowdell in charge of managing the funds of the revolutionary forces, which were deposited at the Hibernia Bank and Trust Company in New Orleans. Crowdell held this position from August 1926 until the end of the war in May 1927. In this capacity she was responsible for sending dry goods, clothing, medical supplies, and military equipment to Creole troops stationed throughout the region. Crowdell also provided tactical support and intelligence to the Creole forces. Its leaders regularly wrote to her requesting information on the movements of other Creole and Liberal units and sharing their concerns about the shaky alliance with the Liberals and their grievances with the occupying U.S. Marine forces. Embittered by their experiences bargaining with Conservatives in 1909, Creoles placed little faith in the good intentions of their Liberal allies and focused instead on using the conflict to achieve their own political objectives.

The United States did not intervene in the conflict in the way Creoles had hoped. Instead, the U.S. Marines launched an occupation that would last until 1933. Despite the United States' ostensibly neutral position, it continued to recognize and support the Conservative administration of Adolfo Díaz. Marines stationed in Bluefields and Pearl Lagoon were deeply suspicious of Creoles' support for the Liberals and took no pains to hide their views. Creoles bristled under the aggressive policing of the Marine forces, and despite pro-American sentiment on the coast, they were outspokenly critical of what they perceived to be the Marines' hostility toward Liberal supporters.

The Marines quickly established martial law in the region and declared Bluefields, Puerto Cabezas, and Pearl Lagoon "neutral zones," although soldiers with the Liberal forces continued to be prohibited from entering these areas. In addition to protecting American lives and property, the Marines were also tasked with establishing and training the National Guard, a domestic military force that would function independently of the nation's political parties. Although the local police retained nominal authority, the Marines assumed the tasks of enforcing the law and policing the major towns and cities in the region. Marine reports detail how soldiers stationed in Bluefields became enmeshed in the fraught racial, gender, and sexual politics of the region.

Creoles protested constantly to the British and U.S. consuls about their mistreatment at the hands of the Marines. They complained of suffering arbitrary detention, surprise searches of their homes, physical assaults, and the sexual harassment of local women. Dr. John Marchand, an American physician who ran the Red Cross hospital in Bluefields and sympathized with the Creole rebels, wrote the U.S. consul, A. J. McConnico, to complain about one soldier in particular,

a Lieutenant H. M. McGee, who could regularly be found intoxicated with other Marines in the city's bars. On one occasion, McConnico saw McGee "familiarly grab the arm of a lady in trying to induce her to go for a walk, or go to a dance." This was apparently common behavior among Marines, and stories circulated of "Naval officers under the influence of drink" who were in the habit of "taking young girls for walks along dark streets in the more sparsely settled parts of town, and that one father at least have made complaint to the Commander who punished one officer by sending him back to his ship . . . that two drunken officers had been forcibly put off the porch by a husband upon their repeated insistence that his wife accompany them for a walk; that drunken officers were in the habit of accosting girls on the streets, much to the grinning delight of loafing negroes when they were repulsed."[32]

Residents also appear to have been troubled by increased rates of prostitution in areas where the Marines were stationed. One officer in Puerto Cabezas reported, "Practically all the prostitutes live in Bilway; most of them are Indians, some are of Spanish descent. There is no Government supervision or segregation, and practically all are infected. As a result, a larger number of the white employees of the company have become infected with gonorrhea, syphilis, and chancroid." In 1932, the National Guard established a "woman venereal hospital and prison" in Bluefields, presumably to crack down on prostitution and reduce the spread of sexually transmitted diseases.[33]

Creoles were outraged by the double standard that the Marines applied: policing local communities while turning a blind eye to soldiers engaged in disruptive and often illegal behavior; they reported multiple cases in which Marines were exonerated after killing local civilians and suspects in custody. These deep social and political tensions exacerbated the already fraught relationship between these communities and the Marines. The reasons had as much to do with politics as race. Even though the U.S. Marines sent to police the region brought with them the same kinds of racial antipathy toward Black people that were common in the United States, they also remained suspicious of Creoles whose political sympathies lay with the Liberal Party.

As an active supporter of the Liberal Party and a revolutionary collaborator, Crowdell confronted retaliation from the ruling Conservative party, the suspicions of the occupying Marine forces, and the limits of the tenuous alliance with mestizo Liberals. The Marines routinely surveilled her activities and searched her hotel, seizing weapons and correspondence that confirmed her involvement with the revolutionary forces. In September 1926, the Conservative municipal authorities in Bluefields seized and sold her home on the grounds that she had failed to pay municipal taxes. Crowdell immediately contested the seizure, petitioning her old friend, British consul Owen Rees; the British charge d'affaires in Managua; the U.S. consul; and her Liberal allies to advocate on her behalf. Demonstrating her detailed knowledge of Nicaraguan treaty law, Crowdell denounced the seizure as "an arbitrary act on the part of the Nicaraguan officials who acted in direct

contravention of Article III of the Harrison-Altamirano treaty, which exempts me from direct taxation" as a Creole born in the region before 1894.

The British government supported Crowdell's position and repeatedly requested that the Nicaraguan government indemnify her for the loss of her property. But the government, led by the Conservative Party, refused and instead claimed that the municipal tax was an indirect tax that did not directly affect her livelihood, The government also claimed that, because Crowdell was a Nicaraguan citizen, the British government had no right to advocate for her in such a fashion.[34] The loss of her property had a disastrous effect on Crowdell's finances; Marine intelligence reports confirm that by the early 1930s, she was "living in poverty" and struggling to maintain her hotel. She rented rooms to Marines and mestizo politicians, who were notorious for nonpayment, leading one British diplomat to wonder how she managed to keep her business afloat.

Crowdell's financial woes were exacerbated by the challenges she faced with her former Liberal allies. In October 1926, General Jose Moncada directed Crowdell to send US$8,000 to Edward L. Ingram, the Creole "Paymaster General of Moncada's army," leaving a balance of $1,988.50 (minus the $11.50 wire fee) in the account she managed. She then received orders to apply the balance to supplies, medicines, and munitions. But the cost of the supplies (a total of $3.796.07) far exceeded the funds in the bank account. Crowdell resolved this budget shortfall by taking out lines of credit at various businesses in Bluefields. By the end of the war in May 1927, she owed these businesses approximately $1,807.57.[35] After the war, Crowdell petitioned General Jose Moncada to provide compensation for the balance due her. But Moncada returned her letter and instructed her to direct her petition to the Claims Commission. Even after Moncada won the presidency in 1928 and the Liberal Party gained control of the government, the government did not compensate Crowdell.[36] Crowdell would spend the next eight years trying to recover her home and the compensation due her.

This was not the end of her troubles. Given her association with the revolutionary forces, Crowdell drew the suspicion of the Marines stationed in Bluefields, who viewed her as a "disturbing political influence." As mentioned, one Marine officer called her a "chronic revolutionist," and another dubbed her "a manipulative octoroon" who wielded an outsized influence on the political life of the region (Brooks 1998).[37] Yet another Marine officer, Captain Merrit A. Edson, believed that "half or more of the ill feeling towards the Marines in Bluefields is due entirely to her efforts."[38] Convinced that her influence in local politics threatened to destabilize the fragile peace that they had been deployed to restore, the Marines subjected Crowdell, along with many other Creole community leaders, to regular surveillance.

Political tensions between Creole communities and Marine forces came to a head in June 1927 following the murders of John Bolton, an American citizen, and his Creole common-law wife, Doreth Fox. On June 25, 1927, three residents on their way to their planting grounds outside of Pearl Lagoon made a grisly discovery:

a dog pulling a dead body from a shallow grave in the sand. The body was badly decomposed, making it difficult to identify the remains or determine the cause of death. But it did not take long to confirm that the body belonged to Fox, a local landowner whose disappearance had been reported four days earlier.[39]

Fox's murder sent shockwaves through the region. It was a sensational story, even in the context of a revolutionary uprising, that circulated in the local and international press for more than a year.[40] The Jamaican newspaper, *The Gleaner*, reported it as a "crime in which Voodoism, greediness for gold and politics were fantastically intermingled."[41] Fox was a local legend, a powerful figure who was both "feared and revered" by the local population. Among Pearl Lagoon residents, Fox was known as a strong woman who built her wealth by taking land from local farmers through coercion and violence. Her admirers depicted her as an iconoclast who defied conventional gender norms. Her detractors described her as "a notoriously wicked woman" known "to be guilty of nearly every crime and misdemeanor—from practicing Black art in all its phases to committing atrocious murders."[42] Fox and Bolton's murders quickly became entangled in larger political struggles unfolding on the coast between rebel forces of the ascendant Liberal Party, loyalists of the ruling Conservative Party, and the occupying Marine forces stationed in the region.

Shortly after the discovery of Fox's body, local authorities found Bolton's remains in a rubber sack in a nearby creek. Bolton had lived on the coast for approximately thirty-five years and was widely known as a supporter of the Conservative Party. *The Bluefields Weekly* reported, "When the Liberals drove the Conservative troops out of Pearl Lagoon . . . Bolton was captured as a spy and a guide for the Conservatives." The editors alleged that Bolton "had tried to stir up strife in Pearl Lagoon and as a result was sent to Bluefields out of consideration for him as a foreigner, instead of being shot as would have been done otherwise." In January 1927, after a few weeks of detention, Bolton was released by local authorities. He returned to Pearl Lagoon where he continued to antagonize residents, who were largely supporters of the Liberal Party.[43] Five months later he was dead.

In the months following Fox and Bolton's deaths, the Marines launched a full-scale investigation into the murders. The military was distrustful of the local authorities, many of whom were Liberal sympathizers. In October 1927, Captain D. J. Kendall, who was stationed with the Marine forces in Bluefields, submitted a Police Operations report that reveals the racial and political subtext that informed their investigation: "A Marine force at the request of the Department of Criminal Judge assisted the negligent, insubordinate, and inefficient local agent of police at Pearl Lagoon in rounding up and bringing to Bluefields for trial the members of the gang of negro Liberals who have controlled and terrorized that locality for some years and I believed who have assassinated not less than five people in the last two or three years." Among their suspected crimes was the "brutal and devaulting murder of an American John Bolton and his Nicaraguan common law wife," Doreth Fox.[44]

Creoles in Pearl Lagoon and Bluefields, however, argued that the Marines used Fox and Bolton's murders as a pretext to punish Creole community members with Liberal sympathies.[45] Local complaints of ill treatment at the hands of the U.S. Marines investigating the murders continue to shape the Creole social memory of that historical moment. Socorro Woods Downs, a Creole feminist researcher from Pearl Lagoon, recalls hearing stories from her grandparents about being detained, questioned, and beaten by Marine soldiers investigating the murders. The fact that one of the victims was a white U.S. citizen allowed the Marine forces to engage in indiscriminate acts of violence against the population in the name of law and order.

The murders and their discursive afterlife in Creole social memory also illustrate how this moment of crisis and upheaval created space for women to contest their communities' gender norms and articulate new modes of femininity and political subjectivity. Unlike Anna Crowdell, whose critical interventions in regional politics have been largely forgotten, Doreth Fox remains a vital figure in Creole social memory. Her memory lives in the region's landscape and cultural imagination; Pearl Lagoon locals refer to the marshy savanna where Fox was murdered as Doreth Cay. Grandparents continue to recount the story to their grandchildren. In these stories, Fox is remembered alternately as "a bad woman" and a woman ahead of her time. Fiction writers have reimagined the mystery of Doreth Fox and her spectacular death in novels and short stories that often tend to fixate on her reputation as an obeah woman (Robb 2007).

Yet, perhaps Anna Crowdell and Doreth Fox are more alike than is apparent. Even though they seemed to have been on opposing sides of the revolutionary conflict, they were both members of the Creole elite who enjoyed significant class privilege and a unique level of individual autonomy. They used this privilege to insert themselves into political and economic spaces traditionally closed to women. They were actively engaged in political struggles and made extensive use of the political institutions available to them, registering their complaints with the British and U.S. consuls, the national government, and the U.S. Marines.

That Crowdell and Fox chose different routes to articulate their political demands—Crowdell opting for strategic respectability, whereas Fox forged a different kind of freedom and a disreputable feminine subjectivity—reflects the larger political systems that conditioned Creole women's participation in and movement through the public sphere. They refashioned the options available to them to serve their purposes, with varying degrees of success. Although their experiences do not speak to the lives of women who did not enjoy the benefits of such class privilege, they reveal how some Creole women navigated the highly militarized social landscapes of the coast during this volatile period of political transition.

In 1927, the United States compelled the Liberal and Conservative Parties to enter into peace negotiations. Under the terms of the Pact of Espino Negro, both sides agreed to disarm and sell their weapons to the occupying U.S. Marines. Díaz was allowed to finish his term until presidential elections were held in 1928, and

the Marines would remain to oversee the creation of an apolitical, professional army. The Conservatives and Liberals agreed to these conditions, with the exception of one of Moncada's generals, Augusto Cesar Sandino. Almost immediately, Sandino began a guerrilla war against the occupying U.S. forces that lasted until 1933 (Gobat 2016; Walter 1993). This period also saw the ascendancy of another Liberal general, Anastasio Somoza García, who rose through the ranks of the National Guard after being appointed its director in 1932. In the mid-1930s, Somoza used his control over the military to seize state power. After assassinating Sandino in 1934 and forcing Sacasa out of office, he assumed control of the government, launching a dictatorship that would, with U.S. backing, rule Nicaragua for the next forty-five years.

SOMOCISMO ON THE COAST

In February 1936, Anastasio Somoza wrote a personal letter to Anna Crowdell. Written in florid prose, Somoza's letter demonstrates how valuable Crowdell's political connections continued to be. He acknowledged Crowdell's "constant labors in the political life of this important coast," which had made her a valued ally among "the inhabitants of Old Bank, Tapapone, Pearl Lagoon, and Rama Kee." He expressed his desire to "establish all types of relations with those people, like yourself, who are intensely interested in the future of this important region of the country." Clearly Somoza hoped to use Crowdell's influence among Black and Indigenous costeños to his own political advantage in the upcoming national elections, in which he felt confident about his chances: "It is my wish to establish direct relations with you and exchange ideas about the political future of Nicaragua, I am sure that you will receive them with pleasure, as they are my best proposals for the greatest good of the Atlantic Coast whenever I become the President of the republic, a very feasible possibility." He ended his letter with these words: "I await your pleasant orders and wish you success in your work, I am pleased to be, your attentive servant and affectionate friend."[46] By the time Somoza wrote to Crowdell, he had already begun to consolidate the system of populist clientelism and civil society co-optation that would define the Somoza dynasty for the next forty years. It appears, however, that the letter made a favorable impression on Crowdell. From the 1930s into the 1950s, she became known as "an ardent Liberalist" and played a decisive role in regional elections, ensuring a high turnout of Black and Indigenous Liberal voters.

By the late 1920s and early 1930s, costeños were placing their hopes for regional development, political representation, and full citizenship in the Liberal Party.[47] Given the degree to which they had supported the Liberals during the recent war and the personal sacrifices they had made to do so, they expected that, once in power, the Liberal Party would address their demands. Costeños' strong show of Liberal support in the 1928 elections brought former general Jose María Moncada to power. Preliminary polling in September 1928 showed that the Liberal Party

enjoyed overwhelming support among regional voters: over two days, 527 voters in Bluefields registered to vote as members of the Liberal Party versus only 162 voters as Conservatives.[48]

Although they appear only sporadically in Marine intelligence reports and coverage by the local press, Creole women appear to have played an important role in consolidating Creole support for Liberalism. They engaged in direct political advocacy and formally participated in the regional and national structures of the Liberal Party and in various modes of informal advocacy. One 1927 article published in *The Bluefields Weekly* describes how a Mrs. H. O. Glover, popularly known as "Aunt Levy," intervened in municipal elections to prevent a Conservative victory in the neighboring island community of Rama Cay. The article described Glover as "a quiet, good-hearted woman, blessed soul who considers it a pleasure to receive into her home . . . well or ill, all the Rama Cay folk who chose to come to her."

Women like Aunt Levy used their significant moral capital in Black and Indigenous communities to influence regional politics: "when it became evident that someone was needed to say a word to these people by way of preparation for the coming election, and to show them the need of uniting with Liberalism; Aunt Levy volunteered her services." Aunt Levy "reached the Cay at the right moment and soon had won the Liberal Party a compact bloc of intelligent voters, who soon saw where their interest lay." When the local head of the Conservative Party arrived at the voting station at Rama Cay, "he was stunned at finding his guarantee [victory] all shattered by a united Liberal front."[49]

The Department of Zelaya eventually became the second-largest base of the Liberal electorate in the country. In the 1932 presidential elections, Liberals won 68.5 percent of the costeño vote versus only 21.5 percent for Conservatives (Walter 1993). After the elections, Admiral C. H. Woodward, who served as chair of the U.S. Electoral Mission that oversaw the 1933 municipal elections, stated, "The coast is Liberal by a large majority." It is difficult to say how much of this support at the polls reflected Creoles' investment in the ideology of Liberalism, which remained largely amorphous and inchoate until the consolidation of the Somoza regime. What is clear is that regional support for the Liberal Party was not unconditional; Black and Indigenous communities expected that their loyalty to the party would be reciprocated with a comprehensive agenda for regional development and national integration. R. M. Hooker, a Creole student at the Moravian College and Theological Seminary in Bethlehem, Pennsylvania, outlined the community's political expectations in an editorial in *The Bluefields Weekly*: "Nicaraguans want to see the construction of a railroad to the Atlantic Coast, they desire a well-organized system of education, they particularly desire to see 51 percent of our National Bank owned by Nicaraguans, they also want to see this bank aid the development of agriculture and endeavor to help our farmers. Nicaraguans, especially those on the East Coast, desire a program for the general welfare of the Atlantic Coast."

Hooker's editorial illustrates not only the pragmatism that characterized Creoles' support for the Liberal Party but also the broader shift in Creole political commonsense, which marked the end of overt resistance to the Nicaraguan state on the coast. The ascendance of the Liberal Party and the "party's consolidation of power under the Somozas" were the "most important factors in the diminution of Creole oppositional politics" in the 1930s. "The domination of national political processes by the Somoza dictatorship precluded tears in the national political fabric, which had provided space and opportunity for the intensification of Creole politics in the past" (Gordon 1998, 83). Thus, the opposition, contestation, and opportunistic political alliances that had made armed rebellion against the state a viable political strategy became less feasible as Somoza's power became more firmly entrenched. In addition, Gordon (83) suggests that Creoles' political aspirations converged in many ways with that of Nicaraguan Liberal political philosophy, which emphasized a commitment to "constitutional government, government by consent of the governed, the rule of law, property rights, laissez-faire economics, modernization, and separation of church of state." As such, throughout the 1930s and into the 1970s, Creole forms of popular dissent became more reformist, integrationist, and accommodationist than earlier political movements.

The emergence of a more quiescent mode of Creole politics during this period was also driven by the global economic crisis of the 1930s and by a blight that devastated banana production. As the regional economy stagnated, Creoles shifted their priorities from the goal of regional autonomy to the increasingly difficult goal of everyday survival. U.S. corporations and capital fled, and the British reduced their diplomatic presence in the region. In turn, costeños slowly shifted their political loyalties from the United States and Great Britain to the national government, addressing their hopes for regional economic development there.

These alliances with the government seemed meaningful precisely because of the personalized, charismatic performance of governance that defined the Somoza regime. Unlike previous Nicaraguan presidents who had never bothered to visit the coast, Somoza regularly visited, as did both his sons. During these trips they often spoke in English to Black and Indigenous audiences, performing a kind of proto-multiculturalism that resonated strongly with costeños. Crowdell affirmed this sentiment during her speech at the fiftieth anniversary celebration in Masaya: "With the visit two years ago that our energetic and capable Leader General Anastasio Somoza made, all costeño hearts beat with happiness in the hope that we would obtain a better life, since he was the first Nicaraguan head of state that deigned to visit humble costeños and to touch with his own hand the sad realities of our lives and to see our anguish with his own eyes in order to find out how to remedy them."

Somoza's letter to Anna Crowdell thus reveals the complex mix of party patronage, popular clientelism, and coercion that defined Somocista populism. Women were essential to this governing strategy. In her study of women's politics in prerevolutionary Nicaragua, historian Victoria González-Rivera (2011, 76) notes that

"the Somozas made a strong appeal for support to Nicaragua's women" by endorsing women's suffrage, creating spaces for their participation in the Liberal Party through the creation of the *Ala Feminina* (Women's Wing), and encouraging their participation in the labor force "in exchange for women's political support." She argues that the Somoza regime developed a complex system of "intimate reciprocity" with Liberal women in which the Liberal party-state cultivated a deep personal connection to female voters by directly engaging with the concerns of their daily lives. Women reciprocated these forms of political recognition with their continued political support and endorsement of the regime. The support of women like Anna Crowdoll was an invaluable asset that underwrote the regime's aspirations for legitimacy.

But the Somoza regime maintained an ambivalent relationship to the region and to Black communities. Vilas (1989, 82) notes that even as the Somozas delivered speeches in English to Creoles and Indigenous communities and "made a great show of their excellent relations with foreign companies and the U.S. government," they also continued to support "government Hispanization projects publicly in Managua." Thus, although the Somozas performed a kind of proto-multicultural recognition in their interactions with Black citizens, they remained committed to an ethnocentric nationalism that valorized the "mestizo culture of the dominant class" while deriding Indigenous cultures as "savage" and "nomadic" (Gordon 1998, 124). Creoles were largely excluded from the nationalist discourse of the Somoza regime. Thus, to the degree that the Somozas recognized the cultural difference of the coast, such difference was largely narrated as an obstacle to be overcome by the political, economic, and cultural integration of the region (Gordon 1998).

Thus, the Somozas deployed a mixed policy of benign neglect and neocolonial integration on the coast that was tacitly racist in its orientation. On the one hand, the regime tended not to intervene directly in local political affairs, instead appointing elite Creole and mestizo costeños to key political positions (if in a somewhat tokenized manner) and then dealing directly with these appointees, not the community. At the same time as the Somozas engaged in this informal policy of local recognition, they continued to exploit the region's resources, enriching themselves and their supporters in the Pacific through the imposition of regional monopolies and the granting of concessions to foreign multinational companies while using Black and Indigenous lands as a safety valve for displaced *campesinos* (Gordon 1998; Vilas 1989).[50]

Costeños took exception to these exploitative policies and continued to call on the government to prioritize the full political and economic integration of the coast. In 1934, Senator Horatio Hodgson delivered a memorial address to the National Congress outlining Blacks' and Indigenous people's frustrations with the government. The memorial contained "a project for the moral and material development of this Department, notably abandoned in the last 41 years by all the political parties of the country since its reincorporation into the Republic." Hodgson argued that,

"The Department of Zelaya is not a colony," and criticized the state's ongoing exploitation of the region's natural resources and its approval of exclusionary concessions: "Since the Reincorporation of the Mosquitia, the most destructive exploitation of the natural resources of this Department has been done by the foreign concessioners that have operated in this region and cunning speculators from outside of the Republic." He lamented that "this department lacks good roads, modern ports, telephone service, and adequate hospital services"—services enjoyed by all the nation's other major cities—but "Bluefields has nothing and produces one-third of national revenues." Hodgson concluded that the government needed a new approach to the region that would facilitate its full integration into the national body (Arellano 2009). Hodgson's speech represented one of the last expressions of militant Creole political discourse during the Somoza regime (Gordon 1998). I suggest that Hodgson's 1934 address and Anna Crowdell's 1944 speech illustrate the transition from Creole militancy to acquiescence. Both reveal how Creoles began to reframe their petitions to the Nicaraguan state through a discourse of patriotic citizenship and national integration while also attempting to maintain a critical stance.

The Creole social memory of the Somoza era differs significantly from that of many Nicaraguans in the Pacific who experienced the full brunt of the Somocista state's violence. Instead, Creoles tended to remember the period as "an uneventful time on the Coast marked by the withdrawal of U.S. capital and business. Times were generally hard economically but tranquil politically" (Gordon 1998, 116). Despite the fact that the Somoza state continued to exploit the coast's natural resources and failed to improve the region's infrastructure and economy, costeños were ambivalent about the regime, at times supporting it but criticizing it when the Somozas failed "to be good to those who were good to them" (González-Rivera 2011, 14). It is not difficult then to understand Crowdell's laudatory statements about Somoza during the fiftieth anniversary of the Reincorporation. Populist regimes rooted in a system of personalistic exchange require loyalty as the price of political influence. By the time Anastasio Somoza García rose to power through a combination of brute force and political pacts, costeños were already well versed in the practice of quid pro quo exchange that defined Nicaraguan politics. The Somozas did not invent this system, but they refined and institutionalized it (Walter 1993). Understanding how this system functioned is critical for understanding why so many people—workers, women's organizations, students, artists, the business class, and the church, as well as Black and Indigenous costeños—supported the regime for more than forty years.

Dictatorships are not simply imposed from above through violence and coercion but are also maintained from below (Gould 1998). The system of Somocista populism constrained regional spaces of political mobilization by tightly controlling access to the benefits of party loyalty and violently policing those who defied the regime. This system resulted in the co-optation of regional politics by a single authoritarian party, which would occur again. Given the extent to which the

Somozas enriched themselves at the region's expense, they clearly gained more from their relationships with costeño Liberals than they gave.

Yet, studying the long history of regional politics reveals that the process of political co-optation is never a complete or totalizing project: it is riven with cracks and fissures of discontent, dissent, and the persistent demands of the past. Although it appeared that the dream of regional autonomy had been laid to rest as Creoles accepted Nicaraguan rule and set about the business of becoming full citizens and participants in the Somoza regime, they continued to hold onto the desire for full autonomy. It would not be until a generation later, in the 1970s and 1980s, that costeños would again explicitly assert their political demands. They would do so with explosive results that would shake the nation to its core and produce one of the bloodiest conflicts in modern Nicaraguan history.

It is not clear how Anna Crowdell responded to these political transformations and the consolidation of the Somoza regime. Her contributions to the archive began to taper off in the 1950s, and it appears that she left Nicaragua during the 1960s and moved to Queens, New York, to live with her daughter Margaret. She died there in November 1977 at the age of 101. By any measure, Anna Crowdell led an extraordinary life. She came of age during the last years of the Mosquito Kingdom, was witness to the violent period of Reincorporation, participated in a series of revolutions, and forged political alliances with Liberals and Conservatives alike in the service of restoring the political autonomy of the Atlantic coast. She defied the gender norms of her era to become one of the most well-known and influential figures in the region and Nicaraguan politics writ large. Her erasure from the official narrative of twentieth-century Nicaraguan nation-building illuminates how the politics of race, region, and gender have produced crucial blind spots in this history. Examining her biography reveals, how, despite gender norms designed to marginalize and silence them, Creole women developed a variety of modes of political activism that allowed them to intervene in the most important political struggles of the time. In so doing, they produced a model of regional activism and female leadership that would shape Black women's participation in social movements throughout the century.

2 · *ENTRE EL ROJO Y NEGRO*

Black Women's Social Memory and the Sandinista Revolution

Oscar, yuh surprise me
assin far a love poem.

Ah sing a song a love fa meh country
small country, big lite
hope fa de po', big headache fa de rich.
Mo' po' dan rich in de worl
mo' peeple love fa meh country.

Fa meh country name Nicaragua
Fa meh people ah love dem all.
Black, Miskito, Sumu, Rama, Mestizo.

So yuh see fa me, love poem complete
'cause ah love you too.
Dat no mek me erase de moon
and de star fran de firmament.

Only somehow wen ah remba
how you bussing yo ass
to defend this sunrise, an keep back
de night fran fallin,
ah know dat tomara we will have time
fa walk unda de moon an stars.
Dignify an free, sovereign
children a Sandino.
 —"Love Poem" by June Beer

"Like a lot of Black women, I have always had to invent the power my freedom requires."

—June Jordan

THE MEETING OF TWO JUNES

On July 19, 1979, thousands of Nicaraguans—students, campesinos, street vendors, housewives, laborers, youth, and the rank-and-file of the Sandinista National Liberation Front (FSLN)—flooded the streets of Managua and the Plaza de la Republica, newly rechristened the Plaza of the Revolution to celebrate the defeat of the dictatorship of Anastasio Somoza Debayle, whose family had ruled the country for more than forty years. Images of defiant young men and women waving the red-and-black flag of the FSLN from the backs of trucks and triumphantly raising fists and weapons to the sky, captured the imagination of the world. It was, as the noted Nicaraguan writer and former vice president Sergio Ramírez (2012, xiii) observed, "a transcendent historical phenomenon": "We did it. We had arrived. The world was going to be turned upside down. Sandino's dream would be achieved. There would be no more submission to the Yankees. Exploitation would end. Somoza's assets would belong to the people, the land to the farmers. The children would be vaccinated, and everyone would learn to read. The barracks would become schools. The rhetoric fit the reality because words were meat and bone with the truth of desire. Nothing could come between them" (36).

The idealism of the young revolutionary government stood in stark contrast to the high price that Nicaraguans paid for national liberation. When Anastasio Somoza fled Nicaragua two days earlier, he left the country in shambles. The FSLN inherited a crumbling economy that was $1.6 billion in debt with only $3 million in the national treasury; in addition, the conflict had claimed 50,000 victims (Close 1999; Chavez Metoyer 2000). Nevertheless, the defeat of the Somoza dictatorship represented a moment of third-world utopian possibility whose reverberations were felt around the world. The international Left responded enthusiastically, and leftist organizations in developed countries quickly launched solidarity campaigns to support the new government. Third-world and Black feminists played a central role in the development of an international solidarity movement rooted in "an integrated critique of racism, colonization, patriarchy and imperialism" (Spira 2013, 40).

In 1983, June Jordan, the African American feminist poet, traveled to Nicaragua to observe the Sandinista Revolution. Jordan was horrified by the Reagan administration's assault on this small, war-torn nation. But she also witnessed something else—an entire generation of women and men radicalized by their participation in the revolution and willing to sacrifice everything to defend it: "I went everywhere I could, and everywhere I went I saw the motto: All arms to the people. I saw all of the people armed: nine year olds, Black women, elderly men. Everyone was armed with World War II rifles or AK-47s or whatever might come to hand; people forming volunteer militias to defend the revolution they had made" (Jordan 1985, 70).

Fighting to overthrow the Somoza dictatorship and restore Nicaragua's national sovereignty gave many Nicaraguans a cause they felt was worth dying for. Meanwhile the revolution's goals of improving the country's social, economic, and

political conditions and creating a more equitable society offered many people something to live for. Among those were Black Creole and Garifuna women from the Caribbean coast—women whose lives were transformed by their participation in the revolution. June Beer was one of these women.

Beer was radicalized by the struggle for national liberation earlier than most costeños. Born in 1935 to a well-to-do Creole family in Bluefields, she became the most important visual artist from the coast and an ardent supporter of the FSLN. A self-taught painter, her work reflected the landscapes, daily activities, cultural traditions, and racial diversity of the peoples of the Caribbean Coast. Much of it featured Black women as mothers, workers, and revolutionaries. One portrait shows a Black woman with a small Afro dressed in army fatigues, her right fist raised defiantly in the air against a vibrant red background. Beer painted Black women (and herself) into the history of the revolution, carving out a space for Black women's radicalism in Nicaragua's political landscape (LaDuke 1985b, 1986; Ramos 2005).

In addition to her work as a painter, Beer, like Jordan, was a poet. In her poetry she explicitly articulated her radical politics and her understanding of the revolution as a process that could address the needs of all Nicaraguans across race and class. In "Love Poem," published after her death in 1985, she outlines a multicultural narrative of Nicaraguan citizenship rooted in a radical politics of love: "Fa meh country name Nicaragua/Fa meh people ah love dem all/ Black, Miskito, Sumu, Rama, Mestizo/So yuh see fa me, love poem complete." She concludes, "Ah know dat tomara we will have time/ fa walk unda de moon and stars./ Dignify an free, sovereign/children a Sandino." This poem reflects Beer's deep conviction that the revolution had something critical to offer the coast—and Black women— at a time when few other projects did. Even its rendering in Creole English, a defining cultural marker of Black Creole costeño identity, demonstrated her early articulation of a multicultural discourse that would be later taken up by the state in some surprising and contradictory ways.

June Jordan met June Beer at the Bluefields Public Library, where Beer worked. Jordan (1985, 72) recalled their conversation about the counterrevolutionary war that threatened Nicaragua's future:

> They beg me to remember to send Black history and Black poetry and Black novels to their library. They beg me to remember them. The most distinguished artist of the Atlantic Coast, the Black painter and poet June Beer, begs me to send her a tape of Paul Robeson singing, "Let My People Go." And quietly she asks me, "Do you think I have a future? Do we [Nicaraguans] have one? Some days I think maybe— maybe not." A few minutes later she tells me why she had been jailed under Somoza. "In the revolution I was too old to be a militant. But my mouth was not too old."

Jordan's description of her brief encounter with Beer is one of the few written accounts that directly examine Black women's participation in the revolution. It is more telling that widely read accounts and oral histories about women, gender,

and the revolution tend to overlook this history (Deighton 1983; Isbester 2001; Kampwirth 2002, 2004; Randall 1994; Randall and Yanz 1981). Yet as I spoke with women in Bluefields—many of whom proudly showed me faded, dog-eared photographs of themselves in their military uniforms, medals, certificates, and the books they used to teach farmers and their families how to read—I kept returning to the same questions: Given the voluminous literature on the Sandinista Revolution, why and how had everyone missed these women? Why were Black women so invisible in this narrative? And what might become visible were Black women's stories to be placed at its center?

As the anthropologist Fernanda Soto (2017, 2) acknowledges, "Representations of the Sandinista Revolution are highly contested narratives." The last forty years of scholarship, as well as memoirs and biographies by former Sandinista militants and their counterrevolutionary detractors, reveal the struggle by different political actors to assert dominance in narrating the revolutionary period. While its critics decried the revolution as an act of national betrayal, the writings of Sandinista militants valorize the revolution for producing a new kind of political subject in Nicaragua, the revolutionary citizen.

Yet like much of Nicaragua's nationalist narrative, this literature leaves out an important location—the Caribbean Coast. Sergio Ramírez mentions the coast only once in his memoir, *Adios Muchachos* (2012), and the feminist writer Gioconda Belli never mentions it at all in her memoir *The Country Under My Skin* (Belli and Cordero 2003). Those memoirs that do discuss the coast or Black and Indigenous peoples often reproduce racist, stereotypical representations even when they frame these retrograde social and economic conditions as a product of the Somoza state's historic abandonment of the region (Borge 1992; Cabezas 1985; Tijerino and Randall 1978).

Given the centrality of the coast as the primary site of a conflict that claimed the lives of nearly fifty thousand people, the lack of reflection on its place in the revolution or in engagement with the political and cultural conditions that gave rise to the Contra War is troubling. These accounts of the revolutionary period reproduce the tendency to treat the coast as a troublesome and marginal geography in the political life of the nation. They obscure what Soto refers to as the "forgotten episodes" of the revolution that do not fit comfortably into any discursive frame produced by both its detractors and its adherents.

Black women's accounts of the revolution complicate these narratives and reveal both the promises and disappointments of that political experiment and its implications for contemporary social movements in Nicaragua. For if the revolution provided everyday Nicaraguans with unprecedented opportunities for democratic participation in the building of a new nation, it also was a period fraught with contradiction and conflict among unequal political constituencies over precisely what kind of democracy they wanted to construct. As Elizabeth Wright, an NGO organizer told me, "There's a lot of myths and mistakes about the revolution. . . . But heavy things went on revolution time."

In this chapter, I explore the "heavy things" that went on during the revolution and how Black women became revolutionary political subjects. I draw primarily from oral history interviews that I conducted between 2009–2017 with eleven Black women activists and community leaders in Bluefields and Managua. I illustrate how the freedom dreams of Black women were shaped by their political and affective entanglements with multiple political discourses, including the global Black liberation struggle, proto-feminist thought, liberation theology, and anticommunist ideology. These discursive engagements often meshed uncomfortably with the project of revolutionary nationalism as Black women both embraced and challenged a partial form of national inclusion that maintained clear continuities between earlier nationalist projects that excluded them as Black people, as women, and as costeñas.

THE MYSTIQUE OF LA MONTAÑA

> We will bury the heart of the enemy in the mountains.
> —FSLN slogan

As emphasized by the autobiographical writings of former FSLN militants, the revolution was not simply a struggle to transform the social order but one that also transformed how the men and women who participated in it imagined themselves as political subjects. Sergio Ramírez (2012, 3) argues that the revolutionary decade "changed values, individual behavior, social relations, family ties, and customs. It created a new ethics of solidarity and detachment from material things, a new everyday culture." These ethics were informed by commitments to national sovereignty rooted in the legacy of the nationalist struggle led by Augusto Sandino, Marxist thought, and political democratization and economic justice grounded in liberation theology. FSLN militants often referred to this ethos as the *mística* of the revolution, a set of social values that formed the heart of FSLN ideals of revolutionary subjectivity. To Ramírez, this ethos was a kind of political sainthood, embodied by a willingness to serve as a martyr for the cause of national liberation:

> It was, in all honesty, a strange way of behaving, a radical change in customs, habits, comforts, lifestyles, feelings, and worldview. Before learning how to shoot a weapon, you learned an ethical behavior that emerged out of love for those who had nothing, in Christian terms, and you accepted the commitment to forsake everything to dedicate yourself to a fight to the death destined to substitute the power of those from above with the power of those from below, in Marxist terms. From a Marxist perspective, it was about class struggle and assuming a new class identity; from a Christian perspective, it was about putting solidarity in practice no matter what the consequences. (27)

But as the memoirs and autobiographies of FSLN militants reveal, the production of this revolutionary subjectivity was not simply an ethical process but was also a

spatial formation (Borge 1992; Cabezas 1985; Ramírez 2009). The mountains, the abandoned rural spaces outside the cities where the brutal excesses of the Somoza regime had been enacted most violently, were where this subjectivity was consolidated.

The *montaña* is a privileged geography in both official and popular narratives about the Sandinista Revolution. It was the landscape where both the FSLN leadership and the rank and file were forged. As the site where Augusto Cesar Sandino and his small army of radicalized peasants first waged war against occupation by the U.S. Marines, the mountains have long been a central feature of the spatial imaginary of Nicaraguan nationalists. The importance of the mountain as a nationalist geography is apparent in the writings of Carlos Fonseca, the founder and ideological architect of the FSLN. Fonseca and other FSLN leaders tended to espouse a "somewhat romantic view of the innate rebelliousness of the Nicaraguan campesino" and of the mountains as an inherently revolutionary landscape (Zimmerman 2000, 152). Fonseca argued that the "Sandino is a living presence in the campo, and even more so in the montaña" (Fonseca 1985, 211).

In his 1976 essay, "Notas sobre la montaña y algunos otros temas," Fonseca (1985) elaborated his theory about the role that rural areas and the mountains played as sites of resistance in the struggle to overthrow Somoza. He anthropomorphized the montaña, imbuing it with an autochthonous sense of rebellion and insurgent nationalism. The spirit of resistance and the tradition of nationalist struggle, he wrote, are "more alive in the countryside and the mountain than in the city" (211). Fonseca juxtaposed the mountains—a transformative social landscape that produced the kinds of self-sacrificial subjectivity that revolutionary action required—with the capital city as characterized by corruption, class inequality, and bourgeois decadence. Sandinismo flourished in the mountains through an ethos of self-discipline, altruism, personal sacrifice, physical fitness, coordinated collective action, adherence to a hierarchical military structure, and the rejection of wealth and bourgeois comforts. It was only in the mountains, Fonseca argued, that one could "consolidate the revolutionary and moral qualities" (212) that would transform pampered young urbanites into committed revolutionaries. Fonseca, like many Sandinista militants, spoke of the mountains as a quasi-mystical, metaphysical landscape that transformed ordinary people into revolutionaries, bringing out their best qualities for the cause of national liberation.

But this narrative of the mountains as a revolutionary landscape was also deeply raced and gendered. What emerges in these texts is a discourse of the montaña not only as a masculinist space but also as a mestizo nationalist geography that reifies the rural mestizo figure as the ideal citizen-subject. Yet women also had a presence in the mountains, which played a decisive role in shifting gender norms during the revolutionary period. Karen Kampwirth (2002, 18) argues that "the FSLN was the first guerilla movement in Latin America that was truly a dual-gender coalition" in which women fought as equals in the armed uprising to overthrow Somoza. Scholars estimate that in the final year of the uprising women

comprised approximately 30 percent of the armed Sandinista forces in the coun-
tryside and the nation's urban centers (Kampwirth 2002, 41; see also Collinson
and Broadbent 1990; Randall 1994; Randall and Yanz 1981; Tijerino and Randall
1978). Women like Doris Tijerino, Dora María Téllez, Mónica Baltodano, Nora
Astorga and others became symbols of the revolution's emancipatory promise for
women (Baltodano 2010; Tijerino and Randall 1978; Daniel 1998; Randall and
Yanz 1981). This desire for full gender equality and social change was also part of
what led a small number of costeñas to join the struggle in the mountains.

Dorotea Wilson is a founding member of the *Red de Mujeres Afrolatinoamerica-*
nas, Afro-Caribeñas y de la Diáspora (the Afro-Latin American, Afro-Caribbean, and
Diaspora Women's Network; hereafter, the Red); she served as general coordinator
of the Red from 2007–2018. She was born in Puerto Cabezas in what is now the
North Caribbean Coast Autonomous Region (RACCN) in September 1948. Her
father was a gold miner, and her mother worked as a domestic. She grew up with
seven brothers and sisters in a large two-story house in Puerto Cabezas that was
run by her grandmother, the family matriarch; her aunts lived on the property in
their own houses. She described the women in her family as strong and indepen-
dent, and their example exerted a powerful influence on her own political and
social formation. When Wilson was very young, her parents separated and split up
the children between them. Her brothers were sent to live with their father in Siuna,
located in what is known as the Mining Triangle, approximately 200 kilometers
west of Puerto Cabezas, while the girls remained with their mother—except for
Dorotea, who was sent to study with the Maryknoll nuns in Siuna.

The Maryknoll Order established a mission in Siuna in 1944 at the request of the
Capuchin Franciscan friars already working in the region. That year they estab-
lished the town's first health clinic and within a year of arriving opened a school,
which ran from kindergarten to sixth grade, serving 280 children. By 1962, the num-
ber of students had increased to 785, with 300 adults enrolled in night classes (Mar-
key 2016).

Siuna was a company town. Dorotea's father worked for the Canadian-owned
La Luz Mining Company, which drew thousands of low-skilled workers to the
area. But working conditions in the mines were miserable; the miners earned des-
perately low wages and frequently died in accidents when the mines collapsed. In
their letters to the headquarters of the Maryknoll Order in New York, the nuns
recounted how the miners' attempts to organize a labor strike for a 35-cent wage
increase in 1954 were brutally repressed by the National Guard. The Maryknoll
nuns initially maintained a cordial, if distant, relationship with the Somoza regime,
but many became increasingly troubled by the state's repression of poor people
struggling to live with dignity and "aching to be the authors of their own history"
(Markey 2016, 137).

Over the next forty years, the Maryknoll sisters cultivated a reputation through-
out Central America as strong advocates of the poor who came to be supporters of
the growing nationalist movements in Nicaragua, El Salvador, and Guatemala.

Wilson recalled the Maryknoll sisters as "very progressive, very revolutionary." One of her favorite teachers was a young nun named Sister Maura Clarke, who later became a household name in the United States after she and three other nuns were brutally murdered in El Salvador by National Guard soldiers (Markey 2016). But that occurred many years after Wilson left Siuna.

After she completed primary school, Wilson was sent by her father to a boarding school run by the sisters of the Carmelites of the Sacred Heart of Jesus in Puerto Cabezas. There she decided to become a nun and entered the convent. As a cloistered religious order, the Carmelitas maintained a firm distance from politics and the ideology of liberation theology that swept the Catholic Church in the 1960s and 1970s. Dorotea felt stifled by the contemplative life and increasingly troubled by the miserable social conditions in which nearly all her parishioners lived. She recalled, "We began to hear about the ideology of liberation theology. The priests began to do Mass in Spanish. In Pearl Lagoon there was a Black priest who delivered the Mass in Creole. . . . It was super, super. So, I said to myself, 'All these things, all these changes.' So, then I told my priest, 'I have to do other things.'"[1]

Witnessing the impoverished conditions in which costeños lived, Dorotea increasingly began to feel that transforming the conditions in which these communities lived would require attending as much to their political and material needs as their spiritual well-being. There was, she recalls, only one hospital in the region, which had been built by the Moravian Church in Puerto Cabezas; there miners could receive treatment for tuberculosis and silicosis, the most common illnesses among the workers. In fact, Wilson's father, who worked in the mines for forty years, later died of silicosis.

In 1974, at the age of twenty-six, Wilson left the convent and began working in the countryside with the Missionary of Christ, a small group of nuns and priests that "set up a communal religious life dedicated to working with the people. We worked mainly in the mountains with peasant women, trying to help them better their lot." She recalled, "It turned out we were right in the heart of the guerrilla zone" (El Nuevo Diario 2011).

> When I entered the Missionary of Christ we began to have communication and make contact with the countryside, with the campesinos. And the insurrectional movement of the Frente Sandinista and the guerrilla already had a presence in the mountains. Many campesinos were already being disappeared. Many Delegates of the Word were already missing in their communities. We would find them one day and the next day they were not there. The Capuchin priests began to make a list of denuncias of all the disappeared. . . . I think that we can still find the list of campesinos disappeared, assassinated and murdered by the Guard and buried in mass graves. Fue un horror. The Guard committed many barbarities.

Delegates of the Word were lay church workers who led prayer meetings and church services in isolated rural areas that priests rarely visited. Traveling throughout the

countryside, many of these church workers were politicized by the suffering they witnessed and became supporters of the FSLN, providing them with food, shelter, and information or acting as couriers. As more delegates became involved with the FSLN, they became targets of Somoza's National Guard (Markey 2016). In 1976, a group of Capuchin priests working in Siuna published a list of crimes committed by the Guardia, including the names of some 300 people who had been killed or disappeared since 1974 for suspected collaboration with the FSLN. Father Fernando Cardenal, a Jesuit priest, used the list in his testimony before the U.S. Congress in June 1976 as evidence that the Somoza regime was violating the human rights of its own citizens (Cardenal 2015).

After a few months working in the countryside, one of the delegates approached Wilson and told her that a man wanted to speak with her. This man identified himself as "Modesto" and asked if she would help provide the guerrillas with medications to treat mountain leprosy, a potentially deadly flesh-eating bacterial disease.[2] This was a difficult assignment because "getting medicine for mountain leprosy was first suspicious, very dangerous, and very expensive." Nevertheless, she agreed. When I asked her if she was afraid when they asked her to get involved, she said, "No." "¿Para nada?" I pressed. "Not at all."

Dorotea worked with the FSLN guerrillas in the mountains for two years, obtaining and sending medicines, messages, and money to support them. Missionaries, priests, and nuns were able to move freely through the countryside because they did not arouse the same level of suspicion as young people and campesinos. But as more religious workers became involved, the Guard began to suspect that they were doing more than spreading the gospel. In 1978, Wilson's cover was compromised after the National Guard discovered her involvement with the FSLN. When she learned that the Guardia was looking for her, Wilson packed a backpack and she and two other sisters went to join the guerrillas in the mountains. From there the three sisters were sent to receive military training.

Wilson served in the mountains with the Pablo Ubeda Brigade, named after the alias of Rigoberto Cruz, one of the founders of the FSLN. Life in the montaña was difficult and doubly so for women, who were expected to perform the same tasks as their male counterparts: serving as lookouts and scouts and being prepared for combat at a moment's notice. Marching through the mountains every day to avoid the Guard, while often being undernourished and exhausted, was physically challenging. Wilson recalled, "We had to carry 40-pound backpacks. We brought the basics—salt, a change of clothes, pants, a shirt, a pair of boots with socks." In addition to these basic items, women had to also address their specific bodily needs while keeping up with their male *compañeros*: "the women had to have other kinds of underwear and we had towels—not Kotex—little towels that we used and that could be washed [and reused] during menstruation."

As a *guerrillera*, her responsibilities ranged from combat to more tactical actions: she recounted, "I was involved in some military actions but mostly I worked as a messenger transporting supplies from abroad to the mountains. I made four trips

to Costa Rica and Panama. We were very ingenious in getting stuff into the country. We packed radios, microphones, and transmitters in paint cans or stuff them into the busts of plastic figurines. We even used commercial airlines to transport ammunition wrapped as Christmas presents" (qtd. in Randall and Yanz 1981, 214).

Despite the challenges that women faced in the mountains, serving as guerrilleras was an important moment in their formation as political subjects. For the first time, significant numbers of women became involved in the struggle to shape the nation's political future: this was a radical disruption of the normative gender order that confined women to the private, domestic realm as passive, apolitical observers. The experience of having proved themselves in the mountain (as well as in armed uprisings in the nation's cities) would form the basis of their demands for greater gender equality in the decade following the revolution's triumph.

In May 1979, Wilson participated in the capture of the mines in the industrial community of Bonanza; she recalled that schoolchildren left their classrooms to support the guerrillas in the attack. The National Guard retaliated with aerial bombardments. With the roads destroyed, the guerrillas "had to go deeper into the mountains between Bonanza and Rosita." Frustrated by their defeat in Bonanza, the Guardia followed the guerillas into the mountains and ambushed the group, killing most of the youth who had participated in the attack. They also massacred a family of poor campesinos who had offered food to the rebels. Wilson's face was pained as she reflected on the day's events nearly forty years later. When she finally spoke, her voice was quiet and sad: "So many were lost."

After capturing the mines in Bonanza, the guerrillas kept moving through the mountains from May to July, trying to avoid skirmishes with the National Guard. They spent each evening listening to Radio Reloj from Costa Rica to find out what was going on in the rest of the country. Wilson was in the mountains when they heard the news that Somoza had fled the country on July 17, 1979, a day that Nicaraguans refer to as the "*día de alegría*," the day of happiness. The brigade then marched for two days straight from the Honduran border and arrived in Puerto Cabezas as the FSLN rolled into Managua on July 19.

Arriving in Puerto Cabezas around two o'clock in the morning, Wilson was about to head home to her family. A family friend stopped her and warned her that her family was in mourning. They had heard that she had participated in the taking of the mines in Bonanza and were told that a Black woman, whom they presumed to be her, had died in the ambush laid by the National Guard following the attack. "They thought that I was dead. I was there, I don't know how they get to know but they thought that I had been eliminated." When Dorotea finally made her way home, her mother was shocked and frightened to see her daughter alive, and then, she said, "We all cried."

Miraculously, the guerillas had won. I asked Wilson how she felt in the days following the triumph and she responded, "Crazy. It was a moment of crying and laughing, the encounter of so much emotion, so much emotion, so many memories thinking about those who were left behind, those that fell, those that were not

able to see the victory. We felt lucky to have survived until the triumph and not to have fallen. And we cried and remembered those that fell. Because this is what we had struggled for." Against all odds, an army of teenagers, poets, students, nuns and priests turned guerrilleros had ousted one of the most powerful and longest-running family dynasties in the hemisphere. David had defeated Goliath. The dictator was gone.

"And then," Wilson said, "the real revolution began."

BECOMING REVOLUTIONARIES

Hortencia Taylor is a feminist researcher who lives and works in Bluefields.[3] Raised by a single mother, she grew up in a family of modest means, where money was tight and opportunities to pursue an education or a professional career were limited. In 1978, when she was thirteen years old, her family decided that she would go to Bluefields to continue her education; one of her aunts agreed to cover her school fees for the first year. But then, the following year the Sandinistas came to power, and her entire life changed. "The first thing they said was free education. So that was for me!" she said laughing. "That came like a ring to my finger."

During the FSLN celebration of the thirtieth anniversary of the revolution in 2009, I visited Hortencia at her home in Bluefields. I sat on her bed as she opened up a large armoire and began rifling through its drawers, pulling out several large, neatly packed garbage bags. She placed them gently on the tidy, floral-print bed-spread and pulled out several workbooks, a pale blue smock, folders filled with faded certificates, and several medals and pins. "I have all the little diplomas and things I won, you know. I keep them as a memory of what I did then." She spoke with pride, her voice warm and nostalgic, about her participation in the literacy campaign and the Juventud Sandinista, the youth organization of the FSLN.

Two weeks after coming into power, the National Reconstruction Government, led by the Sandinistas, announced that it would provide free public education, health care programs, and agrarian land reform. As part of these reforms, the government pledged to launch a national literacy campaign. Within a few months, Hortencia and 90,000 other young Nicaraguans joined the National Literacy Crusade. It is estimated that approximately 60 percent of the literacy brigades comprised young women who had left their homes to live with rural families and teach them how to read. The campaign was enormously successful: illiteracy rates dropped from 50.9 percent to 12.9 percent during the first campaign, held from March to August 1980 (Arnove 1981, 248).

The literacy campaign on the coast ran from October 1980 to March 1981, but initially it was a site of intense struggle between the new revolutionary government and costeño communities. The government had intended to conduct a Spanish literacy campaign in the region, but MISURASATA (Miskito, Sumo, Rama, and Sandinista) All Together demanded that it be a bilingual campaign in which participants would learn to read and write both in their mother tongue and

in Spanish. After the group organized a boycott of the campaign, the government agreed to prepare educational materials in Miskito, Sumu-Mayagna, and Standard English (Freeland 1999; Frühling et al. 2007).[4] Approximately 12,000 people then received literacy instruction in either Miskito, Sumu, Spanish, or Standard English.

Hortencia was sent to the neighboring community of Kukra Hill for the six-month literacy campaign. As we looked over her mementos, she said, "I taught seven people how to read." When I asked her what that experience was like she replied,

> It was great! It was a good experience. I think it was an opportunity for me to begin forming my own ideals of life. And I say that because somehow it was the first time that I break the rules of my own mother. . . . When all the young people was going to *alfabetizar*,[5] my mother did not agree and was crying and was like, "No where, you can't do that." And I said, "No, I want to go. I could do it." And my mom was like, "You don't even have 15 years. What you talking about, going in the bush on your own? You don't even know anything about life—you going see the first snake and you going to want to come back. And I don't think it's good you being out there, you too young for that." And this and this and this—until finally she gave in. And I went to the *alphabetization* for six months.

In the campo the young brigadistas were exposed to the impoverished conditions that defined life in rural communities. Hortencia shared, "It was hard for me, the first days especially because when we arrived they gave us an amount of food and for the first week that food finish and then we had to eat what the farmers had. . . . It was really a learning experience for me in all senses because it make me realize that, well, you think you poor, but somebody out there even poorer than you."

After the national literacy campaign ended in 1981, the FSLN declared the country an "illiteracy-free territory," and it quickly began engaging the young people who had taught the country how to read in other social programs. Hortencia was sent to work with the local chapter of the Sandinista Children's Association (ANS) in Pearl Lagoon and served in that position until 1985 when the government sent her to work in Bluefields. Most of her work focused on developing children's programs, organizing public events, and taking children from the coast to participate in national *encuentros*—exchange programs and camping trips in the Pacific.

The leadership skills that she developed as an organizer in the Juventud Sandinista were applied to good effect in her later work as a community researcher and activist. They helped her become an effective organizer, enabled her to deal with people from different backgrounds, and gave her a strong sense of self-determination. As we looked through her *recuerdos*, she said, "I think I learn a hell of a lot being in the Juventud Sandinista. Like the things I doing right now, yes, I learned some of

it in school. But like organizing workshop, organizing encounter, organizing *cooperativa*, them is things I learn in the 80s, in the *Juventud Sandinista*. Believe me, that you never learn in no school. That you learn in the school of life. And in the Juventud Sandinista them is the things we used to do." Young revolutionaries in the Juventud Sandinista worked tirelessly, organizing Sandinista social programs and participating in a variety of state-sponsored cultural and educational activities. As Hortencia told me laughing,

> I began gaining a salary when I was seventeen years old, and I used to gain a salary like what a teacher used to gain. I mean, that time, I was still a student, but I used to work without *horario* [a schedule]. Like it come a time where my mom used to say, "It look like I going to start beg permission to see you because you out whole day, you have so much activity." Nobody have hours to knock off—you just work till you tired, you sleep, and the next day you go again. But you was always occupied.

Many women I spoke with described feeling as though they were running on fumes and optimism in those days. The work of building a new nation was a full-time job, and the young people who drove the revolution worked ceaselessly to carry out the project of democratizing Nicaraguan society from the bottom up.

In 2013, I visited Elizabeth Wright in her home in Managua to speak about her memories of the revolution. As we sat in her kitchen smoking cigarettes and enjoying a few cold beers, she described the deep sense of utopian possibility that inspired young people like herself to invest their energy in making the ideals of the revolution real:

> You would have had to be there. Girl, it was a just a *feeling*. *Todo era posible.* Anything could happen. That was the mystic of the revolution. Everybody was involved, you work endless hours doing whatever, and you just didn't feel it. You know, it's like anything you do you feel the mystic—love and peace and peace and love. The mystic of the revolution was the feeling of just positiveness in the air. It was such a wonderful feeling because you have the hope and you feel like it's a new beginning. And the hope was, like you say, endless possibilities.

Many activists shared this sense of revolutionary nostalgia. The revolution was a special moment in their lives, a period of becoming conscious of the profound inequalities in Nicaragua society. It marked the first time that they began to see themselves as political subjects with important roles to play in building a sovereign and egalitarian social order. Their recollections of experiencing the *mística* of the revolution reflect its enduring power as an affective, moral, and political discourse that linked personal transformation and political consciousness with the broader transformation of society. But the mística and the structure of feeling that it produced in the early years of the revolution would dissipate in the face of U.S.

intervention, the consolidation of a heterogeneous group of counterrevolutionary forces, and the eruption of the Contra War, a conflict in which costeños would play a central part. The war would leave thousands dead, wounded, displaced, and disillusioned with the promises of the FSLN and produce an enduring ambivalence about this period whose repercussions are still felt in contemporary Nicaraguan politics. Over the next four years the mística of the revolution would give way to a different structure of feeling: heartbreak and the bitterness of political disenchantment.

"Yeah, girl, it was a feeling." I watched Elizabeth as she shook her head and exhaled a thick stream of smoke. "And then the war came, and everything went to hell."

THE CONTRA WAR AND THE POLITICS OF DISENCHANTMENT

The FSLN first articulated its position on the coast in "The Historic Program of the FSLN" in 1969. This document broadly sketched the organization's vision of a sovereign, revolutionary, and democratic government of, by, and for the people and outlined its goals on agrarian reform, women's rights, labor, foreign policy, and culture and education. In Section IX, "Reincorporation of the Atlantic Coast," the FSLN claimed that the revolution would "put into practice a special plan for the Atlantic Coast, which has been abandoned to total neglect, in order to incorporate this area into the nation's life" (Borge et al. 1982, 22). To realize this vision, the FSLN would liberate the region from the legacy of "unjust exploitation" it had suffered at the hands of "foreign monopolies, especially Yankee imperialism" and develop the region's agricultural, ranching, and fishing economy. Further, the FSLN promised to "wipe out the odious discrimination to which the Indigenous Miskitos, Sumos, Zambos and Blacks of this region are subjected" (22).

Yet the FSLN adopted a largely rhetorical, folkloric approach to the coast that demonstrated a profound "lack of reflection on the part of the revolution about the current context of the region and how to make alliances with Indigenous communities on the coast" (Frühling et al. 2007, 40). Even the use of the term "Reincorporation," which remains a politically charged term in Creole political discourse as it stirs memories of Zelaya's 1894 coup, revealed the Sandinistas' ignorance of the region's cultural, racial, and political history. Their limited understanding, combined with Black and Indigenous people's deep distrust of mestizo political leadership, would play a critical role in the conflict that erupted between armed Indigenous peoples and the Sandinista state.

Nevertheless, Black and Indigenous communities initially greeted the revolution with cautious optimism. "Their enthusiasm was based on the Creole community's perception that the Triumph of the Revolution would lead to the recognition of their long-held racially and culturally based demands" for land, self-government,

and local control over the exploitation of the region's natural resources (Gordon 1998, 203). Despite the FSLN's theoretical understanding of the racial discrimination and economic exclusion that Black and Indigenous had historically faced, it proved initially unable and unwilling to recognize these demands. Instead, the new government treated costeños as suspect citizens with questionable loyalties to the project of revolutionary nation-building. This suspicion partly was due to the region's relatively broad support for, or at least little direct opposition to, Liberalism, which caused the FSLN leadership to fear that costeños could hold counterrevolutionary sympathies. But this distrust also stemmed from the FSLN's perception of Black and Indigenous people's demands for cultural recognition and self-determination as a dangerous form of racial separatism that threatened the revolution. When Daniel Ortega traveled to Puerto Cabezas in August 1979 to meet with the young leaders of the Miskitu and Sumu Alliance for Progress (ALPROMISU), the first Indigenous political organization on the Coast, he said, "Indigenous peoples no longer existed in Nicaragua because the revolution marked the end of all forms of ethnic or racist discrimination" (Fruhling et al. 2007, 43; see also Hale 1994). Thus, the Miskitu had become Nicaraguans overnight. Rather than pursuing an agenda of culturally based political and economic restitution, Ortega suggested that ALPROMISU dissolve and its members should join the mass organizations—neighborhood organizations, farming cooperatives, and labor unions—that the government was developing in other parts of the country. As a compromise, ALPROMISU was renamed Miskito, Sumo, Rama, Sandinista All Together (MISURASATA), a representative, Indigenous mass organization aligned with the FSLN government (Frühling et al. 2007; Hale 1994).

But the alliance was short-lived. The FSLN would make several critical mistakes early in its interaction with Black and Indigenous communities that played a decisive role in fomenting conflict between the coast and the government. Coastal activists point to the Frente's poor handling of the literacy campaign, its early attempts to exploit the region's natural resources, and the unilateral creation of the Nicaraguan Institute of the Atlantic Coast (INNICA) as critical blunders. But these missteps pointed to deeper problems: the FSLN's tendency to dismiss Black and Indigenous demands as separatist and counterrevolutionary, its often patronizing and racist discourse about the region, and its initial refusal to recognize local leadership in the region.

After the triumph, Dorotea Wilson returned with her brigade to Puerto Cabezas where the FSLN appointed her to serve as the town's acting mayor. She was the first Black woman to hold this position and at age twenty-five was also the youngest person. She was more terrified when she received the order to serve as mayor than she had been to go into the mountains. Nevertheless, just as she had earlier assumed the responsibility of becoming a guerrillera, she agreed to take on this task of "Sandinizing" the coast. She found that people were anxious and concerned about what the overthrow of Somoza would mean for the region and their

families. They had heard rumors that the revolutionaries would confiscate their property, execute former Somoza supporters, kidnap their children, and institute a totalitarian, communist government in the country.

For many costeños, some of these initial fears seemed to be borne out when the FSLN began importing cadres from the Pacific to administer municipal, regional, and national government agencies and programs. The decision to bring mestizo leaders to the region was particularly insulting to costeños, given that there were several Creole and Indigenous men and women who were dedicated FSLN militants and who would have been logical choices to hold these positions. Black and Indigenous communities felt slighted by what seemed yet another iteration of a mestizo state that was uninterested in acknowledging their historic political demands or recognizing local political leaders. Reflecting on this decision, Dorotea said, "One of the things, a huge mistake that the Frente made, was not recognizing leaders from the community. They began to bring *dirigentes* [leaders] from the Pacific with a different mentality, without knowing the idiosyncrasies of the people, without knowing the culture" (*El Nuevo Diario* 2011).

In mid-1980, the FSLN established INNICA with headquarters in Managua and branches in Bluefields and Puerto Cabezas. Rather than appointing a costeño to lead this institute, the FSLN appointed William Ramírez, a mestizo militant from the Pacific, who spoke neither English nor any Indigenous language and who had no familiarity with the region. Lumberto Campbell, a Creole militant from Bluefields who had served in the mountains, was appointed subcomandante. For many costeños, the creation of INNICA without the participation of costeño political leaders, as well as Campbell's appointment in a subordinate role, "was a sign that the Sandinista Government did not trust the costeño population and that it did not want to give them any influence or their rightful role in the formulation and execution of state policy for the Atlantic Coast" (Fruhling et al. 2007, 48).

Elizabeth Wright acknowledged that the decision to place Campbell in a subordinate position to a mestizo from the Pacific outraged Creoles in Bluefields, particularly those who supported the revolution and the FSLN. She recalled watching young men in her Pointeen neighborhood participate in small, informal military training exercises. Even though they had not fought in the insurrection against Somoza, they welcomed the Sandinistas' triumph and were prepared to help lead the revolutionary process. But they were not given the opportunity to do so. "They sent people to boss us," she said. "Lumberto Campbell wasn't the boss. William Ramírez was Lumberto's boss. Lumberto was subcomandante. So, they didn't even trust him. He wasn't the boss on the coast. He had someone else on top of him that was the boss."

The distrust was mutual. Costeños, for their part, came to view the FSLN as an invading force, bringing a foreign political ideology to the region and subjugating the local population through military occupation. As the FSLN cracked down on local communities to consolidate its control over the region, growing numbers of Indigenous Miskitu and Creole youth began to ally themselves with the Contras.

Some joined the Contras based in Honduras under the leadership of the Miskitu leader, Steadman Fagoth Mueller, who had allied his forces with the National Democratic Forces (FDN).[6] Others fled south to Costa Rica and joined Brooklyn Rivera, a Miskitu activist who had previously been aligned with the FSLN and later became affiliated with the Democratic Revolutionary Alliance (ARDE).[7] As tensions between Indigenous Contra forces and the Sandinistas mounted, costeño communities found themselves caught in the crossfire.

The Making of a Contra

Although many Creoles were initially receptive to the social programs and opportunities that the Frente offered, particularly in the areas of education, health, and culture, they were troubled by what they perceived to be the FSLN's communist leanings and its intention to "Sandinize" the coast through propaganda. They bristled at what they perceived to be the Sandinistas' lack of respect for religious institutions, particularly the Moravian Church, which accused the FSLN of imposing Soviet-style communism on the country. As one of the centers of Creole social life in Bluefields, Moravian High School became a particularly contentious site of conflict between Creole youth and the local Sandinista government.

Tensions reached a boiling point in 1980, when the FSLN accused Jenelee Hodgson, a popular teacher at Moravian High School, of engaging in subversive and counterrevolutionary activities and detained her at El Chipote jail in Managua for three months. Hodgson was a highly respected local leader and founder of Unity for Community Development (which later changed its name to Southern Indigenous Creole Community), a Black cultural nationalist organization that came to prominence in the mid-1970s. She had attended the Latin American Biblical Seminary in San Jose, Costa Rica, in the early 1970s where she was exposed to the teaching of liberation theology and to literature on the U.S. civil rights movement. She told me, "I got into the Christian walk and I was granted a scholarship to go to Costa Rica to study." She added, "And there is where I had a class with Quince Duncan, the famous historian. He was my buddy, and I took Black history with him. It was so beautiful. And that's where my awareness came from."[8]

This introduction to Black struggles in other parts of the world was a formative part of her development as an activist and community leader. She noted that Angela Davis had a tremendous influence on her thinking about the relationship between race, culture, identity, and community development. When I asked her why she admired Davis so much, she replied, "Well, I mean, because she was a rebel! She had some ideas!" Hodgson described the Latin American Biblical Seminary as a "very rich and very enlightening" learning environment. At the seminary she met students from South America, and they debated the merits and shortcomings of the Tupamaro struggle in Uruguay and other nationalist movements in Latin America and the Caribbean. As a result, the students at the seminary developed "a different out view, *our* view." So, when she returned to Bluefields, she said, "I came with that in me." She was transformed from the inside out. "I had

a lovely head of hair, and I came back with [an] Afro" she said. "And I remember my father said to me one day when we were ready to go out, he says, 'You're not going to comb your hair?'" Laughing, she said, "I told him, my hair is combed! That was revolutionary, I tell you."

In addition to embracing a more Afrocentric aesthetic, Hodgson returned to Bluefields in 1975 committed to building a community-based cultural organization that would foment pride in local Creole traditions and their African origins. "I came back very radical. Very radical," she said. After pausing for a moment, she continued: "And I think that's what the Sandinistas they didn't understand . . . it was not rebellion against the government, neither Somoza nor the Sandinistas. At the time, I wasn't really that aware of the political atmosphere. I was bound for culture and I didn't understand how it was so entwined with politics, that both things are so knit together. It's very hard to separate them. But I didn't understand that then."

While teaching at Moravian High School, Hodgson began building support among local teachers and community leaders to develop a local Black organization, Unity for Community Development (UCOD). In this group, as she recalled, "We analyzed the national problems with the youths and studied our cultural roots, a task that always turns political. We did not know that we were getting into hot water. At this time, the man in charge of the region for the Somoza Government, the mayor, summoned us to ask about our activities that were turning political." The group's leaders worked with young people, organizing cultural festivals, retreats, and reading groups in which they would discuss treaties, laws, and essays about Creole political history and culture. In 1978, the group changed its name to the Southern Indigenous Creole Community (SICC) and expanded its membership to include Garifuna and Rama peoples. The group "drew the attention of the state at the local and national levels," and as the struggle to overthrow the Somozas escalated, the state cracked down on SICC's activities (Gordon 1998, 187). When the Sandinistas came to power and Somoza fled, Hodgson recalls, "We waited to see what would happen."

Hodgson's politics were (and remain) a complex and contradictory mix of diasporic Black cultural nationalism combined with a deep antipathy toward communism and a strong identification with the United States. Despite her admiration of Angela Davis, who was fired from her teaching position at the University of California, Los Angeles, because of her membership in the Communist Party, Hodgson was skeptical when the FSLN came to power, because she suspected that they had communist sympathies. She was raised in a religious family, and her father, Bull Hodgson, was a well-known local labor organizer and supporter of the Liberal Party. Her upbringing in the Moravian Church also influenced her political orientation. Moravian pastors had preached the evils of communism from their pulpits for decades, and many costeños were hostile to any political discourse that was overly critical of the United States or seemed to hint at socialist ideology.

Nevertheless, Hodgson initially was willing to participate in Sandinista-sponsored cultural and educational programs that would benefit young people on the coast. Yet tensions quickly emerged between SICC and the Sandinista government. First, the FSLN refused to recognize SICC as a mass organization as it had done with ALPROMISU/MISURASATA. FSLN members apparently were troubled by some SICC members' "flirtation with separatist rhetoric and the group's seeming hostility toward Mestizos" (Gordon 1998, 187). When the Sandinistas began attempting to organize Sandinista Defense Committees, recruiting residents to join Sandinista mass organizations, and importing Cuban volunteers to help carry out government plans in the region, tensions escalated, as Hodgson recalls: "When the Sandinistas took over, they felt like we can't have these people around because it's counterproductive to what they want to do. And the people really stood up because they saw where it was like an invasion. And people start to question it. Because at first a lot of people enjoyed it, the change but then you say, 'Ah. This is not to our betterment. This is more to our enslavement—once again.'"

Following an antigovernment demonstration in Bluefields in 1980, Hodgson was arrested and taken to Managua for questioning. Word of her arrest spread through the town, and many people worried that she would be subjected to torture. Olga Brautigam, a Miskitu teacher at Moravian High School and a respected community figure, went to Managua and negotiated Hodgson's release three months later. Hodgson returned to Bluefields and attempted to continue her work as a teacher and a community organizer, but she found it difficult to work under the scrutiny of the government. When she heard a rumor that the Frente was planning to arrest her again, she went into exile: "I had to leave. I got out and I was told they were going to arrest me again. So, I just left. I just take a little bag, a smaller bag than that," she said pointing to my large shoulder bag, "and I left."

She fled to Puerto Limón, Costa Rica, and tried to figure out her next steps. Shortly after she arrived, Brooklyn Rivera, whom she had met in the mid-1970s during a Baptist youth encuentro in Managua, came looking for her and encouraged her to join the growing Indigenous movement against the Sandinista government.[9] But at that point she had no interest in becoming politically involved. "I really was just trying to survive," she said, "There was nothing in my mind concerning getting involved with the resistance. But Brooklyn came and look for me." He convinced her that she needed to participate in the struggle:

We were seeing the massive influx of refugees from the coast. At that time the people had begun to migrate from all over and they were going to Costa Rica. When we went down to Limón and saw all these young people that were coming in, they were bringing all these stories . . . and I said, "No, man. We have to do something. We have to let the world know." And that's how I got involved. And for them I was ideal because I spoke English, I was a woman, and my background was religious. So that's how I got involved with the Resistance.

From 1982 to the end of 1984, she traveled extensively around the world, representing SICC and ARDE and lobbying support for the Contras. Her travels took her to the highest echelons of state power in the United States, Europe, and the Caribbean. "I traveled a lot," she said. "I went to Washington, DC, a lot. Matter of fact I went to the Rose Garden two times." There she met President Ronald Reagan, whom she admired greatly. When I asked her what the experience of meeting him was like, she simply replied, "Wonderful. Wonderful." More than thirty-five years later, she remains largely uncritical of the Reagan administration and still feels that the United States was an important and powerful ally in the struggle of coast peoples to free themselves from a totalitarian government.

Hodgson's travels were facilitated by her connections to conservative activists in the United States who supported the Reagan administration's assault on the Sandinista Revolution. Hodgson became friends with a woman named Karen Buhl, a conservative South Dakota activist who was instrumental in providing Hodgson with a larger platform. Buhl introduced Hodgson to Phyllis Schlafly, the conservative political activist who helped prevent passage of the Equal Rights Amendment and founded the Eagle Forum. Buhl asked Schlafly to invite Hodgson to speak at the 1983 Eagle Forum Conference. Schlafly was apparently so impressed by Hodgson that she organized a U.S. speaking tour for her. Hodgson traveled throughout the United States speaking to Eagle Forum chapters across the country and warning about the spread of "Communism" in Central America.[10]

By the mid-1980s, Hodgson had fully aligned herself with the most conservative sectors of the U.S. political establishment. She eventually severed ties with Brooklyn Rivera and ARDE because "our soldiers disagreed with Pastora's Marxism-Leninism and Sandinism, as well as his lack of definition toward the enemy." She subsequently became a board member of a new organization, KISAN (Unity of the Native Peoples of Eastern Nicaragua in Miskitu) and later a supporter of the National Opposition Union (UNO) that successfully ran against the FSLN in the 1990 presidential elections. Ironically, Hodgson was not a separatist when the Sandinista government had her arrested in 1980. But being targeted by the state and jailed for her ideas and community activism was a profoundly politicizing experience that led her into exile and then to the Contras.

The Revolution Meets Rastafari

Young costeños were especially targeted by the state because the FSLN often suspected them of having, at best, divided loyalties or, worse, Contra sympathies. During most of the Contra War the government viewed Black and Indigenous communities' cultural politics and their demands for regional self-determination as a form of racial chauvinism and separatism that threatened to undermine the revolution. Young Black people who became involved in the region's small Rastafarian movement, for example, were surprised to learn that their diasporic affinities made them suspect revolutionary subjects. The small Rastafarian movement

mostly attracted young men, but several women became involved. Nora Newball was the first young Creole woman in Bluefields to "go dread." She recalled that members of the community, particularly older women, discouraged her from cutting off her chemically relaxed hair and growing locks. She recounted how one of her teachers at Moravian High School, Miss Merline Forbes, gave her a chemical relaxer, which was almost impossible to find during the war and was prohibitively expensive, after she turned in an essay proclaiming that she planned to begin locking her hair after graduation. It was the last relaxer she would use for nearly a decade. As more young men in the community began to embrace Rastafari, she became intrigued by the movement. She asked her boyfriend, who had also joined the movement, "But where that come from?" He told her, "Ah you see what happen, we don't know about what taking place in the other part of the world with Black people. You know we need to be us; we are a different people." She continued, "And we heard the reggae music, the Bob Marley music, Peter Tosh. And then I started to hear all these things about freedom and stand up for your rights, and I realize that yes, we have rights!"

Gay Sterling, a local antiviolence and land rights activist, was drawn to Rastafari because of its ethos of Black consciousness, pride, and self-determination. She was born in Managua, and when she was fourteen years old, her family moved to Bluefields where she quickly became interested in learning more about Black culture and history:

> I didn't speak much Creole nor English, just Spanish. I had this conflict of identity. I grew up with this conflicted identity, and there was a time when I wasn't aware that I was different, that I was a Black person. And that we have a different cosmovision and a different history. So I was like a Black girl with a mestizo's mentality. When we came back here in the early 70s they used to call us "Black *paña*" because we only used to speak Spanish, living in the heart of Beholden. . . . And I think there is where I decide to work up on my negritude, I needed to develop Black attitude, Black mentality, Black everything. . . . You know, accept my roots. . . . And at that time, Rastafari was the closest thing to that, according to my perception.

For older community members and the local Creole elite, these young militant Black men and women violated the community's norms of racial respectability. Even the revolutionary painter, June Beer, disapproved of them and referred to them as shiftless "*marihuaneros*" (Arellano 2009). Newball and Sterling both shared that, after they became Rastas, they were largely shunned by the community; they no longer received invitations to birthday parties, church events, weddings, or neighborhood gatherings. Many Rastas were unable to find employment because they lacked *buena presentación*. They found themselves on the margins of the community. It was only many years later, after the revolution, that they were able to reintegrate themselves into the community; that is, only after they cut off their locks, began relaxing their hair, and regularly attended church.[11]

Rasta women seemed to find the process of "reintegration" to be a painful experience. "As soon as I cut my locks and I start fix my hair again, oh my goodness, everyone was like 'Praise the Lord!' You know, how hurt that was for me?" Newball said. "But well, I needed a job, I needed to work . . . so well we just kind of a come back into society." Many former Rasta women kept their dreadlocks carefully preserved and packed away among their belongings as a reminder of who they had been and the journey they had made to survive the war and its aftermath. But the experience of having been Rasta made a deep impression on each of them and altered their understanding of the relationship between race, national identity, and the diaspora. In their hearts, they say, they remain Rasta.

Rasta youth were not only policed by their own communities but also by the state, ostensibly because of their use of marijuana. "They would put the law on you and mix you up in drugs and any delinquency and all that is against the law," Sterling said. Becoming a Rasta "was the first time I knew the prison," she said. "I drop jail through being a Rasta." She was not the only one to be incarcerated. Elizabeth Wright recalled that FSLN soldiers arrested several of her young friends who were Rastas and threw them in jail after they refused to say "¡Sandino vive!" during a local pro-government rally. One of these young men told her how the soldiers "had them to lie down and kiss the ground and say ¡Sandino vive! [They] call them negro hijueputa [Black son of a b-tch] and kick them up. We were what? Fourteen? And nobody defended you."

These instances of state violence by the revolutionary government were not isolated incidents. In May 1985, a group of Contra rebels attacked the FSLN military base in Bluefields. After routing the Contras, the FSLN forces violently retaliated against the community. One man recalled, "The next day everyone was told to go to the park to see what happens to enemies of the people." Residents found the bodies of some thirty young men, many of them Creoles, dumped on the ground "as if they were animals." When their mothers asked that their bodies be returned, they were told that "dogs did not deserve to be buried in the cemetery," and the bodies were left buried in a mass grave outside Bluefields. Tomas Borge, the minister of the interior, flew out to Bluefields to apologize for the soldiers' actions and stated that they had acted "far beyond their orders." But the damage was done (Kinzer 1986; Gordon 1998).

These violent encounters with the Sandinista state convinced many Creoles that the government did not respect them or view them as citizens with their own political dreams and aspirations. As Elizabeth Wright observed dryly, "For the state we were the problem." Although women were on both sides of the conflict, they converged in their shared critiques of the FSLN's racist treatment of Black and Indigenous communities and their support for those communities' demands for self-determination and self-governance.

The Contra War affected all the women that I interviewed in a direct, personal way. Many were caught between wanting to support the revolutionary project and struggling to negotiate the FSLN's missteps on the coast. The war fractured

families and communities, pitting relatives and friends against each other. In May 1985, Hortencia was trapped in an ambush, returning home to Pearl Lagoon from Bluefields. She was on the Río Escondido with several members of the Juventud Sandinista when Contras began firing on their boat, forcing them to seek cover.[12] "All I could remember is them hollering, 'Is best you give up because you no have where to go. We going to get you anyway.'" The threat was real and terrifying. The atrocities committed by the Contra forces are well documented; female Sandinista militants who fell into the hands of Contra rebels were often subjected to torture and sexual violence, as was the case with the Creole/Miskitu doctor, Mirna Cunningham, who was tortured and raped by Contra combatants in 1981.[13]

As the Contra fighters continued shouting threats, Hortencia recognized one of them. "I could hear my cousin Rene's voice." Her cousin had left Pearl Lagoon some months earlier. The family suspected that he had fled to join the Contras and avoid the military draft.

As the two groups traded insults, her cousin recognized her voice and then began pleading with her to surrender. Finally, the shouting ceased as night fell, and she and her comrades waited silently for morning to come. Around 3 A.M., she heard several voices shouting "¡Patria libre o morir!" The group waited to ensure that it was not a ploy by the Contras and then went to the riverbank where they found members of the Tropas Pablo Úbeda (TPU), the military special forces unit. The TPU forces brought Hortencia and her colleagues to Pearl Lagoon. Local residents had gathered at the wharf, expecting to see her dead body brought in, and were shocked to find that she had survived the night. "When I reach there my aunts was there, my uncles, my cousins, everybody. And they had up a white curtain with a Black tie." She told her family about her encounter with her cousin Rene, but her aunt and uncle refused to believe that their son was a Contra. Later that day, local authorities called the family to come and identify his body. His group had been ambushed by the TPU. "He never had this whole side of his face," she said gesturing toward the left side of her own face. "It was gone. His eye was pick right out. We recognize him most by his teeth. He had this gold crown. And he was younger than me, you know."

Hortencia was seventeen years old at the time of Rene's death, who was then fifteen. When I asked her how she felt at the time, she was quiet for a moment. "Mixed feelings. It's somebody you grow up knowing, you never expect say that would happen," she said. "But it happen. And you feel sorry for your aunt. She never ask for that. But deep down you say, 'Was him or me.' So, that's what I think in the moment, you know."

Rene's death devastated the family and fractured her relationships with many of her relatives. "It separate the family for like ten years," she recalled. The ambush in the canal and the death of her cousin marked a critical turning point in Hortencia's perceptions of the revolution. She returned to Bluefields and continued her work with the Juventud Sandinista. But something had changed, and she was not

the only one to feel a change of heart. The Contra War led many supporters of the revolution to become ambivalent about the revolution and its impact on the region. When the FSLN finally began to show signs that it was prepared to take the region's demands seriously, this was the first real opportunity for peace, which would lay the foundations for the development of multicultural citizenship reforms that dramatically transformed Black and Indigenous peoples' relationship to the revolutionary mestizo state.

THE STRUGGLE FOR REGIONAL AUTONOMY

The year 1984 was the most violent and tumultuous period of the war. Bluefields remained an active war zone as Contras regularly mounted attacks on the out-skirts of the city. But this year also marked the beginning of a gradual policy shift by the leadership of the FSLN. As the war dragged on and the death toll mounted, the FSLN leadership began to realize that the conflict on the coast required a political, rather than a military, resolution. In September 1984, Daniel Ortega qui-etly initiated a series of preliminary peace talks with Brooklyn Rivera in Washing-ton, DC. In November, the government held open elections, and Ortega won the presidency by a considerable margin. Ray Hooker, a well-known Creole educator and community leader, and Hazel Law were both elected as *diputados* to the National Assembly.[14] On the coast, Mirna Cunningham was appointed the gover-nor minister in Northern Zelaya. The following month, the government formed a National Autonomy Commission to outline the terms for autonomy on the Atlantic Coast (Frühling et al. 2007, 63). Both Hooker and Law were appointed to the commission alongside academic experts, including Orlando Nuñez, Galio Gurdián, and Manuel Ortega.

In January 1985 the government created two Regional Commissions, based in Bluefields and Puerto Cabezas, coordinated by Johnny Hodgson and Armando Rojas, respectively: they guided the first phase of the consultation process for regional autonomy. The Regional Commissions conducted consultations in the communities of Sandy Bay, Karawala, and Desembocadura del Río Grande. Based on these consultations, the National Autonomy Commission published a docu-ment titled *Principios y politicas para el ejercicio de los derechos de autonomía de los pueblos indígenas y comunidades de la Costa Atlantica de Nicaragua* in June. It was the earliest articulation of the legal structure and scope of regional autonomy and served as the basis for the second phase of direct, popular consultation.

From September to December 1985, volunteers with the Regional Commissions met with residents to hear their thoughts on a range of issues including "auton-omy, private property, natural resources, bilingual education, health, housing, [and] agrarian reform" (Frühling et al. 2007, 70). This was dangerous and difficult work. Many of these communities were still active war zones. According to Ray Hooker, there were limited funds and resources to carry out this work; all the

consultations were conducted by volunteers. Only the two coordinators received a salary (Chavarría Lezama 2003).

Creole activists and community leaders in Bluefields were among the key architects of the Autonomy Law and played a leading role in the consultation process. Yet of the thirty-two members of the Regional Commission in the South only six were women; Merline Forbes was one of them. Her name is among those listed on a mural in Reyes Park, in the center of Bluefields, who are considered "the mothers and fathers of regional autonomy." Forbes began her career as a schoolteacher in 1953 at Moravian Primary School. In the 1960s, she became the first Black woman in Nicaragua to be offered ordination in the Moravian Church, an offer she initially declined. After the National Autonomy Commission invited her to participate in the first regional commission, she agreed to do so, saying, "The dream was that we would have more participation, making serious decisions in government and not just being manipulated like puppets" (Chavarría Lezama 2003).

While costeño activists were serving on the Regional Commissions and the process moved closer to completing a draft of the Autonomy Law, other Creole women—many of them Forbes's former students at Moravian High School—were leaving the country on scholarships or being given diplomatic assignments for the Sandinista government. For example, Elizabeth Wright, after participating in the literacy campaign and joining the military reserve, received a scholarship to study communications at the National Autonomous University of Nicaragua (UNAN) in Managua. Her husband, a committed Sandinista, began working for the government and was offered the opportunity to serve as a diplomat to either Sweden or the newly established Republic of Mozambique. When he asked her where she would prefer to go, she immediately chose Mozambique. It was an eye-opening experience that disrupted her own internalized racist views of the continent and its peoples: "The people were educated, Black people there were very educated because all the people went to Europe to study. It wasn't like little Bluefields. You thinking of Africa, you thinking of da-dum-da-dum-da-dum, the drum beats. But you find all these enormous buildings, the people are educated, and even people on the street are educated compared to the *pañas* in Managua. So I felt like in my element!"

While Elizabeth was settling into life as a member of the diplomatic corps in Maputo, Hortencia was attending a university in Czechoslovakia (now the Czech Republic). Hortencia was thrilled by the prospect of encountering a new cultural environment, a new language, and meeting students from all over the world:

> But what was strange there again is like, okay, you coming from this little community, this forgotten community of Pearl Lagoon on the Atlantic Coast in the 80s. So imagine coming from Pearl Lagoon in the 80s, going to Europe, Central Europe. . . .

You meeting all these people—from Chile, from Cuba, from Russia, from Nicaragua, from everywhere. Just imagine that big jump, you know, from Pearl Lagoon to Central Europe in the 80s. Being Black, being a woman and you whole life they telling you say is a man going to decide over your life and now you find yourself here.

While Elizabeth and Hortencia were working and studying out of the country, the conflict between the Sandinista government and costeños was beginning to take a dramatic turn. By October 1986, the two commissions had completed a draft proposal of the Autonomy Law. From April 22–24, 1987, 220 delegates from both Regional Commissions convened at the Great Multi-Ethnic Assembly in Puerto Cabezas to debate the draft legislation. The delegates approved 95 percent of the articles unanimously, and the remaining ones were approved by an overwhelming majority (Chavarría Lezama 2003). The draft legislation was revised, published and distributed throughout the region and made available in English, Miskitu, and Spanish. The draft was then sent to the National Assembly and was passed as a constitutional amendment in September 1987.

The law creates two autonomous regions on the Atlantic Coast and recognizes the multicultural and multilingual character of the region. In addition to granting a set of cultural rights to coastal communities, it also recognizes their historic land claims and their right to govern themselves according to their own cultural customs. For the first time in Latin American history, Black and Indigenous communities had a strong juridical framework in which to make their demands for land, recognition, and rights to the state.

Elizabeth told me that on the day in 1987 when she and her husband learned about the Autonomy Law, they immediately decided to return home. She continued, "We believe in autonomy, that's why we came back from Africa. Because we felt like that was a solution for us. Not that we were independent but that we would be able to find a way we can meet these people. Not that they would conquer us but we figure that's a way—*a revolutionary way*—for us to build a nation together but respecting our traditions, respecting us."

Unfortunately, the law came with no guarantees nor enforcement mechanisms. Even the architects of the law acknowledged its limitations and ambiguities regarding the form that communal governance should take and the process by which the state would grant collective land titles to Black and Indigenous communities. Nevertheless, both the FSLN government and regional leaders assured coastal communities that the state would continue to work to perfect the law through a process of dialogue and consensus to ensure that its objectives would eventually be met.

But that process was not to occur. In February 1990, the FSLN lost the national election. In a surprise victory, Violeta Chamorro led the National Opposition Union—a coalition of far-right, centrist, and leftist political parties linked in

their opposition to the FSLN—to victory in a stunning reversal that shocked even her supporters. The revolution was over, and it seemed that the dream of autonomy might be finished before it even had a chance to begin (Frühling et al. 2007; Gordon 1998; Lacayo 2006).

CONCLUSION

Memory is malleable. It is, as Karen Kampwirth (2004, 15) argues, "a slippery thing, a thing that refuses to stay put." The passage of time changes how we remember the past and the meanings that we ascribe to it. As Michel-Rolph Trouillot (1995) reminds us, social memory is not linear: our understanding of the past is indelibly altered by the conditions of the historical conjuncture in which it is recalled in the present. As I conducted the interviews for this oral history of Black women's memories of the revolutionary past, I was struck by how their feelings about that moment and the contested narratives that surrounded it are constantly being reworked by contemporary political conditions.

When Daniel Ortega returned to power in 2007, the coast responded again with guarded optimism. After nearly twenty years of conservative governments and neoliberal economic reform, communities on the coast were prepared to give the Frente a chance to prove, as Ortega promised, that this time things would be different. Within weeks of returning to power, the Ortega administration made public education free and compulsory again and reinstated universal public health care. Rural communities finally received electricity that remained on twenty-four hours a day. The government resumed construction on the Managua–Bluefields highway, fulfilling a century-long promise to connect the coast with the rest of the country. These reforms made a significant impact on costeños who felt that they had been all but forgotten by the state. The FSLN's policies toward the coast led many people, including Black women, to rethink their feelings about the party and to overlook other problematic aspects about the new and improved FSLN.

But the honeymoon was brief. As Ortega completed his first, second, and then a third presidential term—altering the electoral process, pushing through constitutional reforms to dismantle term limits, consolidating his party's control over the court system, and co-opting municipal governments to strengthen his hold on power—coastal activists, including those who had been willing to "give him a chance," became increasingly critical of the Sandinista state. The administration's assault on Black and Indigenous land rights activists, combined with the failure to protect these communities' communal lands from both multinational corporations and landless mestizo settlers, soured their view on Ortega's return.

I visited Hortencia at her home in Bluefields in February 2017. We spoke in her kitchen as she prepared a few snacks and asked me how the book was coming along. When I said that I was interested in writing a chapter about Black women's participation in the revolution, she shook her head ruefully and laughed. "You

should write a next chapter," she said. "Yeah, what's that?" Placing her hands on her hips, she replied, "You should write a chapter about Black women who participate in the revolution and wish they hadn't!"

It was an abrupt change from the way that she had described her memories of the revolution seven years earlier, then only three years into the Ortega administration and the return of the FSLN to power. Her comments in 2017 reflected the pervasive sense that the Frente had fooled them in the 1980s by giving them hope that the revolution would transform the country's unequal social order and that it was now fooling them again. The failure of regional autonomy to produce a more equitable political order and the pernicious machinations of the country's two major parties to undermine the autonomy process seemed to reinforce the idea that the revolution had failed in its mission—a mission, they argue, that never meaningfully included Black women or Black communities. Although many of the women I interviewed acknowledged that their contemporary activism was shaped by their involvement in the revolution, the unfolding of the authoritarian turn profoundly altered how they both made sense of the past and narrated their own role in the process.

I returned to Nicaragua in July 2017 in time to witness the thirty-eighth anniversary of the revolution. The day after my arrival I went to visit Elizabeth and watch the live broadcasts of the celebration. As I listened to the speeches, I was struck by how much space Daniel Ortega and Rosario Murillo have taken in official commemorations of and narratives about the Sandinista Revolution. The celebrations reflected how Ortega and Murillo have rearticulated the official narrative of the revolution by placing themselves at its center (Hale 2017). This discursive shift continues to exclude the ambivalent memories of Black and Indigenous peoples that unsettle the claims of those who hail the current FSLN government as the second coming of an unfinished revolution. Contemporary official renditions of that period sanitize all the inconvenient, forgotten episodes of that fraught political experiment by erasing its complexity and contradictions. And yet, the Sandinista Revolution remains an important part of how many Nicaraguans narrate themselves as political subjects, despite the Ortega-Murillo administration's efforts to re-narrate it to serve their own ends.

Later that evening, after rain had forced the celebrations to end early, Elizabeth and I sat on the verandah behind her house, enjoying the breeze and chatting about the day's events. We discussed the revolution—what it had meant for her, its limitations, its possibilities, the missed opportunities, and her deep disappointment with the FSLN's authoritarian turn. Her bitterness was palpable as she spoke about how Daniel Ortega and Rosario Murillo had co-opted the FSLN party and the memory of the revolution. Yet, she was reluctant to call the revolution a failure.

"I'm still a revolutionary," she said. When I lifted an eyebrow in surprise, she replied emphatically, "Sure. I'm still a revolutionary. Because we still yet have poverty. We still have injustice. That class struggle continues. So, yes, I still believe in

the revolution even with all its problems. But not this Ortega government." She paused. "I still believe in the revolution. Because I don't believe in man. No. I believe in the *dream*."

It is increasingly difficult in Daniel Ortega and Rosario Murillo's Nicaragua to access the multiple truths that defined everyday Nicaraguans' experience of the revolutionary period. Yet the idea of the revolution itself, the belief that ordinary men and women can seize control of their destiny and alter the course of national history retains its affective power. Although official narratives of the revolution continue to marginalize the place of Black women in that story, Black women activists engaged in the struggle for land rights and the defense of regional autonomy may yet prove to be some of the most credible heirs to the revolutionary legacy as they emerge as the most vocal critics of the *Orteguista* state. They are joining the growing movement among a new set of political actors, including feminists, anti-canal activists, environmentalists, and journalists, who are offering an alternative political vision that refuses the undoing of democracy under the authoritarian turn. Black women are still fighting, as June Beer wrote in "Love Poem," to defend the rights and futures of their communities. The next chapter will map the contours of this struggle during the era of neoliberal economic reform and how Black women activists responded to the challenge of surviving on the economic margins of the nation in the postrevolutionary period.

PART 2 MULTICULTURAL DISPOSSESSION

that it had only been three years since the FSLN had brokered a truce with regional Contra forces. The swearing in of the regional governments appeared to signal that the gains of the previous decade, which had been achieved at great sacrifice, would not be lost under the new Chamorro administration (Frühling et al. 2007).

The electoral results reflected the distinct political and ethnoracial dynamics at play in both regions. On the north coast, the Regional Council was split between the FSLN and YATAMA, the militant Indigenous Miskitu organization. The two parties garnered twenty-two and twenty-three representatives, respectively, whereas the UNO won only three seats. On the south coast, the electoral campaign was primarily between the FSLN and the UNO coalition. The UNO won a majority with twenty-four representatives, the FSLN won nineteen seats, and YATAMA only four.

In the south, party politics were also clearly delineated along racial lines. Nearly half of the twenty-four UNO *concejales* elected to office were Creole versus only six of the nineteen FSLN representatives; three of the four YATAMA representatives were Miskitu. The UNO's victory in the regional elections was also reflected in the administration of the regional government. UNO candidates, many of them Creoles, filled key posts, including president of the Regional Council and the Regional Coordinator. Members of the UNO coalition made up the Executive Board with the exception of a single YATAMA representative. Given the overwhelming representation of the UNO in the regional government, costeños in the south anticipated that the region would enjoy a mutually beneficial relationship with the central government and the Chamorro administration (Frühling et al. 2007). This would not be the case.

In the RACCN, Dorotea Wilson and Alta Hooker, both members of the FSLN, were among the new concejales who were sworn into office that May. Wilson had previously served as the mayor of Puerto Cabezas and had participated actively in the peace negotiations between the Frente Sandinista and Miskitu. But Wilson was an exception: most concejales had no direct experience in government. Alta Hooker, a former nurse who led the Regional Health Delegation in the north from 1987–1990, described the daunting challenges that the newly elected representatives faced. "None of us elected to the first Regional Council had any idea what we were supposed to do," she said. "It was our only governmental experience; we didn't know what participatory democracy was. Up to then, most of the new council members only had experience in military matters" (Hooker 2006). Hooker and Wilson were two of the few women elected to serve in the new Regional Councils.

After the CSE officials left, the new political representatives were left with the task of implementing regional autonomy. But the Regional Councils faced daunting challenges, which became apparent almost immediately. The first was the low level of education among the newly elected members; a considerable number lacked basic literacy skills, and few had any formal secondary or postsecondary education (Frühling et al. 2007, 123). In addition, few council members had any

professional experience that would have prepared them for the work of governance. Many lacked a working knowledge of parliamentary procedure and were unfamiliar with foundational legal documents, including the Autonomy Law, the Constitution of the Republic, or any other legislation relevant to governance of the coast.

The regional governments were also hampered by the central government's ambivalence about these new political institutions. Shortly after they were sworn into office, the regional representatives learned that the Chamorro administration had failed to provide them with an operating budget for the Special Development Fund for the Atlantic Coast as outlined in the Autonomy Law. With no funding, the regional governments lacked the capacity and resources to staff administrative offices or travel to regular session meetings. As a result, the councils were effectively unable to govern.

It quickly became clear that the Chamorro administration also lacked meaningful policy objectives in the region and an understanding of the value of regional autonomy, viewing it merely as a "Sandinista invention" (Frühling et al. 2007, 124).[1] Just how little commitment the new government had to implementing the Autonomy Law was made clear when the Chamorro administration created a new government agency, the Institute for the Development of the Autonomous Regions (INDERA): it bypassed the legal protocols for providing funding to the regional governments. Its primary function was to "act as a buffer, deflecting criticism from coast people that would otherwise be directed squarely against the central government" (Hale 2007).[2] While the state refused to provide consistent and adequate funding to the regional governments to carry out their basic functions, INDERA enjoyed a large budget. It established offices throughout the region, hiring bright, young costeño activists. Despite employing these activists, regional backlash was swift. In 1991, the Regional Council in the RACCS approved a resolution calling for INDERA's dissolution because it violated the Autonomy Law (Hale 2007, 126). Less than a year into the new administration the "traditional conflict between the Atlantic coast and the Managua had reappeared" (126). The government dismantled INDERA but the damage was already done.

Costeños also expressed concern about the neoliberal economic recovery plan that the Chamorro administration began to implement in its first year. The regional economy was then in shambles. Devastated by a decade of war and economic blockade, it suffered another blow from Hurricane Joan in 1988; afterward the region lacked basic communications, utilities, and transportation infrastructure, and its fishing, lumber, mining, and agriculture industries were in great disrepair. Several government-owned factories and operations—a lumber mill in Bluefields; two seafood-processing plants in Corn Island and El Bluff; facilities refining palm oil, coconut, and sugar cane in Kukra Hill—could have been revitalized to stimulate economic production and generate employment in the region. Instead in 1990, the government established the National Public Sector Corporations (CORNAP)

to privatize these publicly owned state enterprises. Over the protests of coastal residents and the Regional Councils, the government sold off these public assets, often to individuals and companies with little to no experience or interest in developing the coast (Frühling et al. 2007, 135).

Even after the Chamorro administration dismantled INDERA, it preferred to manage its relationship to the region through a very small number of individuals and institutions, opting to channel funding and limit direct communication to the Regional Coordinator. This clientelist relationship with the administration would come to define the dynamics between the Regional Councils and the central government.[3] Regional Coordinators often used the funds that they received from the central government to bribe their supporters, exchange favors, and create pacts to maintain their hold on power. This system of political corruption and partisan party politics undermined the ability of the regional governments to function. The first four-year term of the autonomous regional governments was largely shaped by the central government's lack of political will, an under-educated and unprepared initial group of regional politicians and officials, and the formalization of clientelism and corruption in the autonomous regional governments.

In 1994, the Regional Councils held their second elections. The UNO coalition had disintegrated by this time, and a new political party—the Constitutionalist Liberal Party (PLC)—had emerged. The PLC was a far-right political party that had developed a broad national base of support in the years after the revolution. Its leader, Arnoldo Alemán, was a former official in the Somoza government who rose to prominence after he was elected mayor of Managua in 1990.[4] As mayor, he became popular among voters for implementing a series of public works programs aimed at modernizing the capital. Unlike other political parties, including the FSLN, the PLC aggressively campaigned on the coast, seeking the support of costeño voters. The strategy paid off, and the PLC swept the 1994 regional elections, giving the party "nearly total control of the region's political institutions" (González 1997). When Alemán ran for president of the country in 1996, costeños supported him, and the PLC won 50 percent of the combined vote from the two autonomous regions; in the RACCS, the PLC won 71 percent of the vote. The votes of the costeños secured him the presidency.

As they had with the Chamorro administration, costeños in the RACCS hoped that with a majority PLC Regional Council in power, the Alemán administration would be more responsive to their political demands. But rather than supporting costeño aspirations for political self-determination, it deepened and formalized the practices of intervention, manipulation, and clientelism that had emerged under the Chamorro administration. This relationship was defined by an "autocratic and caudillo style" of governance in which partisan loyalty and obedience trumped the political and economic needs of costeño communities. Alemán's administration tightly constrained the independence of the Regional Councils by providing them with a bare-bones operating budget that had no funds for capital

expenditures, controlling public expenditures in the region, and siphoning off the income that was generated from the exploitation of the region's natural resources to the central government in Managua. This allowed Alemán to use state funding as a tool to reward his supporters and punish his opponents.

As a result, the regional governments were largely inoperative during Alemán's tenure in office as the national political parties, including the FSLN, attempted to leverage control over autonomous political institutions. These efforts were especially evident in the administration's development policies and initiatives in the region. It resisted pressure by the regional governments to reform the Autonomy Law and allow for greater regional control over the use and exploitation of the region's natural resources. Instead, the government pursued a centralized model of regional development that emphasized creating favorable conditions for private foreign investment and following the "logic of the market" in managing the region's natural resources. As one Alemán adviser stated, "The most important thing is to open a path to integration of the coast instead of making more concessions to autonomy" (Frühling et al. 2007, 220). Thus, the Alemán administration's development agenda for the coast reproduced the same kinds of integrationist, assimilationist model of national inclusion that had historically characterized the state's relationship to the region.

By the time that I arrived in Bluefields in 2004, many costeño residents and regional activists had come to regard regional autonomy as little more than "a beautiful dream," as the Creole historian Hugo Sujo told me. Women had been actively involved in the development of the autonomy process from its inception, and many women activists continued to insist that regional autonomy was the only way to protect the cultural and political rights of Black and Indigenous communities. From hosting focus groups in small communities at the height of the Contra War to participating in the regional *consultas* to craft the first drafts of the Autonomy Law, women played a critical role in advancing the project of regional autonomy.

Yet, regional politics continued to be a man's game throughout the early 2000s. Of the forty-seven representatives elected to serve in the Regional Assembly in the RACCS in 1990, only five were women. Those numbers barely improved in the following elections; from 1994–1998, six women served as concejales; from 1998–2002, nine women were elected to the Regional Council; and from 2002–2006, there were only ten (González, Figueroa, and Barbeyto 2006). This small cohort of female politicians often struggled to ensure that women's gendered strategic and pragmatic interests were part of regional policies (Molyneux 1985). The few women who did gain access to meaningful spaces of power in the regional governments were largely unable to transform the entrenched corruption that pervaded the region's political institutions; instead, they often became ensnared in their own political scandals.

In 2006, Lourdes Maria Aguilar Gibbs, a Creole member of the PLC, was elected president of the South Autonomous Regional Council, making her the

first Black woman to occupy this powerful position. During her time in office, she made several significant policy interventions that directly benefited women in the region. She created the Secretaría de la Mujer and the Comisión de la Mujer y la Niñez, Adolescencia y Juventud. This commission was part of a network of feminist and women's NGOs and local agencies engaged in projects to end violence against women, support gender-based development initiatives, and do local community work. The commission produced one of the first regional agendas for women in April 2008: the Regional Public Policy on the Prevention and Attention of Gender-Based Violence in the RAAS. Aguilar also made it a point to attend the many public gatherings, conferences, symposia, and community events sponsored by national and regional feminist organizations.

Yet Aguilar's tenure in office was plagued by accusations of political corruption and infighting among representatives in her own party. These tensions came to a head in May 2009, when regional authorities accused her of financial mismanagement and corruption and revoked her access to regional government funds. These authorities, many of whom were members of the PLC, alleged that Aguilar had written a check to herself for nearly C$300,000 (about US$12,500), some C$34,0000 of which could not be accounted for. Aguilar claimed that the funds were spent on a special session of the Regional Council held in a remote community north of Bluefields the previous year. The Regional Council subsequently brought public charges against Aguilar and removed her from her post; later that year she successfully appealed the decision and returned to complete the remainder of her term (Parrales 2009a).

Observing this political impasse, it is difficult to know what to make of the situation. Travel to the region's rural communities was difficult and expensive, particularly when forty-five political representatives, government officials, and administrative staff were traveling; yet the cost of the special session of the Regional Council seemed excessive to me. Yet, by the time I arrived in the region, it was common knowledge among residents that most politicians in all the political parties and at every level of governance were engaged in various forms of corruption to varying degrees. It was largely understood that corruption was a basic part of the way that politics was done. Politics is "dirty business," as one activist told me, and costeños tended to assume that anyone in politics, no matter how well intentioned, would eventually be compromised by the demands of the national parties, the dysfunction of the regional government, or an inability to resist the temptation of easy access to government funds. Rather than call for an end to corruption, a political demand they tended to view as something of a pipe dream, community members criticized politicians who used their political power to enrich themselves while doing nothing for their constituents. Several activists argued that male politicians routinely engaged in similar and often more excessive forms of political corruption without facing similar consequences. Indeed, many of the male politicians who accused Aguilar of corruption had faced serious political scandals during their time in office without reprisal and continued to occupy positions of authority for years.

After her ouster from public office, Aguilar appeared on the *Black Woman's Voice*, a Creole-English radio program that I cohosted with Angie Martinez, a local feminist activist and researcher, to discuss the crisis in the Regional Council. In her interview, Aguilar alleged that she was the victim of the party's attacks because she refused to carry out the directives of the national party leadership or enable the political schemes of local PLC party members. She claimed that several concejales led by Francisco Sacasa, a mestizo politician, had met with Brooklyn Rivera, a longtime leader in the Miskitu community, to discuss the possibility of carving a third autonomous region out of the RACCS that would represent the political interests of mestizo residents in the region's interior hinterlands. These lands formed part of the communal land claim of Black and Indigenous peoples, which I discuss in greater detail in chapter 5. Aguilar vehemently opposed this plan and mobilized her political influence in the Regional Council to shut it down. She said the attacks occurred because "I am Black and because I am woman and because I fighting against the national interests and I fighting for our interests."

Throughout her interview, Aguilar described herself as a regional patriot and a political maverick willing to defy the directives of her own political party. Yet this claim was also contested, because although Aguilar challenged her party in some ways, she also capitulated in others. For example, she approved the Tumarín hydro-electric mega-project, which would have required the displacement of some two thousand Indigenous and mestizo residents, a move that was widely condemned by costeño civil society and by locals (Parrales 2009b). Yet, Aguilar was also a strong defender of Black and Indigenous land rights claims, refusing to support efforts by the national government to undermine them. Her uneven record as a regional advocate demonstrates the complex terrain that regional political representatives and authorities must navigate in their negotiations with the central government.

Local activists whom I spoke with shared their belief that Aguilar's hands were not altogether clean. They recounted how Aguilar herself made this clear at a gathering of Black women activists held in Bilwi (Puerto Cabezas) in February 2009, where she was invited to speak about Black women in politics. She began by talking about how she got started in politics running as a representative for her neighborhood. At some point during her first campaign, it became clear that she was not going to win with the votes just from the residents in her neighborhood, and so she went to the barrio where her family lived and paid people to come to her neighborhood and vote for her. This tactic worked, and this initial victory set her on the path to being elected president of the Regional Council. Aguilar laughed as she told this story to the stunned audience; she then explained that she told it to them so that they would understand what she had to go through as a woman to get to a position where she could actually do things for other women.

Apart from this revelation that she stole an election, people were also shocked by how she referred to a male fellow party member, who had become one of her

greatest opponents in the regional government. She referred to him as "Sister ____" or "Miss ____" a thinly veiled reference to the widely circulated rumors that he had long engaged in transactional sexual relationships with teenage boys. Using homophobic rhetoric to degrade and humiliate a political opponent seemed like a cheap shot, especially when delivered by a self-declared defender of women's rights at a Black feminist gathering. But the underlying point of her speech was simple: to bring women's gendered interests into politics, to make these ideas tangible in the form of policy, programs, and resources, women have to play hardball like men because politics remains a man's world.

Aguilar's speech at the gathering laid bare the *realpolitik* that structures regional politics. Her comments not only revealed that men do not have a monopoly on political corruption or unethical behavior but they also demonstrated the contradictions that female politicians encounter in government. Rather than the presence of women transforming the institutional practices of the Regional Government, female politicians engaged in the same kinds of self-serving, unethical, and pragmatic political practices as their male counterparts.[5]

By the late 1990s and early 2000s, the promise of autonomy was beginning to feel like an illusion. As the regional governments became increasingly dysfunctional, it appeared that many costeños had abandoned autonomy as a viable strategy to reconfigure the region's relationship to the central government. This was reflected in the growing rate of voter abstention in regional elections; in 1990, the Supreme Electoral Council reported an abstention rate of 22 percent in both regions; in the 2002 regional elections, this rate increased to 45.2 percent of voters in the RACCN and 75.35 percent in the RACCS (Frühling et al. 2007, 204). Multiple studies by national NGOs found that although costeños valued autonomy as a legal instrument of political self-determination and social transformation, they lacked confidence in national and regional political institutions. When asked whether autonomy was the best solution to resolve the problems of costeños, by 2004 only 58.9 percent agreed that it was, compared to 75 percent in 1997 and 2001. Survey participants assigned nearly equal responsibility to regional and national government authorities for failing to meaningfully support regional autonomy; 67 and 73 percent reported having "little or no confidence" in the regional and central government, respectively (Frühling et al. 2007; PNUD 2005).

As regional autonomy became a distant political dream, costeños focused on surviving the increasingly harsh economic conditions produced by the neoliberal market reforms that began under the Chamorro administration and intensified throughout the decade. The growing lack of governability in the region, combined with the stagnation of the regional economy, led women to cultivate a variety of strategies to navigate the crisis and ensure the survival of their families. The impacts of neoliberal reforms reverberated in the most intimate spaces of regional daily life and shaped how women understood themselves as political subjects and social actors in the postrevolutionary period.

EVERYDAY NEOLIBERALISM

I met Diana in June 2004 when I made the first of what would become many trips to Nicaragua. A mutual friend had arranged for me to stay with Diana while I participated in a team research project for the Caribbean and Central American Research Council (CCARC).[6] She lived in Barrio Santa Rosa on a small plot of land where she had built a house alongside her mother, Miss Tere. Although initially she struck me as shy and reserved, after living in her home for a few days, I learned that she was wildly funny, with a ribald sense of humor that left me bent in fits of laughter over her kitchen table. We took to each other immediately, and when we went into town together to run errands, she would proudly introduce me to her friends as her "American daughter." A mother of two, she had been unemployed for more than ten years when I arrived. Her husband worked on a cruise ship, as did her sister Angela and two brothers-in-law; they all sent her small sums of money each month that she used to pay the mortgage on her home and her children's monthly school tuition. With consumer costs growing, however, this money never seemed to be quite enough. Each month she had to work harder to buy basic necessities: milk, eggs, beans, bread, flour, sugar, and cooking oil. She told me that she worried that her husband might not be divulging the true amount of his monthly earnings; she suspected that he was not faithful on the ship and was spending his earnings on other women. In addition to providing for her own children, Diana had to help make ends meet for her sister's three children and other family members whose employment was either sporadic or nonexistent. Although she longed to find work, there was, she lamented, simply no work in Bluefields. When I asked Diana what she felt were the biggest challenges Black women faced in Nicaragua, her answer was unequivocal: "We don't have jobs. The government should do more to help the people find work."

Money was a constant source of anxiety for Diana. Once it became clear that she would likely not find salaried work in Bluefields, she, like many Creole women, began to take or create *chamba* for themselves. *Chamba* is a kind of informal flexible labor that allows women to take care of their domestic responsibilities while also generating income to meet their families' basic needs. Every woman I knew had some kind of *chamba*—baking birthday cakes, braiding hair, painting nails, or importing used consumer items or specialty Black hair care products from the United States. One of the highest-paid Avon saleswomen in the country was a Creole woman who lived a few blocks from my house. And each day at the Multiethnic Women's Research Center at the URACCAN where I worked, a young woman, Jasmine, would come to our offices and sell savory beef patties, traditional Creole pastries, beauty products, and knock-off designer handbags.

There are many things that I remember from my visits to Diana's home, particularly sitting on the veranda on a sweltering afternoon trying to catch a breeze from the bay. I also recall our conversations in the kitchen when she would share the heartache of a difficult marriage, a faithless partner, and the daily struggle to

survive. She told me once, "You know, Courtney, if a man make his money and he go out and drink it up the first night and come home with nothing for his family he sleep on his back." She was quiet. "But the woman? She toss and turn the whole night wondering what she going do, how she going take care of her children. Man never think on it. Him no lose sleep. But she? All she do is worry."

I was not yet familiar with the term "neoliberalism" when I met Diana on that first trip to Bluefields. I was an inexperienced undergraduate who had yet to learn the finer points of free-market economic theory. But I quickly began to observe and understand neoliberalism's bodily and emotional effects by becoming intimately familiar with Black women's daily struggle for survival. By the time I arrived in Bluefields, the toll of neoliberal economic restructuring was evident in the stories that these women shared about how precarious their lives had become. They talked about suffering from anxiety, high blood pressure, headaches, body aches, and diabetes. They described the challenges of raising their children as single mothers. Neoliberalism as they narrated it was not a bloodless, economic experiment but an embodied phenomenon (Sutton 2010; Yarris 2017).

Life in Bluefields at the beginning of the twenty-first century was hard (Lancaster 1992): the signs of these difficulties were evident everywhere. In 1991, *Barricada*, the official FSLN publication, reported that unemployment and underemployment on the coast ranged from 90 percent of the economically active population in the RACCN to 70 percent in the RACCS, a figure that remained constant over the years. The autonomous regions were and remain the poorest regions in the second-poorest country in the hemisphere. In 2005, approximately 65.5 percent of residents in both regions lived in poverty, while another 25.4 percent lived in extreme poverty. The United Nations Development Program ranked the Human Development Index of the RACCN and the RACCS, respectively, at 0.466 and 0.454, well below the national average of 0.596.[7] Despite the fact that they were the poorest parts of the country, the autonomous regions were also the most expensive places to live in Nicaragua; the regions' poor highway infrastructure meant that consumer goods had to be imported either by plane or via land and river routes, resulting in higher prices for basic goods. Costeños described this period as one defined by a constant sense of economic precarity.

When Violeta Chamorro was sworn into office in April 1990, she inherited a nation devastated by more than a decade of war, economic stagnation, and a foreign debt of approximately US$11.695 billion, the highest per capita debt in the world. In addition to the bloody human toll of the Contra War, which claimed the lives of some 30,000 Nicaraguans, the country was also devastated by the loss of productivity, U.S. economic sanctions, and limited access to international foreign aid. The material damages of the war amounted to a staggering US$9.087 billion (Close 1998).[8] These challenges would have been daunting for even the most seasoned politician. But Chamorro was a political novice with limited experience whose appeal as a political candidate stemmed primarily from being the widow of Pedro Joaquin Chamorro, a revered journalist and anti-Somoza critic who was assassinated in 1978

(Close 1998). Appearing at political rallies dressed in white, Chamorro presented herself as a mother and a nationalist capable of ushering in a new period of peace, healing, and reconciliation (Chamorro 1996; Kampwirth 1996).

But the "Mother of the Nicaraguans" was not an administrator (Kampwirth 1996; Close 1998). As Cynthia Chavez Metoyer (2000) observed, during her campaign, Chamorro failed to articulate a clear strategy for Nicaragua's political or economic recovery. But it quickly became apparent she was invested in a neoliberal development agenda that "relied on privatization, credit restriction, and massive cutbacks in state personnel" to stimulate economic growth. Chamorro selected "a group of technocratic political neophytes," chief among them her son-in-law and other members of Nicaragua's traditional oligarchy "who shared an unshakeable, though untested, belief in the efficacy of the free market and the virtues of free trade" to serve as her cabinet (Close 1999, 63). They eagerly embraced the reforms dictated by international financial institutions including the International Monetary Fund (IMF), the U.S. Agency for International Development (USAID), and the World Bank. The aim of these strategies was to "de-Sandinize" the country, which meant not only seizing political power from the FSLN but also radically restructuring the redistributive economic model of the Sandinista government (Close 1999).

To begin rebuilding the economy, the Chamorro administration relied heavily on foreign aid, which the George H. W. Bush administration had promised would be forthcoming after the FSLN was voted out of power. But access to loans and foreign aid was also contingent on the administration implementing a series of structural reforms outlined by the IMF and the World Bank. In September 1990, USAID agreed to provide a US$118 million grant to Nicaragua under the condition that the Chamorro administration introduce a stabilization program within the following six months. The government unveiled the Plan Mayorga in late 1990. It was designed to stabilize the economy and bring down inflation through the implementation of a series of strict austerity measures; the introduction of a new currency, the gold córdoba; and the privatization of state enterprises. To curb inflation, the government devalued the córdoba by 400 percent.

The plan backfired, and hyperinflation reached 13.49 percent by the end of the year as consumer prices jumped by 358 percent (Fernandez Poncela and Steiger 1996). Over the next year the country underwent "a 30 percent contraction in salaries that affected half of all Nicaraguans." The government's austerity measures led to massive protests by Sandinista labor unions that threatened to rupture the country's fragile peace. The government was forced to broker an agreement with the unions, Plan Mayorga was scrapped, and the administration replaced it with Plan Lacayo. Although Plan Lacayo called for fewer austerity measures, it "represented a continuation of the UNO's neoliberal program" (Chavez Metoyer 2000, 76). As a result, the country fell into a deep recession. By 1992 it was estimated that between 40 and 58 percent of the population was unemployed (Chavez Metoyer 2000; Fernandez Poncela and Steiger 1996; Close 1998).

In September 1991 the administration signed a loan agreement with the IMF contingent on the implementation of a series of structural reforms. In it, Chamorroro agreed to privatize state-owned enterprises, lay off government employees, reduce tariffs, and cut back on social expenditures, all to balance the budget (Close 1999; Chavez Metoyer 2000).[9] The government also implemented a regressive tax structure that minimized direct taxes based on income and property and increased indirect consumer taxes on cigarettes, beer, rum, and soft drinks (*Envío* 1991). To reduce the number of government employees, Chamorro initiated an Occupational Conversion Plan in which it offered an incentive package to state employees who agreed to resign from their posts. When this failed to produce the desired response, the administration began to lay off government employees. As mentioned, the administration also created a new government agency, the National Public Sector Corporations (CORNAP), to manage the privatization of 351 state-owned enterprises, including a national airline; coffee, banana, sugar, and tobacco corporations; a Pepsi-Cola bottler; a beer brewery; construction firms; and smaller agricultural producers and distributors (Close 1999, 133).

The effects of these reforms were devastating for most Nicaraguans. The administration's efforts to stabilize the national currency and bring down inflation sent prices on basic consumer goods soaring; yet as food prices increased, the government continued to roll back consumer subsidies on basic foodstuffs. A 1992 study by the Fundación Internaciónal para el Desafío Económico Global (FIDEG) found that 78 percent of households reported a reduction in food consumption as a result of the economic crisis. A 1993 World Bank study found that 28 percent of Nicaraguan children under the age of five suffered from malnutrition, which was linked to 35 percent of all child deaths between the ages of one and four. In 1993, the average cost of living in Nicaragua was C$734 ($US104) a month, but approximately 42 percent of households earned less than C$700 (US$100), and another 20 percent earned less than C$400 (US$43). Government spending on education, health, and other social programs decreased by 37 percent from $70 per capita in 1985 to $44 in 1993. State expenditures on health dropped from US$35 per capita in 1989 to US$19.1 in 1993. Chavez Metoyer (2000, 91) notes that in 1988, "25 out of every 100 Nicaraguans could not afford access to medical care; by 1993 that figure rose to 43." By 1996, annual per capita income had fallen to $500, making Nicaragua the second-poorest country in the hemisphere after Haiti (5).

Women disproportionately shouldered the burden of these free-market reforms. Feminist economists argue that international financial institutions prescribed and states enacted market reform measures with no consideration of their gendered effects (Fernandez Poncela and Steiger 1996; Chavez Metoyer 2000). Yet as Chavez Metoyer (2000, 56) argues, "It is precisely at the household level where policymakers expect social services that are cut from state budgets to be absorbed without any implications for the monetary economy." The privatization and downsizing of state industries and institutions, for example, hit women particularly hard since approximately 60 percent of government employees were women.

A study by the Luisa Amanda Espinoza Association of Nicaraguan Women (AMNLAE) found that in 1991 nearly 16,000 women working as agricultural laborers, industrial workers, health professionals, educators, administrative workers, and civil servants lost their jobs. As women were pushed out of the workforce, their families' standard of living plummeted. A 1994 study found that 72.5 percent of all female-headed households lived below the poverty line compared to 67.5 percent of male-headed households (FIDEG 1994, cited in Chavez Metoyer 2000).

As state resources contracted and work vanished, growing numbers of Nicaraguan women turned to the informal economy and labor migration to ensure the survival of their families. When I returned to Bluefields a few summers later, I stopped by Diana's house for a visit. Her mother, Miss Tere, was sitting on her front porch. She informed me that Diana had left the country in search of work. She gave me Diana's number and address, and I gave her my contact information to pass on to her.

Several months later, I received a letter from Diana. She had finally had enough of dealing with her husband's foolishness. She told me that he had been fired and sent home from the ship for drinking too much and consistently showing up late for work. For a time, he worked for the city's public transportation system, collecting fares and providing change to the passengers. But disgruntled by the low pay and embarrassed to be seen performing such menial labor, he then stopped working altogether. When he was home, she said, he hounded her, criticizing her cooking, her cleaning, their home, her "lax" child-rearing practices. And she would have taken it—for the children's sake—but then she learned that he had another sweetheart, a mestiza teenager who was already six months pregnant at the time. "I saw him with her on the bus," she wrote. Diana left him and, shortly after the divorce was finalized, began making plans to move to Miami where she found work as a domestic. She earned more than a schoolteacher in Bluefields, she reported, and although the work was difficult, she enjoyed making her own money.

But she missed her children, whom she had left in her mother's care, and wondered whether she had made the right choice leaving Bluefields. If she stayed, she could not provide for them financially but worried about leaving them. Would she still be a good mother?

Diana was not alone in her doubts. Since 1990, a growing number of Creole women have left the country in pursuit of better economic opportunities. Some like Diana went to work as domestics in Costa Rica, the United States, or the Cayman Islands. The majority, however, looked to the cruise ship industry, historically the primary labor migration destination for Creole men. As more women joined the stream of Nicaraguan labor migrants leaving the country, it raised new questions around the politics of mothering, care, economic survival, and the social impacts of labor migration on Creole identity.

SHIPPING OUT: WOMEN'S LABOR MIGRATIONS

Cruise ships are surreal, strange places. They are like floating cities of consumption and spectacle—complete with outdoor recreation, entertainment, and shopping malls—where men and women from around the world cater to the whims of first world customers looking to escape the stress of their first world lives. The ships travel from place to place, circumnavigating the boundaries of sovereign nations and claiming foreign allegiances to avoid taxes and labor laws. They come ashore only long enough to allow their guests to sample the cultures of exotic places with exotic names—Nassau, Ocho Rios, Roatán, Aruba, Negril, San Juan. The passengers are then whisked back onto the ship before they have had enough time to splash their feet and take in the local culture. Cruise ships epitomize what the French anthropologist Marc Augé (2008) describes as "non-places," those spaces of late capital seemingly devoid of the kinds of historical memory, affective attachments, or modes of sociability that create a sense of place.

In July 2014, I boarded *Princess of the Seas*, a ship owned by Royal Caribbean Cruises. The trip was courtesy of my partner, whose orchestra had been hired to perform. I had come along in the hope that I would encounter a Creole woman working on the ship; if nothing else, I figured that I could learn something about the experiences of people laboring in these spaces. Creoles refer to the long-established tradition of traveling to work on cruise ships as "shipping out," and since the 1990s, Creole women have increasingly shipped out in search of better employment opportunities.

When we arrived at our room, a young woman smiled and greeted us warmly. "Welcome to the Royal Caribbean," she said as she smoothed the sheets on the bed. "My name is Jenny, and I will be your stateroom attendant. Your cabin will be ready shortly." Her Mosquito Coast Creole accent was unmistakable. Her employee badge confirmed my suspicions—there was a small Nicaraguan flag beside her last name. I introduced myself and told her that I had lived in Bluefields off and on for many years. I quickly told her about my work and asked her if she would be willing to speak with me about her experiences on the ship.

Two days later Jenny returned to our cabin after completing her morning shift. She still had on her uniform: a crisp white shirt with a light-blue vest, her badge, pressed navy-blue pants, and sensible black shoes. She made herself comfortable on a tiny loveseat as I set up my camera and audio recorder. I assured her that we would complete the interview within the hour; we were well aware of the considerable risk that she had taken to speak with us, given that ship policy strictly forbade fraternization with guests. Finally, with everything set up, we began the interview.

Although Jenny had only been working for Royal Caribbean for about three years, she had "been ship out," as Creoles say, for nearly a decade. Like other ship-out recruits, Jenny decided to leave Bluefields because of the depressed economic

conditions in the region. After graduating from Moravian High School, she enrolled at the Bluefields Indian and Caribbean University. But after becoming pregnant, she decided that she needed to get a job to support herself and her family. Jobs were scarce, and after months of looking, her uncle, who worked on a cruise ship, recommended that she consider going on ship.

She shared how her uncle had helped her get her paperwork together to work on the ship. He took her to see Wade Hawkins, owner of the Seaman's Express, which for many years was the primary recruiting agency in Bluefields for the Royal Caribbean, MCL, and Carnival cruise lines. Hawkins claimed not to keep records of everyone whom he recruited for the cruise lines, but it is estimated that he recruited between 3,400 and 5,000 workers from the early 1990s until his death in 2017. Hawkins shared that, as economic opportunities in the region disappeared and the crisis of structural adjustment deepened, for many costeños shipping out became their "only hope." He reported that on average sixty to seventy young men and women came to Seaman's Express each day looking for work. Among them, he said were women "having trouble with their spouses, because they left them pregnant or they have one or two children to maintain. They beg me to give them an opportunity to go out and I try to see what I can do for them" (León 2003). Hawkins reported that he saw a marked increase in female ship-outs after 1996 and that their numbers continued to grow into the early 2000s. Nevertheless, he shared that women constituted only about 20 percent of all ship-outs and that men continued to make up the vast majority of cruise ship labor migrants.

Talking in our small cabin, Jenny shared, "I'm the onliest one in my family working." She added, "I take care of my whole family." When I asked her how many people she was supporting, she replied, "It's eleven of us." Shocked, I replied, "That sounds like a lot of pressure." Jenny smiled, shrugged, and said, "At first, yes. But you get used to it."

She had an eleven-year-old daughter who was being raised by her grandmother. "I wish I could be with her . . . but well, those are sometimes the sacrifice we have to do in life. I miss her a lot." The most painful part of being on the ship was not being able to see her daughter grow up: "I first leave my daughter when she was only two years and one month. I used to cry a lot. I think I cry for my whole first contract. When I went home, my daughter she didn't want to come to me. I was like a stranger for her. If I want to go anywhere with her, I have to take somebody else from the house so I could go and pass some time with her. She didn't want to see me."

Her eyes began to fill with tears. "What hurt me the most was the first day she start class. I was not there to take her with me," she said. "So I felt like . . . it's a lot of things." She struggled for words as she began to cry. "It's very hurtful."

Adjusting to life on the ship at first was difficult, she recalled. In addition to missing her family, Jenny had to become accustomed to the demanding work schedule. As a stateroom attendant she was responsible for cleaning up the rooms. Although she said she enjoyed her work, it was sometimes difficult to keep up

with the demands of the job. She might spend up to ten hours each day working, but her schedule was entirely dependent on when guests left their rooms each day. The company discouraged workers from working overtime but at times she could not avoid it.

Cruise ships are floating resorts composed of "two parallel occupational structures": an upper-level crew consisting of the captain, officers, technicians, and seamen and a lower-level crew comprised of workers who staff the boat's kitchens, utilities, restaurants, and cleaning services (Wood 2000). These ships are deterritorialized spaces where the strictures of labor rights, environmental protections, and wage equity that are imposed by states on land do not apply. As Rick Mitchell (2003), argues, untethered "to any particular place nor subject to American jurisdiction and able to sail—with a low-wage, multinational crew—at a moment's notice through unregulated international waters while evading taxes, laws, and minimum wage, the slippery cruise ship has become the space par-excellence of unfettered globalization." Scholars of the cruise ship industry have observed that most ships have a "clear ethnic cast to this hierarchy," recruiting officers from Western Europe, staff (cruise director, hotel management, entertainment, and administrative staff) from North America, and crew members from Asia, Latin America, Eastern Europe, and the Caribbean (Wood 2000, 353). The ethnic and racial division of labor on these ships is also reflected in the wages that employees receive from the company. Nicaraguan ship-outs reportedly earn between US$500–1,200 month working on the ships as domestics, servers, bartenders, and utility crew (León 2003; Bolaños Chow et al. 2008). Because of their native Creole English skills, however, I personally knew several female ship-outs who were able to move into more public-facing positions working at the Concierge Desk or serving as hosts for guests, and they earned considerably more; I knew of at least one woman who reported earning upwards of US$1,500/month. Upper-level management, administration, nautical crew, and entertainers, however, were paid standard U.S. wages that were considerably higher than the rank and file.

All the Nicaraguan ship-outs whom I spoke with began as members of the utility crew doing the most difficult, dirty, and dangerous work on the boat; some were gradually able to work their way up to positions as state room attendants, bartenders, or working in one of the ship's restaurants. Indeed, Nicaraguans were most likely to be concentrated in low-skill service positions on the boat; few made their way to upper-level crew positions where they consistently interfaced with customers. Nevertheless, the low wages that workers receive on the ship are still significantly higher than what they might earn in a professional job back home.

A study by Manuel Orozco (2008) confirms that the vast majority of ship-outs use their earnings to support their families back home. Approximately 74 percent of costeño labor migrants come from Creole households, and as a result, remittances are a vital source of household income for their families: on average ship-outs send home between US$151–200 each month. Receiving families use these

remittances to cover or defray the costs of food, health care, education, and housing for at least four people (Bolaños Chow et al. 2008). Although there are currently no official statistics on remittances sent by ship-outs to the region, clearly their impact has been critical for maintaining the regional economy. *Envío* reported that in 2001, three money-transfer agencies channeled US$3.7 million to the entire RACCS. By 2005, ship-outs sent US$12.9 million to the city of Blue-fields through banks and money-wiring services (Rocha 2009). These amounts do not fully account for remittances, however, because many ship-outs often send money with their coworkers who are returning home to avoid paying transfer fees. Even that conservative estimate provides an annual average of US$280 per inhab-itant of the coast compared to the national average of $180 per inhabitant in remit-tances. Jose Luis Rocha (2009) estimates that the coast likely receives $37.5 million in remittances annually, which would average $750 per inhabitant.

Despite the importance of remittances for sustaining the regional economy, community members and leaders expressed concern about the social and cultural shifts produced by increased labor migration and the influx of this money. They were particularly concerned that the importation of harmful social values of conspicuous consumption, financial dependency, and materialism was eroding traditional community values of solidarity, community care, a strong work ethic, and respectability. Local pastor and politician Rayfield Hodgson stated (Robb 2003, 329),

> Today's mentality is party, party, party. You see a Black guy coming home from the ship with perhaps $3,000 or $4,000 in his pocket and what does he do? He looks for a boom box to play at full volume walking through the streets. He looks for expensive weird clothes. He looks to go out drinking every night until the only thing left to do is beg for money for the trip back to the boat. He'll go from door to door begging for a loan and will pawn his land, his house or whatever he might have bought in order to return to the ship. This is a badly informed society and because of that we're a directionless people.

Still others argued that the increase in labor migration among young Creoles had eroded their investment in their education. Anxiety about the devaluing of educa-tion was a recurring theme in regional and national discourse about the social effects of shipping out. Residents often saw the divestment from education as a reflection of the impoverishment of local cultural values among young people. This "mentality" was demonstrated in these workers' inability to delay personal gratification, think long term, prioritize education over earnings, and save their money, rather than engaging in conspicuous displays of wealth and consumption. In many ways, local discourse about the negative effects of shipping out and the harmful cultural values of globalization that accompanied this phenomenon con-verged with larger racist narratives about Black peoples' "bad" cultural values (Kelley 1994; Thomas 2004). Yet the obsession with education as the primary

solution to the region's poverty also struck me as curious in an economy where having an education was often not enough to secure good jobs, when jobs remained in distressingly short supply, and where they were often attainable only through participating in clientelistic networks of party patronage.

In addition to these general concerns about importing bad cultural values into the community, the increased number of young Creole women shipping out also evoked a particularly gendered set of anxieties about the effects of labor migration. As Goett (2016) notes, the figure of the female ship-out generates a particular kind of multileveled moral anxiety. At one level, community members were concerned about the effects of mothers abandoning their children to be raised by relatives while they labored on cruised ships. Popular and scholarly literature on the phenomenon of outward labor migration, particularly by women, often focuses on how the separation of parents and children contributed to a process of what some experts refer to as "family disintegration." Development and immigration policy experts attributed the rise in drug and alcohol abuse, intrafamily and sexual violence, underage pregnancy, crime, and citizen insecurity on the coast to the disintegration of the heteronormative family unit as the site where positive social values are inculcated and enforced (Bolaños Chow et al. 2008).

Local community members also argued that ship-out parents often attempted to compensate for long periods of separation from their children by placating them with fancy toys, clothing, and gifts, but that these efforts produced their own dangerous effects—igniting a thirst in young people for consumer objects that exacerbated the erosion of local cultural values. Community members expressed concern about the growing influence of foreign values on their children via new media and communication technologies, the influx of flashy consumer goods, and the loss of communitarian values among young people. During a focus group on land rights in Pearl Lagoon, Martha, one of the participants, stated, "The Direct TV, cellphone, eh! [It is] attractive, the young people don't know . . . they will do anything to get it. Then what? After problem come!" As Martha's comments illustrate, shipping out become a sign of the deterioration of the community's social norms and cultural values in the face of neoliberal globalization and the economic crisis.

The second concern centered on the ship itself as a sexually unregulated space in which communal pressures of gossip, surveillance, and familial honor are suspended. Community members often speculated on the suspect sexual virtue of single women who had worked on the cruise ships and whether they had engaged in casual sexual relationships with their coworkers; married women were often suspected of engaging in extramarital affairs. There was some truth to these speculations. Women I knew who had worked on cruise ships did describe the experience as one of increased sexual autonomy. Although some women like Jenny maintained monogamous relationships with long-term partners from back home, other women told me that they took full advantage of their time on the ship to meet and date men from other countries.

I spoke with one friend, Shara, about her experience working on the ship. "I miss the ship life, gal," she said. The ship was a diverse, cosmopolitan environment where she met people from all over the world—Filipinos, Europeans, other Black people from the Caribbean. "There was so many men. You could decide who you want, who you no want. I mean you could pick, choose, and refuse!" We both roared with laughter. She told me about the Jamaican she dated who wanted her to come back to the island with him. "I really liked him," she said. "But I could never do that. My son is here, my family is here. I missed home." Yet returning home had been hard. Although she was happy to be back, she knew that people had heard about her life on the ship and that she was the subject of a lot of gossip. People talked about the colored contact lenses she wore, the gold chains draped around her neck, the name-brand clothing she bought for her son. But when we spoke, she was unfazed. "I'm a big woman and I work for everything what I have. So make people talk them *rass*. I never asked nobody for anything and people talking about what them hear I do on ship. But they wasn't there."

It was revealing that community members focused their concerns about the sexual morality of ship-outs nearly exclusively on women, even though it was common knowledge that men on ship were also often unfaithful to their spouses; in casual conversations I often heard men brag that they had "a woman in every port." When I first arrived in Bluefields in the early 2000s, one of the largest public health campaigns focused on encouraging women married to ship-outs to get tested regularly for HIV/AIDS and to use condoms with spouses who may have had other partners. But this was a particularly difficult task because, as many women reported, their partners often accused them of having been unfaithful at home while they were working to support the family on ship. As a result, many women did not ask their partners to use condoms, even if they suspected that they had other partners, thereby increasing the likelihood of their exposure to HIV/AIDS and other sexually transmitted infections. Although I never saw any official statistics on rates of HIV/AIDS infection in the region, I often heard the claim among local activists and NGO workers that Black and Indigenous communities in the RACCS suffered from the highest rates of transmission in the region and that Creole housewives constituted the largest number of new cases each year.[10]

As these stories illustrate, community members, policy experts, and labor migrants themselves often narrated the crisis of structural adjustment and neo-liberal restructuring as a moral crisis. Even though shipping out became an increasingly important survival strategy among Black women—and one chosen at considerable personal sacrifice—it generated a new set of social problems and moral anxieties over the long-term well-being and survival of the community. As the regional economy continued to stagnate and more women chose to migrate outside the country to provide for their families, some women began to look to a new, more dangerous livelihood to weather the crisis: the regional narcotics trade.

DRUG DEALERS AND BAD MOTHERS: CRIMINALIZING THE COAST

In the early morning hours of May 4, 2004, ten masked men entered the Bluefields police station located in Cotton Tree, a historic Creole neighborhood. There were five police officers on duty in the station that morning. The assailants tied them up, taped their mouths shut, and then murdered four of them, stabbing two in the heart, slitting the throats of the other two, and leaving one officer alive. They then raided the police arsenal and stole thirty-one AK-47 assault rifles and eight pistols. The national media described the scene as Dantean: "blood on the walls, bodies everywhere." The police murders shocked the nation, igniting a national discussion on the social impacts of the growing regional narcotics trade (Gomez and Flores 2004).

I arrived in Bluefields for the first time just one month after these murders. I recall seeing a battered police truck in front of the station, which apparently was destroyed by the same men who had killed the four officers, and shuddering as I walked past it. Rumors about the killings abounded. Local residents shared that they believed the police had been murdered by Colombian *sicarios*, assassins employed by drug cartels; many speculated that the slain officers were corrupt and had been involved in the drug trade themselves. Some claimed that the corruption went all the way to the top levels of the National Police.

Shortly after I arrived, the National Police and the Bluefields municipal government held a public march, "¡*Si a la vida, No a la droga*!" The city canceled all classes in local schools, and the streets were thick with children in matching school uniforms, Boy Scouts, church groups, and local youth bands. I noticed that there were few other people in attendance. When I asked Diana why she had not attended the march, she sniffed and replied, "We no trust the police. Because them is the same ones mix up in this drugs business."

The local and national media also picked up on Creoles' lack of participation in the march and criticized costeños for failing to stem the tide of drug trafficking. A political cartoon in *La Prensa* depicted a Creole man with full lips, a large nose, and kinky hair discussing the march. He announced, "As a resident of Bluefields, I want to say that that we are sick of being painted as a lawless drug town." A voice from seemingly nowhere asks him, "So then why don't you march against drugs?" To which the Creole man replies, "What are you crazy? With all these drugs around and no one to protect us?" The national media depicted costeños, Creoles in particular, as hypocrites who would not take a firm stand against the drug trade while complaining about racist representations of the region. Creoles meanwhile pointed to the discriminatory treatment that they experienced at the hands of the police and how racist representations of the drug trade not only made their communities acceptable targets of state violence but also obscured the role of the state in facilitating the growth of the trade.

In February 2013, members of the National Police stopped Grace Gordon, a local educator, at the Bluefields Wharf on her way home from a trip to the municipality of La Desembocadura del Río Grande. The police, she was later told, were stationed at the wharf searching for a suspected *mulero* (drug mule) traveling from La Desembocadura. When Gordon arrived at the wharf, she was identified by the police as a potential suspect and required to submit to a full-body search. She recounted this humiliating experience at length to *La Prensa*: "The police were at the wharf registering passengers, they told me that if I didn't let them search me they would put me in handcuffs and take me prisoner. A female officer took me to a bathroom, she told me to take off my clothes, I took off my shirt, she felt my chest, she told me to take off my pants, my panties and to do three squats and I had to do this . . . because I did not want them to arrest me" (León 2013).

Creole activists and community members in Bluefields were outraged by the humiliating treatment that Miss Grace, a beloved and respected figure in the community, had received at the hands of the police.[11] In the days following the incident, several community groups along with the Bluefields Black-Creole Indigenous Government organized a public march demanding an apology from the police and a shift in the local department's policies regarding counter-narcotics policing methods. One woman, who had been subjected to similar treatment several years before the incident with Miss Grace, stated that police harassment is a common experience for costeños, who are often racially profiled in the state's ongoing effort to police the growing trade in narcotics in the region. She pointed out that the disproportionate policing of Black and Indigenous peoples is not only an issue on the coast but is also a standard feature of counter-narcotics policing throughout the country. "It's not only on the panga, it's in Rama also, it is in Managua, it is in Tasbapaunie, everywhere you go the police try to abuse," she said. "They take out your purse, they count you money, they want to see how much money you have, if you have a few thousand cordobas or dollars it has to be illegal. *Enough is enough.* We cannot continue with this."

It was a complaint that I had heard often from Black and Indigenous costeños. Popular discourse and mainstream media representations of the drug trade in Nicaragua tend to focus disproportionately on the coast as the primary site of the trade while rarely addressing the significant traffic in the Pacific. In her work on multicultural governance and counter-narcotics policing in Nicaragua, Jennifer Goett (2011, 356) argues that the gendered discourse of Black criminality and drug trafficking is one of the "principal ways that racial and cultural difference is produced in the post-revolutionary political imaginary": it has effectively rendered Creole communities as not simply made up of noncitizens but also of anti-citizens whose social delinquency and criminal behavior threaten the internal stability of the nation-state. The representation of Bluefields, in particular, as a city floating on a sea of dirty drug money has become a defining part of the general perception of the region.

These narratives, what I term the "narco-myths of Black criminality and immorality," circulated internationally and drew resonance from comparable discourses

throughout the diaspora. They recycle a well-worn catalog of stereotypical discourses that mark Black communities as immoral sites of pathological violence, crime, and illicit sexuality that threaten to contaminate the nation. Journalists describe Bluefields as the "epicenter" of the drug trade, a vector of a deadly social virus that threatens to "infect" Nicaragua, or a plague that is eating away at the city. In these narratives, journalists depict Bluefield as a fallen city, "a lost paradise," that has been overrun by the trade and the moral failure of Black and Indigenous communities to resist the lure of fast, easy money (Valencia 2011; Debusmann 2007; McDermott 2012; Martínez 2011; Miranda Aburto 2014; Logan 2006; Carroll 2007; León 2015a).

These accounts typically begin with an interview with a local fisherman who either combed the region's beaches or went sea diving in search of what locals refer to euphemistically as "the white lobster"—or observed others doing this. These accounts then describe how, after discovering this "blessing from the sea," locals quickly insert themselves into regional trade networks, selling their products to regional and national distributors. Predictably, however, the promise of easy money sours quickly as the ills of addiction, violence, and the deterioration of the moral order create conditions of social instability and citizen insecurity (Franklin 2008; Valencia 2011; Debusmann 2011; McDermott 2012; Miranda Aburto 2014; Logan 2006; Carroll 2007; León 2015a).

In the early 2000s, several international publications published a series of articles about the regional drug trade that recycled these racialized narco-myths (Carroll 2007; Burnett 2004; Logan 2006; Franklin 2008). I was struck by how one, in particular, evoked ideologies of Black criminality and immorality that informed regional discourse on cocaine's broader social impacts. As one journalist wrote, "At first glance, Bluefields in Nicaragua looks like any other rum-soaked, Rastafarian-packed, hammock-infested Caribbean paradise." But unlike these other locales, Bluefields holds a secret: "People here don't have to work. Every week, sometimes every day, 35kg sacks of cocaine drift in from the sea. The economy of this entire town of 50,000 tranquil souls is addicted to cocaine"—and everyone in Bluefields is in on the secret (Franklin 2008):

At the Midnight Dream reggae bar, dozens of young Black men wearing baseball hats, NBA sleeveless shirts and Nike Air sneakers are bedecked in gold chains and partying with women who openly snort cocaine. The recent discovery of bales of cocaine along a nearby beach financed the celebration ... When the lyrics scream out "I feel so high, I can touch the sky," practically on cue the three girls at the next table pile coke on the back of their ebony hands and snort openly, laughing. Then they start the maypole dance the traditional fertility festival for this month, May, which has evolved into a wickedly sexy dirty-dancing routine. A stunning line of 1.8 m [5 ft 9 in] Black women swirl on the dance floor. A Rasta man stumbles by, his nose white, clumps of coke stuck in his beard.

The writer explicitly suggests that the region's morally suspect cultural practices underwrite the growth of the drug trade. Even the practice of harvesting and consuming sea turtles becomes evidence of the inherent immorality of the region and its inhabitants: "The waiter offers carne de tortuga—a grilled slice of endangered Hawksbill Sea Turtle. While locals insist they only slaughter the older specimens, that did little to ease my sensation that *here in Bluefields pleasure trumps morality*" (Franklin 2008, emphasis added).

These narratives of Black moral depravity and criminality—that "pleasure trumps morality"—lie at the heart of the larger discourse about the nature of social life on the coast. These narratives, however, are also deeply gendered. As Goett (2011) notes, media accounts and local police often targeted young Creole men as the primary actors—as traffickers, consumers, and distributors—in the trade. But women were also implicated in the narco-myths that developed about the region during the era of neoliberal restructuring. They were frequently targeted as enablers, bad mothers, and active participants in the drug trade, who facilitated the growth of the trade by failing to inculcate the proper cultural values in their children and instead encouraged their participation in the trade through their own moral depravity and fetishistic materialism. In 2003, former Bluefields mayor, Moisés Arana, lamented the fact that the region was increasingly the most active site in the nation's growing drug trade:

> We in Bluefields are famous on the Pacific side of the country for being the country's most active drug traffickers. We are regrettably also in first place in several other tragic, but much less mentioned, areas. We are first in the percentage of adolescent mothers 15 years old or younger. It is public knowledge that many girls between the ages of 4 and 6 are paid a couple of córdobas [less than $0.15] by taxi drivers for oral sex. We are also first in liquor consumption and in the number of bars. We have the second highest population living with HIV/AIDS. And we have been in first place in venereal diseases since the seventies. On the other side, we rank very high, if not first, in the number of churches, which is an expression of the predominance of a very religious concept of life. Very religious, but not very Christian; a lot of rituals and prayers, but very little social commitment and solidarity. (Arana 2003)

Arana admitted, however, that the growth of the drug trade was linked to the lack of economic opportunity in the region, which drove many people to turn to the illicit economy for survival: "There are no jobs here—unemployment is 85 percent. It is sad to say, but the drugs have made contributions. Look at the beautiful houses. Those mansions come from drugs. We had a woman come into the local electronics store with a milk bucket stuffed full of cash—she was this little Miskitu woman, and she had $80,000."

Arana further argued that the region's reliance on the drug economy generated high levels of "social decomposition." He stated, "It has become normal to see

drugged-up adolescents and young people wandering through the streets of Blue-fields, which has increased street crime because they steal to buy more drugs. . . . And there are some communities where 60–70% of the population—men, women and children—use drugs, be it marijuana or crack." Arana admitted, "Given the poverty and decades of government neglect, it was 'understandable but not justified'" that some Black and Indigenous communities turned to the trade as a source of much needed income. "There is no shame," he said. "It's almost an innocence—they don't understand the consequences" (Arana 2003).

Arana's editorial echoed mainstream media representations of the region as an immoral space where disrespect for public safety, moral decency, and the rule of law flourished. Creole residents and activists bristled at these stereotypical narra-tives, which assumed that everyone in the community was in on the trade. One colleague described it as a kind of "regional character assassination" that conve-niently placed the blame for the growth of the trade on Black and Indigenous communities while obscuring the state's role in facilitating its expansion.

In response to the discursive criminalization of the region, many community members and local activists adopted a narrative of moral respectability. On a cer-tain level, this response was understandable and partially rooted in the truth. Most Creole families in the region do not have a direct connection to the drug trade but survive on the remittances sent by loved ones on cruise ships or working in call centers in the Pacific. They work informal jobs to make ends meet or wait for con-sulting jobs in the NGO sector that have become less frequent as the state has slowly cut off access to international philanthropic funding for most of the region's NGOs. Most Black women in the region have refused to cross the line from infor-mal to illegal labor as a means of making a livelihood.

Yet, if it is true that most Black women in the region are not involved in the drug trafficking, that does not mean that Black women are entirely uninvolved in the regional trade in narcotics. Traveling to rural communities north of Bluefields or barrios in the city, I heard whispered stories from residents about which of their neighbors were known to be involved in the trade, often operating their businesses out of their homes. Although some trafficked largely in marijuana, the second-largest drug market in the country, others sold crack and cocaine as well. It did not appear that any of these women were living like drug kingpins; rather it seemed that most were supplementing their limited income with drug sales when supplies were available. When supplies were not available, they struggled like everyone else to keep the lights on and food on the table. For critics of the drug trade, these women posed a serious threat to the future of the community: they were accused of enriching themselves at the community's expense and destroying the region for their own selfish gain.[12]

The ambivalence that surrounds the drug trade in the region illustrates that costeños analyze the trade in terms of both its material and moral economy. As a material economy, drug trafficking is a logical, if lamentable, response to the state's and private capital's long-term abandonment of the region. The growth of the

drug trade reflects the failure of the state to provide jobs, economic opportunity, and sustainable development in the region. The drug trade has become a survival strategy of last resort for desperate and impoverished costeño communities attempting to navigate the nation's long-lasting economic crisis.

But community members were equally likely to highlight what they felt to be the individual moral failings of unprincipled men and women pursuing "easy" or "quick" money and participating in vulgar displays of conspicuous consumption: these activities were seen as signs of the loss or corruption of community values of collective care, mutuality, empathy, and local accountability. Community members attributed the corrosion of these social values to the failures of the state, the globalization of mass media and urban Black popular culture from the United States and the Caribbean, labor migration, the diminished influence of social institutions like the church in public life, and the lack of economic opportunity in the region. Nevertheless, they argued, as one NGO activist wrote in a 2010 editorial in *El Nuevo Diario*, that the growth of the regional drug trade had inculcated a new set of "anti-values" in costeño society that normalized drug trafficking at the expense of older traditional values: "Formerly in communities it was more important to be a respected person than to have this or own the other, nowadays the roles have been reversed it is more important to have, than to be someone respected and admired in the community, making successful drug traffickers by collaborating with them to evade the precarious or no justice of our region and turning them into the new paradigms to follow."

The editorial writer argued, "Need and historical abandonment are not excuses to become part of the international drug network; on the contrary, it is necessary to collaborate more with the army and the police in the fight against this scourge" (*El Nuevo Diario* 2010). Although people were aware of the material conditions that have produced the drug trade, they continued to privilege individual agency and moral accountability as the most important factors in the proliferation of narcotics trafficking and consumption in the region. Even women who participated in the drug trade internalized these communal values and critiques and policed themselves accordingly.

This was illustrated in a feature on a local Bluefields celebrity that was published in *El Nuevo Diario* in 2013. Dalila Marquinez Garth, known popularly in Bluefields as Popo, is a local radio host and well-known leader in her community, but this was not always the case. She said, "I sold drugs in Beholden," a traditionally Creole neighborhood. "I had a house and I used to sell drugs because I liked having money and it didn't matter to me what happened to those poor people; I would go into my room and there was the money that I had gotten in this ugly way. All that is behind me; my life is different now" (Arellano 2013). She claimed that her love for her children was ultimately what led her to stop selling drugs. After she sent her four-year-old son to visit her father-in-law, "my son told my father-in-law that I was selling drugs, so my father-in-law came with the Bible and opened my eyes and made me understand all the evil that I was doing."

Popo's account grounds her decision to leave the drug trade behind as a moral choice. After she stopped selling drugs, she became actively involved in her community, supporting the local baseball team and hosting *Take a Look Around*, a radio program sponsored by the FSLN. She became something of a local celebrity, and when I returned to Bluefields in 2013 after my fieldwork ended, I was hardly surprised to see her face on a large billboard downtown endorsing one of the national cellphone companies. It appeared that Popo had put drug dealing behind her and instead stayed busy making *chamba* for herself working with the government.

But things were more complicated than they appeared. In 2012, local police arrested Ted Hayman and Glen Hodgson at the Glorias Costeñas baseball stadium on charges of international drug trafficking and money laundering (León 2012a, 2012b; Romero 2012). Hayman was widely known at the time to be one of the most powerful traffickers in the region.[13] Immediately, residents in Bluefields and Tasbapauni began to protest his arrest, alleging that the police had engaged in excessive force and violated Hayman's civil and human rights. When the police raided Hayman's mansion in the Loma Fresca neighborhood, a representative of YATAMA arrived and engaged in a heated argument with local police, claiming that they had violated his rights as a member of the Indigenous Miskitu community. "Is he a drug dealer? Where is the proof? Show me the proof!" (Dixon 2012). Popo was also one of the most vocal critics of Hayman's arrest and his alleged mistreatment at the hands of local police. She declared that his arrest had "nothing to do with drugs." When asked what it was about, she said that she did not know but intimated that his arrest may have been more a political than a criminal matter. After speaking with local police, she declared, "They didn't know anything. They are just following orders from Managua." She vowed that the community "would do everything possible" to support him "because he has helped everyone" (Dixon 2012).

Although his most ardent supporters claimed that Hayman was not involved in the drug trade, most community members I spoke with were fully convinced that he was guilty of the crimes with which he was charged. But they also were ambivalent about the state's uneven approach to counter-narcotics policing. Local journalists covering Hayman's arrest and the subsequent raids on his properties in Bluefields, Tasbapauni, Corn Island, and Managua pointed out that the National Police refused to share any evidence that they had gathered to charge Hayman, instead operating under a cloud of secrecy (Dixon 2012, 2013).

Community responses to Hayman's arrest revealed the ambivalence that surrounded the growth of the narcotics trade in a moment of social and political abandonment. For although many costeños roundly criticized the negative impacts of the trade on Black and Indigenous social life, they also recognized that it was one of the few stable industries in the region (Orozco 2011, 2012). Hayman's arrest reveal how debates over the moral and material economy of drug trafficking are much more complex and fraught at the local level than the national or international

press suggests in their accounts of the drug trade. Popular local discourse and media representations of the growth of the regional drug trade tended not to consider these internal debates within costeño communities, instead painting residents as willful participants in the trade and reducing participation in it to the moral failures of the community to resist the lure of easy money and "a pretty life." But I witnessed these debates play out in a range of spaces from living rooms to NGO gatherings, academic conferences, and conversations with friends and neighbors. They revealed how the moral and material economies of the drug trade intersected and diverged in costeño social discourse on the relationship between the private and the public sphere, the disintegration of Creole kinship structures, and the assault on social institutions and traditional community values under the neoliberal turn.

CONCLUSION

By the early 2000s, the optimism of the autonomy project had dissipated and been replaced by a profound cynicism. Over the following decade, that cynicism deepened as the government transitioned from the neoconservative and neoliberal administrations of the 1990s and early 2000s to an ostensibly democratic socialist administration under the FSLN. Creole activists argued that, despite the ideological shift that the 2006 election of the FSLN seemingly represented, the government continued to meddle in and manipulate the region's autonomous political institutions. Elizabeth Wright, an NGO activist and entrepreneur, told me,

> So, we have a law that is autonomy. And the law of autonomy is for coast people, for us to participate in integration of the state of Nicaragua. For us we should not have Managua taking part in our autonomy. We have the right to organize according to our custom, to elect and be elected in the autonomous government. Why Managua have to interfere? The answer to this question is because they do not respect autonomy. For them [the Central Government] it was the stupidest idea that came up in the revolution. But we know that autonomy is a consequence of the revolution to try to integrate the Caribbean coast into the national state.

Despite having secured regional autonomy in the law, Elizabeth argued that "Managua," as she and many costeños refer to the central government, continued to intervene in regional politics, using seemingly neutral tactics to exert its influence. This was true of all the national political parties. She pointed to the historic strategy of withholding financial resources and programs or using them as forms of party patronage as the key means by which the state disempowered the regional governments and undermined the project of regional autonomy:

> "What control us here with the power is the money that they have. So they use their money to cow us down. Right? How you going compete is like the Spanish

say, *tigre suelte, burro amarrado*. That means the tiger is loose and the poor donkey is tied up. That's the race we running against here. It's unjust, it's unfair and it's not equal."

Even though the FSLN had returned to office offering a range of social programs designed to alleviate poverty and stimulate the national economy, Elizabeth argued that the state continued to engage in a project of centralized development—particularly regarding approval of the interoceanic canal project—that undermined regional autonomy through a combined strategy of underfunding, clientelism, and co-optation. I discuss this political project more fully in chapter 6, but it is worth mentioning here because it reflects the emerging discourse of militant Black organizing rooted in a critique of slow genocide that I witnessed over the course of my fieldwork in Bluefields. Creole activists accused the state of Nicaragua of starving autonomy out and creating the social and economic conditions for the disappearance of Black communities. Elizabeth asked me, "Where's the program? Show me the money. Immigration is rampant. Poverty—we don't have jobs. We do not have jobs. You go to any office in Bluefields—what you find? Mestizos from the Pacific. We don't find Creoles. So what happen to us—we losing everything. We losing our identity. We're about to disappear. It may sound like a stupid thing to say. It sounds funny. But it's true. We are in process of extinction as a people."

Elizabeth was echoing a concern that I had heard many times before in conversations with Creole activists and residents; namely, that the state's stranglehold on the autonomous regional governments would result in their disappearance as a people. It was around this time that I began to hear Black activists use the discourse of genocide to describe the community's experience of state violence. Elizabeth continued:

How you going tell me that we integrating and you come giving me crumbs off the master's table? You come to my house. I invite you, I accept you in. You eat all my things, you sit at my table, and when you done you walk away with all my dishes. You take all my food and decimate my family. . . . The only thing that will survive is Creole folklore—that's what we are to these people, to the Nicaraguan state. Remember now, we not taking it personal. We not even talking about the government, the FSLN, we talking about the state. There is a difference between the state and the government and the party. We are talking about the state of Nicaragua *no el gobierno* [emphasis added]. Government are transitory—they come, they go. It is the state. It doesn't matter which government; nothing has changed for us.

By the early 2000s, it appeared that regional autonomy—at least according to the women I worked with—was a failure. The regional governments met only sporadically, and when they did, they often failed to reach consensus. Corruption scandals abounded, and there was no shortage of political gossip about the

various intrigues and backroom deals that went on behind closed doors. Politicians took their policy directives from Managua, and the lack of political will to transform these conditions seemed insurmountable. Yet Creole activists refused to let the dream of autonomy die: they wanted regional autonomy to work and to realize the full potential of that dream. In response to the seeming failure of autonomy, Black women activists began to mobilize around an enduring political demand: the demarcation and titling of the Bluefields Creole communal land claim.

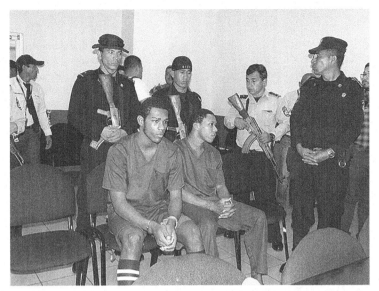

Brandon Lovo and Glen Slate on trial for the murder of Bluefields journalist, Ángel Gahona. The two were convicted, and their sentences were subsequently overturned on appeal.

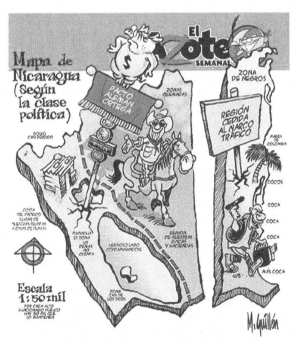

Mapa de Nicaragua (según la clase política). This political cartoon from the satirical news supplement, El Azote published by La Prensa, inadvertently maps out the geographical racial commonsense of Nicaragua. Of particular note is the Caribbean Coast, which is described as a lawless "Zona de Negros" that has been ceded to the narcotics trade.

Portrait of Anna Crowdell, an activist, hotel owner, and Mosquitian nationalist. The mixed-race daughter of a Creole woman and a German ship captain, Crowdell would become one of the most influential and important figures in regional political struggles for nearly a half-century. The Crowdell Hotel served as headquarters for the Union Club, a home for foreign diplomats, and a planning ground for regional rebellions in the early twentieth century.

June Beer's union member card. June Beer was the first painter from the Caribbean Coast to depict the landscapes, peoples, and cultures of the region in her work. She was an early supporter of the Frente Sandinista de Liberación Nacional (FSLN) and was actively involved in the project of revolutionary nation-building through the government's many cultural organizations and programs.

A display of the uniforms that brigadistas in the literacy campaign wore and their teaching materials.

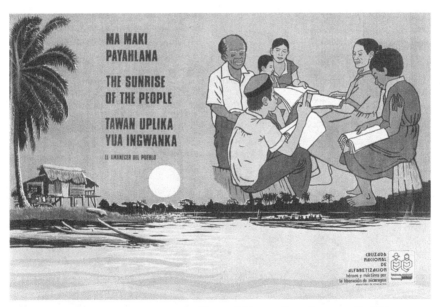

FSLN government poster promoting the National Literary Crusade on the Caribbean Coast in Miskitu, Creole English, and Mayagna. The shift from a monolingual Spanish campaign to a multilingual one reflected the advocacy of Black and Indigenous communities who demanded that the campaign on the coast be taught in their native languages. In many ways this shift marked the emergence of the multicultural discourse that would come to define Sandinista statecraft in the region.

The *Mothers and Fathers of Autonomy* mural in Reyes Park, Bluefields, Nicaragua. The list includes the names of notable figures including Merline Forbes and Yolanda Campbell Hooker, among many others.

Black and Indigenous activists deliver testimony to the Inter-American Commission on Human Rights in October 2015. From left to right: Marcia Aguiluz, CEJIL; Nora Newball, of the Bluefields Black-Creole Indigenous Government; Dolene Miller, CONADETI; Jorge Mendoza, Indigenous Territorial Government of Twi Waupasa.

4 · DANGEROUS LOCATIONS

Black Suffering, Mestizo Victimhood, and
the Geography of Blame in the Struggle for
Land Rights

OCCUPY BLUEFIELDS?

Bluefields made national headlines in November 2009 after a group of Creoles took over 865 acres (350 hectares) of land in the northern outskirts of the city. According to the news reports and accounts by those who participated in the land occupation, nearly 1,000 men, women, children, and elders marched through the city, making their way up the road that leads from the city's northernmost barrios into the rural areas surrounding Bluefields. Carrying machetes, baskets of food, and chanting "Back to the Land!" the protestors entered a heavily wooded area and cleared out small plots of land (León 2009a). Within days hundreds of people began to make their way into the area. Almost immediately, several mestizo individuals, the University of the Autonomous Regions of the Nicaraguan Caribbean Coast, and the Nicaraguan Navy claimed that they owned the property and called the police to dislodge the protestors.

The land takeover and the conflict that emerged from it reflect broader debates about the rights of Creoles to lay claim to the city. That the state privileged unverified land claims by local mestizos and dismissed Creole people's historical claims to the land illustrates the central paradox of the regulation of race, space, and territory in Nicaragua: if the coast is imagined as the central locus of Blackness—*una zona de negros*—within the larger racial geography of the nation, how is it that Creole claims to coastal lands are constantly negated and undermined by the state and rendered illegitimate in the popular imagination?

In 1987, the National Assembly passed Law 28, the Autonomy Statute, which established two autonomous regions on the Caribbean Coast and inaugurated a formal process of multicultural recognition. Since its passage, Afro-descendant and Indigenous communities in both the North Caribbean Coast Autonomous Region (RACCN) and the South Caribbean Coast Autonomous Region (RACCS) have

insisted that the state formally recognize their historic claims for land rights that lie at the heart of the promise of regional autonomy. Yet the law failed to provide a clear process for the demarcation and titling of Black and Indigenous communal lands. To rectify that gap in the law, in 2003, the National Assembly passed Law 445, which provides a juridical framework for the demarcation process that not only formalizes Black and Indigenous land claims but offers a mechanism for navigating the overlapping property regimes (private, communal, and state ownership) and competing claims of Black and Indigenous communities and mestizo settlers.[1] Yet despite passage of the law, the process still faced considerable challenges and was often painstakingly slow; although Indigenous communities in the RACCN and the RACCS received their titles relatively quickly after the bill became law in 2003, Creole communities continued to find it difficult to get the government to demarcate and title their lands. This was particularly true of the Bluefields land claim, which was the last territory to receive title in 2016 (Areas Esquivel 2016; Consejo de Comunicación 2016). This led to growing anger among Creole communities and regional activists who argued, "Without land autonomy means nothing."

National media coverage of the 2009 land occupation recycled deeply rooted tropes of Black criminality and political opportunism by framing it as an attack on the state. One article titled "Blacks in Bluefields Rise up against the Government" (León 2009a) featured a photo of a shirtless young Black man staring straight into the camera as he brandished two upright machetes while others looked on. Another article, "Invading Lands in Bluefields" (León 2009b), focused on the fact that the land occupation was taking place on private property. Ironically, even though none of the statements that Creoles made in either of these articles supported the idea that they were rising up against the government, the sensationalist headlines had the effect of reinforcing the idea of "Black costeños as criminal, opportunistic, counter-national and profoundly undeserving" (Goett 2006, 19).

In this chapter, I argue that Creole land rights and the juridical framework that grounds their land claims are increasingly under attack by mestizo settlers in the region who deploy a discourse of mestizo victimhood and reverse discrimination that obscures historical processes of structural racism and Creole displacement. Although this may seem to be a contradiction in terms under a self-proclaimed multicultural state, I argue that the official multiculturalism in the postrevolutionary neoliberal era actually facilitated the emergence of new and evolving forms of anti-Black racism that reinscribe Black marginality and reconstitute mestizo racial privilege (Hooker 2005a; Hale 2006; Goett 2016; Lipsitz 2006; Bonilla-Silva 2010). The Nicaraguan state's ambivalent stance on Creole land rights revealed a tacit endorsement of the historical project of internal colonization that has defined state policy toward the coast for more than a century. I deploy Paul Farmer's (1992) concept of the "geography of blame" to address the fraught racial politics of the Bluefields land claim, analyzing how mestizo encroachment on Afro-descendant and Indigenous communal lands is justified by a discursive strategy of mestizo victimhood: mestizos claim to be marginalized by Black and Indigenous peoples'

attempts to secure their communal lands; assert local control over use of the region's marine, timber, and mining resources; and ensure their economic survival by using the legal tools of the Autonomy Law and Law 445.

But if the discourse of mestizo victimhood has become a central part of representations of the struggle for land and power on the coast, Creole women's participation in the land occupation demonstrates the ways in which they "push back" against the geography of blame by foregrounding the historical roots of their land claims and insisting on their rights as mothers and workers to access the land. The land occupation is an example of women's efforts to restructure social space in Bluefields and reaffirm the legitimacy of Creole land claims in the city. Their use of historical narrative, their knowledge of the national legal framework for land rights enshrined in Law 445 and Law 28, and their enactment of maternal politics were critical tools in these efforts. Rather than allowing Creole demands for land to be used as scapegoats for the ongoing dispossession of landless mestizo farmers under the geography of blame, Creole women land activists highlighted the failure of the state to meet the needs of both Black and mestizo citizens and articulated a multiracial project of regional autonomy expansive enough to include all the region's diverse communities.

CLAIMING THE CITY: THE SPATIAL MEMORY OF STRUGGLE

In contemporary regional struggles, Creole activists and community members often frame their contemporary land claims through popular narratives of the long struggle for land and political power within the city. As Gurdián, Hale, and Gordon (2003) argue, this history forms a critical part of Creoles' collective social memory that animates contemporary land claims on the Atlantic Coast. Creoles' sense of place and belonging is deeply rooted in the landscape of the city and reflects why it continues to be read as a Black space, even though Creoles no longer comprise a demographic majority in Bluefields. The four oldest barrios in the city—Old Bank, Cotton Tree, Beholden, and Pointeen—are all predominantly Creole neighborhoods that hug the shoreline of the Bluefields Bay. Traces of Creole political, cultural, and social history linger in the landscape.

I spent many days walking through these neighborhoods with local activists, who pointed out to me the spaces that to an uneducated foreigner held little cultural meaning or political relevance. Over time I came to understand how—despite shifting demographics—Bluefields remains a profoundly Creole city. My home in Cotton Tree placed me in the heart of the city's Creole political history. The street on which I lived, Calle Commercial, was formerly known as King Street. Looking south from my front porch, I could observe the lovely, if neglected, two-story wood-frame building that once housed the government offices of the Mosquitia.

In contrast to many of the city's newer neighborhoods, narrow lanes—some paved, others hazardous and muddy—cut through many Creole neighborhoods in the heart of the city. Turning north on Calle Commercial, I would wind my way

through the bustling traffic, perhaps stopping to purchase fresh coco bread from the Miskitu women who sold baked goods there each day and avoiding the aggressive moneychangers posted on Wing Sang Corner, which earned its name during the height of Chinese commercial activity in the first half of the twentieth century (Sujo 1998). Continuing north toward Pointeen, I would pass the Moravian High School on the western side of the street and the Moravian Church on its eastern side, whose stately, dignified appearance reflects the enormous influence it has exercised on historical processes of Creole identity formation for more than 150 years. Reaching Pointeen, I would head west to Beholden, the largest Creole barrio in the city and the most predominantly working-class area. After one block, I would arrive at the corner where Barrio Pointeen and Beholden meet on the street that runs north–south through Beholden all the way to the tip of Old Bank.

Just south of the Pointeen/Beholden corner, a broad, intermittently paved road that locals call Crowdell Lane passes by a row of houses. In the middle of the row sits an empty plot of land, overgrown with grass, birds of paradise plants, and dasheen. The only signs that a building existed here are a short staircase and the fragmented remains of stone pillars. Toward the back of the empty plot, three enormous royal palm trees sway elegantly in the breeze, their fronds swinging back and forth; these palms are a defining part of the Bluefields skyline and are clearly visible from the other side of Bluefields Bay. To an outsider, there is nothing particularly noteworthy about this abandoned lot, but locals know that the Crowdell Hotel—once a hotbed of Creole political activity—once stood there before it was decimated by Hurricane Joan in 1988.

After passing the Crowdell Hotel, I would head north through Beholden, stopping to speak with friends who live along its main thoroughfare. Inevitably, I would pause to admire a large mural painted on the front of a nondescript unpainted concrete house. The mural features a large portrait of Marcus Garvey, the founder of the Universal Negro Improvement Association (UNIA), in full UNIA regalia staring proudly back at the viewer. The real history, however, lies across the street, where a UNIA meeting hall once existed.

What I learned by simply walking through the streets of Bluefields was how social memory resides not only in individual memory, archives, cultural texts, social practices, and institutions but also within the very landscape of the city itself. Buildings like the Mosquito King's government building and the lot where the Crowdell Hotel once stood, as well as public art pieces like the Garvey mural, serve as visual markers of a genealogy of struggle and resistance to racist processes of state control and mestizo hegemony. Creoles' efforts to lay claim to the city are informed by this suppressed spatial and historical memory that the state has attempted to erase, for example, by using the Mosquito Kingdom's administrative building to house the National Police. The practice of renaming Creole neighborhoods, social spaces, and city streets with Spanish names is another attempt to

obliterate or neutralize spatial markers of the social memory of struggle against the mestizo state that continue to hold great meaning (Gurdián et al. 2003).

The 2009 land occupation is a contemporary manifestation of historical struggles over Bluefields and the broader region. Despite the city's reputation as the quintessential location of Blackness and racial difference in the popular imagination, Creoles struggled to advance their urban communal land claims as the growing presence of mestizo cultural and political hegemony erased the visual markers of Creole political history and social memory. The land occupation, then, should be read as a symbolic attempt to claim Bluefields, reassert the legitimacy of Creole land claims, and articulate a historically and spatially grounded narrative of Creoles' demands for land and resources. But this struggle is not simply symbolic; struggles over control of space are also attempts to reshape the boundaries of what is politically possible in a particular locality. In other words, as the visible markers of Bluefields as a Creole Caribbean city vanish, it becomes increasingly difficult to justify Creoles' political claims. By reasserting their space in the city and disrupting hegemonic narratives that normalize mestizos' political and economic ascendance, Creoles attempt to shift the discourse of regional land conflicts and expose the process by which Creoles have been and continue to be dispossessed by the mestizo state's historic campaign of colonial nation-building.

THE POLITICS OF INVISIBILITY AND BLACK SUFFERING

I went with members of the Bluefields Black-Creole Indigenous Government (BBCIG) early one Sunday morning to visit the site of the land occupation about two weeks after the first group of people began to clear brush from the area. BBCIG representatives, Nora Newball and Dolene Miller, had promised to hold a meeting with the community to discuss what had transpired from their meetings with the Intendencia de la Propiedad, held to formulate next steps in their getting state recognition of the occupation as legitimate and securing land titles for each family.[2] We took a taxi to Barrio Loma Fresca, located on the city's northern outskirts, rode to the end of the street where the pavement ended, and from there set out on foot to the settlement. The sky was gray and overcast, threatening rain; the unpaved streets were thick with red mud.

As we made our way into the hills, we trudged past mestiza women seated on their front porches, some holding infants or with children tugging at their clothes as they watched our small party march by. Judging from the relatively new appearance of the small wood-frame houses, it seemed that many of these families had not lived in the area for very long. I asked Nora and Dolene about these women, and they shared that they were among the group of mestizo families that had been granted small plots of land from the municipal government on which to build their homes. For many of the Creole people involved in the land occupation, these land grants had proven to be the proverbial last straw. Although the Creole

Communal Government had submitted the Bluefields claim to this land in 2006 to the Intersectorial Commission for Demarcation and Titling (CIDT)—the agency responsible for receiving communal land claims and approving requests to begin the demarcation and titling process—their petition was not approved until January 2010. While the Bluefields land claim was languishing in the CIDT, the municipal and regional governments, with the support of the central government, were granting plots of land to local mestizo families, many of whom were not originally from the region—and this was not the first time that such land grants were given. The state's willingness to provide mestizo families with land in the heart of a Creole communal land claim while ignoring the needs of Creole families living in similarly depressed economic conditions demonstrated to many the state's true intentions regarding the titling of Black communal lands in Bluefields.

After trekking up and down several large hills, we finally reached the new settlement. A cluster of about forty-five people had already gathered there for the meeting. Women made up at least half of the growing crowd. As we waited for the rest of the group to arrive, I spoke briefly to some of the people who were there—some clearing out brush with machetes, others standing around under umbrellas, or sitting with their family members. There I met Miss Lena Brown and her granddaughter Jenny, who were among the first group of people to enter the area and begin clearing it of brush.[3] Miss Lena said that she was participating in the takeover because the house where she and her children were living with her sister, brother-in-law, and their large extended family was too crowded. She and her children needed land to build their own homes, plain and simple. She said, "We is not afraid. We going to work and we going to hold on until when the government give us [a] piece. Because we no have a home and it's *three* family in one house. I have eight children and all of us need a piece, you know?" (qtd. in Morris 2010). All of the women at the gathering echoed this sentiment.

People continued to trickle into the meeting; within an hour about one hundred people had gathered in the clearing. After opening the gathering with prayer and songs, including a brief rendition of "We Shall Overcome," Nora began to provide a brief update of their meetings with the local Human Rights Attorney's Office, the Property Administration (Intendencia de la Propiedad), and the Mayor's Office. She shared that despite their efforts to get the Intendencia de la Propiedad, the municipal and regional governments, and the FSLN to provide land and housing to these Creole families, these institutions had made no attempts to do so, and there was little indication that they were going to do so. Indeed, state officials dismissed the Creole occupants as *crackqueros*, or crack cocaine dealers and addicts, squatters, and criminals infringing on the legitimate property rights of the land's owners, even though no competing claims to the land had yet been legally substantiated.

People at the gathering were particularly offended by the *crackqueros* reference. As Goett (2011) notes in her analysis of the intersections between multicultural

governance and counter-narcotics policing strategies in Nicaragua, most media representations of the drug trafficking tend to focus disproportionately on the Caribbean Coast as the primary site of the trade while rarely addressing the significant traffic on the Pacific Coast. The *crackqueros* reference also had significant gendered implications, because young Black and Indigenous men are presumed to be the central actors—the traffickers, consumers, and distributors—in the drug trade. As Goett (356) argues that the gendered discourse of Black criminality and drug trafficking constructs Creole communities, Creole men particularly, as anti-citizens whose social delinquency and criminality threaten the internal stability of the nation-state. As a result, the rights that Creole and Indigenous peoples received under the multicultural citizenship reforms of the 1980s have been undermined as the state professes to embrace a multicultural form of governance while actively criminalizing Black communities and targeting them in its counter-narcotics policing efforts. Much like the depiction of costeños as savage and primitive in the nineteenth century, the twenty-first-century stereotype of Creoles as criminal and delinquent "discredit[s] costeño claims to political agency" (Hooker 2010, 332). Indeed as one woman at the gathering complained, it is assumed that Creoles do not need assistance from the state because they "live off drugs money." But the discourse of Black people making an easy living on easy money obscures the conditions of poverty and economic precarity in which most Creole families live. Narratives of Black criminality and laziness position entire communities as unworthy recipients of state aid, making it difficult for Creoles to access assistance from the government or to exercise the rights to autonomy, territory, and livelihood that they are entitled to by law.

Thus, the *crackqueros* narrative had two significant effects. First, by focusing primarily on the participation of Black men, the state and the media erased the central leadership roles that older Black women played in the land seizure and subsequent occupation. Second, by linking the land occupation to narcotics trafficking, these officials attempted to delegitimize it by ignoring the historical and legal basis for the occupiers' actions. This strategy of reading Creole political activism in a historical vacuum reinforces long-held discourses of Black foreignness and marginality and heightens the existing sense that Creole self-determination imperils the larger project of national development, citizen security, and political stability.

In response, Creole women participating in the land occupation mobilized a gendered counter-discourse of moral legitimacy to challenge these controlling images of Black communities as criminal, deviant, and unworthy political subjects (Hill Collins 2000). None of the news reports on the land occupation ever identified Miss Lena as a key actor, although according to the accounts of community members and representatives of the Bluefields Black-Creole Indigenous Government, she, her sister, several adult nieces, and their children were the first people to enter the area and to begin clearing it for settlement. After her husband was injured in a work-related accident, Miss Lena assumed responsibility for providing for her

eight children, several of whom have small children of their own. A devout Baptist, Miss Lena is an active member of the Black Farmers Back to the Land Movement, which has helped her maintain a small farm near Pearl Lagoon that she works with her two sons. She commutes from her farm in Pearl Lagoon to Bluefields where several of her children live with her sister in a crowded concrete house in Barrio Nueva York.

When she heard that the Bluefields municipal government had a program to provide people with twenty to twenty-five manzanas of land, she went to their offices to see if she could participate in the program; there she was told that they were no longer giving away land.[4] Disheartened, she returned to her sister's house empty-handed. But then one year later, she says, something miraculous happened. "I got up one morning and when I look in my room, I glimpse just a glare and like someone was telling me, 'Get up. Go look the land. Go look the land.'" She went to her sister and said, "Yvonne, let's go look a piece a land." They walked all over the city that day, she said, looking for land, but "everywhere we pass the Spaniard them got pure barbwire." Finally, they headed north and stumbled on a "big woodland." She called her son to come and look at the place, and when he agreed that it was a suitable location, they immediately set to work clearing the land.

Miss Lena attributed her decision to find a piece of land to settle on and work to divine inspiration and to her need as a poor mother to provide her children with the means to acquire their own homes. Shortly after she and her family began to clear the land, a mestizo man arrived with the police, claiming to be the owner of the property. Following her son's advice, Miss Lena went to the BBCIG to tell them what was going on and to see whether they would support her in her efforts. She describes the first meeting with Nora Newball and Dolene Miller.

> They look on we and we looking on them and well, everybody facing one another. She say, "What is oonu[5] problem?" I say, "Ay Miss Nora and Miss Dolene," I say. "We is here because we need a piece of land. And we went in a place there." She said, "Who send you all in there?" I say, "No one, is just the good spirit send us there because we needed a piece of land. That's what send us there." She say, "Oh my God," and she hug we up, and we was so happy until we cry. She say, "This is what I waiting on! To see some Black people come in and own something. Because the Spaniards them going finish it" . . . She said, "Okay, when them go to you now, you tell them show you they paper. As long as them do so with a paper, we going respect it."

When they returned to the land, the same man reappeared, insisting that they vacate the property. Miss Lena asked the BBCIG representatives to organize a meeting with the alleged owner. But when they requested that he show them his title to the land, Miss Lena said, "He couldn't show nothing. He no have papers, just he mouth. But then that's how Spaniard own things. . . . And we just keep on and they call the meeting and they no show no paper yet. *No paper yet.* So well we just keep on. We keep a working."

As I discuss in the next section, the practice among mestizo settlers—whether wealthy landowners, politicians, or landless farmers—of claiming ownership to properties to which they held no title remains a common strategy of land theft in Black and Indigenous communities. Miss Lena criticized how local state representatives defended the dubious property claims of individual mestizos and local institutions. Community members noted with some irony that rarely does the state respond when mestizos routinely squat on Black and Indigenous communal lands; yet when a group of organized Creoles occupied lands that are said to constitute part of their historical land claim, "they call the police" (León 2009b). This apparent double standard in the state's treatment of Creole and mestizo land occupation reveals the degree to which race continues to structure state practices of control and the regulation of citizenship on the coast. As shown by the responses of the state officials, mestizo claims to coastal lands have been and continue to be perceived as more legitimate than those of Black people precisely because mestizos' superior claims to full citizenship allow them to defend their rights to Nicaraguan lands as citizens who deserve the full benefits of state protection. So, there is a double irony: on the one hand, spatial and cultural strategies of control produce the coast, and Bluefields in particular, as the quintessential site of pathological Blackness—even though Creoles are now a minority in the region—yet Creole communities' historical claims to land and territory in the region are always construed as illegitimate.

Although the BBCIG was clear that the land occupation was a separate action from the larger process of communal land demarcation and titling, the women who participated in the occupation often linked the two by grounding their land claims within a larger regional genealogy of Creole land struggles. They viewed their efforts as a critical response to ongoing patterns of displacement by and conflict with the Nicaraguan state and its policy of facilitating mestizo settlement on the coast as part of a larger campaign to incorporate and assimilate the region into the mestizo nation-state. Reflecting on the land occupation some months later, Miss Lena discussed the action as rooted in a politics of refusal that she traced back to her grandfather's participation in the 1926 uprising against the state. She shared that her grandfather had been a member of the Twenty-Five Brave, a group of Creole soldiers led by General George Hodgson. As Gordon (1998) writes, the participation of the Twenty-Five Brave in the Constitutionalist War remains a salient part of Creole social memory of the community's historic struggle for autonomy. Miss Lena framed her own participation in the occupation within a broader politics of Creole militancy and regional resistance that underwrites contemporary Creole politics.

Many of the women who participated in the land occupation repeatedly referred to Creole peoples' historical rights to occupy these lands; they identified the 1894 Reincorporation, the state's subsequent occupation of their lands, and the current influx of mestizo settlers in the region as the key causes of their current displacement. This analysis clearly links their contemporary struggles for land to

the historical efforts of Mosquitian nationalists to regain the semi-sovereignty of the Mosquitia. Creole women activists and farmers rejected the national media's representations of the Bluefields land takeover as an illegal seizure of privately owned property, arguing that the lands are their birthright as coastal peoples whose land tenure predates the formation of the Nicaraguan nation-state. Thus, members of the BBCIG and the occupation participants continually shifted the burden of responsibility back to the state and asserted that they were acting in accordance with the law. They further argued that if the state had moved in a timely fashion to demarcate and title communal lands there would have been no need for them to occupy the land.

The struggle for land and resources in Bluefields reveals how the Nicaraguan state continues to privilege the needs of mestizo settlers while turning a blind eye to Black suffering and the persistent forms of structural inequality that alienate Creole and Indigenous communities from the promises of multicultural citizenship. Nevertheless, when Black communities and activists attempt to critique these forms of structural racism, they confront a range of official and popular discourses that obscure Black suffering and undermine the bases of their political demands. Creole activists have responded to these discourses by grounding their contemporary political practices and demands in a larger history of regional struggle and unfulfilled promises by the Nicaraguan state. These activists' historical intervention was challenged by the emergence of a new racial narrative that attacked the project of regional autonomy and multiculturalism as a system of reverse racism against mestizos.

"THEY DISCRIMINATE AGAINST US AS MESTIZOS": MESTIZO VICTIMHOOD AND THE GEOGRAPHY OF BLAME

In January 2010, less than two months after the land occupation began, a group of about 120 mestizo campesinos connected to the Junta Directiva Mestiza in Kukra River (León 2010), gathered at the Santa Rosa Bridge in Bluefields and marched through the city decrying what they alleged was the discriminatory nature of Law 445. These farmers were particularly outraged by the government's titling of the Bluefields territory, which they claimed contained hundreds of manzanas of land that belonged to 600 mestizo settlers (León 2010). Their outrage had no basis in fact, because the government did not officially title the Bluefields land claim until October 2016 (El 19 2016). Yet, angered by Law 445's law's apparently exclusive focus on Black and Indigenous communities, they marched through the town to demand its repeal.

One protestor explained his grievances with the law to a local mestiza journalist: "We have rights, too. We respect the rights of others but we have rights and the law does not include us." When asked whether he thought that Law 445 was a form of discrimination, the protestor responded emphatically: "We are being

discriminated as mestizos. They discriminate against us as mestizos. We are Nica-raguans and we have rights." He went on to say that the protestors came to Blue-fields to find a peaceful resolution to the problem and did not want to resort to violent means. Still, the way he phrased the protestors' intentions left considerable room for interpretation; it was unclear whether mestizo settlers would resort to violence as the titling and demarcation process moved forward.

I later learned that Francisco Sacasa, a *concejal* in the Regional Council affili-ated with the Constitutionalist Liberal Party (PLC), had not only paid many of these farmers to attend the march but had also provided them transportation to Bluefields. It was further alleged that Sacasa paid many of the protestors to occupy communal lands in areas where the government was planning to construct a high-way from Managua to Bluefields.[6] Still, although it would be easy to read the dem-onstration as an astro-turf protest designed to advance the political agenda of an unscrupulous politician, I suggest that the discourse emerging from it illustrates the vexed racial politics of land struggles on the coast.

As my fieldwork proceeded, I became increasingly aware of mestizo anxieties that communal land rights would leave them with nothing and place them in a position of subservience to Creole and Indigenous communities. Many mestizos who are occupying Black and Indigenous communal lands are among the poorest of the nation's poor. Traveling by *panga* through the region's serpentine water-ways, I would often see the homes of poor mestizo families precariously perched on riverbanks or eroding shorelines.[7] The desperate poverty in which these fami-lies lived was apparent, even when glimpsed momentarily from the back of a speeding boat. I recall wondering, *"How on earth does anyone survive out here?"* Yet there they were, eking out a living on the coastline or rivers' edges without access to social services, education, health care, or employment. Most of these settlers did not move to the coast because they perceived it as a particularly desirable place to live but because they needed land to survive, lacked the capital or access to capital to purchase property anywhere else, and the coast is the only place in the country where land can be had cheaply or for nothing at all. One of the central complaints that Creoles make about mestizo settlement in the region is that mes-tizo settlers view the region as *"tierra de nadie"*; that is, land that belongs to no one (PNUD 2005). The sense of impunity that characterized mestizo settlement in the region was exacerbated by the state's indifference to the illegal seizure of these communal lands. Creole residents and activists were aware that the state's failure to protect communal lands also undermined Black and Indigenous private property claims; I heard many stories of costeños who had lost their property and spent years in court fighting with mestizo settlers who had squatted on their land and refused to leave. What became apparent was that, despite their poverty, mestizo colonos felt empowered to settle on Black and Indigenous lands pre-cisely because they were aware that the state lacked the political will to remove them.

Another key challenge faced by Creole activists in obtaining communal land demarcation and titling is that the vast majority of mestizos in the region, and many Afro-descendant and Indigenous peoples as well, do not fully understand the historical justification for regional autonomy and communal land titling. The force of the law is undermined by the state's general unwillingness to comply with it, which has produced a climate in which mestizos have become increasingly more hostile to the land claims of these communities. Meanwhile, throughout the 1990s and the early 2000s, the Nicaraguan state—under several administrations— has facilitated mestizos' ignorance and lack of understanding, tacitly endorsing mestizo settlement in the region as a strategy for ensuring party loyalty and miti- gating class tensions between domestic elites and landless farmers. The geogra- pher Gerald Riverstone (2004, 62) argues that the ever-advancing agricultural frontier "has served as a 'political safety valve' that allows mounting social pressures from unequal development in Pacific Nicaragua to be absorbed by the sparsely inhabited Caribbean Coast region." The current land conflict is not the result of a national land shortage but rather is the product of intersecting factors, including the failures of agrarian land reform, neoliberal economic shifts that have displaced rural workers from their lands in the name of national development, and the re- concentration of land and wealth in the hands of the nation's traditional ruling class (Goett 2006; Riverstone 2004; Ruiz 2013). Rather than address the structural causes of land dispossession and displacement, the state has increasingly come to rely on the Caribbean Coast as a site for poor mestizos in the Pacific who have become the surplus labor of a neoliberal economy that has no use for them.

But the regional land grab has not only served the interests of the central gov- ernment and the nation's ruling class; it has also benefited corrupt regional politi- cians and elites who impeded the demarcation process when it came into conflict with their own interests. Creole activists often complained about Black and Indig- enous politicians, FLSN and PLC party functionaries, and influential local leaders who held contested properties in Black and Indigenous communal lands. They also pointed to government functionaries who privileged the demands of their political parties over those of their home communities by backing state-led devel- opment initiatives, natural resource concessions, and the dubious land claims of their political allies. Thus, Creole communities had to fight not only against the mestizo state but also against Black and Indigenous political figures who used their institutional power to undermine those land claims that did not serve their agenda.

Although the state historically advocated mestizo colonization using an explicit discourse of racial inferiority, cultural backwardness, and regional underdevelop- ment, contemporary state policy is enacted under the banner of multicultural nationalism. Studying the institutional processes by which the state has histori- cally facilitated mestizos' increased dominance and access to coastal lands and natural resources is critical for understanding how mestizo privilege as a racial project is (re)produced through seemingly race-neutral and invisible mechanisms

that continue to systematically undermine Creoles' land claims (Omi and Winant 1994). Analyzing this process through an ethnographic lens demonstrates "how privilege is created and sustained but protected from political critique" (Lipsitz 2006, 106).

During my fieldwork, I observed how mestizo political mobilization on the Caribbean Coast increasingly made use of a discourse of victimhood that positions them as the victims of discriminatory laws and state policies that privilege Black and Indigenous political demands. This narrative of mestizo victimhood foregrounds mestizos as worthy, legitimate citizens whose rights to equal protection under the law are threatened by Black and Indigenous claims for regional redress and the redistribution of land and resources that they have historically claimed. The narrative of mestizo victimhood does double work: it allows the state to turn a blind eye to Black suffering while also (re)producing the racial fiction that Creoles are in a structurally more advantageous position than mestizos. As Bonilla-Silva (2010) points out, racial privilege is not uniform; differences of class, gender, sexuality, education, and region determine the extent to which specific individuals benefit from race privilege. Nevertheless, it is clear that compared to Black and Indigenous communities, who are either ignored by the state or perceived as a perpetual threat to the nation, mestizos enjoy a level of structural privilege that allows them to occupy communal lands on the coast, transform them into private property, and profit from them with the implicit backing of the state.

One of the more pernicious aspects of the discourse of mestizo victimhood is the unstated but implicit assumption that mestizos are entitled to the region's lands and resources, a position that mestizos share across ideological and class differences. This sense of entitlement is a central component of how the logic of mestizo race privilege elides the legacy of internal colonialism and state-sponsored displacement of Afro-descendant and Indigenous communities. Mestizos on the coast engage in both explicit and implicit forms of identity politics to claim rights and privileges that are not encoded into law but are socially sanctioned and strengthened by the state's ambivalent stance on land demarcation and titling. This makes it possible to paint contemporary measures like the demarcation law and communal land titling as unfair policies that ignore mestizo aspirations for land and resources. I witnessed this historical amnesia in multiple spaces: NGO gatherings, presentations at regional universities, radio broadcasts, and daily conversations. Ironically, it was precisely the discourse of multiculturalism that many mestizo activists and intellectuals in the region deployed to cement their claims to coastal lands.

During a gathering held at the offices of the National Commission on Demarcation and Titling (CONADETI) and sponsored by the BBCIG, a well-known mestizo costeño politician affiliated with the FSLN gave a presentation on Law 445, in which he argued that the Autonomy Law recognized the multiethnic rights of all the region's various ethnic groups; given that mestizos were one of these ethnic groups, they too were guaranteed rights to land under the

law. He added that many mestizos "feel like costeños even if they are not born here." When I commented that these laws were not about mestizos' feelings of belonging and affinity for the cultural traditions of the coast but were rooted in a historical grievance that they were designed to remedy, he became visibly agitated and accused me of trying to invent an ethnic conflict on the coast that did not exist. I then asked him how he could make these claims when the language of Law 445 limits communal land claims to the region's Indigenous and ethnic communities; that is, to Afro-descendant communities that have historically occupied the region alongside Indigenous communities.[8] Under this law mestizos cannot legally be considered eligible for communal land titling, especially given that their patterns of land tenure have tended not to be communal but private. He dismissed my question, telling me that as a foreigner I misunderstood the law.

This incident illustrates the complex and sophisticated means by which mestizo identity politics has been reconstituted under the banner of multicultural recognition. Beginning in the early 2000s, mestizos in the region began to actively develop a discourse of identity politics to capitalize on the imagined benefits of multicultural citizenship reforms. This discourse turned into action in January 2010, just before the Sacasa-funded protest, when a group of mestizo settlers in the Kukra River area formed their own directive board to represent the interests of mestizo settlers in the territory; specifically, the directive boards are the executive branch of the region's local communal governments. Under Law 445, Afro-descendant and Indigenous communities are empowered to form their own communal governments and directive boards to represent the interests of their communities, advance their land claims, and after receiving title, regulate the development of natural resources. The Law 445 also grants communities the right to earn 25 percent of all income generated from the exploitation of the region's natural resources; the communal governments are responsible for receiving and managing the use and administration of that revenue, what Creole activists often referred to as the "25 percent." The law did not extend these rights to mestizo settlers. Yet, their interpretation of the law demonstrated how it could be manipulated in ways that undercut Black and Indigenous political demands.

Critical race theorists in the United States have pointed to the ways in which white people have historically attacked policies like affirmative action, which are designed to redress racial inequality, as forms of reverse discrimination that harm them. Liberals and conservatives alike have argued that the only way to address racism is to espouse an ideology of race neutrality that treats all people as individuals and ignores racial difference. Although in theory this idea appears to promote racial equality, in practice it reinforces white supremacy by reducing racism to individual intentions and interpersonal interactions and ignoring the ways that historical and ongoing patterns of structural racism determine nonwhite people's access to resources and opportunity. In the case of Nicaragua, the state's marginalization of the Caribbean Coast has historically been linked to ideas of the region as a site of racial alterity, underdevelopment, and primitive Indigenous cultures in

need of Hispanic civilization. Although contemporary racial discourse tends not to use the rhetoric of classic Latin American racism, the region continues to be imagined as a primitive space, inhabited by culturally backward communities unable to realize the area's economic potential.

By focusing only on those forms of racial discrimination that take place at the level of lived experience or interpersonal relationships, mestizos are unable to see their own racial privilege vis-à-vis Black and Indigenous peoples. Ignorant of their country's history and empowered by a deep sense of entitlement, mestizos use the discourse of victimhood to argue that they should be entitled to the same kinds of multicultural citizenship rights that Black and Indigenous communities enjoy while disregarding the historical processes of structural violence, racism, and economic exploitation that necessitated those reforms. Widespread ignorance of the unequal relationship that historically existed between coastal communities and the mestizo nation-state shapes the discourse of mestizo victimhood and promotes the idea that Black and Indigenous peoples are discriminating against poor mestizos by refusing to share what are considered to be special privileges. Not being able to access these rights and the resources that they are imagined to confer is seen as a violation of their rights as legitimate national subjects. By bypassing the historical bases of these laws, mestizos create a discursive space in which they can mobilize the language of reverse discrimination to further delegitimize Black land claims while strengthening their own structurally privileged position.

Juliet Hooker's work (2005b, 2009) on the uneven effects of multicultural citizenship reforms provides a useful entry into understanding the formation and logic of contemporary multicultural racisms in Latin America. The narrative of mestizo victimhood is possible in this current historical moment because of how multiculturalism in Nicaragua tends to reduce unequal racialized/regionalized relations of power to folkloric cultural difference. In this context, racism is abstracted from its structural and ideological moorings and liberalized so that one can speak of discrimination only in highly individualized and personalized terms. This move also elides the structural ways in which mestizos continue, borrowing from George Lipsitz, to benefit from identity politics. It is clear that the recognition of cultural difference alone does not necessarily lead to racial justice. Rather a multicultural politics that privileges cultural difference over strategies for redressing systematic racial inequality can overlook ongoing processes of racial inequality that are rendered illegible by the discourse of multicultural difference (Hooker 2005b). In his work on race and incarceration in the United States, Dylan Rodriguez (2006) defines whiteness as synonymous with "collective entitlement to ownership." This definition suggests that "when nonwhites threaten, attack, or steal the common property of white civil society, they are actually violating the sanctified materiality, and the vicarious and deeply valued collective bodily integrity, of whiteness. Multiculturalism is, in this sense, a keystone for the rearticulation of white supremacy as a simultaneously (and often contradictory) incorporative and exclusionary regime of social ordering" (28).

As the dominant racial group in Nicaragua, mestizos enact a similar form of racialized collective entitlement. Multiculturalism in this context has evolved as a project of mestizo re-entrenchment that has not unsettled the normative property rights of mestizo citizens. These commonsense ideas of normative citizenship underwrite mestizos' right to defend their collective entitlement to various forms of property by whatever means necessary, including violence. During the January 2010 campesino march in Bluefields, Pedro Sarantes, secretary of the illegal mestizo directive board, stated that, although the march was a peaceful event, what would follow if the government allowed Law 445 to stand might not be: "If there is not a peaceful response to the problem that also benefits the 600 people that have property titles, well, perhaps there will be violence. The organizing committee will not be able to stop the people" (León 2010). This response reveals the lengths to which structurally powerful groups will go to maintain their position of privilege in the face of grassroots efforts to dismantle those inequalities. It also demonstrates how mestizo racial privilege is configured as a kind of zero-sum game in which mestizo structural power is directly the inverse of Black and Indigenous structural power; that is, when Black and Indigenous people "win" any political concessions, they do so only by diminishing the citizenship rights and political power of mestizos.

The discourse of mestizo victimhood relies on and reproduces what the medical anthropologist Paul Farmer (1992) refers to as the "geography of blame," which holds that social redress and racial justice for the region's Afro-descendant and Indigenous communities marginalize poor mestizos whose presence on the coast is driven by their need for land and livelihood. The trope of the industrious, long-suffering campesino is deployed as a counter-narrative that reifies racialized discourses of Creoles as lazy, opportunistic, and duplicitous quasi-citizens whose demands for land are not grounded in meaningful political grievances. Following Hooker's lead, I extend her argument and suggest that the narrative of mestizo victimhood as a central ideological component of the geography of blame is premised on a simple equation: the fulfillment of Black and Indigenous collective rights under the multicultural order lessens the individual rights of mestizos to enjoy the full benefits of normative citizenship.

My point is not to dismiss the legitimate needs of impoverished mestizos; as I show in the next section, Creole women activists often expressed a deep empathy for poor mestizos' needs for land and livelihood while criticizing how powerful mestizo politicians and social elites have manipulated the fears of the mestizo poor to foment hostility between mestizo settlers and Black and Indigenous communities. Rather, my aim is to highlight how mestizos' economically vulnerable position is often used as the pretext to justify the assault on Creole land rights, which reduces possibilities for cross-racial solidarity that would serve both communities. Mestizo poverty is real. But it is telling that these settlers do not occupy the lands of wealthy mestizo landowners or corporations in the Pacific but squat on the land of people who structurally are more vulnerable than they are. Rather

than challenge the state for its consistent inability to meet the needs of its citizens and fulfill the promise of agrarian land reform and the redistribution of property, mestizos are encouraged by the state's ambivalence to lay the blame for their problems on Black and Indigenous communities that are seen as recalcitrant and as refusing to share the benefits of multicultural citizenship reforms with their mestizo neighbors. Mestizos then perceive that the conflict for land, resources, and power is not produced by the state's anemic response to Black and Indigenous land claims but is the result of Black political wrangling and self-interest.

Mapping the geography of blame—the institutional practices, racial narratives, and collective actions that mestizos engage in to shore up racial privilege and undermine Black and Indigenous projects for self-determination—illuminates how more structurally powerful actors simultaneously shift the burden of blame to more marginalized political actors, erase historical patterns of exclusion, and absolve the state of entrenched patterns of negligence and exploitation. The path of broken treaties and broken promises, forcible land displacement, external corporate exploitation, internal colonization policies, and the present surge in mestizo settlement has led to a situation that is untenable for the survival of Black and Indigenous communities. The logic of the geography of blame allows mestizos to elide the significance of these historical processes that have excluded the non-mestizo Other from the benefits of citizenship. This move ultimately absolves the mestizo nation-state of responsibility for the persistent challenge of racial and economic inequality in the region while ostensibly embracing the values and policies of a multicultural, pluriethnic, liberal democratic state. Using this logic, mestizo political actors position Creoles as the central antagonists in the struggle for land in the city of Bluefield and focus their political energy on dismantling the legal framework that supports Black and Indigenous communal land claims. Creole women land activists, however, hold a radically different perspective on the roots of the region's pervasive poverty and offer a vision of racial justice and regional solidarity that recognizes the justifiable economic needs of mestizos for land and resources while maintaining the historical and political legitimacy of Creole land claims. It is to this analysis that I now turn.

SITUATED KNOWLEDGES: CREOLE WOMEN'S COUNTER-GEOGRAPHIES

The Bluefields Black-Creole Indigenous Government is housed in a hot, cramped office on the second floor of the CONADETI-CIDT building, a whitewashed, two-story concrete structure that sits on the corner where three neighborhoods meet. Although the official function of the BBCIG is to represent the political interests of the Creole community in Bluefields, it has become a significant player in regional and national politics, most notably because of its explicitly denunciatory critiques of the central government, the manipulative influence of the national political parties, and the pervasive corruption of the regional government. Since its

formation in 2004, the BBCIG has struggled to advance its mission despite the chronic lack of state funding and support from coastal civil society and external donors, as well as limited access to material resources; nevertheless, it has become a critical site of Creole organizing in the city. Indeed, this government agency is one of the few institutions designed to respond to the political demands of the city's Creole community; it is often the only place where Creoles can articulate their concerns or solicit support for local efforts to strengthen their political power in the region. Despite its small size, the office constantly hums with activity as people stream in and out to talk to Nora and Dolene about what is taking place in their neighborhoods, request their assistance to secure funding for community events and programs, or seek support and advice about property disputes in and around the city. I spent many afternoons in the BBCIG office observing and participating in heated conversations with community members as they described problems in their neighborhoods, property disputes with mestizos, and related concerns around police abuse, crime and insecurity, and the lack of economic opportunity in the city.

I visited the office one afternoon to discuss the land occupation with Nora and Dolene, who had both played an active role in supporting it by acting as mediators between the municipal and regional governments and the community members participating in the occupation. From their perspective, the land occupation was a direct result of Creoles' growing frustration and disappointment with the state's promises to demarcate and title their communal lands. It was an expression of Creole people's deepening sense of anxiety over the shaky status of their communal land claims. From its beginning, BBCIG activists insisted that the occupation should be read as a response to the state's ongoing indifference to the political demands of Black communities.

During our conversation, Dolene and Nora repeatedly emphasized that the 1987 multicultural citizenship reforms and Law 445 had not come about as a result of state benevolence but were the result of years of struggle and confrontation. By foregrounding Black and Indigenous peoples' political agency, Nora and Dolene also disrupted the geography of blame by challenging the idea that they are the privileged recipients of state largesse, rather than political actors who have forced the state to make certain legal concessions through struggle and advocacy. However, that struggle continues because, even though the state created the legal framework for communal land demarcation and titling, this process proceeded extremely slowly. Dolene suggested that this lethargic response reflected the state's ambivalence toward the process and made it appear that Black and Indigenous communities were antagonizing the state when they insisted that the process move forward. She told me,

> So, we are saying if the law gives rights to everyone, if the law tells us how to go about it, then why we are not working toward it? Why it seems like it is the Communal Government fighting against the state? Why it look like if we are the bad one

instead of the state coming in? Because those are the national authorities. We have sent enough documents to the National Assembly, to the President of the country, to the General Attorney—those who have to do with these things. And we haven't gotten one answer. Is it because we are not important to them? Or is it because politically they don't want to address it? Or is it because we have right in our claim? We no know. But at least they should have the decency to answer this group of people who are just asking and also demanding because we have requested in all different forms so we can sit down and work this thing out in a better way. . . . Because it's not that you are going to fight against the state, it's not that you going to fight against the Spaniard—they are majority, it doesn't make any sense to fight—but they also have to understand and respect the rights of the people. Nobody's going to move them. But they have to understand if they do not have a [title], they would have to sit down with the communities and see how we can recognize their responsibility toward taking care of what is there.

Dolene and Nora's analysis reflected their understanding of how historical patterns of uneven economic development and contemporary processes of neoliberal capitalism increased mestizo migration to the region, thereby creating the conditions for the current land conflict. They argued that the issue is not simply a matter of addressing the economic roots of mestizo migration and the usurpation of communal lands but also identifying the state's role in this process. Dolene stated, "We are not against Spaniard. What we are against is the policy of the state to occupy and colonize the Atlantic Coast."

They also pointed to the ways that the national elites and regional politicians manipulate poor mestizos by suggesting that were Black and Indigenous communities to realize their political aspirations for land and meaningful self-governance, then poor mestizos would be left with nothing. But this is only part of the challenge; Hooker (2010, 269) argues that mestizos also reject "the prospect that Black and Indigenous costeños will wield political power over mestizos," because it goes against "long-standing ideas about who is entitled to exercise political power in Nicaragua." Their fear of losing political power to Creoles and Indigenous people and their investment in maintaining their own racial privilege and political dominance prevent mestizos from forming alliances with Creoles and Indigenous peoples based on their shared identity as costeños and poor people, according to Nora. Such an alliance would offer an opportunity for these communities to collectively confront the uneven development of the country and address the ways that the coast remains on the margins of the nation-state. Nora and Dolene pointed to the fact that Law 445 guarantees the communities 25 percent of all revenue generated through the exploitation of natural resources within their territory. Nora told me,

That's why I said, I cannot understand, you know, why, especially the mestizos costeños don't find a way, you know, to come together and join with us. Because we can't give away our rights. They have to understand that *we* have rights and come

together with us for all of us to get benefit out of it. You understand what I mean? If I give away my rights and I say, "Okay, cause I too little bit and you is plenty high you take it," you not going get nothing out of it. It going be just a dead land there. But then if I come with you and I say, "Okay, you have the rights to claim the territory and because of you have the rights you claim them, and I going get benefit because that's the 25 percent what the law give me."

Dolene echoed her comments: "If you invest your 25 percent in bettering your community, everybody gets benefit. It's not only for the Black people."

Mestizo efforts to form their own directive board in the Kukra River area and to create a separate department in the South Atlantic Autonomous Region in areas where they are the majority—rather than consider forming alliances with the legally established Black and Indigenous communal boards—reflect the anxieties that surround the possibility of Creole and Indigenous governance in the region: these efforts are also driven by the sense of entitlement that mestizos have to political power. Mestizos have historically rejected the possibility of Blacks exercising political power in the region because, as one mestizo settler claimed, "Blacks cannot govern us because they do not think as we do" (Hooker 2010, 269).

BBCIG activists argue that the state has reinforced the narrative of mestizo victimhood by stoking fears among them that demarcation benefits Black and Indigenous peoples at their expense. They point to the fact that the demarcation law calls for a process of *saneamiento* that provides a means of addressing the legitimate private property claims of mestizo settlers who settled in communal territories prior to passage of the law. The state has failed to educate mestizo residents about how the law also recognizes private property and provides mechanisms for land-leasing options that would protect mestizo farmers from losing access to land. Dolene argued,

> The best way of working out a solution on the problem is through dialogue, mediation, and consensus and that is the principle also of the law. Why it is so difficult? Because people are afraid. They believe that they are not going to get anything but then the state haven't told them, haven't even explained to them the context of this law for the Atlantic Coast. What they have done is like put them against the minority. So you see, you have the state against the communal government and now you have the population, the Spaniard, against the minority.
>
> We also make an example: we cannot go to the Pacific and take a piece of land because we need and because we poor. We cannot do it.

Another of the many challenges that Nora and Dolene faced in their work as land rights activists was the perception by local politicians and even many sectors of the Creole community that they were too extreme in their defense of Black communal land rights. During the 2009 land occupation, for example, many people shared with me their belief that Nora and Dolene had instigated the land

takeover as a way of forcing the government's hand. Yet when I spoke with those who started the occupation, they consistently denied that Nora, Dolene, or any members of the BBCIG had any prior knowledge of the action. The size of the protest that followed local police efforts to dislodge the occupants far exceeded any of the modest protests that the BBCIG had previously organized. BBCIG activists responded to these critiques by arguing that, although they had not led the occupation. they actively supported the community in its efforts to compel the state to comply with its own laws. Dolene shared,

> So, I mean, what can be done? People are saying, "Oh because you all are too radical in your way of thinking, you all are too strong in pointing out your position." We ask, what is the best way to do this when you have a law? When the Constitution protects you? When you have an autonomy process? What is the best way? When people doesn't want to hear you? Or people just put you aside because you are not in the line of the politics? What you must do? The only thing left is to continue stressing on the rights of the people, and that's what we have been doing, stressing on our rights; stressing on the importance for everyone to be part of the process so we can do things the better way. And people might think say that Black people are not suffering. We are suffering. Because we are not out there begging, they might think say you don't need. Or they might think say we are too proud. And if you are a political leader you would go down side, down inside the mud and the grassroots so you can *see* exactly what's taking place. And it's awful. It's ugly. Our people have to leave families to go outside to feed their people, because jobs are not here.

As stated previously, many poor mestizos perceive Creoles' ability to work outside the country and earn wages in U.S. dollars as an advantage that mestizos do not have in the region. But Dolene argued that Creoles' comparative advantage in the labor migration market obscures how the community has suffered from ongoing state neglect. The deepening pattern of outward labor migration has serious implications for the future of Creole land politics and the social stability of the community. Dolene's analysis demonstrates how the lack of employment opportunities in the region forces Creoles out of the country, which has the effect of weakening their political power as the number of Creoles living in the country continues to shrink:

> We don't have any jobs. The fishing is a problem. The resources are being exploited. . . . And some that try to make agriculture barely for subsistence is not even enough to give them a living when we used to export to the Caribbean. The economy for us was agriculture—banana, then come mining, then come forest, then come fishing. We still supporting the national budget with a high percentage of resources, and how much is being invested back to us? And then what happen? Our Creole people have to leave and while we leave, the Spaniard come in. That is not a racial problem, is a thing of opportunity because they are starving, *too*. It's not their fault; it's public policy.

Dolene's careful reading of the extreme poverty that compels mestizos from the Pacific to migrate to the Caribbean Coast and settle on communal lands stems from an awareness that the life chances of mestizos are determined by the same economic processes that force Creoles to leave the country to work in low-wage, low-skill jobs, which nevertheless are propping up the regional economy through the steady stream of remittances. Responding to Dolene's observations about the economic forces that drive mestizo settlement on the coast, Nora pointed out that when mestizos migrate to the region they "come with a lift," which is to say that the state facilitates mestizo settlement not only by turning a blind eye to their usurpation of communal lands but also by providing them with access to aid programs funded by the state and transnational philanthropic organizations that are often not available to Black communities, which are assumed not to need these forms of assistance. Here is an excerpt of their conversation

NORA: But when them come in, them come in with a lift.
DOLENE: With a lift—*exactly*! Back up by the state.
CM: And that's the race part.
DOLENE: Right, because they feel they are supported by the state.
NORA: When they come in they come in with a lift. They come in with—I mean, look
 now, a basket of vegetable is a lift. You understand? Of whatever—plantation, pro-
 grams and things like that are there for them.

BBCIG activists criticize the state's strategy of pitting mestizos against Black communities trying to access the benefits promised to them under Law 28 and Law 445 while simultaneously obscuring its responsibility for the regional land conflict. They argue that the state encourages mestizos to "go against the Black" by perpetuating the idea that the fulfillment of Creole land claims will have an adverse impact on the economic opportunities available to mestizos in the region. This strategy effectively shifts the burden of blame to Black communities and conceals how the state continues to undermine Creole land claims even as it professes to recognize their multicultural rights. It also encourages mestizos to remain invested in the maintenance of their racial privilege while continuing to exploit the region's lands and resources in ways that will ultimately harm all the region's inhabitants through the loss of land, extensive environmental degradation, and the flow of wealth and resources out of the region. Lipsitz's (2006) critique of the possessive investment in whiteness in the United States is applicable here—in many ways, the state manipulates poor mestizos' aspirations for economic advancement and fears of Creole dominance in the region in ways that limit their ability to recognize how the state engages in projects of neoliberal economic development that reproduce structures of class inequality that continue to marginalize them. In other words, as long as mestizos remain wedded to the racial project of mestizo victimhood and the geography of blame, they will be unable to address the disproportionate

impacts of neoliberal capitalism on their lives and hold the state accountable for its role in this process.

Donna Haraway (1988) developed the concept of "situated knowledges" to discuss how social location shapes the process of knowledge production and the way in which groups who are differentially located in racial, gendered, and classed structures of power understand the social order in which they live. These situated knowledges are necessarily partial because what one sees is conditioned by one's location. This partial vision, however, does not mean that one cannot understand forms of knowledge that emerge from social locations different from one's own; instead, being aware of the "rootedness" of one's political vision creates possibilities for dialogue, solidarity, and mutual recognition. This awareness enables one to make specific knowledge claims that are grounded in a critical understanding of the broader processes that structure unequal relationships of power between different communities while also insisting on the partial nature of all knowledge claims. Haraway states, "We seek those ruled by partial sight and limited voice— not partiality for its own sake but, rather for the sake of the connections and unexpected openings situated knowledges make possible" (590).

I argue that Creole women's analysis of the racial dimensions of contemporary land politics offers such an "unexpected opening" for rethinking hegemonic state and popular remedies for the region's increasingly volatile land conflict. They reject the geography of blame as an "irresponsible knowledge claim" because it relies on an ahistorical representation of Creole political aspirations and obfuscates the structural processes that privilege mestizo political demands in the region (Haraway 1988). Drawing from the work of community activists like Miss Lena and the representatives of the BBCIG, I argue that Creole women's analysis of the state's role in the contemporary land struggle is rooted in their social position as mothers, activists, and workers whose racial, gender, and class positions place them outside the structures of power that shape politics on the regional level. Their community activism is focused on transforming these structures and creating spaces for racial and regional justice that are inclusive enough to address their needs as Black women, as well as those that affect the region in general. Moreover, they refuse to be placed into a competitive geography of blame that pits Blacks and mestizos against one another in the struggle for land and resources without interrogating the larger processes that determine the unequal distribution of resources and opportunity in the region. Instead, these women argue that the state has the capacity to redress the historical demands of Afro-descendant communities and simultaneously address the very real economic concerns of poor mestizos in the region.

Creole women's situated knowledge provides a useful lens for understanding the failure of the neoliberal multicultural project in Nicaragua to transform historical and ongoing patterns of racial and economic inequality on the coast. Their experiences of racial alterity and economic marginality shape their vision in ways that allow them to apprehend how power and privilege function structurally in ways that systematically

exclude Black and Indigenous peoples from the national body politic while simulta-
neously reaffirming mestizo racial privilege and state power. Rather than simply
focusing on regional conflicts between mestizo settlers and Black and Indigenous
communities, their analysis exposes how seemingly local political struggles both
shape and are shaped by larger national and transnational economic and political pro-
cesses (Harcourt and Escobar 2005). Creole women's insistence that historical pat-
terns of economic exploitation, the movement of transnational capital through the
region via North American corporations, and the state's policy of capitalizing on
the region's natural resources to enrich national elites inform their partial perspectives
on power and inequality, which are reflected in their rejection of the geography of
blame and the discourse of mestizo victimhood.

Haraway (1988, 583) argues that situated knowledges "produce maps of con-
sciousness" that directly challenge the "irresponsible knowledge claims" of the
powerful who attempt to (re)create the world in their own image and erase other
ways of seeing that challenge these naturalized mappings of the social world. This
creates the space to develop counter-geographies that radically challenge the ideo-
logical premises on which these unequal social maps, which normalize the domi-
nance of certain groups and the subordination of other groups, are based. Following
Haraway, I suggest that Creole women's situated knowledges reorient the geogra-
phy of blame by insisting on naming the relations of power that produce these
unequal spatial relations between Creole communities, mestizo settlers, and the
mestizo nation-state. Their partial perspectives demonstrate the ways in which
the geography of blame relies on an ahistorical, uncritical reading of conflicts over
land and resources, Creoles' contemporary political demands, and the rights of
these communities to territory and collective self-determination.

Rather than attempting to place all the blame on mestizo settlers, who may
occupy a structurally privileged position vis-à-vis Black and Indigenous commu-
nities but still live in conditions of intense poverty, Creole women focus their
analysis on the institutions and structural processes that marginalize Black land
claims. Their analysis suggests that there is a way to create more just geographies
that address the challenges confronting the region's diverse communities while
advancing a project of racial and regional justice that recognizes the historical
rights of Afro-descendant and Indigenous communities to the lands they have his-
torically occupied. These alternative visions of social justice destabilize the racial-
ized geography of blame and the narrative of mestizo victimhood and offer
"unexpected openings" in the struggle for land and resources on the coast.

CONCLUSION: FROM THE GEOGRAPHY OF
BLAME TO THE GEOGRAPHY OF SOLIDARITY?

In this chapter, I argued that Black women push back against official and quotid-
ian efforts to invalidate Creole communal land claims in the city of Bluefields by
challenging the narrative of mestizo victimhood and reverse discrimination, on

the one hand, and discourses of Black deviance, criminality, and cultural pathology, on the other hand, that dehistoricize their contemporary struggles for land rights and full citizenship. I explored the 2009 land occupation in Bluefields and the subsequent community mobilization that emerged from it as a key moment in which Black women activists articulated their critiques of the state and the unfulfilled promises of multicultural reform as demonstrated by the ongoing failure to demarcate and title the Bluefields land claim. Most importantly, however, they pointed to the often veiled and implicit ways in which the state undermines Creole land claims, facilitates their continued displacement, and naturalizes the growing encroachment of landless mestizos on these communal lands while continuing to affirm the rhetoric of multicultural citizenship. These women articulated a clear understanding of the role of the state in facilitating mestizo encroachment on Creole communal lands.

Creole women deployed historical narratives of regional resistance and refashioned them to articulate their needs as mothers, laborers, and community organizers. These women's participation and leadership roles in the land occupation reflected how the politics of place inform their community-based activism and suggests that one of the central ways that Creole women organize against anti-Black racism is by laying claim to the city and insisting on their historical and moral right to occupy these lands. Creole women's articulation of land being connected to their work as mothers, farmers, and citizens demonstrated their attempts to create their own counter-geography that brought their political concerns and demands to the center of the analysis of contemporary land struggles (Sassen 2000). This marked a profound shift in the discourse of land politics, which has tended to be gender neutral and articulated largely through the language of cultural difference and place, rather than incorporating a critical gender perspective. As Katherine McKittrick (2006, xix) reminds us, "The ways in which Black women think, write, and negotiate their surroundings are intermingled with place-based critiques, or respatializations. . . . One way to contend with unjust and uneven human/inhuman categorizations is to think about, and perhaps employ, the alternative geographic formulations that subaltern communities advance." Creole women's gendered articulation of land politics during the 2009 occupation offered such an "alternative geographic formulation" for enacting justice and legitimizing Creole land claims.

Finally, Black women pushed back against racist discourses of Black criminality and illegitimate citizenship by rooting themselves in a regional tradition of insurgent struggles to reconstruct regional autonomy following Reincorporation. This allowed these community activists to historicize their current land claims, refute accusations of political opportunism, and critique mestizo narratives of victimhood that ignore the systematic discrimination that Black communities on the coast continue to suffer. Additionally, they leveraged their demands by deploying their "moral capital" as mothers, community caregivers, and farmers (Goett 2006). This gendered reading of the social meanings and material concerns that

inform contemporary Creole land politics reflects the ways that Creole women offer a more inclusive vision of political struggle; this vision provides a radical alternative to the geography of blame by insisting on political analyses and solutions that get to the historical roots of the regional land grab and expose the structural processes that (re)produce friction between mestizos and Creoles in the region.

In this way, Creole women's grassroots political analysis created openings for moving beyond a geography of blame to one of political solidarity that is attentive to the political concerns of the region's diverse communities. This solidarity is not premised on the folkloric celebration of multicultural difference but instead insists on the capacity of visions of racial justice to create more equitable social arrangements for all people. Given the extent to which racial difference and inequality produce the coast as an abject landscape on the periphery of the mestizo nation-state, investing in a project of racial justice would by necessity entail addressing the rampant economic inequalities in all coastal communities. But engaging in a regional politics of multiracial solidarity requires that mestizos divest from the project of racial privilege and recognize how their political futures are fundamentally tied to those of Black and Indigenous communities.

In 2009, when Black women activists began to offer this geography of solidarity as an alternative political vision to the divide-and-conquer strategies of the state, the conditions were not yet right to operationalize this vision. But as the Ortega administration pursued a model of centralized, extractivist development, it created new openings for previously unimaginable political solidarities that brought Black and Indigenous struggles for communal land rights from the margins to the center of Nicaraguan political debate. In the process, Black women activists would assert a new role not only as regional advocates but also as leading figures in the struggle against the authoritarian turn.

PART 3 RESISTING STATE VIOLENCE

5 · "SEE HOW DE BLOOD DEY RUN"

Sexual Violence, Silence, and the Politics of Intimate Solidarity

Come down, Brother Will, come down/ Come see what the man have done/ Grab up the knife/ Stab up he wife/ See how the blood dey run.
—Traditional May Pole song

In May 2009 two French women working with blueEnergy, a local environmental NGO, were raped and assaulted on the beach in the small community of El Bluff. The two women had gone to the empty beach in the late morning for a swim. They changed into their bathing suits, left their belongings on the shore, and waded out into the warm Caribbean waters. It was not until they were some distance out that they saw a Creole man take off down the beach with their things; they swam quickly ashore and chased after him into the dense brush west of the beach. When they caught up with him, he turned around, machete in hand, and ordered them to remove their clothes. He then raped one of the women and sexually assaulted the other.

Within days, news of the sexual assaults had spread throughout the region's NGO grapevine and was discussed frequently on various radio programs. In the weeks after the attacks, I closely followed the developments around the case. I spoke with volunteers and staff at blueEnergy and listened to the news reports waiting to hear progress on the case. Before year's end, the National Police apprehended the assailant. What the news reports failed to reveal was the tremendous amount of institutional power, personal connections, and state resources that were mobilized to track down and capture the rapist. The director of blueEnergy tapped into his personal contacts in Nicaragua's large network of NGOs and the government to help the police investigate the crime. He was able to enlist the support of colleagues and friends with deep connections to the Sandinista elite who were able to focus the state's attention on the rape. The French Embassy stepped in to support the victims and assist the Nicaraguan government in its investigation.

Aminta Granera, head of the National Police, sent detectives from the capital to investigate the case, with the admonition not to return until they had a suspect in custody.

The uncharacteristic speed with which the state responded, resulting in the capture and trial of the assailant, was striking; particularly since the vast majority of sexual assault cases never go to trial at all. It was all the more remarkable given that sexual violence is an all too common part of many women's lives in Nicaragua. It indicated that, out of a desire not to lose face in the international community, the Nicaraguan government was willing to seek forms of redress for the white, foreign victims of the Bluff rape that it rarely provides to its own female citizens. What made the Bluff case exceptional was not the violence itself but rather the identity of the victims, whose whiteness made their violation and suffering immediately legible to the state in a way that is only rarely the case for Black women.[1]

As the epigraph to this chapter suggests, violence against Black women is ordinary, the stuff of popular calypsos and May Pole songs. Sexual violence is an open secret; its frequent occurrence is common knowledge within the community. Yet Creoles rarely organize publicly to address it. If it is so common, why does it remain largely invisible in public discourse? The Bluff rape and the state's response to it created an opportunity to think through the racial dimensions of sexual violence against women in Nicaragua and to explore why violence against white foreigners and mestizas is so much more visible than pervasive patterns of everyday sexual violence against Afro-Nicaraguan women. It prompted several critical questions: How are these forms of violence made (in)visible in the public sphere? How are multiple publics socialized to read Black female suffering? And finally, how do Black women respond to these misreadings, and how does that shape their political subjectivity?

I argue that Black women have historically refused to participate in larger debates on sexual violence taking place in Nicaragua because they recognize that, unlike the two French women who were raped at the Bluff or mestizas who regularly appear on nightly news programs to denounce abusive spouses and partners, Black women are not seen as legitimate victims whose experiences of violence need to be addressed by the mestizo nation-state. As members of a community whose claims to citizenship and national belonging are perceived by the mestizo nation as being, at best, tenuous, and, at worst, fictitious, there is little empathy for their stories of violence and sexual exploitation. Because their experiences of sexual violence remain largely invisible or illegible in the public sphere, Black women have a limited ability to disrupt what Rebecca Wanzo (2009, 6) refers to as "the sentimental logic that determines which citizens deserve sympathy."

Sympathy as a public emotion is often imagined as a self-evident, human response to the suffering of others, but as many scholars have noted, there is nothing natural or transparent about how sympathy is allocated in the public sphere or why particular kinds of narratives of suffering garner more attention than others. Thus, we must contend with "the problematic economy of value [that determines]

who gets to mobilize affect" and the complex ways in which race, region, class, and gender shape responses to Black women's experiences of sexual violence (Wanzo 2009, 6). As Wanzo's analysis suggests, we must attend to the cultural reading practices that govern how stories of gendered suffering and violation are interpreted by various publics, including state institutions, feminist social movements, and local Afro-descendant communities on the coast. These cultural logics reveal that the ability to lay claim to legitimate victim status is one that is fraught with historical narratives of racial and sexual difference that too often position Black women as illegitimate and illegible victims.

Since the 1990s, the mainstream women's and feminist movements in Nicaragua have attempted to combat gender violence by urging women to "break the silence" around this issue, demonstrating how these activists have appropriated transnational women's human rights discourse to advance local political projects. Most of the feminist literature on sexual violence in Nicaragua, however, has focused largely on the Pacific and failed to consider how this phenomenon unfolds on the Caribbean Coast. Those studies that do have tended to explain patterns of sexual violence in coastal communities by attributing them to "the culture of silence" that pervades the costeño discourse on sexuality. This explanation has become a form of political commonsense in national and regional feminist literature on violence against women on the coast. During my fieldwork in Bluefields, NGO activists and state representatives often lamented this pervasive culture of silence.[2] They interpreted Black women's refusal to speak publicly about their experiences of gender violence as an indication that they were both indifferent and accustomed to it and lacked the kinds of feminist consciousness that would enable them to mobilize against it.

Yet, in my conversations with activists and female community members, I found that Black women had a great deal to say about sexual violence even if those interventions never made their way into police reports or transnational legal arenas. They shared those stories with me in kitchens or while sitting on the verandah catching a breeze, shouting over beers at a bar, or whispering over coffee in the living room while their children played outside. They shared stories of teachers exchanging good grades and scholarship opportunities for sex from female students. They spoke of elderly men living with their granddaughters as wives and of rural families who relied on the income that their underage daughters earned from sex work. Gossip and women's collective memory served as the archive for those incidents of gender violence that occurred in the barrios of Bluefields, the rural communities located north and south of the city, and in schools and universities and that could not be publicly spoken. This informal archive demonstrates that even though Black women have not historically mobilized politically to end this violence, neither have they been willing to let the memory of that violence disappear.

The National Police never came to these communities with the order that they were not to leave until the assailant was found and brought to justice. No foreign embassies mobilized their resources to see that these women's rapists would be

prosecuted. No well-connected NGOs came to the rescue to ensure that these crimes would be resolved. Most of these crimes remain in the realm of hearsay because the state has not provided sufficient resources to investigate them and Black women remain wary of the state's willingness to pursue justice on their behalf.

The circulation of these stories in private spaces reveals that, far from being ignorant about the prevalence of gender violence, Creole women are "engaged in everyday acts of theorizing about their lives, experiences, and struggles" (Oparah 1998, 3). Yet this analysis rarely finds its way into activist and scholarly research on violence against women on the coast. This suggests a need to reconsider the culture of silence narrative. Silence does not equal an absence of the kinds of critical gender consciousness that are considered an essential tool in broader political efforts to end sexual violence against women and children. Silence is a particular kind of public story that requires more substantive theorization.

This chapter examines the consequences of the widespread public investment in the culture of silence narrative. It is a narrative that obscures as much as it reveals and relies on a caricatured reading of Black social life in the region that strips Black women of political agency. To understand why the culture of silence has become the framing public narrative for sexual violence in the region, it is necessary to identify and analyze the kinds of narratives that circulate in the public sphere about sexual violence and Black women's experiences of suffering. This requires examining both the racial narratives produced by the larger mestizo nation about Black women's non-normative sexuality and the counternarrative of inviolable strength that Black women have created to disrupt these controlling images (Hill Collins 2000; Harris-Perry 2011). I demonstrate how these dual narratives produce a kind of representational illegibility that makes it difficult for Black women to name their suffering in ways that are legible to broader social publics. The culture of silence narrative elides the ways that Black women strategically move between modes of silence and speech to navigate the fraught discursive terrain of sexual politics and attempt to make their claims in spaces where their experiences of social suffering can be rendered legible. In the absence of equal access to justice and state protection, Black women have begun to create their own public spaces for resisting everyday sexual violence and for articulating a complex critique of the intersections of state neglect, social indifference, and political precarity that make it difficult for Black women to speak in the public sphere.

This discursive shift in the region marks the emergence of an organic, grassroots feminist politics that offers more complex narratives of sexual violence and Black women's social suffering. Black women activists in the region are engaging in what I term a politics of "intimate solidarity" that is grounded in an ethos of activist engagement, legal advocacy, community leadership, and collective care. This work is embedded in a larger project to identify the multiple levels—from state policy down to the individual body—at which Black women's citizenship and human rights are violated and to organize collectively to reassert those rights.

This politics emerges from Black women's difficult yet productive engagements with the mainstream mestiza women's and feminist movements and from their articulation of an antiracist feminist regional politics that identifies and contests the unequal social, political, and discursive conditions that distort Black women's experiences in the public sphere. As the chapter demonstrates, this work takes place in a variety of locations from kitchens to verandahs to NGO offices and meetings held in public parks where Black women gather to do the work of addressing violence against women and holding the state and their communities accountable for their repeated failure to protect Black women's bodies and lives. In the process of so doing, they are actively creating political spaces in which Black women's voices can be fully heard.

BREAKING THE SILENCE: FEMINISTS IN THE PUBLIC SPHERE

Over the last three decades, Nicaraguan feminists have done a great deal of work bringing the issue of violence against women into public consciousness. Like anti-violence advocates around the world, they have struggled to change popular thinking around gender violence, arguing that violence against women is not a private matter limited to the confines of the domestic sphere but rather is a manifestation of a deeply entrenched patriarchal order that relies on women's economic, political, and social subordination to men. As the feminist researcher Sofia Montenegro (2000) has argued, this is reflected in the high rates of female-headed households, women's limited participation in the formal economy, unequal family relations, the drastic curtailment of women's reproductive rights, and precipitously high levels of gender violence within (and outside) the home.

Although there are only limited statistical data on sexual violence in Nicaragua, the data that do exist, which have mostly been generated by feminist NGOs and researchers without the support of the state, demonstrate that it is a widespread and pervasive social phenomenon. It is estimated that at least one of every three Nicaraguan women has experienced sexual abuse in her lifetime. A 2013 study by the Institute of Legal Medicine (IML) found that of the 5,616 cases of sexual violence reported to the National Police, 60 percent of the cases involved victims under the age of thirteen (IPAS 2014). This is a particularly alarming statistic, given that approximately half of the country's population is under the age of fifteen (López Vigil 2003; IXCHEN 2006). It is estimated that between ten and seventeen sexual crimes are committed in the country each day: one takes place about every 156 minutes (IXCHEN 2006; Confidencial 2017).

What is even more disturbing is that these are conservative estimates because sexual crimes against women and children tend to be vastly underreported, with only one in four women likely to press charges against her assailant. According to the 2011–2012 Nicaraguan Demography and Health Survey (ENDESA), 70 percent of women who experienced rape before the age of fifteen did not seek help or press charges against their assailant.[3] Those who do press charges face a criminal

justice and legal system that is under-resourced, inefficient, and often indifferent to the needs of survivors. Conversely, perpetrators operate in the criminal justice system with impunity because the vast majority of rape cases either do not make it to trial or are overturned in the courts. Indeed, a study by the Centro Dos Generaciones (2007) found that 83 percent of accused perpetrators were released from police custody during legal proceedings.

Intrafamily sexual violence is particularly widespread and is linked to other social problems that have yet to be meaningfully addressed by the state; for example, Nicaragua's high rates of teenage pregnancy are tied to the pervasive sexual abuse of preadolescent and adolescent girls. From 2006–2016, approximately 16,400 girls under the age of fourteen gave birth after being raped (IPAS 2014; IPAS et al. 2016).[4] The UN Population Fund has reported that Nicaragua has the highest rates of underage pregnancy in Central America, which has the distinction of having the highest rates in Latin America and the Caribbean (Montenegro 2001). According to the Centro de Mujeres IXCHEN (2006), the majority of sexual crimes in Nicaragua are committed against minors (under the age of sixteen), more than half take place in the home, and most are committed by older men who are known to their victims.

One of the most significant challenges faced by Nicaraguan feminists in their fight against sexual violence is the widespread impunity that operates in the criminal justice system and shapes the state's approach to policing gender violence. For many feminists, this crisis of impunity is epitomized by President Daniel Ortega, whose stepdaughter Zoilamérica Narváez accused him in 1998 of sexually abusing her from the age of eleven until she left home as a young woman. The case set off a firestorm in Nicaragua, and feminist activists pointed to it as a clear example of how pervasive sexual violence is throughout Nicaraguan society.[5] As one Bluefields activist lamented, "Our president is the biggest rapist in the country."

Feminist and women's NGOs have worked with transnational NGOs, philanthropic foundations, international institutions such as the United Nations, and foreign governments to offer women and girls the resources to denounce sexual abuse, have their cases prosecuted, access therapeutic services, and empower themselves to publicly criticize society's silence toward sexual violence. Although the state has done little to confront the sexual violence crisis, women's and feminist NGOs and grassroots organizations have been instrumental in bringing this issue into the public sphere. Through research, education, policy advocacy, direct action, and the strategic use of mass media, these activists are directly challenging pervasive *machista* social values that normalize violence against women.

Nicaraguan feminists have played this central role in transforming the national discussion on sexual violence, despite what Karen Kampwirth (2008) refers to as an "anti-feminist" backlash by the *Orteguista* state that has attempted to vilify them as anti-family social deviants hell-bent on destroying the heteronormative social order. In June 2012, the National Assembly approved Law 779, the Comprehensive

Law on Violence against Women. Passage of this law was a remarkable achievement in the historic struggle to end violence against women in Nicaragua: it marked "a radical shift from focusing on intra-family violence to specifically addressing violence against women in both public and private spheres . . . and acknowledging that violence against women was a product of unequal power relations" (Neumann 2017). The law expanded the definition of gender crimes to include femicide, approved the creation of new specialized courts to address gender violence, and finally banned the use of mediation—a common legal tactic that had historically disempowered women in the process of filing claims against their abusers—for any crimes outlined in the law. Although Law 779 still had significant flaws—most notably its failure to recognize the rights of lesbian, bisexual, and trans women—it "met most demands of the women's movement, so the women's movement claimed it as a victory" (Jubb 2014, 299). Unfortunately, that victory proved to be short-lived.

Almost immediately, right-wing conservatives, representatives of the Catholic Church, and men's rights groups attacked the legislation as "anti-family" and discriminatory against men. Bishop Juan Abelardo Mata decried the legislation as anti-Christian, claiming that "the new mark of the beast is not 666 but 779" and that the law "[destroyed] families."[6] Even though feminists countered that it was the men who perpetuate violence against women and children who fractured families, not the law, conservative critics struck back—filing multiple suits against the government contesting the law's constitutionality. Although the Supreme Court of Justice upheld the law in a 2013 ruling, it recommended that the national government reinstate the practice of mediation. In September of that year, the National Assembly passed Law 846, the Law of Modification to Law 779, which most notably reintroduced family mediation for gender violence crimes with the exception of rape and femicide.

In response to this new law, feminist critics pointed out that the reinstatement of mediation is a regressive state policy that reprivatizes gender violence by treating it as a domestic matter, rather than a broader social problem. Moreover, mediation did not always work; in 2012, approximately 30 percent of all femicides took place before formal mediation could begin and a significant number took place after an initial mediation between the victim and her murderer (Solís 2013). The return of mediation reflected the deep social and cultural influence of the Catholic Church, which continues to wield considerable authority in shaping state policy. Passage of Law 846 signaled the alignment of religious doctrine with state practice and revealed the emergence of a new antifeminist governing strategy by the FSLN that has defined its authoritarian approach to both women's and multicultural citizenship rights (Montenegro 2001). This stance is characterized by the state granting formal discursive recognition of women's rights while undermining those same rights through ongoing support for policies that disempower women, reprivatize gender violence by defining it as a "family issue," and place the burden on

women to navigate violence with marginal backing or protection from the legal system. Thus, Law 779 functioned largely as "a showcase law" that allowed the state to discursively perform liberal democratic recognition of women's human rights while in practice leaving Nicaraguan women and girls, as Pamela Neumann (2017) argues, "to fend for themselves."

As the debate over Law 779 and the reintroduction of mediation demonstrates, feminist activists must contend with a juridical order that continues to prioritize the integrity of the family over the individual rights of women. Many mainstream feminists' critiques of the limits of Law 779 and Law 846 did not, however, consider how differences of race and region complicate the application of these laws. As scholars of Indigenous women's struggles against gender violence on the coast have shown, questions of state recognition, access to justice, and equal protection under the law take on a very different valence in the context of the region's autonomous legal system, which attempts to mediate often contradictory demands for both women's and multicultural human rights. A closer examination of the ways that multiculturalism and gender justice interact reveals that the "culture of silence" that prevails on the coast is not simply the product of Indigenous social norms and customs but is also produced by the very legal mechanisms that the state has produced to guarantee the full protection of women's human rights.

MULTICULTURALISM VERSUS WOMEN'S HUMAN RIGHTS

The question of culture looms large in mestiza feminists' analysis of the social and political origins of sexual and gender violence in Nicaragua. Sofia Montenegro, for example, argues that Nicaraguan sexual politics is defined by a "culture of lovelessness" that was forged through the violent, rapacious encounter between Spanish conquistadores and Indigenous women and produced a social order that fosters and normalizes patriarchal violence. She carefully maps how this social order has historically been reproduced through state policy, juridical norms, social customs, and the gendered division of the labor market. Despite the nuanced analysis that she and other mainstream scholars have brought to the historical production of sexual violence, their feminist critiques of sexual violence in Nicaragua focus almost exclusively on the Pacific. When they do turn their attention to the Caribbean Coast, the literature uncritically reproduces the culture of silence narrative while overlooking how Black and Indigenous women's responses to sexual violence are conditioned by broader social and political processes that remain largely unexamined.

I observed this dynamic during a visit to the Centro de Mujeres IXCHEN office in Bluefields, which is part of a larger NGO that provides sexual and reproductive health services to women, as well as attention mental health and legal support for sexual abuse survivors. I spoke with the director, Yahaira Valdez,[7] about the prevalence of sexual violence on the coast and its impact on women from different cultural and racial backgrounds. She stated that culture significantly influences how different ethnic groups perceive violence against women. For example, compared to

Afro-descendant and Indigenous women, mestizas were much more likely to report sexual crimes to the police and seek justice from the legal system. Yahaira thus concludes that "the mestiza woman has already broken the silence [around sexual violence], but with the other ethnicities it is more like a private matter." This willingness to break the silence and speak publicly about being sexually victimized—indeed the very ability to speak up—suggests that mestizas have acquired a critical gender consciousness that Afro-descendant and Indigenous women lack as the result of being embedded in hyper-patriarchal cultures.

She referred to the challenges that Miskitu women face confronting sexual violence in their communities, which are caused by the state's recognition of Indigenous customary law; that is. the right of a community to address criminal offenses based on its own cultural norms, traditions, and *cosmovisión*. Feminists have argued that this practice can produce violations of individual human rights, particularly among women, when men in these communities use customary law to evade prosecution for their crimes against women (Montes and Woods 2008). In many rural communities on the coast, when customary law is followed, conflicts and criminal offenses are mediated and resolved by a *whita* or communal judge who has the authority to send cases to the Nicaraguan court system if he or she feels that the case is severe enough to warrant prosecution.

The figure of the *whita*, however, has become a key site of critique by feminist activists in the region: they argue that allowing the whita to handle sexual offenses rather than directing them to the National Police can lead to serious violations of women's human rights in these communities. Yahaira pointed to the common practice in rural villages of perpetrators bribing the whita not to press charges or having the whita act as a mediator between the perpetrator and the family of the victim, to whom the perpetrator will pay damages according to the custom of *tala mana*, which means "blood payment" in Miskitu. Damages often include money or farm animals whose value presumably is sufficient compensation for the level of harm inflicted on the victim. Although this practice is more common in Indigenous communities, it also occurs to varying degrees in some Creole and Garifuna villages in the region's rural areas (Montes and Woods 2008). According to Yahaira, the corruption of the whita and the impunity that rapists enjoy in these communities as a result demonstrate that Afro-descendant and Indigenous cultures are more patriarchal than mestizo communities and thus more likely to violate women's human rights.

Mainstream feminist critiques of these ostensibly oppressive cultures must compete, however, with the national discourse of multicultural citizenship and respect for cultural difference that the Nicaraguan state has espoused since the 1980s. During the interview, Yahaira said she believed that the different cultures of the coast needed to be respected, preserved, and not forced to assimilate into the dominant mestizo culture. But she also harbored reservations about the compatibility of collective multicultural rights and women's individual human rights and stated that respect for cultural difference has to be moderated by an awareness that

"sometimes it is culture that does not favor advancing the rights of women. Some-times culture goes against development."

Interestingly, Yahaira did not discuss the structural conditions that also facili-tate widespread sexual violence. Many of the communities that have whitas, for example, also did not have a Comisaría de la Mujer y la Niñez[8]—or regular police stations, for that matter—where women could report sexual crimes and gain access to forensic specialists or treatment after sexual assault or rape. Instead, survivors must make their way by boat to Bluefields, which had the only Comis-aría in the region before it was dismantled in 2016, to formally denounce their attacker and receive medical treatment. There are no direct land routes to Blue-fields from other communities, and boat travel is expensive, unreliable, and often impossible during the rainy season, which lasts from June until December or January. The state has consistently failed to develop roads that would facilitate less expensive land travel; more importantly, it has not developed the legal infrastruc-ture in the communities that would make it unnecessary to travel to Bluefields to press charges against a rapist. If the problem of sexual violence on the coast is one of culture, then it would seem that the problem is created not only by the culture of Indigenous and Afro-descendant peoples but also by a patriarchal political culture that facilitates violence against women through its structural neglect and indiffer-ence. Simply put it is more convenient to let a whita handle messy matters of sexual violence on the community level than for the state to provide the kinds of resources that would allow survivors to have a broad range of legal options to adjudicate these crimes. Nor do these critiques consider that survivors may, in fact, feel safer appeal-ing to a whita to address their experiences of sexual violence given these communi-ties' general distrust of the Sandinista state, in particular.

The argument that Afro-descendant and Indigenous cultures sometimes work "against development" and against advancing the individual human rights of women parallels larger transnational debates taking place on the degree to which the recognition of collective cultural rights negates the individual human rights of vulnerable populations within minority communities. In *Is Multiculturalism Bad for Women?* Susan Moller Okin (1999, 10) argues that human rights advocates have too often wrongly assumed that "feminism and multiculturalism are both good things which are easily reconciled" and that, unlike liberal Western cultures that have presumably been transformed by feminist activism, minority cultures (which interestingly only include African, Middle Eastern, Asian, and Latin American cultures) are distinctly more patriarchal than their Western counterparts. Femi-nist human rights scholars have criticized Okin's zero-sum analysis that multicul-turalism undermines women's rights and minority women "might be much better off if the culture into which they were born were either to become extinct (so that its members would become integrated into the less sexist surrounding culture) or, preferably, to be encouraged to alter itself so as to reinforce the equality of women— at least to the degree to which this value is upheld in the majority culture" (23). The

feminist legal scholar Leti Volpp (2001) argues that Okin relies on an essentialist concept of culture that views minority groups as static, ahistorical, immutable, and impervious to the dominant cultures that surround them. Tellingly, Okin's position reveals some key premises underlying liberal feminist analyses of women's subordination in nonwhite, non-Western societies: that non-Western women are passive, nonagentive subjects incapable of developing their own analysis of unequal gender relations who need to be liberated from their oppressive cultures by liberal Western feminists.

In Nicaragua, the feminist discourse of saving Black and Indigenous women from their communities dovetails uncomfortably with the legacy and ongoing processes of anti-Black racism that posit coastal cultures as in need of assimilation into the mestizo body politic to become truly civilized. Women's silence about gender violence is perceived as an indication of the fundamentally flawed nature of these regional cultures. This discourse presumes that some cultures inherently produce the ideal liberal subject of feminist human rights and others simply produce passive victims who cannot become empowered political subjects in their home communities. More importantly, this narrative obscures how Black and Indigenous women are not only harmed by patriarchal gender norms at the local level but also by the racial violence of the mestizo state.

In their study of Indigenous women's struggles against gender violence on the north Caribbean coast, Arelly Barbeyto Rodriguez and Dolores Figueroa (2016) argue that understanding Indigenous and Afro-descendant women's silence about sexual violence requires a more robust analysis of the complex and overlapping legal systems that govern how these crimes are produced and policed at both the local and national level. Under the Autonomy Law, Indigenous and Afro-descendant communities were granted the right to practice their own forms of governance, territorial administration, resource management, and customary law. Thus, in their efforts to achieve justice, Indigenous women must navigate multiple legal systems that each operate according to its own juridical and cultural norms. Revealingly, the state has also relied on narratives of the exceptional violence of rural coastal communities to undermine demands for full recognition of local customary law and to erode the legitimacy of Indigenous legal practices and institutions. National actors challenge what they perceive as the "lack of harmonization between the state justice system and communitarian power structures in the area of gender-based violence" (372). The Nicaraguan judiciary has challenged the legitimacy of communitarian legal institutions by arguing that they violate national law and international agreements, most notably the Convention on the Elimination of All Forms of Discrimination against Women (CEDAW). The claim that communitarian legal practices and Indigenous customary law violate women's human rights thus provides the pretext for a "return to the subordination of spaces of Indigenous power and governance to the national—neo-colonial—hierarchy, under the pretext that the former violates women's human rights" (372).

The mestizo state's assertion of its sovereign right to manage and intervene in communitarian legal institutions obscures the fact that, as Barbeyto and Figueroa argue, "patriarchal regimes are present in both systems of justice" (2016, 372). It further overlooks the fact that, in many cases, Indigenous women prefer to handle these painful matters at the local level where they can wield more meaningful influence over the process, testify in their native tongue, call on local family networks to demand greater accountability from perpetrators, and use mediation as a tool to attain justice while also maintaining the social and familial networks that make the communitarian legal systems possible. Although mainstream feminists critiqued the reintroduction of mediation as a juridical tool because it places the imperative of family unity over the individual rights of aggrieved women, Barbeyto and Figueroa's examination of Indigenous women's struggles against gender violence finds that the use of mediation does not inherently carry the same negative valence on the coast: "Indigenous women's notions of justice clash with the national feminist movement, in that as Indigenous women, they opt for inter-legal practices that benefit them, especially if these are to be found at the communitarian level" (382). This suggests the need to reconsider how the normative language and claims of women's human rights discourse are unsettled by the contradictory structures that regulate Indigenous women's access to gender justice.

As Barbeyto and Figueroa demonstrate, mainstream feminist discourse on gender violence has not engaged with the broader political conditions that structure Indigenous women's claims for legal redress. Their analysis betrays a tacit assumption in the mainstream discourse that all women are affected by gender violence in the same ways and are using the same legal mechanisms to access justice. It further reveals the limits of mainstream feminist understandings of what constitutes gender justice and the multiple routes available for securing it. A closer examination of the tension between national and communitarian legal processes demonstrates that what is often interpreted as Indigenous women's silence in the face of widespread gender violence is more accurately understood as the production of racial illegibility. Indigenous women's silence is too often read as a capitulation to patriarchal violence, rather than as a strategic attempt to navigate overlapping patriarchal legal systems and leverage their limited power at the local level to demand more tangible and immediate forms of justice.

As I argued at the beginning of this chapter, silence is not self-evident. Building on Barbeyto and Figueroa's analysis, I argue in the rest of the chapter that silence is not a transparent social fact but is better understood as a methodology that Black women strategically deploy to negotiate the fraught political terrain of regional sexual politics. It is a methodology that they use both to contest reductive narratives about Black female hypersexuality and re-narrate themselves as respectable community leaders who can transcend the violent conditions in which they live. But as the critiques of local activists suggest, silence as a method produces its own limitations and blind spots.

THE METHODOLOGY OF SILENCE

In Nicaragua, as in other parts of the African diaspora, Black women have had to contend with racist and sexist perceptions of their sexuality. Like the "Jezebel" in the United States (hooks 1981; Hill Collins 2000) or the celebrated *mulata* in Brazilian national folklore (Freyre 1956 [1935]; Gilliam 1998; Caldwell 2007), the image of the oversexed Black woman who is readily available and amenable to the sexual advances of both Black and white men reflects a historical preoccupation with deviant Black sexuality. In the case of Nicaragua, Black women must contend with the dominant mestizo gaze and the representation of the Black female body as a site of uninhibited sexual excess and desire. I argue in this section that not only must Black women navigate the widespread tendency to blame women for rape but must also contend with warped representations of Black femininity and sexuality linked to larger ideas about the coast that mark them as inherently rape-able (Hill Collins 2000; McKittrick 2006; Smith 2005). These controlling images are both spatial and social narratives that shape Creole women's complex and contradictory responses to sexual violence.

In an article in about Caribbean women's experiences of racism in the Pacific in the feminist magazine *La Boletina*, one young Creole woman shared, "It bothers me a lot that [mestizos] think that costeñas are easy, that we just love sex, that we are all animals in bed. Changing this belief is very difficult" (Acuña 2004, 30). Alta Hooker, rector of the University of the Autonomous Regions of the Nicaraguan Caribbean Coast (URACCAN), recounted how she was once "practically attacked" in a taxicab when the driver discovered that she was not a foreigner but a costeña visiting the Pacific. She shared, "He told me that women from the Coast are hot and he began to touch me. Just for being a Black woman from the Coast!" In a related article, Carla Bush, a Creole sociologist, shared a similar experience: "With Blacks there is no sympathy . . . Many times I've arrived to a job and automatically they assume that because you're a Black woman, you have good *culo*, you know how to screw" (Morales 2009).

The figure of the "hot" coastal woman has been a pervasive trope in Nicaraguan literary and popular culture since at least the late nineteenth century. The widespread perception that Afro-Nicaraguan women are amenable to men's sexual advances—in the workplace, in taxicabs, on the streets, and so on—means that even when Black women do complain about being sexually harassed or abused, mestizos tend to assume that they are willing participants in consensual sexual encounters. The myth of the "hot" costeña obscures Afro-Nicaraguan women's violation and makes their suffering illegible and incomprehensible to mestizos and, often, sadly, their own communities as well.

For many Afro-Nicaraguan women, silence—that is, choosing not to publicly disclose experiences of sexual violence to their communities and the mestizo nation—functions as a survival strategy that ensures their self-preservation. In her

study of rape, labor migration, and African American domestic workers in the U.S. Midwest, Hine (1989) argues that Black women developed a "culture of dissemblance" as a response to the constant threat of rape. She defines dissemblance as "the behaviors and attitudes of Black women that created the appearance of openness and disclosure but [that] actually shielded the truth of their inner lives and selves from their oppressors" (913). Hine claims that silence and dissemblance serve as strategies for subverting negative representations of Black womanhood; they allow Black women to create alternative self-representations that reflect their virtue, positive self-image, and humanity. These counter-representations of Black women often provided the only images of respectability and virtuous Black femininity that they could lay claim to in a hostile, white supremacist, patriarchal culture.

Similarly, Creole women have cultivated a comparable counter-discourse: the strong, respectable woman who is a moral and emotional pillar in her community (White 2001). Much like the strong Black woman that U.S. Black feminists have theorized, this counter-image functions to establish Black women's high moral character in the face of assaults on their virtue and to provide an alternative representation of Black femininity that privileges their social roles as mothers, communal caregivers, and community workers. In her groundbreaking study of Creole women's experiences of racial and gender discrimination, Socorro Woods Downs (2005, 11) argues, "The experience of racial and sexual discrimination makes Creole good wives and mothers, rather than people with their own life aspirations." The dictates of Creole respectability demand that women place the well-being of their families and partners before their own needs and internalize domestic violence as an indication of their personal and domestic shortcomings in these social roles. As one activist, Gay Sterling, told me,

> Black people we was taught that our underwear when we wash them we need to hide them. Never hang your underwear in front of you house, we always hang it in the back or if it's possible in the bedroom, to say it that kind of way. And that has influence us in the sense that when things that we consider very shameful and hurt like incest, like rape, and those stuff, even domestic violence we don't speak about it—because society demand a status. They have design—what can I call it in my own words—like a prototype for you, as Black woman you need to be this way. And anything that is out of that is like a shame, a disgrace. So, if you have problems with your husband, it is because you are not a good woman. If your husband look another woman and have affairs is because you are not complete. You are not satisfying him. Always it's your fault.

As I discuss in the following section, Black women activists have attempted to disrupt this logic of blame. But it is difficult to do so because of the ways in which the social pressure to be a good wife and a good mother silence Black women. Gay shared, "At the end of the day woman is always relate to wrongdoing or error, to all that is bad. So, for Black woman is the double. Because Blackness is always related

to evil, to what is not good, to badness. 'I had a Black day.' That mean you had a hard day. So, Blackness, being a Black woman is like double discrimination. It's double pressure."

As Gay's comments suggests, Black women face tremendous societal pressure to privilege the needs of their families and husbands and to invest in the performance of Creole respectability. Her characterization of these performances as a kind of prototype of ideal Black femininity speaks to the ways that women are compelled to reproduce these social norms. Black women are expected to suffer stoically and withstand gender violence for the sake of preserving their family's reputation. The articulation of Creole respectability rests on the reinforcement of heteronormative standards regarding sexual propriety, work ethic, Protestant Christianity, and extending one's caregiving role from the household to the larger community through service in the church, neighborhood, village, and so on. But the performance of Creole respectability produces contradictory outcomes. On the one hand, it seems to reinforce gendered social norms that constrain women and reproduce patriarchal power relations. On the other hand, however, it also empowers women to assert a greater role in the social life of the community by encouraging them to play an active role in policing and maintaining the moral order (Goett 2016).

There is often a profound contradiction between Creole women's public presentation of themselves as independent, assertive, and strong community figures and their private experiences of intimate violence in their daily lives. I witnessed this contradiction among Black women activists with whom I worked, who would routinely engage in dissemblance to preserve their public image as community leaders. I recall visiting a colleague in her office to discuss an upcoming gathering about women's participation in the regional government and trying not to stare at the blue and black ring circling her left eye. She refused to talk about how she got the black eye and dismissed it as nothing. I did not raise the subject again.

Woods Downs argues that the twin factors of shame and low self-esteem produced by racial and gender discrimination lie at the core of Black women's refusal to share their stories of violence and subordination in public: "When a woman is emotionally wounded she feels threatened, she becomes fearful and insecure about herself, and she cannot speak out" (2005, 17). Woods's argument reflects local commonsense discourses on the performance of strength, which tend to mark it as a performance rooted in a community and individual ethos of shame that compels women to internalize abuse and reprivatize intimate violence as a personal matter rather than a social phenomenon. Shame is reflected in what Woods suggests is many women's low self-esteem, which is produced by the pervasive and persistent experience of racial and gender discrimination. There is considerable truth to the claim that shame forms the affective foundation of the performance of strength, and it is important not to diminish its emotional implications for Black women.

But the performance of strength is not only characterized by shame as a normative social value: it is also deeply rooted in Creole women's shared investment

in the value of personal pride. Pride in this context connotes both positive and negative valences. Creoles, in general, tend to be highly critical of individual community members who "feel too proud." Feeling too proud can reference a range of negative behaviors, including putting on airs by engaging in conspicuous displays of material consumption, presenting oneself in a manner that belies one's humble origins, or behaving as though there is no contradiction between one's public persona and private struggles. When pride is enacted as a means of covering up one's individual shortcomings or to conceal the chaotic, violent domestic situation in which one lives while criticizing others, it is seen as a deep character flaw that calls into question the person's honesty and integrity.

Yet there is also a strong sense of individual self-determination that characterizes "being proud" that I observed among Creole women. They refused to see themselves as victims or survivors but instead insisted on seeing themselves as fighters. As Jennifer Brown, a local activist and organizer with the Afro-Descendant Women's Organization of Nicaragua (OMAN) explained to me one evening, when most Creole women experience gender violence, they prefer to solve their own problems in their own way: "The way how them see it, I don't want this woman solve my problem because who she is that she could solve my problem when I could solve it. Why I have to go to she when I could do it? That is how we is."

Often solving one's own problem meant not reporting the abuse to neighbors or the police—whom Creole women tended overwhelmingly to see as corrupt, inept, and racist—but rather confronting abusers on their own. As Brown's comments suggest, Creole women often had very different ideas than mainstream feminists about the best way to address the problem of gender violence. Indeed, Creole women expressed a great deal of pride in their ability to stand up for themselves against violent and abusive partners. When sharing stories about other women who had been abused or sexually violated, Creole women spoke admiringly of those who had demonstrated their ability to defend themselves. Being able to defend oneself constituted a key component in community norms of ideal Creole womanhood, which rejected narratives of ideal femininity that mark women as passive and submissive and instead valorize Creole women's strength and resilience in the face of adversity.

This form of active self-making, grounded in an ethos of personal autonomy and self-reliance, was reflected in the ways that Creole women asserted themselves in their personal relationships. In my own anecdotal experience, Creole women seemed less likely than mestizas to press charges against their abusers or report cases of sexual violence yet exercised a contradictory yet strong sense of personal agency in their homes and relationships. Overwhelmingly, Creole women claimed that they were more likely than mestizas to leave or kick out abusive and unfaithful spouses. They insisted on having the deed to their homes made in their names. They raised children as single mothers, relying on extended female kinship and community networks to do so. They served as the primary breadwinners for their immediate and extended families and provided emotional and financial support

to female friends and relatives attempting to extricate themselves from abusive home environments. And they were often vocal critics of prominent men in the community who abused their partners or were known to sexually exploit women and girls. Thus while Black women often would not speak publicly about their own experiences of sexual and gender violence, many would go to tremendous lengths to criticize the abusive behaviors of men in the community who perpetrated such violence against Black women, girls, and boys.

Indeed, Creole women often expressed scorn for mestizas whom they tended to view as weak and lacking the kinds of self-determination and self-sufficiency that they prized among themselves. Unlike Creole women who felt that they could handle their problems themselves, mestizas were characterized as too quick to run and tell their troubles to others. Mestizas, it was said, had no shame, as demonstrated by their willingness to share their private troubles with their neighbors and the police. The implication was that if a woman should have the misfortune of being in an abusive relationship, then she should stand up for herself. Creole women did not appeal to the law to defend them in abusive relationships but insisted on the right to defend themselves. They had almost no faith in the state's ability, or willingness, to protect them; so they took it upon themselves to do so. On more than one occasion, I heard Creole women respond to accounts of individual women's airing of their "dirty laundry" by sucking their teeth and asking rhetorically, "She no shame?" Here the reference to shame not only speaks to community norms of personal propriety that dictate that private matters are best handled at home but also signals a deep investment in agency and self-determination; put differently, the question might be better posed as "Doesn't she have any pride?"

Pride as a modality of expressing one's personal strength and moral fortitude is enacted through personal aesthetics, community service, leadership capacity, and the ability to provide guidance and support for others. It would be difficult to tell, for example, from their outward appearance and public persona that many of the activists with whom I worked were often or had previously been the victims of some form of gender violence. They maintained a strong demeanor of respectability, personal discipline, and leadership that allowed them to present an empowered version of themselves to the broader public. That this performance could still be enacted even under conditions of violence reveals the complex ways that Black women navigate these harsh realities.

I was shocked, for example, when Evelyn, a colleague with whom I worked at one of the regional universities and who taught courses on gender and women's human rights, tearfully shared her story with me over lunch one day at a popular restaurant on Bluefields Bay. A stylish, middle-aged mother of three and grandmother of six, Miss Evelyn was among the most respected professors on the campus, popular with Black students for her encyclopedic knowledge of local and diasporic Black history; she was widely considered *una mujer destacada* (an outstanding woman) in Bluefields civil society. She often dressed in bright African

prints and kept her short, curly hair in a small natural, which she considered to be an important practice of performing an empowered, politically conscious ideal of Black femininity. Still, the public persona she curated as an activist and an educator hid a painful personal history of domestic abuse and emotional turmoil in a long and unhappy marriage.

Over lunch, Evelyn told me that she had been forced to leave her previous job because her spouse was so controlling and jealous that he often would come unannounced to her workplace and sit glowering in a corner as she carried out her tasks. She paused, gazing sadly at the bay, and said,

> A lot of times people see you working but they do not understand that inside you are struggling with a lot of doubt. That's why I say to be a woman and to be a leader and a mother—it's not easy. In our culture, there are certain things we feel should be just between the four walls of the home. These things you cannot discuss outside the home. So you have professionals who are out there doing a good job but when they go home their life is something totally different than what you see out there or the person you see out there. And that's not easy. Sometimes I come to class and *oh my God* my heart is aching. And I have to go into class, and I have to teach. I would go to the bathroom, wash my face, come and take a glass of water. And you just have to take it; it's your responsibility. And then I go into class, and I try to forget everything.

She turned, looked directly into my eyes, and said, "I have been doing this for *years*. And it's killing me." She began to cry uncontrollably and, before cutting the interview short, said, "You know, there are lot of women out there like me." Miss Evelyn's comments reveal how Creole women carefully curate a mode of respectable public presentation that preserves their sense of pride while also maintaining a façade of personal strength that downplays the kinds of intimate violence that they may experience in their private lives. This investment in saving face by maintaining a public persona of individual strength reflects their determination to present themselves as empowered women who can effectively manage the trials and difficulties of their personal and public lives.

Rather than embrace victimhood, a status that Creole women cannot legitimately lay claim to, they choose to position themselves as strong women who can represent and speak for the community despite the violence they are subjected to in their daily lives. The performance of strength, even under conditions of violence and abuse, is an important part of women's ability to claim a space as community leaders. If the only cultural capital that Black women have in their communities is to be perceived by others as strong, it is hardly surprising that so few of them have chosen to speak out more vocally about their own experiences of violence, even when it is clear that they have been or are currently being victimized. To speak about one's own experiences of violence is to name oneself a victim and give up

one of the limited sources of power, community recognition, and leadership that are available to women. Thus, the performance of strength is an important "habit of survival" (Scott 1991) for many Creole women.

The performance of strength, however, also has the unintended consequence of shifting the responsibility of preventing sexual violence to women, rather than challenging men to change. It is assumed that because Black female bodies are so devalued by the racialized misogyny of the dominant culture and machismo in Creole communities that women must take on the task of protecting themselves from sexual abuse by not placing themselves in any situations that might result in violence. Thus, as bell hooks (2003, 140) notes, "A major emphasis then in Black female life is on 'prevention' rather than crisis management after victimization."

Although the focus on prevention can be an important strategy for minimizing the possibility of sexual violence, it mirrors the larger society's tendency to dismiss sexual violence against Black women and reproduces the patriarchal logic that women invite such violence through their behavior. As a result, when Black women do speak about their experiences of sexual violence, they must confront the fact that they are no more likely to be believed by their friends, families, churches, and communities than they are by the dominant mestizo culture. Indeed, as Jennifer Goett notes, Creoles overwhelmingly tended to blame young girls and women for the sexual violence that they experience at the hands of older men, who often coerce girls and teenagers into exchanging sexual favors for money and gifts. These young women and girls are not perceived as the "victims of the unwanted sexual advances of older men, but [as] willing accomplices in a value exchange that gives them access to consumer goods that they otherwise would be unable to purchase" (Goett 2016, 70).

Ultimately, the performance of strength, although useful as a strategy of self-preservation, does little to enable a progressive gender politics. Rather, it has largely had the effect of reproducing a kind of hyper-respectability among Creoles that relegates gender violence to the private sphere and does little to address the structural roots of women's suffering. In addition, although the performance of strength provides an important counterbalance to narratives of Black female hypersexuality that place Black women outside the category of ideal victims, it has failed to make Black women's suffering and experiences of gender violence legible to the larger community and broader national publics and normalizes indifference to those experiences: it limits Black women's ability to develop more complex modes of public presentation.

Stories matter. On the coast, the idea of Black women's "hot" sexuality and their investment in the performance of strength as a counternarrative to this disreputable representation are not only social practices but are narrative acts that do particular kinds of discursive work in the public sphere. Analyzing these narratives reveals the kinds of explanatory frameworks that Black women use to talk about their experiences of violence, the tropes that they deploy in the telling, and the

ways in which these narratives of Black femininity enable and foreclose the telling of particular kinds of stories by reframing the narrative in terms that are legible to them and their communities.

Examining the stories that women tell (and do not tell) about their experiences of gender violence reveals that silence is a complex and fraught partial strategy that requires a deep critical engagement. There is often much more to the story than silence taken at face value would tend to suggest. Finding the way to break these silences is no less complex, and it is important to pay careful attention to the multiple ways and spaces in which public speech becomes possible. When we do this, we may find that such work is taking place in unlikely locations and through illegible forms that we may not have previously considered—like, for example, a public park.

INTIMATE SOLIDARITY AND THE POLITICS OF SELF-RECOVERY

Reyes Park sits in the middle of Bluefields. It is a gathering space where children come to play, vendors sell their wares, and *bluefileños* congregate in search of gossip, romance, or shade under the park's towering trees. On one warm, sunny afternoon, a small group of local Black feminist activists gathered there to map out a strategy to address violence against women in the region. It was a multigenerational gathering of grandmothers and young single mothers. As the group members slowly trickled into the meeting, they chatted excitedly with one another, catching up on the day's events, and discussing the items they wanted to place on the agenda.

The main agenda item that afternoon concerned the case of a young woman from the neighboring community of Rama Key whom the group had helped to press charges against the young man who had sexually assaulted her. Securing justice for this young woman had not been easy. As Jennifer Brown explained, more than three months after the attack, "The boy was still yet free, teaching class because he is a teacher. He was up and down the streets of Bluefields *pasearing* [walking around] because his mother is a *concejal* [representative in the Regional Council], she belongs to the Sandinista Party, she was making incidence [advocating], *negociaring* [negotiating], and every door was closed to this girl like, 'Sorry we cannot do nothing for you.' So, she just have to let it go. So, she come to us looking for help."

The group began working with the young woman in April 2016. When the case went to trial in October of that year, they continued to mobilize, going to court each week to protest—standing silently in the back of the courtroom holding posters condemning the perpetrator and demanding justice. Their efforts were successful: the young man was convicted and subsequently sentenced to fifteen years in prison. But the victory was short-lived as the perpetrator's mother continued to use her political influence to have the sentence overturned. Her first step was

to pressure the young woman to recant her story and withdraw the charges. This was accomplished through a campaign of harassment and intimidation that caused the young woman to seek an attorney to withdraw the case, go into hiding, and stop communication with the group. "After they condemn him and she gone back to her community is like the family *hostigate* [harass] her, they wanted to try to harm her physically," Jennifer explained. "So, since she cannot stand the *hostigation* [harassment] no more, she decide to go look a lawyer to see how she could find the way to take him out."

Women continued to come into the meeting as Jennifer brought everyone up to speed on the case. Their biggest concern was that no one in the group had heard from the young woman for several weeks. She had been run out of the neighborhood where she had been staying in Bluefields, had lost her cellphone, and had made no attempts to reestablish contact with anyone in the group. Breaking the silence had cost her dearly, and the group was fearful for her safety.

As they discussed the case, group members criticized the role of the state in blocking Black women's access to justice. They pointed to the ways in which the systematic corruption and the intervention of the FSLN in local affairs created the conditions for undermining women's exercise of their human rights even as the state claimed to defend those rights. They complained about how the state's failure to provide equal protection to Black and Indigenous women seeking legal redress for sexual violence created a context in which these women became increasingly reluctant to speak publicly—not because of the "culture of silence" prevalent in the region but because of a deeper "culture of impunity" that characterizes the Nicaraguan criminal justice system. Knowing that the likelihood of a just outcome was slim proved to be a greater deterrent for Black women than the social pressures of their own communities. The conversation continued:

JENNIFER: People see that these people doing these things and they go free. Then I not go going to go denounce because I go public with all my faults—and them destroy you up—

PEARL: Talk all kind of things about you in public—

GAY: And I still no get justice. So I just going to back up. That's why we cannot permit these things.

As the conversation suggests, one of the primary reasons that Black women tend not to speak publicly about gender violence is because of their perception that there is little to be gained by doing so. In this context, activists have begun to rethink what it means to break the silence on sexual violence and to shift their strategy from simply supporting the individual claims of aggrieved women to creating the conditions for a public conversation on sexual violence that challenges the community to acknowledge this widespread and pervasive phenomenon. During the conversation Gay, who I mentioned previously, stated,

Look now, I say, *"Pueblo chiquito y infierno grande"* (literally small town, big hell). Everybody know what everybody doing, and who doing and who no doing in Bluefields. So what them talking? It's time to voice out. Not because supposedly prominent men in our society committing these act, we going pretend say nothing happening. What about that man up Loma Fresca what pay 500 cordobas over the years to the little girl them, and the mamas them go and sell them daughter—and everybody know who that man is! Everybody know who that man is and nobody say nothing!

Miss Gay's comments reveal a different kind of feminist logic about the politics of silence that is worth examining. They suggest, as I have argued throughout the chapter, that sexual violence is a public secret that many people in the community know all too well. As she observed, the issue is not one of silence or ignorance but of complicity and the collective refusal to name this violence publicly. Her comments suggest that regional efforts to end violence against women must tap into the informal archives that women in the community have maintained and bring them out into the public sphere. Thus, the imperative to break the silence is not only the responsibility of survivors of sexual violence but also is incumbent on community members to hold perpetrators and the state accountable for its failure to protect Black women and girls. This suggests a need to reconceptualize breaking the silence as a collective rather than an individual speech act.

Responding to Miss Gay's comments, another group member, Aleyda Taylor, pointed out that getting the community to respond collectively to the problem of gender and sexual violence would require a shift in public thinking about Black women's bodies and sexuality that moves beyond dichotomous representations of Black women as either hypersexual nonvictims or hypermoral superwomen.[9] "We have to make a consciousness into our society and make them know seh nobody cannot touch a child nor a woman. If I even walking naked down the street, nobody have right to touch me. My body is my body. I am the owner and if I say, 'Well, everybody have some,' then that is my problem." At this, Aleyda paused, smiled, and waited until the group's laughter subsided. "But if I say 'No.' It's no! And we have to establish that and make people know woman is not object for you fi do whatever you want with nor [is] a child."

Others in the group clearly shared Miss Gay and Aleyda's outrage. By the end of the hour the group had sketched out a strategic response to the harassment campaign that the young woman faced and put together a list of action items to address before the week's end. It included speaking about the case on several radio programs, circulating an open letter to the judge presiding over the case as well as municipal and regional authorities, contacting the national Women's Human Rights Attorney, and prepping posters and materials to display at the courtroom as the case was being argued.[10]

I was surprised to learn a few days later as I sat talking with Jennifer on her verandah that this group of women is not an official organization. Some of the

group's members have extensive experience working with national and regional feminist organizations, including the *Red de Mujeres contra la Violencia* (which is no longer active in the region); the *Red de Mujeres Afro-Latinoamericanas, Afrocaribeñas, y de la Diáspora, Voces Caribeñas*; and other civil society organizations. Through their participation in these spaces, they learned many of the tools of feminist activism, including public policy development, government lobbying, media advocacy, and public education in community-based workshops and local programs. According to Brown, the group was born out of a broader collaborative political effort known as the *Movimiento Autoconvocado Pro-Derechos Humanos de la Mujeres* to bring together local NGOs and community organizations to address increased levels of domestic, sexual, and gun violence in Bluefields. Rather than attempting to address these issues as individual groups, representatives of the group are developing institutional relationships to address these issues collectively.

As a small grassroots effort, the group is not a state-recognized NGO; it receives no funding from national or international philanthropic organizations nor any support from the state, which remains uniformly hostile to feminist organizations. Nevertheless, the group has continued to combat institutional patterns of impunity, advocate for victims, and accompany them through the legal process. Its members have used local media outlets, particularly the radio, and social media and led educational workshops in Black communities to increase public understanding of gender violence as a social rather than a domestic problem. The group also works with mainstream women's and feminist movements in the Pacific, but with a sophisticated understanding of the local social and cultural dynamics that Black women must negotiate in their efforts to access justice and make their private suffering visible to the public.

This work has not come without its challenges. Local antiviolence activists must contend with communities that remain hostile to attempts to empower women to denounce their assailants. One activist revealed that many have received death threats because of their work and been the targets of harassment and intimidation. Some use pseudonyms on their social media accounts and limit their social activities to private spaces to protect themselves and their families. Nevertheless, they persist with their work.

Although some of the women have many years of experience working with other feminist organizations in the region, others became involved in the work because of their personal experiences with gender and sexual violence. In conversations, they often shared that those traumatic experiences and their inability to access justice for these violations were why they began to advocate more actively to defend Black women's rights. The emergence of a local movement against gender violence is linked to Black women activists coming to terms with their own experiences of violence and their attempts to develop a collective process of healing and self-recovery among Black women in the region.

Although she was proud of the group's political work, Jennifer Brown shared with me that she was more invested in the emotional work that the group was

carrying out in the community. For her, the group not only functioned as a site to mobilize politically to address gender violence in the region but also provided an important space for engaging in a practice of collective healing for Black women. I shared with her how surprised I had been to see women at the meeting speaking publicly about the abuse that they had suffered. The reason for this, Jennifer told me, was because of the extensive work that the group had done to create an environment where women could feel safe talking about their lives. She said, "But you know why [she is] comfortable? Because she know that the majority of us that is in there having similar problems like her. So that's why she get that confidence. You understand? For you to get that confidence you have to know seh that I passing through the same thing so then you feel confidence about telling me what you are passing. But if don't know or you don't open up—because we open up in the group—then them never going to feel comfortable. . . . So we have to free weself."

I found Brown's use of the word "confidence" revealing. As bilingual Creole English and Spanish speakers, Creole women often Anglicize Spanish words in their daily speech practices. Here the word "confidence" not only connoted the need to help Black women cultivate greater self-esteem, as it does in English, but also seemed to refer to the meanings of *confianza*; that is, trust, intimacy, and faith in oneself and one's community, as the word suggests in Spanish. For example, the expression *ganar la confianza* implies that an individual has gained or won the trust of another. What I saw happening at the gathering in the park was an attempt by a small, grassroots group of women to win one another's trust by demonstrating a willingness not only to fight to defend each other's rights in larger institutional settings but also a commitment to collectively share stories and healing from the trauma of gender and sexual violence. By opening themselves up as organizers to women in the community, the group's members are slowly building an environment of confidence and trust that empowers women to speak about their experiences of violence, knowing that there is a larger community of women standing behind and alongside them.

This attempt represents a new kind of political practice in Black women's regional activism: the emergence of a politics of intimate solidarity. I define "intimate solidarity" as a dual project of activism and self-recovery that is rooted in an ethos of activist engagement, political critique, community leadership, and collective healing and transformation. It is an attempt to tell a fuller, more complex story about the violent conditions of Black women's lives. As the sociologist Avery Gordon (1997, 4) notes, "Even those who live in the most dire circumstances possess a complex and oftentimes contradictory humanity and subjectivity that is never adequately glimpsed by viewing them as victims or, on the other hand, superhuman agents." Rather than investing in either of these narratives, Black women activists engaged in the practice of intimate solidarity are organizing to address the contradictory realities that these narratives have produced by creating political spaces that bridge the private and the public and enable them to narrate their experiences of suffering and violence in terms that recognize their

full and complex personhood. Black women are not superwomen nor are they perpetual sufferers. Rather they attempt to negotiate their experiences of victimization with their own desires for erotic autonomy, individual and collective self-determination, political recognition, and new modes of representation in the public sphere.

What I witnessed in Reyes Park was an attempt to articulate a new form of Black feminist politics in the region. The politics of intimate solidarity combines a structural critique of gender violence with locally based efforts to help Black women recover from the traumatic effects of sustained exposure to those forms of violence. The practice of intimate solidarity is a strategy for crafting new narratives about how Black women negotiate and contest living under intimate, social, and structural forms of violence. It is an attempt to refashion representations of Black women in the public sphere and to create spaces for Black women to talk about the impacts of this violence on their own terms. It is rooted in a commitment to countering the hegemonic narrative of Black cultural silence with the articulation of public cultures of mutual care and support while grounded in an ethos of social justice and the defense of women's human rights.

Moreover, it demonstrates that the kinds of critical perspectives that Black women routinely enunciate in private spaces can be translated and brought into public discourse. In the new narratives that the practice of intimate solidarity produces, Black women are neither hypersexual anti-victims or long-suffering superwomen who can handle violence on their own. They become more complex subjects who alternately accommodate, contest, and resist the multiple forms of violence that structure their social lives. Intimate solidarity is a practice that enables public speech—but speech that is articulated collectively and challenges the larger community to speak the truth of what is widely and commonly known about the reality of gender violence in Black communities. In so doing, it presents important insights into understanding the work that silence does in these communities and creates new possibilities for breaking it in ways that empower and heal Black women.

CONCLUSION

Over the last forty years, Black feminist scholars have examined the politics of silence and sexual violence in the lives of Black women. This literature argues that systems of heteropatriarchal white supremacy have produced Black women's silence by marking them as violable citizens whose rights to bodily integrity are neither protected by state institutions nor the communities in which they live. Although this literature makes an important contribution to our understanding of Black women's sexual politics, it has also tended, as Evelyn Hammonds argues, to render Black female sexuality through metaphors of absence, invisibility, and erasure that obscure the ways that Black women talk back to dominant discourses that distort the realities of their intimate lives. Simply put, we need richer ethnographic

accounts that examine how Black women strategically deploy silence as a method-
ology of survival to navigate the unequal discursive terrain that shapes public
responses to Black women's social suffering. This approach demonstrates that
Black women's sexual lives are much more complex than simple appeals to the
regulatory power of silence would seem to suggest and are shaped by a complex
matrix of intimate, affective, political, and social conditions that demand deeper
consideration.

Examining Black women's regional activism against gender violence reveals
that there are multiple strategies for breaking the silence that are obscured in
hegemonic discourses about the ideal mode of feminist politics. Although Black
women are aware of the patterns of silence that surround sexual violence, they
do not simply attribute this violence to immutable forms of cultural difference;
instead, they ground their cultural analyses of gender violence within broader
structural processes of multicultural dispossession that limit their ability to speak
publicly about the violence experienced in their private lives. Thus, the work has
focused equally on developing more legible forms of feminist advocacy in the
region, creating spaces for Black women's self-recovery, and producing new coun-
ternarratives that allow Black women to assert themselves as political subjects in
the public sphere.

In this chapter, I have argued that intimate solidarity, as a political practice
developed by Black women activists, represents a local strategy for creating condi-
tions that enable Black women's speech in the public sphere. These activists are
building spaces—in public parks, neighborhood workshops, and through pro-
test—to make Black women's voices legible to their own communities and to
demand justice on their own terms. Although they make use of national and inter-
national legal frameworks to make these demands, their activism reflects a
sophisticated understanding of how local Black sexual politics both enables and
constricts Black women's public speech about sexual violence and provides new
spaces for political critique and collective healing. Their work demonstrates that
Black women's speech is possible and that silence is a material condition that can
be transformed through collective action.

The formation of this regional feminist politics is linked to the emergence of a
broader movement to resist state violence, political corruption, and the erosion of
regional autonomy. The authoritarian turn in Nicaragua has revitalized grassroots
forms of activist engagement as regional activists have found their access to civil
society and government institutions curtailed by the concentration and recen-
tralization of state power in the hands of the Frente Sandinista. Like feminist
organizations in the Pacific, Black women's groups—and Black civil society organ-
izations, in general—are currently struggling to survive the state's increasing
repression of civil society, the disappearance of transnational philanthropic fund-
ing, and the dismantling of collaborative relationships between civil society and
local, municipal, and regional governments to provide project funding for antivio-
lence work and victim support services. As Pearl Watson, a regional activist who

works with the *Red de Mujeres Afro* and the Sexual Diversity Group, an LGBT rights organization, observed, "The order from the national government is don't work with the woman's organization them. It's not easy to fight the system because them cut you off from all [sides]."

In the absence of state support for Black women's efforts to access justice, these activists have begun to develop more grassroots approaches to dealing with the problem of sexual violence at the local level. As Pearl's comments reflect, these activists have a nuanced understanding of how the state manipulates multicultural and women's human rights discourse to serve its own ends and simultaneously disempowers Black women while undermining the autonomous legal frameworks that would allow them to access justice. Intimate solidarity represents a grassroots feminist discourse born out of regional struggles for racial justice, just economic development, and tangible transformation in gender relations within their communities.

6 · FROM AUTONOMY TO AUTOCRACY

Development, Multicultural Dispossession,
and the Authoritarian Turn

In October 2016, President Daniel Ortega gathered 430 communal and territorial representatives from the Caribbean Coast to formally grant the last remaining collective land titles to Indigenous and Afro-descendant communities. This was, on its face, a historic achievement. Since 2007 the FSLN has granted title to twenty-three territories representing 304 communities and encompassing a total area of 37,841.99 square kilometers, 31.6 percent of the national territory. Ortega framed the 2016 event as the fulfillment of a historical mandate initiated by the FSLN to comply with the promises of political self-determination, multicultural recognition, and territorial titling that were made with the Autonomy Law in 1987. After recounting his memories of the violent conflict of the 1980s, Ortega stated, "Well, the road was hard! Now we are meeting here, as we said, fulfilling this commitment, which has to do with the law of autonomy, has to do with all the agreements there were there with the peoples of the Caribbean North Coast, South Caribbean.... What we are recognizing is a right! I mean, we're not giving anything, we are simply recognizing a right" (Areas Esquivel 2016).

Ralph Mullins, president of the government-appointed Creole Communal Government of Bluefields, accepted the title on behalf of the Creole community and lauded the government for its actions: "Like he [President Ortega] said, 'this is not a gift,' but this is the only government that has recognized us as minority communities of the Caribbean Coast." He told the audience, "The government of Comandante Daniel Ortega can be sure that on November 6 we are going to cast our vote for the Frente Sandinista, which is the only party that includes ethnic minorities and Afro-descendant peoples" (Areas Esquivel 2016).

Back in Bluefields, the response to the titling was decidedly less enthusiastic. One month later, a group of Creole leaders representing the Bluefields Black-Creole Indigenous Government (BBCIG) filed a suit alleging that the government

had granted an irregular title that did not comply with the legal guidelines outlined in Law 445, which regulates the land demarcation and titling process (República de Nicaragua 2003). The title that the government granted to the Bluefields community was 93 percent smaller than the claim that the BBCIG had filed in 2012 with the National Commission on Demarcation and Titling (CONADETI in Spanish). Yet the government failed to obtain prior consent from the community for this reduced claim, instead substituting its own version and bypassing the legal process (Acosta 2017; Álvarez 2016; Creole Communal Government of Bluefields 2013; Salgado 2014). Additionally, the title included internationally protected wetlands where building and agriculture are prohibited by international agreements. "What they did was they gave us 150,000 hectares of swamp" remarked one activist bitterly (CALPI 2017). Creole activists claimed that the communal government led by Ralph Mullins was an irregular, illegal parallel government that was created to facilitate implementation of the Ortega administration's centralized economic development objectives in the region, specifically the construction of an interoceanic canal that would cut through both disputed and titled Black and Indigenous territories (Acosta 2017).

Black activists argued that the Sandinista government's rhetorical commitment to Afro-descendant and Indigenous communities' collective rights was not matched by its policies. Ortega's celebratory narrative ignored the deepening conflict between the central government and Black and Indigenous communities over a range of issues. They alleged that the government had violated their rights by approving the construction of the canal without their consent and failing to protect their territorial rights in the face of illegal mestizo settlement, violent land conflict, and widespread ecological destruction. By granting an illegal title the government had violated the constitutional norms and international human rights agreements that protect the territorial and political rights of Afro-descendant and Indigenous peoples (*Noticias de Bluefields* 2016).

These activists were particularly angered by the FSLN's co-optation of local leaders and its repeated intervention into the affairs of local Black and Indigenous communal governments.[1] They alleged that the government had intervened in 90 percent of the administrations of the region's communal governments, revealing how co-optation and intervention had become the tools of choice to circumnavigate the laws that limited the state's ability to control the region's natural resources. They viewed FSLN's incursions into local-level politics as an attempt to "domesticate autonomy" and bring it into alignment with the Ortega administration's vision of centralized capitalist accumulation (González 2017).

The debates over the Bluefields title and the independence of local communal governments revealed the stark contradictions between costeño visions of autonomy and the state's policy toward the region. As Ortega's comments showed, Sandinista rhetoric about autonomy framed it as an extension and fulfillment of the revolutionary project. Integration of costeños was enacted primarily through the appointment of Creoles to visible positions in the party structure and the

government, as well as the approval of mega-development projects ostensibly aimed at strengthening autonomy. As the party that originally approved the establishment of regional autonomy, the FSLN persistently proclaimed itself as the only party that could implement it.

But Creole activists argued that, far from strengthening regional autonomy, the Sandinista party-state radically weakened it through co-optation and intervention. Nora Newball was one of the community leaders who filed the constitutional challenge against the irregular land title; she had been deposed from her post as president of the Bluefields Black-Creole Indigenous Government when the FSLN approved the formation of the parallel government. She argued that the FSLN diminished regional autonomy by strategically manipulating the laws to consolidate Sandinista hegemony at all levels of governance. "We have autonomy, in general," she said. "But we ask ourselves what kind of autonomy are we talking about? There is no autonomy here. We do not manage our natural resources here. They simply want to say that here we are autonomous because they are restoring the right to our language, our culture, our traditional dances, our food, in education but that is not everything. What about the land?" (CALPI 2017).

Newball's statement encapsulated important contradictions between the government's and costeños' understandings of autonomy: Sandinista multicultural rhetoric narrated autonomy as an institutional mechanism for assuring the integration of cultural difference into normative ideas of citizenship, whereas Black and Indigenous costeños were cultivating a more militant understanding of it as a political project rooted in the struggle for regional self-determination, political representation, and the ability to meaningfully determine the material conditions of Black and Indigenous social life.

This chapter examines how the process of multicultural dispossession has unfolded in the context of deepening authoritarianism. Specifically, I trace the continuities between the postrevolutionary period of neoliberal economic reform and the FSLN's project of political ascendance as an extension of the state's long-standing colonial relationship to the Caribbean Coast. I explore how the Ortega administration's vision of political integration and its centralized, neoliberal model of development came into conflict with the political aspirations of Black and Indigenous communities. The Sandinista state's co-optation of multicultural discourse and regional autonomy led to the emergence of more grassroots, autonomous forms of political activism against the authoritarian turn and also helped inspire a militant critique of the state's assault on regional autonomy and land rights as a form of slow, institutionalized genocidal violence. Black activists have engaged in forms of activism that link regional struggles, the nationalist anti-canal movement, transnational forms of human rights litigation, and digital media activism. But unlike their new political allies in the anti-canal movement, Black activists did not merely demand the return to a normative democratic political order but rather highlighted the foundational racism that characterizes Nicaraguan state sovereignty. This chapter examines how these dynamics played out in local debates

over leadership and representation and shaped the strategies that Black activists in Bluefields developed to build a multiscalar movement against the authoritarian turn.

AUTONOMY IS THE REVOLUTION ON THE COAST

When President Ortega returned to office in 2007, his administration declared it the beginning of the "second stage" of the Sandinista Revolution. He claimed that it would complete the revolution's unfinished business by eradicating poverty, creating jobs and economic growth through a series of mega-development projects, reestablishing a system of direct democratic citizen participation, and developing a project of national reconciliation to decrease political polarization in the country.

Multicultural recognition is a defining feature of this discourse and is central to its rhetoric of reconciliation, restoration of the rights of the poor and minority communities, and social transformation. Accordingly, the full integration of the coast into the national body politic figures prominently in Ortega's statements and policy initiatives. Thus, the titling of Black and Indigenous communal lands is not only the fulfillment of a historical mandate but also affirms the FSLN as the only political party that recognizes and honors these rights.

According to the Sandinista multicultural discourse, autonomy is not a historic project led by Black and Indigenous peoples to restore their ancestral rights to territory and regional self-governance; instead, it is an extension of the revolutionary project and the progressive benevolence of the Ortega administration. Accordingly, Sandinista autonomy is not hostile to nationalist projects but has folded these projects into the state's centralized economic development agenda. One Miskita politician affiliated with the FSLN succinctly stated this claim: "Autonomy is the new revolution in our region" (*El 19* 2014). This narrative is further illustrated in an official statement that commemorated the twenty-seventh anniversary of the passage of the Autonomy Law. The statement quoted Carlos Aleman, coordinator of the North Caribbean Coast Autonomous Regional Government, who said, "Autonomy is how we continue deepening the revolution here on the Coast, the titling of Indigenous lands, the electrification of the communities, improvements in the roads, improvements in [agricultural] production. This is the whole process that the country is living through but that has to do with the ethnic and cultural element" (*El 19* 2014).

The performance of state benevolence and regional gratitude is a critical affective dimension of this official rhetoric. In his speech accepting the communal land title on behalf of the Bluefields Creole community, Ralph Mullins repeatedly thanked "Comandante Daniel y la Compañera Rosario" and praised the administration as being the "only government that has recognized the rights of afro-descendant and Indigenous peoples." He thereby demonstrated how the state strategically uses events like the titling ceremony to stage carefully orchestrated performances of harmonious multiculturalism. These choreographed scenes of political benevolence

and gratitude are intended to elicit an affective response of loyalty and a sense of national inclusion designed to visually and discursively align the interests of the coast with those of the FSLN party-state.

These performances serve to legitimize the state's policies in the region while also obscuring how the Ortega administration has perpetuated the colonial project of modernization and the centralized development of previous governments. Creole activists in Bluefields, for example, pointed out that even though the government handed out titles to local communities, it consistently failed to carry out the last and most important part of the demarcation, the process of *saneamiento*. During this step, as outlined by Law 445, the government is required to help local communities regularize land claims, resolve any conflicts over private property held on communal lands, and develop agreements between communal and private property owners to ensure that communal land is not sold. Yet despite the state's granting of communal titles to Black and Indigenous communities, landless mestizo farmers, mostly from the Central Pacific region and displaced by agro-industrial corporations, continued to stream into the region.

From 2015 to 2018, Indigenous activists in the RACCN reported that mestizo *colonos* had murdered approximately five dozen community leaders and residents. Hundreds more costeños reported being chased out of their communities and forced to abandon their planting grounds. To date no one has been prosecuted for these murders. The government claims that the violence stems not from widespread mestizo settlement but from unscrupulous communal authorities who sell the land to hapless settlers who are also harmed by this corruption (Inter-American Commission on Human Rights 2015b). But these scenes of latent state violence, unfolding on the margins of the nation, are rarely reported in the national media, which allow the Ortega administration to provide its own narrative about the effects of its regional development agenda.

In other ways, the FSLN appeared to have learned its lesson the second time around. To solidify its performance of multicultural recognition, the administration appointed several Creole political figures to prominent positions in the municipal, regional and national government. None wielded more power in the region than Lumberto Campbell, who served as the secretary of the Development Council of the Caribbean Coast from 2006 to 2014 and as vice president of the Supreme Electoral Council since 2015. According to the costeño political scientist Miguel González (2015), Campbell's voice "is the voice that the high leadership of the FSLN listens to on questions related to the Caribbean Coast, especially President Ortega and his inner circle."[2]

Campbell has often repeated the political claim that "for the coast, autonomy is the revolution"; thus, this claim reflects the comandante's "vision of the coast as a region fully integrated into the country in which the rights of Indigenous and Afro-descendant peoples have been clarified and no conflicts regarding communal property, illegal occupations of private property, or abuses of authority and territorial

jurisdiction exist." It is a vision of multicultural autonomy in which the coast's many ethnic groups and the region's governing institutions exist harmoniously with the central government "inspired by the principles of the revolution and leadership of the FSLN." This political vision exists alongside a pragmatic economic vision in which "development can only occur if private economic actors and foreign and national capital can generate employment, investment and growth and that these will materialize through large scale infrastructure projects (the generation of energy, extractive industries, agro-industrial expansion, and technological innovation) in which the state will be an efficient facilitator" (González 2015).

In Campbell's vision of economic and political regional integration, the FSLN is the only political party that can fulfill the historic mandate of regional autonomy, a project that he helped build. Thus, he has supported what González characterizes as a model of ingenuous authoritarianism: "The comandante is convinced that it is necessary to strengthen the revolution, which means governing with hegemony, with the FSLN in control of autonomous institutions and tolerating a small and domesticated dissent, through alliances and agreements."[3] Campbell's commitment to the Ortega administration's centralized model of economic development and his insistence that this economic agenda is compatible with a system of decentralized regional autonomy have become critical parts of orthodox Sandinista discourse in the region.

This discourse pervaded every level of governance. In February 2017 I met with Bridget Budier, the political secretary of the FSLN Party in Bluefields. A half-dozen people sat outside her office, patiently waiting to meet with her. She greeted me warmly and ushered me into her office. I had met Budier many years earlier when I interviewed her about racial discrimination in Nicaragua after she and her family were denied entry into a popular Managua nightclub.[4] I began by asking her about the state of regional autonomy under the FSLN. She spoke enthusiastically about the development plan and the government's commitment to provide a dignified life for costeño residents through its social programs.

When I asked her about the critiques that I heard from local residents and activists regarding the conflict over the two communal governments, the greatly reduced size of the Creole territorial claim, the unconstitutionality of the canal project, and, most importantly, the FSLN's consolidation of institutional power in the region, she bristled but responded politely: "Every government want to control the state, every political party have a program, for example, like the Democrats and Republicans [in the United States]." When I replied that this system of bipartisan power sharing was not working out that well in the United States, she exclaimed, "You understand!"

I pressed further, saying, "When I talk to people here, they say things like 'If you are not connected to the party, you cannot get a job.' I hear people say things like 'We don't really feel like we are picking our political representatives; we cannot say what we want, because the orientation comes from Managua, and if we

want something that goes against what the government wants but that we think is best for the coast, that's not going to happen because the order is coming from the Central Government.'"

She fidgeted in her seat and frowned but maintained her composure, responding,

> Well, you know, I think people have they point and maybe sometime you need a discussion about that. Now what I think people said is like "Okay, we have a plan of development, and this is what we want to achieve." So everybody have the same discourse.... So, if you talk to somebody from the regional government, they are going to talk about the plan of development, if you talk to me, if you talk to somebody who is in the [central] government, you are talking about the plan of development, because otherwise you jumping up and you do not know where you want to go. So, I think there is where people might say, "They repeating." No, this is our just our thing.[5]

I had the distinct feeling that we were talking past each other. I rephrased the question: "Again I am not talking about the programs. I think most people seem to like the idea of the development plan. I am more concerned with the actual system of governance, which is to say is Nicaragua at this moment a truly open and democratic society?"

Budier paused and then replied,

> I ask what is democracy? And people don't seem to give me the right answer. So, I said democracy is when you are doing things, when you consulted at some moment where the rights of people is being respected—and you going to have some opposition! Even Christ when he was here and try to do the best he could, even he was criticize. So, for me this is democracy, when your human right is being respected, when you see the thing is being done for the majority. And you going have people who don't agree with absolutely nothing.

Budier's comments illustrated what I have come to think of as Sandinista rhetoric under the authoritarian turn. It is a sophisticated discursive strategy that has enabled the administration to align incongruent political ambitions and agendas with its centralized agenda of political consolidation and expansion of an extractive development model on the coast. This rhetorical strategy incorporates an affective language of peace, love, reconciliation, and national unity under the messianic leadership of the FSLN and its two leading figures, Comandante Daniel Ortega and La Compañera Rosario Murillo. The use of religious symbolism and discourse is a defining feature of Sandinista rhetoric: all government programs are framed as the fulfillment of both a political and divine obligation to serve the nation's most vulnerable citizens. Thus, Budier's reference to Christ was not incidental but intentional. Regional FSLN representatives also use religious discourse,

framing the party's mission using ecclesiastical values of piety, self-sacrifice, generosity, charity, and solidarity to describe the administration's development agenda. Thus, critiques against the administration are often framed as moral attacks on the party rather than as policy differences.

The administration's rhetorical approach also tended to conflate development and democracy, treating them as interchangeable signs of good governance and robust citizen participation. In public pronouncements and official government media, state representatives argued that previous neoliberal administrations had pursued free-market expansion at the expense of the nation's poorest and most vulnerable citizens, a critique that is not without merit. The FSLN responded by pursuing a model of limited redistributive development, offering tangible, immediate, and direct aid to impoverished farmers and poor families across the country. Ortega campaigned on populist promises that he immediately put in place through an ambitious set of social programs. The popularity of these programs was so widespread precisely because previous neoliberal administrations had abdicated their role in the provision of public goods and services, turning them over to the private and NGO sectors.

But the political implications of the Ortega administration's programs quickly became apparent. In 2008, the administration established Citizens' Power Councils (CPCs). Ostensibly this model of direct democracy would enable greater decision making and citizen empowerment at the local level. But critics alleged that the CPCs merely extended the FSLN party-state's control over local political affairs. Rather than enabling direct democracy, they became an institutional mechanism for managing the distribution of resources, employment opportunities, access to social programs, political influence, kickbacks, and favors from the party.

Nevertheless, although the CPCs exercised a hegemonic influence in daily political affairs, theirs was not a totalizing influence. In fact, it was precisely at this moment that many Creoles began to create their own autonomous political spaces that refused the encroachment of national political parties and the government. These ongoing tensions reflected, as Cupples and Glynn (2018) argue, the fundamental contradictions in the Sandinista rhetoric on autonomy, multiculturalism, and inclusion: the administration "maintain[ed] a pro-Caribbean Coast autonomy discourse, while subjecting the autonomy process to colonial and imperializing strategies" (22). These strategies included placing Creole party loyalists in prominent but largely symbolic positions of power to provide the appearance of regional consent to the state's development agenda, the co-optation of autonomous political spaces, and defaming and harassing Black activists who opposed the state's policy ambitions for the region. Thus, the state sought "to contain pro-autonomy energies within a nationalist and Sandinista narrative frame and marginalize the radical" political visions of Black and Indigenous communities (22). The FSLN party-state's encroachment into regional and local political institutions became a key site of struggle when the Ortega administration resurrected a hundred-year-old development dream.

CANAL DREAMS

In June 2012, the Bluefields Black-Creole Indigenous Government (BBCIG) sub-
mitted a territorial diagnostic for the Bluefields communal land claim to the
National Demarcation and Titling Commission (CONADETI) to formally begin
the land titling process.[6] The diagnostic presented a land claim for two million
hectares of land that included half the territory of the former Mosquitia. The
BBCIG based its claim on three legal documents: an 1841 title that the Miskitu
king Robert Charles Frederick granted to the Bluefields Creole community; a 1916
title from the Titling Commission of the Mosquitia to half the island of Deer Cay
in the Bluefields Bay; and a 1934 legislative decree that granted 40,000 hectares of
land to the Bluefields Indigenous Creole community. BBCIG leaders claimed that
these historical precedents "fully justify the territorial claim of the Black Creole
Indigenous community of Bluefields over its traditional and historic territory"
(BBCIG 2013; PNUD 2005).

Completing the claim had been a lengthy and difficult process. The BBCIG,
with the support of foreign philanthropic organizations, regional NGOs, and
researchers, conducted a census of the Afro-descendant population, completed a
comprehensive ethnographic and socioeconomic study, documented Creole land
tenure and land use practices, and hosted a series of workshops to resolve prop-
erty disputes between Creole and Indigenous communities within the Bluefields
territory, as well as with the Twelve Indigenous and Afro-Descendant Communi-
ties of the Pearl Lagoon Basin and the Rama-Kriol Territorial Government. For
many years the BBCIG had received no funding at all from the state despite being
a recognized governing body. Thus, it had to look to the international human
rights funding sphere to be able to do the necessary research. The BBCIG then
convened a communal assembly in which representatives from local communal
governments in the territory reviewed and approved the territorial diagnostic. In
2012, CONADETI accepted it and proceeded to the next steps.

Members of the BBCIG were cautiously optimistic about the process. It
appeared that the Bluefields Creole community would at long last receive a com-
munal title to their ancestral territory. But the title was not forthcoming. As the
months and then years dragged on, local activists demanded to know why the state
was delaying the process, especially while landless mestizo farmers from the Pacific
continued to settle on Black and Indigenous lands.

On June 13, 2013, the National Assembly approved the "Special Law for the Devel-
opment of Nicaraguan Infrastructure and Transport in respect to the Canal, Free
Trade Zones and Associated Infrastructure." Law 840 allowed the state to grant a
fifty-year concession (with the possibility of a fifty-year renewal) for the construc-
tion and exclusive management of an interoceanic canal to the International Hong
Kong Nicaragua Canal Development Group (HKND). The canal, which the gov-
ernment claimed would be three times the size of the Panama Canal, would be
275 kilometers long, bisecting the country from east to west and cutting through

wide swaths of Black and Indigenous communal lands, as well as through the private property of mestizo farmers on the coast and in the Pacific. To obtain these lands, the law granted the state and the HKND Group the right to expropriate any lands deemed necessary to carry out the canal project.[7] There was no bidding process, nor was there any public discussion of the law: the FSLN-controlled National Assembly debated the law for a mere three hours before approving it.

Law 840 sparked an outcry among civil society organizations and Black and Indigenous communities. Human rights groups pointed out that the canal would have a disastrous impact on the environment, property rights, and livelihoods of the nation's most vulnerable populations. Azahalea Solís, a human rights attorney, argued that the law granted "excessive privileges" to Wang Jing, the chairman and CEO of the HKND Group and in so doing was "renouncing its sovereign authority over the territorial space." Yet the canal's potential impact was difficult to determine because the government had not completed an environmental and social impact assessment. Within weeks of the law's approval, environmental organizations, human rights organizations, and Indigenous and Afro-descendant groups filed a series of suits against the government on the grounds that it violated private and communal property rights, the right to a clean and healthy environment, the right to water, the right to livelihood, and the right to fair, transparent, and informed consent. On July 1, members of the BBCIG and the Rama Kriol Territorial Government (GTRK), which represents Black and Indigenous communities in the adjacent territory south of Bluefields, in collaboration with the Nicaraguan Center for Human Rights (CENIDH), filed one of the first constitutional challenges. Between 2013 and 2016 the BBCIG and GTRK filed ten suits against Daniel Ortega (Cupples and Glynn 2017).

Black and Indigenous communities were not the only ones concerned about the canal law. Mestizo farmers from Nueva Guinea became alarmed by the proposed canal routes, all of which would run through private property held by small-scale farmers. In November 2014, representatives from campesino communities formed the National Council in Defense of the Land, the Lake and Sovereignty. Their goal was simple: repeal Law 840. The council began holding protest marches and demonstrations, circulated a petition to repeal the law signed by 28,698 Nicaraguans, and filed multiple suits against it. From 2013 to 2018 there were more than ninety peaceful marches and demonstrations throughout the country; thousands of people participated, often traveling on foot nearly three hundred kilometers to the capital.

The state responded aggressively to the protests by sending FSLN-affiliated paramilitary groups and antiriot police who used tear gas and rubber bullets to disperse the demonstrators. The police illegally detained protesters, many of whom were beaten while in detention, and arrested others on fraudulent charges related to the protests. Francisca Ramírez, a forty-year-old farmer from La Fonseca district in the municipality of Nueva Guinea, became one of the most vocal critics of the canal law and the state's repressive response. She

received death threats, her family suffered police harassment, and two of her vehicles were temporarily confiscated by the police. The writer and former Sandinista politician Sergio Ramírez described her as "the only real leader in the country" (Le Lous 2016).

The emergence of the anti-canal movement produced a new set of political alliances among environmentalists, campesinos, journalists, intellectuals, and Black and Indigenous activists. Dolene Miller and Nora Newball were selected to serve on the Municipal Council in Defense of the Land, the Lake, and Sovereignty, representing both the interests of Black communities in Bluefields and the campesino movement and engaging in a politics of solidarity that they had begun to cultivate years earlier (Salazar 2017). As these new alliances were consolidated, the anti-canal movement developed into a large, broad-based social movement representing the single greatest challenge to the authoritarian turn. The "place-based singular struggles" that converged in the anti-canal movement evolved into a much larger critique of the Ortega administration (Doornbos 2016, 28).

Nora Newball shared with me how the anti-canal movement allowed Black activists to connect with mestizo campesinos in the region. Mónica Lopez Baltodano, a human rights attorney with the Popol Nah Foundation, invited Newball and Miller to speak with a group of mestizos from the district of La Unión in the municipality of Nueva Guinea. More than 150 mestizo farmers crowded into a local school gymnasium to hear the BBCIG's presentation on the Bluefields land claim, the history of regional autonomy, and the laws that govern these processes. Although she knew that the vast majority of Nicaraguans were largely uninformed about the Autonomy Law and Law 445, Newball was surprised by how little these farmers, many of whom had lived in the region for many years, knew about the demarcation and titling process.

The encounter confirmed much of what Black activists had long suspected about the state's role in fomenting division between mestizo settlers and Black and Indigenous communities. Newball recalled,

> They even mention that the politicians go into those areas and they tell them that the Black people and the Indigenous people because they are owners of the territory— because the laws give them right—they have plans to run them out of the land. You see? Because is the contrary of what they does do here. Here now what they do, in Bluefields or let's say for example with the Rama-Krioles, especially these two territory, what the politicians come and tell us here is that if we go into that area where these mestizos *campesinos* are they are going to kill us because this is people with machete and they don't want to hear anything about the owners of a territory. They tell us if you don't war, then just stay out of those area. So, we could understand the plan, the strategy what the government have been doing first to take away the territories of the native people. And second for those people that live inside of the autonomous territory they don't care or don't want nothing to do with autonomy.

Newball also pointed out that educated mestizo professionals from the Pacific had little understanding of regional autonomy.

The BBCIG used these new alliances to challenge mestizo human rights activists to communicate the political situation of the coast to the mestizo majority. They insisted on a real politics of solidarity that went beyond political expediency and demanded that mestizo allies become versed in regional antiracist politics. This was critical because as the canal movement gained strength, Black and Indigenous political demands were often sidelined in public discourse about the movement; the national media tended to focus on the state's repression of the campesino movement, which became "the main object of solidarity proclamations" while "public sympathy with the particularities of Indigenous resistance [did] not [evolve] to the same extent" (Doornbos 2016, 29). This began to shift in 2015 as the wave of mestizo settler violence against Indigenous communities in the northern Caribbean coast moved to the center of Nicaraguan political discourse, and regional activists and journalists called on the government to address this growing humanitarian crisis. Nevertheless, opportunities to build multiracial solidarity in the context of the anti-canal movement marked an important turning point in these communities' struggle for recognition, autonomy, and territory.

BBCIG activists were quick to point out, however, that these alliances were pragmatic. As one BBCIG member remarked, "The thing with the mestizos *campesinos* them they was comfortable. Them never was concern about the Law 445, but the state get greedy when it make that law. They condemn it, it tick the mestizos them, it make them jump! If something bite me but no bite them, them no care! But afterward the same mosquito what bite me start bite them, too, then them start jump! That is what cause the reaction . . . and there is where the state make a mistake."

On December 18, 2013, the Supreme Court of Justice (CSJ in Spanish) dismissed all thirty-one constitutional challenges against the law. This was disappointing but not altogether surprising because the FSLN has dominated the nation's judicial branch since the 1990s. In their ruling, the justices claimed that the government had acted within the boundaries of the law and reiterated the government's commitment to honor the cultural and territorial rights of Indigenous and Afro-descendant communities. Undeterred, members of the anti-canal movement took their case before the international human rights community. In March 2015, attorneys and activists representing eleven organizations and movements appeared in a public hearing of the Inter-American Commission on Human Rights (IACHR) to demand the repeal of the Law 840.

Despite the growing movement against the canal, the government moved forward with its plans. On December 22, 2014, Wang Jing, the Chinese billionaire at the head of the HKND Group, broke ground on the project in Rivas. But the promised canal never materialized. Jing reportedly lost 85 percent of his fortune when the Chinese stock market crashed in 2015. Wang Jing has not returned to

Nicaragua for some time, and it seems increasingly unlikely that the canal will ever be built.

But the canal law sets a dangerous precedent. While it remains on the books, it provides a legal loophole that allows the state to expropriate land, thus removing political obstacles to its project of centralized development. It provides the state with a legal mechanism to circumvent Black and Indigenous communal land claims and multicultural political rights established under the Autonomy Law and Law 445. In Bluefields, debates over the canal sharply polarized the community as the state developed a new tactic for undermining the regional struggle for territory and repeal of Law 840, provoking a crisis over the meanings of local leadership, representation, and autonomy.

HAULING AND PULLING: THE POLITICS OF CO-OPTATION AND LOCAL DIVISION

In December 22, 2013, the BBCIG convened a communal assembly at the gymnasium of Moravian High School to elect the new officers of the Executive Committee. Representatives from Creole communities throughout the RACCS attended and elected Nora Newball to serve as president of the Executive Committee of the BBCIG for a four-year term. The election was carried out in accordance with BBCIG's bylaws and the terms of Law 445 and was certified on January 20, 2014, by Vernadine Lopez, then president of the Regional Council of the RACCS.

The following February, a group of Creoles led by Merando Hodgson, a pastor and former member of the BBCIG, filed a constitutional challenge alleging that the elections were illegal because not everyone who was present at the communal assembly was eligible to vote. In response, the regional Appeals Court suspended the certification of the BBCIG, leaving it in legal limbo. The suit had been filed in Bluefields, but the local courts quickly sent the case to the Supreme Court of Justice (CSJ). Even though the CSJ had quickly reviewed and dismissed all the BBCIG's suits against the government related to the canal project, the court dragged its feet on Hodgson's constitutional challenge. When it finally reviewed the suit, Hodgson failed to appear in court. The Appeals Court should have then dismissed the case. But the case remained open, and thus, the integrity of the 2013 communal government elections remained in dispute.

The timing of the suit was clearly political. Regional elections took place only six weeks later, and in a historic victory, the FSLN secured thirty of the forty-five seats in the Regional Council of RACCS. For the first time in the history of the autonomous regions, the FSLN had complete control of all the region's legislative and judicial institutions from the national to the municipal level. The only political institutions that the party did not control, however, were the communal and territorial governments protected under Law 445. As leading figures in the

anti-canal movement, Nora Newball and Dolene Miller were known as fierce critics of the Ortega administration. After the emergence of the anti-canal movement, they became increasingly vocal in their critiques of the state's policy toward the coast and its performance of multicultural recognition while dispossessing Black and Indigenous communities of their territory, natural resources, and livelihoods and intervening in communal governance structures. Since their formation in 2004, the communal and territorial governments of Black and Indigenous communities had distinguished themselves from municipal, regional, and national political institutions by remaining fiercely nonpartisan. They resisted the encroachment of national-level political parties, choosing only to back regional parties while maintaining a wary stance toward the national parties. They cultivated a strong local vision of self-determination that placed regional and communal concerns at the center of their political and economic agenda.

For the Ortega administration to bring the system of regional autonomy into alignment with its centralized vision of revolutionary development, the FSLN needed to extend its control over the communal governments. On September 29, 2014, Rayfield Hodgson, a *concejal* in the Regional Council, held an assembly to elect a new Executive Committee for a parallel Creole Communal Government of Bluefields. He claimed that he did this to "avoid the BBCIG remaining leaderless . . . since the past elections were made null and void because of the personal interests of those who were not thinking about the well-being of this ethnic group." But the BBCIG was not leaderless; the CSJ had not issued a ruling on the suit against Newball and the Executive Committee.[8] Approximately 390 people attended the assembly, including Bridget Budier, political secretary of the FSLN for the municipality of Bluefields, and Carla Martin, the mayor of Bluefields (FSLN). Ralph Mullins, a schoolteacher and coordinator of the Family Cabinet in the Santa Rosa neighborhood, was elected president of the new parallel government. His election was certified forty-eight hours later by Mario Holmes, first secretary of the Regional Council and also a member of the FSLN, even though the BBCIG had presented a petition to the Regional Council with nearly 1,000 signatures in support of the original BBCIG Executive Committee.

The following month, Judith Abraham, president of the Regional Council (FSLN), ordered the closure of the BBCIG office and demanded that it turn over all documents related to the Bluefields land claim. Community members sided with the BBCIG and slept on the floor outside the office for three nights to ensure that no one would attempt to break in and steal the documents; they also began to collect funds from the community to keep them in that space. Abraham withdrew the closure order, and the BBCIG returned to its office, continuing to fight against the parallel government.

The formation of the parallel government created intense division in the community. Newball and the BBCIG Executive Committee immediately filed a constitutional challenge against both Rayfield Hodgson and Mario Holmes, alleging

that they had formed the parallel government at the behest of the Ortega adminis-
tration. Hodgson, however, responded to the lawsuit using a discourse of multi-
cultural recognition: "You cannot rule against the decision of a people, the Black
people voted and they [the BBCIG] have to respect it" (qtd. in León 2014).

Despite the fact that the CSJ had not issued a ruling on the suit, the national
government begin to direct all government funds, programs, and policy initiatives
to the parallel government, obtaining approval for local infrastructure projects
and revising the initial territorial claim. In November 2014, Rayfield Hodgson
convened a meeting in which both Bridget Budier and Johnny Hodgson, the
Regional Political Secretary of the FSLN, were present. According to former mem-
bers of the parallel government's Executive Board, Hodgson presented a new pro-
posal by the government to title the Bluefields land claim. The alternative demarcation
proposal radically reduced the territorial claim by 93 percent from 2,004,952 hect-
ares (4,954,344 acres) to 114,696 hectares (283,419 acres). Hodgson told the
members that the government was prepared to approve the proposal the follow-
ing month, and he urged the group to approve the proposal before then. Several
members objected, pointing out that Law 445 requires that the territorial land
claim be approved by a vote during a communal assembly and could not be sub-
mitted without this approval. For the reduced land claim to be approved, it would
need to go through the same legal process as the initial land claim. The meeting
was adjourned without the approval of the proposal, but it immediately became
clear why the government had proposed the reduced land claim.

By reducing the size of the claim, the government achieved three objectives.
First, it confined the Bluefields Creole territory to areas that would not be in the
path of the interoceanic canal. Second, 4.9 million acres minus 283, 419 acres would
effectively become national lands, allowing the state to grant concessions, exploit
natural resources, and sell or lease them. In addition, because these lands would no
longer be communal lands, the central government would not be obligated to seek
community approval for them or return 25 percent of the revenues generated from
these economic activities to Black and Indigenous communities in accordance
with Law 445. Third, by titling the reduced Bluefields land claim, the Ortega admin-
istration could present itself as a progressive government committed to protecting
the rights of these communities.

The Nicaraguan's state's three-pronged strategy of dismantling local, autono-
mous political institutions through the creation of parallel, pro-government com-
munal boards, reducing the Bluefields Creole land claim and using legal subterfuge
to push through the canal law was further bolstered by the endorsement of local
Creole FSLN party members and leaders. Not only did they actively support the
parallel government, labeling the female leaders of the BBCIG as "frustrated" hys-
terical women who refused to concede power, they praised the government for sup-
porting the Creole land claim while dismissing critics as idealists who were blocking
the government's pragmatic development agenda. Carla Martin, the mayor of Blue-
fields, stated that the government's demarcation proposal was more realistic than

the original claim: "What has really been delaying us is that there have been colleagues who have not been able to agree. There is a group that is claiming beyond what may belong to us. And those of us who are realistic say this is what belongs to us and this is what we should claim" (CALPI 2017).

Government representatives also depicted critics of the canal project and the reduced title as self-serving, anti-development contrarians. Johnny Hodgson, the Regional Political Secretary of the FSLN, stated,

> When the Development Strategy was prepared one of the things that was established was that we take advantage of the natural resources that God has given us to generate wealth and well-being for the people, and this is what we are trying to do, some do not understand—others do—but they do not want us to advance, to be successful, they oppose simply to be oppositional. . . . As Sandinistas in the Government we are entrusted with two missions, they are not easy missions. . . . No other government has had success defeating Poverty, much less selfishness, we have to convince many people to combine efforts to defeat Poverty and Selfishness.

He also dismissed the accusation that the reduced title was an attempt to expedite the interoceanic canal project:

> The canal has nothing to do with the Creole people. The canal passes through territory that is already demarcated which is the Rama and Kriol Territory. And in order to build the canal through that territory, you have to have free, prior, and informed consent. That is something established by the United Nations. It has its procedure and its form and if you do not do that you cannot build the canal. And that process is already underway. But that has nothing to do with the Creoles. The Creoles' territory gets demarcated and nothing happens. It is not linked. (CALPI 2017)

The co-optation of the BBCIG illustrates the mechanisms through which the FSLN party-state has imposed its will on the nation's political institutions and how it has strategically used the laws that established regional autonomy to make autonomy synonymous with a neoliberal development agenda.[9] This strategy has sought to disempower these communities, contain the political possibilities of autonomous regional governance, and delegitimize the grassroots political critiques emerging from Black and Indigenous communities. To some degree the FSLN has been successful, but its victory has not been complete. At the local level, the role of the BBCIG became a central issue in struggles over community representation and leadership that moved far beyond Bluefields. It reinvigorated grassroots critique of the state and became an important touchstone in broader debates over the state of democracy. And as it became clear that the state lacked the will to meaningfully comply with the spirit of the nation's laws to protect and uphold regional autonomy, Black and Indigenous activists took their struggle against the state to the transnational human rights sphere.

FIGHTING THE SYSTEM

In October 2015, Newball and Miller participated in a public hearing before the Inter-American Commission on Human Rights (IAHCR) with Lottie Cunningham, director of the Center for Justice and Human Rights of the Atlantic Coast of Nicaragua (CEJUDHCAN); Jorge Mendoza, president of the Miskitu communal government of Twi Waupasa; and attorneys with the Center for Justice and International Law (CEJIL). The petitioners alleged that the Ortega administration had failed to complete the process of saneamiento and failed to protect them from a wave of violence by mestizo colonos. They further accused the government of engaging in a campaign of "political harassment" and intervention into the region's communal and territorial government structures (Vilchez 2015; Inter-American Commission on Human Rights 2015).

During her testimony, Nora Newball delivered a scathing indictment of the state of Nicaragua. In it, she described the convoluted process by which she was removed from her position in the BBCIG and the parallel government was illegally formed. She argued that these forms of intervention revealed a latent form of institutionalized racism, enacted through the structural mechanisms of normative governance: "Today we see how the same state that has approved the laws that restore our rights now promotes the opposite, creating division, conflict, and confrontation within the Afro-descendant community" (IACHR 2015).

In their responses, state representatives insisted that the administration had not interfered with the elections of communal governments. Regarding the "supposed violence" against Indigenous communities in the region, Javier Morazán, the fiscal director of the Special Anti-Corruption and Organized Crime Unit of the Public Ministry, claimed that the state had not received any complaints of violence stemming from territorial disputes; instead, the violent crimes in the region were related to family conflicts, property and inheritance disputes, domestic violence, and narcotics trafficking within Indigenous communities. He further alleged that land trafficking was the result of corrupt Indigenous communal authorities linked to YATAMA that sold land to unsuspecting mestizo colonos, who were then compelled to defend their property claims from aggrieved Indigenous communities. Thus, the state shifted the blame for violence and land grabbing in the region to Indigenous communities while also diminishing the conflicts as internecine community squabbles that were not linked to larger political processes (IACHR 2015).

The state's discursive strategy was mirrored in its framing of the conflict between Creole activists and those Creoles embedded in the FSLN party structure and the Ortega administration as a local power struggle, a narrative that Creole activists flatly rejected. By the time Newball delivered her testimony to the IACHR, tensions in the Creole community over the state's intervention were high, and BBCIG activists and FSLN supporters were taking to the radio airwaves and social media to denounce one another. One community leader, a

well-known local personality who aligned herself with the FSLN, hosted a weekly radio program where she routinely blamed Newball and Miller for creating the conflict by refusing to accept the new, state-recognized parallel government. Pro-government radio hosts dismissed them as hysterical women who had disrupted the social order by getting "mix up" into politics. The rhetoric of regional Sandinista supporters mirrored the state's discursive stance at the IACHR hearing, which reduced political conflicts to interpersonal squabbles between local power brokers.

It was common in Bluefields to hear residents lament the lack of unity among Black people as a kind of pathological cultural trait, a "crabs-in-a-barrel" mentality that prevented Black people from effecting policy change at the regional and national level. BBCIG leaders and their community supporters argued instead that the local conflicts reflected the larger political dynamics at work that were actively reshaping the nation's political institutions. Jennifer Brown, a local feminist activist with the Black Women's Organization of Nicaragua and the Red de Mujeres Afrolatinoamericano, Afrocaribeña y de la Diáspora, said that people often "say Black people in Bluefields is not united. It like it hard for them to unite. But it's a policy that the government, in reality, have create to separate us."

While Creole and Indigenous activists were denouncing the state of Nicaragua in the international human rights arena, the parallel government forged ahead—with the support of the national government—with the irregular, reduced land claim. In December 2015, the parallel government submitted the irregular claim, which contained 88,468 land hectares and 61,109 marine hectares, including the Bluefields Bay and protected wetland areas, to CONADETI. On March 13, 2016, CONADETI recommended approval of the title of the parallel government, a mere three months after its submission, even though it had taken the government more than twelve years to accept the original BBCIG claim. The national government then approved the reduced claim in less than a month. Ironically, the day after the government announced its approval of the title, the national center-right newspaper, *La Prensa*, reported that, just one week earlier, government officials had offered four million hectares of available land to Russian and Latin American foreign investors during the Ronda de Negocios y Foro Mediático Rusia-América in Uruguay. Thus, even as the state was declaring that it was restoring the rights of Black and Indigenous communities, even in a very limited way, it was using coastal lands to attract private foreign investment.

In August 2016, the regional government held a ceremony in Reyes Park to commemorate the 175th anniversary of emancipation in Bluefields. Judy Abraham Omeir, president of the Executive Board of the Regional Council, opened by reading a statement by the Regional Council declaring August as Black Heritage Month and that it would "create regional and national consciousness about the contributions of enslaved Africans to the social and economic well-being of Nicaragua." Suddenly, in the middle of reading this statement, a group of Creole protestors, led by Nora Newball, Dolene Miller, and other members of the BBCIG, disrupted the

ceremony, shouting, "We want our land! No to the interoceanic canal!" and heckling the speakers. When the next speaker, Johnny Hodgson, began to talk about the history of slavery and emancipation in the region, Miller shouted him down, accusing him and other officials of failing to defend the community's land claim. "Where the land, Johnny?" she asked. "You eat the demarcation law! Hey you, Judith, you eat the demarcation law!"

The situation escalated when Miller threw a fistful of money into Hodgson's face calling him a sellout and a traitor to his people. She later said she threw the money because Hodgson had made a vulgar hand gesture at her.[10] "Today this group of Black politicians are demonstrating that they suffer from mental slavery, submitted to the will and interests of the state party," she said. "That's why I threw the money in Johnny's face, for two reasons: for being a traitor to his people and for being vulgar, because he made a vulgar gesture at us" (qtd. in Lacayo 2016).

State and party functionaries lamented the "lack of unity" among Black people on what should have been a historic celebration. Hodgson remarked later, "We have to have patience; there was a small group trying to cause a provocation at the beginning of the event, but our *comandante* calls on us to have patience and not fall into provocations. They have the freedom to do what they want, but we are demonstrating with concrete facts that Blacks in Nicaragua have key positions in almost all the ministries of the country" (qtd. in Lacayo 2016).

The ruckus at the emancipation celebration illustrated the deep divisions in the community. It signaled a shift in local discourses of political leadership, representation, and the limits of multicultural recognition. Activists and residents increasingly decried the administration's efforts to co-opt local leaders and thus fracture and politically weaken their communities. In their critiques, they increasingly began to distinguish between community leadership and political leadership imposed by the government.

Elizabeth Wright, a Creole activist, highlighted the difference between community leaders and party functionaries, whom she termed *dirigentes*: "A *dirigente* is not the same as a leader." When I pressed her to explain the difference between the two, she said, "A leader is a natural and he leads anywhere he goes. He represents his community. He speaks for his people. He is the one who takes responsibility for his people. And he reach us, it doesn't matter the limit, but he going there for his people. That's a leader that people would follow you." And a dirigente? "I really don't know the word for that in English," she said and continued,

> A dirigente is like a director. That is the person who is organized. A dirigente would be something like a manager. You do the institutional work. You are the one who follow the rules of the institution, that's a dirigente. So, a leader is different from a dirigente. Lumberto Campbell *es un dirigente del partido Sandinista*. But he's not a leader.... A dirigente is the person holding power in an institution. But a leader moves his people."

As Wright explains, a dirigente is defined by his or her political loyalties. Where a leader is answerable to his or her communities and is willing to do whatever is necessary to defend the interests of the community, a dirigente is accountable to the political party or institution in which he or she serves:

> The thing with all the dirigentes from the coast that they have there—they [the party] chose you. You didn't work your way there. You didn't do anything to get there. They chose you because they know that you are going to be loyal to them. And if you are going to be loyal to the party from the Pacific, autonomy is not on your agenda. It can't because you only can emerge as opposition because they have this boot on your neck. So how you going to join the man that has the boot on your neck and expect that him going give you a chance to do anything?

Many of the people whom Wright characterized as dirigentes had at one time been considered respected leaders in the community. During the postrevolutionary period of neoliberal economic reform, these local leaders, many of whom had been working for the FSLN, forcefully condemned the state for neglecting the region and violating the autonomous and territorial rights of costeños. The FSLN had played an instrumental role in the approval of Law 445, which made their about-face, after they returned to power, even more unsettling for residents, who accused these Black leaders of being "swallowed by the system."

Creole activists rejected the state's placement of Creoles in highly visible government posts as cynical tokenism. They pointed out that, in practice, these individuals exercised little autonomy, often running offices and government agencies that were underfunded and under constant surveillance by the central government. They alleged that the Ortega administration, particularly Rosario Murillo, wielded almost total control over all government institutions and that government officials could make no public statements or appearances that she had not approved. When local communities called on these functionaries to share their concerns about state policy or asked them to participate in community events that were not sponsored by the government, they often declined, claiming that they had not received *orientación* from Managua to do so.

The word *orientación* came up often in interviews and everyday conversations about the encroachment of the state: it had many meanings. On the surface it referred to authorized official state discourse, which meant that government representatives needed to adhere to the administration's policy positions when discussing related issues in public. But the meanings of orientación seemed to extend beyond simply toeing the party line. For example, it became standard in all government speeches for the speakers to give thanks to "Comandante Daniel Ortega y la compañera Rosario Murillo." Government speeches, official documents, and institutional reports repeated party and government slogans extolling the virtues of *buen gobierno*, solidarity, unity, reconciliation, love, and Christian charity. These

performances of party propaganda were replicated at the departmental, regional, and municipal level. One Creole woman who worked for the government told me in 2013 that Rosario Murillo personally oversaw and approved every government event, statement, or public declaration. She referred to Murillo as "the Lady" and explained to me, "Nothing is allowed to happen unless the Lady say so. You cannot speak without the Lady's permission." When she told me this in 2013, I was incredulous; by 2017, her claims were borne out everywhere I looked. From government billboards to radio commercials to local cultural gatherings, the rhetoric of the FSLN pervaded even the most mundane parts of Creole social life. Another colleague shared with me how she quit her job working for the regional government when she was instructed to submit her speech, to be delivered at a forthcoming educational event, for review by her new boss. She received handwritten comments on the speech a few days later, criticizing her for failing to thank Ortega and Murillo by name and telling her exactly what to say. I heard about similar incidents occurring in other government contexts.

As these stories illustrate, not all Creoles who worked for or with the government agreed with the state's intervention into and co-optation of the region's local political institutions. On several occasions I interviewed government officials who were critical of the state and the performance of revolutionary autonomy by many Creole Sandinista leaders. But they were only willing to make these critiques anonymously because they feared retaliation. In January 2018, Shanda Vanegas Morgan, the first Black woman from the coast to serve as the co-executive director of the National Forestry Institute (INAFOR), was compelled to step down from her post after she uncovered widespread government corruption, including misappropriation of funds, the use of institutional funds for personal projects, and evidence of an administrative cover-up in various schemes (*Trinchera de la Noticia* 2018). Other people were also dismissed from their posts for speaking without authorization or publicly criticizing the government.

As it became evident that local and regional leaders could not meaningfully affect state policy toward the region from within state institutions, activists and residents began to argue that it was better to fight from outside the system. This would mean revitalizing, as a site of political struggle, the grassroots that had been largely abandoned during the postrevolutionary period. This return to the grassroots produced a radical shift in local thinking about the meanings of political leadership and an increased recognition of women's central role in leading Black social movements. This shift was illustrated by the growing sense of ownership that local residents took in sustaining the original BBCIG and supporting Miller and Newball as political leaders.

This was a critical turning point in the BBCIG's growing role as a space of Creole political dissent. Newball and Miller had both faced many years of criticism, ridicule, and skepticism from community members who felt that they were not the best individuals for the job. Others alleged that they were involved in the communal government for their own personal financial benefit. Still others criticized

them as being overly emotional and mentally unstable. For many years, I had heard residents dismiss Newball and Miller as too emotional and radical in their approach to politics. As the FSLN increasingly intervened and co-opted local communal boards and the small political spaces of Creole social life, Miller and Newball seemed less crazy and more like the kinds of grassroots leaders whom the community wanted.

When I returned to Bluefields in 2017, I was surprised by this shift in public perception. Even people I had heard dismiss the pair as crazy and irrational now spoke about them with pride and respect as the "only ones that go against the government." As Elizabeth Wright told me, "We have to support these girls. They do not always do things the way I would do it. But they're the only one out here standing up to the government. So, we have to support them."

Many of the women activists whom I worked with, as well as several of their male colleagues, argued that part of the perception problems that Newball and Miller faced stemmed from long-standing gendered social norms about who could be a leader. Community members were much more likely to recognize the leadership of prominent men—particularly pastors, politicians, and professionals—than they were to acknowledge the everyday, grassroots leadership of women. Although residents were deeply wary of politicians, state officials, and Creole FSLN dirigentes, they did not always acknowledge women's community work as leadership. As the struggle over local political institutions intensified, however, community-level understandings of real political leadership began to shift from valorizing institutionalized forms of leadership to grassroots enactments of it.

When I asked Creole activist Jennifer Brown how she would describe Black women's leadership role in the community, she explained to me how Creole farmers used to plant their fields "First Time." From a distance the farms looked disheveled and unkempt. Instead of the clean, rational lines of industrialized monocrop agriculture, Creole farmers planted in a more symbiotic fashion, clustering beneficial species together and using an ecologically diverse approach to farming. Black women's leadership was the same, she said: "It's hard to see the leadership of Black woman. If you have a community way of seeing things, you could find them easily. But if you have a political way of seeing a leader you would never identify a Black woman, her leadership. Because we is like how we used to plant in the old time days, that is how Black woman leadership is. Between the mess, the disorder, the struggle there we is. And nobody see we, only the one what them put up on high stage. Them is the 'leader.'"

Brown's articulation of what the anthropologist Richard Price (1983) terms "First-Time knowledge" illustrates some of the affective contours of radical Creole political counter-discourses. He describes the concept of "First-Time" among the Saramaka of Suriname as the "era of the Old Time people," an ancestrally based temporal perception of the world in which people are "acutely conscious of living in history, of reaping the fruits of their ancestors' deeds, and of themselves possessing the potential, through their own acts, to change of the shape of tomorrow's

world" (5). As an epistemological practice, First-Time knowledge is "the fountain-head of collective identity" (6) that encapsulates the shared social wisdom that is gleaned from a deep engagement with the ancestral past. Each individual's First-Time knowledge expertise is idiosyncratic and distinct, shaped by his or her experience in the social life of the community. Brown's reference to Creole First-Time knowledge reflected a critical counter-discourse to Sandinista logics of capitalist development and centralized political authority. Her characterization of the difference between a community way and a political way of viewing leadership illustrated how these perceptions operate on the ground. Rather than attempting to realize their political aspirations within state institutions, Black activists and a growing number of community residents began to articulate the need to develop their own autonomous political institutions that operated outside the purview of the Sandinista state.

These activists were among the first I heard to articulate a forceful critique of state violence that did not simply target the current FSLN party-state but rather placed the Ortega administration's institutionalized violation of their human rights within a broader historical genealogy. Despite its revolutionary rhetoric, the Ortega administration's orientation toward the region was just as exploitive, extractive, and exclusionary as its neoliberal and colonial predecessors. In response, Creole activists insisted that their central goal was, as Brown put it, "to create consciousness amongst the people, make them conscious about racism as a system."

For Creole activists the excesses of the Ortega administration were not aberrations from an otherwise functional democracy but rather reflected how the logic of racism is embedded in the normative operations of the state. As the FSLN party-state continued to co-opt local political institutions and civil society groups, BBCIG activists and their allies increasingly turned to transnational spaces such as the Inter-American Commission on Human Rights and emergent social media platforms like Facebook and Twitter to "create consciousness" about the struggle for political rights, multicultural recognition, and collective territory.

DIGITAL AUTONOMY

Yes, yes, yes. Good morning radio listeners. We just want to thank you for tuning into another education program. Ten o'clock with 22 minutes and you know, here we are. Dolene in the radio station and also George in the radio studio. Well I sure you want to hear from each and every one of us today and the topic we will be sharing on. We know that you want to be conscious about the situation and well usually on Saturdays as an educational program we try to bring this program to do in our Creole so that you can understand a little bit more ... Sometimes when we hear the Spanish news its difficult to understand what is really going on that is very necessary. So let's get to it we going to get to the actual situation.

The video is grainy and pixilated and occasionally takes a few seconds to load—no doubt the result of the low bandwidth of internet service on the coast—on Facebook Live. But the sound quality is good, and the picture is clear enough to see Nora Newball, Dolene Miller, and George Henriquez crowded around a small table in the studio of Radio Siempre Joven, 99.7 FM, as they host a weekly segment of *Demarcation Now!*, a radio program sponsored by the BBCIG. The table is covered with microphones, cellphones, notebooks, news clippings, a Bible, a copy of the Nicaraguan constitution and of Law 445, and historical documents relevant to the long struggle for Black and Indigenous land rights.

As the central government continued to push BBCIG activists out of spaces of formal political power, these activists began to look to other arenas to continue their work of community-based political education and advocacy. From 2007 to 2009, Nora Newball, Dolene Miller, and later, George Henriquez hosted *Demarcation Now!*, airing every Saturday for two hours. It was focused on explaining the demarcation process, the historical bases for Creole land claims, and the impact of government policy and larger political events on the Creole community in Bluefields. The program was conducted in Creole English to ensure that Creole listeners would be able to be informed about political events that directly concerned them and so they could pay close attention to the news and official statements by the government.

When *Demarcation Now!* was first broadcast, it represented a radical intervention in the regional media landscape. Although it was not the only political program on the radio, it was one of the few that was not linked to a national political party. But the differences between *Demarcation Now!* and other programs were also reflected in its content and presentation. BBCIG activists used this space to educate the audience about the multicultural citizenship reforms enshrined in the Autonomy Law and Law 445. They presented complex policies in an accessible way, ensuring that their listeners would be informed about political debates as they unfolded in real time. Although BBCIG activists initially launched the program to mobilize support for the demarcation process, it became an important space for the circulation of a militant, locally grounded counter-discourse of regional autonomy. In addition, BBCIG activists created a participatory environment by encouraging their listeners to call in to the program and to air their opinions. Although they encouraged civility among their listeners, they did not insist that their callers agree with their opinions but that they "fight ideas with ideas," rather than attacking individuals. As a result, *Demarcation Now!* was a highly effective mobilizational space, providing, as one journalist described it, "a master class in the art of radio as a tool for citizen organizing and popular education" (Adler 2019).

As Cupples and Glynn (2018, 28) note, the coast has "a long tradition of highly participatory and democratic community radio," which has long been an important public venue where citizens can share their critiques of the state. Radio

remains the most significant media space for local political activists in the region. As a marginal geographic area in the political life of the nation, the coast receives little coverage in the national media. A 2010 study by the Media Observatory at the Central American University (UCA) found that 90 percent of national news coverage in the country's eight leading print, radio, and television media outlets focused almost exclusively on issues centered on the capital. The study also found that reportage on issues related to the rights of Black and Indigenous peoples accounted for only 0.6 percent of media coverage. When I first arrived in Blue-fields in 2004, residents often complained that the national media routinely failed to cover substantive political issues about the region and instead focused almost exclusively on *sucesos*, sensational stories about drug trafficking, political corruption, vehicular accidents, shootings, and grisly "crimes of passion." Thus, community-based media played a vital role not only in providing greater coverage of regional politics but also in producing more nuanced coverage that challenged stereotypical representations of the region.

Nevertheless, in recent years, the region's tradition of participatory community radio has been "undermined as repression and censorship have intensified" under the Ortega administration (Cupples and Glynn 2018, 28). Since the government telecommunications agency TELCOR has not released any official data on the impact of radio, it is difficult to determine the reach of programs like *Demarcation Now!* But the program's significance was reflected not only in the degree of active listenership but also in the state's response. When the program began airing, the show was broadcast on a local Creole English-language radio station until it was abruptly canceled in 2009. BBCIG activists alleged that the state pressured the station owner to stop broadcasting the program.

BBCIG activists then attempted to secure airspace on Bluefields Stereo, which is housed in the Regional Government's offices. They began broadcasting there in May 2010 until, in February 2011, BBCIG leaders arrived to do their weekly broad-cast and found that the transmitting equipment had been removed. Dolene Miller publicly accused "Orteguista officials" of carrying out instructions by the national government to shut the program down. Officials told them to submit a formal proposal to return to the airways but never responded to their request. BBCIG activists filed a suit against the regional government for violating their constitu-tional rights to freedom of expression. Hundreds of local Creole residents held an eight-hour demonstration at the Regional Government's offices, facing off against the local police. Later that month the Appeals Court ruled that it had "no juris-diction to decide for or against the complainants." Undeterred, BBCIG activists secured a slot on another station with a smaller signal and irregular livestreaming ability. Despite ongoing efforts by the state to pressure the station into canceling the program, at the time of this writing, they remain on the air (Adler 2019; Baca 2011; Cupples and Glynn 2018).

Despite the local, limited scale of *Demarcation Now!*'s media presence, as well as subsequent radio programs, the government clearly felt compelled to intervene

in their activities. The state's repeated attacks on these programs illustrate the threat that the circulation of Black counter-histories poses to the Ortega administration, precisely because they challenge the official narrative of seamless, centralized economic integration. The community's swift response to the state's efforts to shut down *Demarcation Now!* also reveals the importance of community-based media to residents, who rely on it as an important source of information about local and national political debates.

The state's assault on community-based media and the tightening of access to traditional media outlets unfolded at the same time that new social networking sites emerged. BBCIG activists began to use social media platforms like Facebook and Twitter, communication applications such as WhatsApp, and digital newspapers and blogs to share their struggle with broader publics. They oriented much of this media activism toward the Creole diaspora in Costa Rica, the Cayman Islands, Canada, the United States, and on cruise ships. Black and Indigenous activists and their mestizo allies quickly proved to be adept at using social media to articulate a counter-discourse of militant Black self-determination.

In 2017, BBCIG activists began using Facebook to livestream *Demarcation Now!* This not only made the program available to Creoles living in the diaspora but also enabled the digital public sphere to engage in real-time debates about regional politics and the encroachment of the Sandinista state in the autonomy process. Watching these broadcasts nearly 4,000 miles away, I observed how costeños were actively participating, voicing their support or critiques of BBCIG activists and sharing their critiques of the state. In her study of Eritrean diasporic media practices on the internet, Victoria Bernal (2014: 9) argues that "what makes the internet a powerful and transformative medium is that ordinary people are able to use cyberspace as an arena in which they collectively struggle to narrate history, frame debates, and seek to form shared understandings beyond the control of political authorities or the commercial censorship of mass media." Similarly, coastal activists engaged with the internet and social networking sites as a critical space from which to contest official narratives about political conditions on the coast and the meanings of regional autonomy.

Facebook remains the most popular social networking site in Nicaragua. When it was launched in Spanish in 2008, there were only 19,280 accounts registered. By 2011, the number of Facebook accounts in Nicaragua had jumped to 400,000 (Zuniga and Hopmann 2013).[11] In 2018, the site had 2.8 million profiles in Nicaragua, about half of them in Managua. The increase in social media use among Nicaraguans can be attributed to nationwide improvements in telecommunications technology and the growing availability of smartphones and data plans. Media experts often lamented that the general public did not tend to use these tools in ways that were "productive" and instead wiled their time away on the internet "chatting on Whatsapp or resending memes created by some kid in Mexico" (del Cid 2019).

On the coast, however, digital media quickly became a critical tool for Black and Indigenous movements and the defense of community-based media. Creole

activists, for example, did not simply use Facebook to stream *Demarcation Now!*; they also used this platform to livestream demonstrations, community programs and gatherings, political events taking place in the region, and political memes that satirized the regional and national governments. Local NGOs, like the Legal Assistance Center for Indigenous People (CALPI) in Bluefields and the Center for Justice and Human Rights of the Atlantic Coast of Nicaragua (CEJUDHCAN) in Puerto Cabezas, produced high-quality, professional documentaries about Black and Indigenous struggles against the state and posted them on YouTube; these videos were then widely circulated among Facebook users.

Studies of social media and social movements have debated the efficacy of valorizing social media sites like Facebook as political tools. Though Facebook may feel like a global public square, it is a privately owned corporation, and its ability to selectively regulate user-generated content on its platform has led scholars to caution against relying on it as a tool for social transformation. Additionally, the ability to engage digital political advocacy while not actively participating in traditional social movement spaces and activities has led others to criticize the emergence of what one scholar termed "slacktivism"—passive, self-aggrandizing forms of political mobilization that do little to transform the social order while giving one the feeling of having done something meaningful (Glenn 2015; Bonilla and Rosa 2015).

But these critiques take on a different valence in the context of political struggles in Nicaragua, where the state has repeatedly attempted to intervene in social media spaces. In addition to creating official Facebook accounts for government agencies, the FSLN also sponsored Facebook pages and groups designed to appear as independently run, grassroots media platforms, like the *Noticias de la Costa Caribe*, which posts a combination of beauty advertisements, sports news (particularly about baseball, a regional obsession), humorous YouTube clips, and official press releases on government-sponsored events and programs. But the government's efforts to control this discursive space extended far beyond consolidating its control over these platforms to using them as tools of government surveillance and repression. BBCIG activists alleged that they were often targets of government-sponsored defamation campaigns through social media. They described being subjected to online harassment, receiving death threats, and being slandered in memes and posts by party loyalists. Many regularly changed their profile names to avoid being targeted. Colleagues in Bluefields who worked for the state but were opposed to its actions told me that they were afraid to like or share any posts online that might be construed as critical of the government for fear of losing their jobs. As these accounts suggest, in the case of Nicaragua, online activism has tangible offline consequences that reveal this space as a highly contested site of struggle (Bernal 2014).

Nevertheless, despite the state's efforts to repress digital and community-based media, it has been unable to contain or regulate this space. As these digital media tools became more accessible, local activists and journalists used these platforms to counter official and popular narratives of regional politics—marking

the beginning of a wave of local media production that has not been seen in the region since the early twentieth century. Between 2011 and 2017, local journalists created at least a half-dozen media platforms including *La Costeñísima, Noticias de Bluefields,* and *Notiweb Bluefields,* as well as several new radio programs led by young women and costeños living abroad. These platforms provided an important source of information about the state's policies in the region, particularly because local government agencies and officials were refusing to divulge this information. Community media outlets relied particularly on Facebook to engage not only local audiences but also costeños living abroad or laboring on cruise ships who were anxious to know what was going on back home.

In March 2017, Elizabeth Wright sent me a text message through WhatsApp. "Have you seen the video of this little girl from Pearl Lagoon that wrote a poem about autonomy?" She told me to look it up because "it's important for the book." I found the clip on the Facebook page of *Noticias de Bluefields.* Wearing a schoolgirl's uniform—a starched white blouse, pleated navy-blue skirt, white knee socks, and sensible black shoes—the young girl stood in front of a white sheet hung behind her on the wall. I was startled when she spoke in a firm, deep voice delivering her powerful message in a style reminiscent of the Jamaican dub poets, Mutabaruka and Jean "Binta" Breeze (Sharpe 2003). She began, "This here recitation/a true reality/So me want/oonu [you all] listen to me," she thundered. "I will only talk the truth/about we municipality/and how politician go about/ changing we destiny."

> All day they come
> talking about true democracy.
> So they deh come dey
> tell we got autonomy.
> But remember, autonomy is a
> a self-governing, by you and by me
> and how inna di world a stranger
> di manager over we?
> . . .
> Them come try fi wash we brains
> Saying they got the remedy
> Gain concessions on top of concessions
> Soon nothing are left fi we.
> We rich
> And yet so poor
> Sometimes they haul we
> By we nose
> Because we own top leader them
> Is destroying we resource.
> So no look come tell me about autonomy,

tell me about the nasty policy.
just like the blind leading the blind,
lickkle by lickkle we going down the drain
like a sad dictatorship
(*Noticias de Bluefields* 2016)

By the time I saw the video, more than 10,000 people had viewed it, and it had been shared hundreds of times. Dozens of people commented admiringly on her performance, describing her as "a Lady Rubén Darío" and affirming the accuracy of her analysis. "YOU SAID A MOUTH FULL MY LAGOON GYAL, THIS IS JUST WHAT WE LIVING HERE P/L!" said one woman.

Over the months, I watched as Creole friends and colleagues scattered throughout the diaspora in New York, New Jersey, Florida, California, Mexico, Canada, Costa Rica, and the Cayman Islands shared this post and others like it in the months leading up to the April 2018 uprising. That this performance of political critique circulated as widely it did illustrated how powerfully costeño activists had grasped the power of social networking sites as a multi-scalar tool of struggle. The digital sphere became its own kind of autonomous space that proved remarkably resilient and effective in the discursive struggle with the Sandinista state. In these spaces, Creoles circulated their own counter-discourses of Black history and the long struggle for regional autonomy that exposed the contradictions of the Ortega administration's narrative of harmonious multiculturalism and the process of multicultural dispossession enacted under this rhetoric. They uncovered the cracks in the state's development agenda by publicly naming the mechanisms of manipulation, intervention, and co-optation through which it is operationalized. In the process these activists' and local community members' engagement with digital autonomy revealed how they created a model of diasporic locality that enacts regional struggles within a multiscalar framework of structural inequality. In so doing, they laid the groundwork for the struggles that would follow.

CONCLUSION

On November 5, 2016, Daniel Ortega won his third consecutive presidential term; his wife, Rosario Murillo, began her first term as vice president. The FSLN garnered 72 percent of the vote according to the Supreme Electoral Commission (CSE in Spanish) (*BBC News* 2016), securing an absolute majority in the National Assembly with 65 percent of the seats. But these numbers were deceiving. Nicaraguan NGOs reported historically high rates of abstention; nearly 68 percent of registered voters did not participate in the presidential election. These organizations also observed widespread patterns of voter fraud and irregular procedures at polling stations, ranging from people being denied the right to vote; some entering the polling places with their thumbs stained with ink (indicating they

had already voted) and others leaving the polling station with their fingers unmarked (indicating that they had not voted); arbitrarily removing observers and polling volunteers without warning; manipulating state employees to secure their vote; and using government funds to produce campaign propaganda (Chamorro 2016). On the coast, the regional party YATAMA, made history when its leader, Brooklyn Rivera, won a seat in the National Assembly representing this independent party. Yet he won less than 2 percent of the vote, and other YATAMA candidates were sidelined in the election. The outcome led to widespread protests on the coast, particularly in the RACCN, which turned into full-scale riots that resulted in extensive damage in the city of Puerto Cabezas (Miranda Aburto 2016; Hobson Herlihy and Spencer 2016).

When I returned to Bluefields in 2017, things felt palpably different. More people spoke openly about their critiques of the government. The general mood was one of frustration and outrage at the government's repeated interventions in the communal government. I met with Nora for coffee shortly before leaving the country and she told me, "Black people walking around Bluefields with a different purpose, now, a different mentality." Yet the Ortega administration's hold on power seemed to be so strong that I wondered how long it would take to mobilize these feelings of political outrage into a nationwide movement robust enough to mount a meaningful challenge to the administration. How long would it take to build such a movement? I asked Elizabeth Wright her thoughts. Her response startled me.

"This thing cannot go on forever," she said. "I give it maybe twenty years."

"Twenty?" I yelped. "That can't happen. He's already been in power ten years. Maybe another ten years. If Rosario tries to take over, I think the people won't stand for it."

"You could be right. You know these *paña* dem love [to] war." We laughed and then we sighed. Ten years is a long time, and I worried about what another decade of Daniel Ortega and Rosario Murillo would do to the country.

We could not possibly imagine how wrong we would both prove to be. We had seen the storm clouds building but could not have dreamed that the crisis was much closer than we thought. When it finally broke, Black and Indigenous costeños would become one of the most visible and militant actors in the protests and insert their critique of the structural racism of the Nicaraguan state into the broader movement against the regime of Daniel Ortega. It would begin with a fire in the Indio Maíz Biological Reserve on the Caribbean Coast.

CONCLUSION
Transition *in Saeculae Saeculorum*

The wave of popular unrest that was unleashed in Nicaragua in April 2018 represents the gravest political crisis that the country has experienced in more than forty years. During that spring, thousands of Nicaraguans took to the streets demanding the resignation of President Daniel Ortega and Vice President Rosario Murillo and calling for early elections. The state responded by cracking down on the protests, sending in National Police and government-backed paramilitary groups to violently disrupt demonstrations and using the law to criminalize protest and dissent as forms of "domestic terrorism" (Amnesty International 2018a, 2018b; Inter-American Commission on Human Rights 2018). The eruption of a massive political uprising against the Ortega administration took the state and seemingly entire world by surprise. In the months following the emergence of the protests, critics and analysts on both the Right and the Left struggled to make sense of what they meant, their ideological orientation, and whether the uprising spelled the end of the Ortega administration or whether he would be able to maintain his grip on power in the face of widespread discontent.

Certainly, no one seemed more surprised by the crisis than the international Left, which has struggled to make sense of the protests and what they mean for the future of Nicaraguan politics. Despite the growing evidence of state-sponsored terror and intimidation, the mounting death toll, and the administration's ongoing policy of repression and retaliation against its political opponents, the Left has remained intensely divided over how to make sense of the dynamics that gave rise to this new movement, the political forces driving it, its aims and objectives, and, ultimately, its political legitimacy. Antigovernment protestors claimed that the protest movement is a nonpartisan popular uprising against an increasingly authoritarian administration that has dismantled the nation's democratic institutions and produced a social and political climate of fear and repression. Right-wing critics highlighted the violence of the Ortega administration as illustrative of the inherently antidemocratic nature of socialist governance. Under this argument, socialism as a political project was eternally doomed to fail in the face of an efficient free-market system that ensures long-term growth, facilitates economic

development, underwrites democracy, and protects individual freedoms. Meanwhile the Ortega administration and its supporters argued that the protests were a soft coup engineered between national right-wing (*derechista*) elites and U.S. agencies and NGOs affiliated with the State Department, the CIA, and the radical Right. As has historically been the case in Nicaragua, the reality on the ground is much more complex. Making sense of these competing explanatory narratives requires taking a closer look at the political tensions that were percolating in Nicaragua over the eleven years since Daniel Ortega and the FSLN returned to power.

Many among the international Left have framed the current crisis using a Cold War political lexicon that does not adequately account for how the terrain of Nicaraguan politics has changed since the FSLN was voted out of power in 1990. Simply put, Daniel Ortega is not the same political figure that he was in the 1980s, and the FSLN is no longer the revolutionary vanguard. After returning to power, the FSLN pursued a project of centralized, neoliberal capitalist development and solidified its hegemony bolstered by a power-sharing arrangement between the party and the country's elite corporate class. Daniel Ortega dressed up the agenda of capitalist expansion as a leftist project by simultaneously engaging in a project of economic redistribution through social spending and programs that benefited the nation's poorest citizens while leaving the vast majority of the nation's wealth, property, and commerce in private hands. Yet as William I. Robinson (2018) argues, "Some among the international left cannot seem to let go of the illusion that governments such as the FSLN in Nicaragua . . . still represent a revolutionary process that advances the interests of the popular and working-class masses— this even as the new ruling castes turn to escalating repression to dispossess those masses, plunder the state and impose the interests of transnational capital." Political conditions in post–Cold War, neoliberal Nicaragua shifted dramatically in ways that require not only recalibrating analytical frames for understanding Nicaraguan politics but also complicating an understanding of what constitutes right-wing and leftist politics at this historical juncture.

Black and Indigenous activists argue that the crisis reveals the limits of liberal politics in all its ideological variations; namely, how neither the Right nor the Left takes seriously the foundational role that the politics of anti-Black and anti-Indigenous racisms play in shaping state formations and modes of governmentality. These activists have argued that both ideological projects rely on and reproduce a teleological agenda of national progress that consistently sidelines Black and Indigenous communities as impediments to the political and economic development of the nation. For although it is clear that the complex political visions of Black and Indigenous peoples are not served by conservative political actors, who have largely tended to ignore the demands of these communities, the nominal Left also enacted its own forms of profound violence under the guise of multicultural recognition and populist inclusion.

In their critiques of the state's repression of the civic movement, for example, Black and Indigenous activists argued that the widespread phenomenon of state

violence is nothing new for Black and Indigenous communities. In her 2019 testimony to the Commission of InterAmerican Human Rights, Nora Newball stated, "The state's response to Nicaragua's socio-political crisis has been similar to that which it has always had with respect to Indigenous and Afro-descendant peoples. The state blames the victims of social problems, disqualifies and criminalizes the work of whistleblowers as well as NGOS, and human rights defenders who have supported the claims of our people" (Inter-American Commission on Human Rights 2019).

But if costeños were critical of the state's repression, they were equally critical of the civic movement against Ortega, even as they continued to participate in this newly constituted political formation. For although the emergent political leaders of this new social movement claimed to speak for all Nicaraguans, they also continued to largely ignore the specific political demands of Black and Indigenous communities from the coast. As Dolene Miller (2019) observed, "If the state and government of Nicaragua does not comply with these issues of significance to the peoples of the Caribbean Coast, the social outbursts will not be able to meet the great needs of the Nicaraguan population and the Caribbean Coast will again remain an annexed territory, open to exploitation and without viable alternatives for the development and respect for the human rights of its multi-ethnic population."

In some cases, supporters of the civic movement also reproduced their own forms of deep anti-Black racism that undermined the larger goals of this movement. During the thirty-ninth anniversary celebration of the revolutionary triumph, local journalists filmed Kymani Alvarez, a young Creole boy from Bluefields, defending the Ortega administration and declaring, "No one is going anywhere . . . the Comandante is staying (*el Comandante se queda*). Bluefields is free, Nicaragua is free, Nicaragua wants peace." As the video of Alvarez's speech circulated through social media, an antigovernment critic attacked the young boy in an expletive-laced racist rant that quickly went viral: "And get rid of Blacks too f-cking Black son of a b-tch color of shit horrible f-cking charred son of a b-tch evil purple *vicho* that gave birth to this piece of shit."[1] Similar social media posts attacked Black FSLN supporters, claiming that they supported the regime because they were accustomed to being slaves. Within days, government supporters took to social media to express both their support for the Frente and to argue that the Civic Alliance was not only driven by a group of right-wing coup mongers but, even worse, also by racists who could not accept Nicaragua as a multicultural, pluriethnic nation-state. FSLN supporters began tweeting the hashtag #YoSoyKymani alongside a drawing of the boy dressed in a pro-FSLN T-shirt with a red and black bandana tied around his neck.[2]

In their tweets, pro-government supporters argued that, unlike supporters of the Civic Alliance the FSLN was committed to "LEADING THE STRUGGLE FOR PEACE, EQUALITY, AND RESPECT FOR OUR CHILDREN! NO TO RACISM!" Another supporter tweeted, "Although it hurts them, Nicaragua is a

diverse, multicultural, plurilingual country. Your words full of hate and contempt toward a costeno boy reveals once again who is promoting the coup: fascists, out- dated oligarchs, sell-outs (*vendepatrias*)—Racists!"[3] Another declared, "The true people of Nicaragua are not racist."[4] These performances of antiracism powerfully illustrate how the FSLN has appropriated the language of multiculturalism to anchor its own political agenda. While supporters of the Frente extolled the vir- tues of multicultural recognition and aligned antigovernment protestors with the country's most politically reactionary sectors, they largely ignored the critiques of Black and Indigenous activists who were critical of both the Right and the Left's co-optation of multicultural discourse and erasure of regional critiques of both the administration and the opposition movement. Although these expres- sions of explicit anti-Black racism among supporters of the Civic Alliance were uncommon, what was more troubling was the Civic Alliance tendency to consis- tently overlook the concerns and political leadership of costeños, many of whom had long been engaged in the struggle against the authoritarianism of the Ortega administration.

But the administration's use of a discourse of racial justice and multicultural rec- ognition as a foil for external critique was not only reflected in these performances on social media; the Ortega administration also deployed this rhetoric in interna- tional spaces and processes where it attempted to assert its legitimacy in the face of growing and widespread condemnation of its domestic human rights abuses. This was particularly illustrated by the administration's strategy of sending Creole and Indigenous representatives to these arenas to represent the interests of the state. In September 2018, vice minister of foreign affairs Valdrack Jaentschke participated in a conversation sponsored by the Inter-American Dialogue, providing the admin- istration's perspective on the country's political crisis.[5] Jaentschke then went on an international press tour, speaking with media outlets in the United States and Europe and defending the government's actions as a legitimate response to a failed coup attempt. When a group of Indigenous and Black activists requested an audi- ence with the Inter-American Commission of Human Rights in March 2020, the delegation representing the state of Nicaragua included two well-known Creole leaders in the FSLN and the president of the Rama-Kriol Territorial Government, who at the time was battling accusations from local residents that he had signed an agreement with the state permitting the construction of the interoceanic canal through Rama-Kriol territory without the knowledge or consent of the commu- nity. In their testimony, to the commissions, these state representatives reaffirmed the Ortega administration's claim that it was the only government committed to defending the rights of Black and Indigenous communities.

Watching the tensions unfold from my home in the United States, I struggled to understand what was taking place and, as Creoles say, "to pick sense from non- sense." I followed news coverage from the national press and more localized reports on Facebook, Twitter, and regional radio programs about how the protests were playing out in Bluefields. When I considered heading to Bluefields myself to

see what was happening, concerned friends and colleagues urged me to stay home; as one woman told me, "I am sorry to tell you, my dear; if something happened to you, we would not be able to do anything about it." Worried that the government might be monitoring their social media accounts, many friends and colleagues insisted on channeling all communication through WhatsApp. I asked Elizabeth Wright what she thought about the Civic Alliance and whether it posed a real challenge to the Ortega administration. She was not optimistic: "The main problem is lacking real leadership. A statesperson, and there are many reasons to explain this but that is for another book. So, for now, it seems like we going to live in 'transition' *in saecula saeculorum*."

I asked her what she planned to do: Would she and her family follow the thousands of Nicaraguans who had fled the country to Costa Rica, or would they stay and try to wait the crisis out? She was ambivalent, her voice weary: "I don't know, Courtney. I cannot take another 30 years of this and it's not going anywhere . . . in 197 years of 'independence' this country has had twenty-two wars. Do the math." It was hard not to share her fatalistic outlook. Indeed, it was one that many of the activists that I worked with in Bluefields seemed to share. They remained committed to the struggle to see Daniel Ortega and Rosario Murillo removed from power and were steadfast in their efforts to ensure that the political demands of Black and Indigenous communities would find a place on the agenda of the Civic Alliance. But even they struggled to find hope in these troubling times. I shared their fatigue as I watched the news day in and day out, read the headlines reporting the growing number of murdered protestors; of political dissidents jailed by the hundreds as domestic "terrorists"; the violent clashes taking place in the nation's streets, universities, even in churches; and the activists and civilians convicted in sham trials for inciting public violence. I understood Elizabeth when she said that it felt like the struggle for a more just Nicaragua would continue forever and ever without end.

MULTICULTURAL DISPOSSESSION IN A MOMENT OF CRISIS

Around 5:15 P.M. on August 23, 2018, members of the National Police arrived at the home of Jennifer Brown, a well-known Creole feminist activist, to issue a citation ordering her to appear at the police station in Bluefields that evening at 7 P.M. The citation did not include any information regarding why the police were ordering Brown to come to the station, and when she asked the police officers what the matter was about, they simply told her, "Get there tonight and you'll find out." In the months following the April uprising, Brown had been actively involved in local efforts to support the civic movement; she had demanded justice for two young Creole men, Brandon Lovo and Glen Slate, falsely accused of and subsequently convicted for the murder of Ángel Gahona, a local journalist who was shot and killed while streaming coverage of the protests in Bluefields. Residents immediately decried the issuing of Brown's citation—and the unusual manner in which it

was executed—as an attempt by the police to get Brown to the police station with the intention of arresting her while no one was paying attention. The Meso-american Initiative of Women Human Rights Defenders issued a Defender Alert condemning the citation as an example of the state's ongoing criminalization of human rights defenders and calling on the IACHR to issue protective caution-ary measures for Brown. Earlier that year, Brown and her partner, another well-known local activist, were chased by police and assaulted in front of their home following the cancellation of a planned nonviolent demonstration. Over the next year, Brown and her partner would continue to experience ongoing intimi-dation and harassment by local authorities, slander and defamation by pro-government media, and criminalization by the state, which resulted in the couple requesting protection from the Bluefields Court of Appeals by filing a writ of habeas corpus.[6]

With few exceptions, most accounts of the 2018 civic uprising in Nicaragua have ignored the role that racial discourse and the performance of multicultural recognition played in bolstering the Ortega administration's claims to political legitimacy. Indeed, journalists and scholars alike for the most part paid little atten-tion to the critiques of Black and Indigenous activists about the origins of authori-tarian state violence or the fact that the Caribbean Coast has historically been the Nicaraguan state's preferred testing ground for the development of illiberal, undemocratic models of governance that then become the state's standard operat-ing procedure nationwide. Black and Indigenous activists argued that the rest of the nation was ignoring the wave of violence unfolding on the coast at their own peril—a claim that was tragically borne out in the wake of the 2018 crisis. Watch-ing the crisis unfold from the United States, I knew that this was not a moment for declaring "I told you so." The political stakes of this crisis are much too high for that kind of gloating. But the intervention offered here is to understand that remedying the roots of contemporary authoritarian state violence will require moving beyond criticizing individual political figures or a single administration and coming to terms with how particular kinds of inequality, specifically anti-Black and anti-Indigenous racisms, are embedded within the very structures of democratic governance that the civic movement seeks to defend.

Taking seriously the political and analytical interventions of Black and Indige-nous activists compels us to come to terms with the fact that democracy is not inherently a just political project but that many forms of violence, dispossession, and exclusion can be enacted within its legal frameworks. Throughout this book, I have argued that since the electoral defeat of the FSLN in 1990, multiple admin-istrations from both the Right and the nominal Left have strategically deployed multicultural recognition as a tool to manipulate, co-opt, contain, and domesticate the radical political demands of Caribbean Coast communities for land, autonomy, and self-determination. I describe this process as one of multicultural disposses-sion, encompassing the many ways in which administrations across the political spectrum systematically used multicultural discourse and juridical frameworks to

advance centralized state projects for economic development, resource extraction, and neoliberal capitalist expansion in the postrevolutionary period. In so doing, multiple administrations were able to claim to be upholding the rights of Black and Indigenous communities in accordance with the nation's constitution and international human rights agreements while also maintaining a firm hold on the region's resources and political institutions. Under normative liberal analytical frames, injustice is understood to be the product of the misapplication or under-application of the law. But examining the historical and contemporary experiences of Black and Indigenous communities and their persistent mistreatment at the hands of the Nicaraguan state, it becomes painfully clear that injustice is not incidental to or an aberration from the democratic order but is, in fact, a normative feature of its structuring.

It is said that Anastasio Somoza García was fond of using the following expression to describe his preferred style of governance: *plata para el amigo, palo para el indiferente, y plomo para el enemigo* (silver for friends, the stick or the club for the indifferent, and lead [as in bullets] for one's enemies). This is the classic model of Latin American-style dictatorship that has come to define authoritarian populism in the region throughout the nineteenth and twentieth centuries. It is the form of state violence that is perhaps most visible and most quickly offends liberal democratic sensibilities. Yet as many scholars have argued, authoritarianism in the twenty-first century does not always wear the face of naked violence, corruption, and *caudillismo*. It does not always articulate itself at the barrel of a gun or through cash stuffed into a briefcase. It is often mundane in enactment and expression: authoritarianism can be enacted through the pen, the gavel, via the letter of the law, and at the ballot box. The forms of authoritarianism we face in this new century are not defined primarily by the spectacular seizure of state power or the immediate militarization of daily life but is instead enacted in ways that seem more similar to what many scholars of politics in post-Soviet Russia describe as "managed democracy." This is a phenomenon that strikes many as unprecedented. Yet, as I have argued throughout this book, there is precedent for these forms of authoritarian, managed democracy in Nicaragua that is reflected in the state's historic and current governance of Black and Indigenous communities on the Caribbean Coast.

The Black women activists with whom I worked in Bluefields know this better than anyone. In this book I examined Creole women's complex political responses to historic and contemporary processes of authoritarian state violence. I argued that in the thirty years following the end of the revolutionary period, Black women activists emerged as critical leaders in the struggle for regional autonomy and the defense of Black and Indigenous collective rights. Their work focused on resisting the process of multicultural dispossession in its varied neoliberal and authoritarian guises, which they argued reproduces historic patterns of slow genocidal violence rooted in anti-Black and anti-Indigenous racisms. In the process they developed a practice of what I term "diasporic locality," which

describes how they engage in a multiscalar strategy of political mobilization and critique that bridges the local, the regional, the national, and the transnational. As a place-based model of political engagement, diasporic locality represents a rejection of the progress-oriented logic of both the Right and the Left and instead insists on autonomy; the defense of Black and Indigenous life, livelihoods, and ancestral land claims; and the right to dignity and self-determination (Goett 2016).

I have worked on the Caribbean Coast for nearly seventeen years. In my many conversations with Black women activists they often shared that they became involved in the struggle for meaningful regional autonomy, land rights, and human rights because they are committed to ensuring the collective survival of Black and Indigenous communities. They expressed fear that, without land and self-determination, Creole communities are "on the verge of disappearing," as one activist told me many years ago. In a series of focus groups on Black and Indigenous women's participation in the struggle for land rights that I conducted with Creole feminist researcher Socorro Woods, women consistently shared that by securing their communities' rights to land they saw themselves securing a future for their children and descendants. These encounters revealed to me that Black women's activism historically and continues to be rooted in a vision of Black futurity beyond the liberal political visions of the nominal Left and the Right.

The future remains uncertain in Nicaragua; the only thing that is sure is the reality that there will be more struggle as the country attempts to recover from the preceding decade of authoritarian populism and a renewed period of political violence and conflict between the state and its citizens. Yet Black women activists continue working in their communities, taking to the airwaves and social media, testifying before the IACHR, denouncing the state in their writings, and developing grassroots public health and political education programs to protect their communities in the face of pervasive government neglect. They continue working, as June Beer wrote nearly 40 years ago, to "defend dis sunrise, an keep back/ de night fran fallin." Their work reminds us that even as processes of state violence seem to unfold forever and ever without end, the struggle for life also continues and that life can be made and survival is possible even under the most precarious and uncertain conditions.

ACKNOWLEDGMENTS

Writing a book is a ritual that requires many hands, a labor whose debt can never fully be repaid. Many hands have touched this work, and it would not exist in the world today without the generosity, trust, support, and commitment of the many intellectual and political communities that made it possible.

This book belongs to many communities but above all to the Creole women—the activists, housewives, teachers, church ladies, artists, NGO staff, government workers, street vendors, and schoolgirls—who shared their lives with me, trusted me with their stories, and taught me everything that I know about Nicaraguan politics. I have struggled to determine how to express my gratitude for their support while keeping them safe. As I write these acknowledgments, political conditions in Nicaragua continue to deteriorate. This past week the government stripped two prominent NGOs on the Caribbean Coast of their legal status and seized their assets and properties. One month ago, Hugo Torres Jimenez, a former Sandinista militant who led the raid in 1973 that resulted in Daniel Ortega's release from prison, died in detention after being arrested by Ortega's government in June 2021. Arbitrary arrests and detentions have become shockingly common, and dissident media report that activists are often tried on trumped-up charges of terrorism and insurrection and convicted in absentia in hurried closed-door trials. In response, hundreds of thousands of people have fled the country seeking asylum in Costa Rica, the United States, and elsewhere. Given these circumstances, I decided that I would name those activists who are known public figures and withhold the names of friends, colleagues, and acquaintances with whom I have worked to shield them from any potential backlash.

The members of the original Bluefields Black-Creole Indigenous Government have been among the staunchest defenders of Black and Indigenous land claims and the regime of regional autonomy. Nora Newball and Dolene Miller, in particular, have been longtime supporters of this book project, and when completing it felt like an impossible task, their commitment helped me remember the true stakes of the work. Respect to Lottie Cunningham for her persistent advocacy and defense of Indigenous territory and communities in the RACCN. Special thanks to Elizabeth Wright (pseudonym) and her family for welcoming me over and over again into their home in Managua: their influence is all over this work. Jennifer Brown gives me hope for an autonomous, Black feminist future in the region. Thank you, sis. I met Gay Sterling much later in my research on the coast, but I have great admiration for her work on behalf of Black women and girls. Many thanks to Dorotea Wilson and the members of the Red de Mujeres Afrolatinoamericana, Afrocaribeña, y de la Diáspora. Thank you, Ras Ariel Hamilton, for the reasonings. Miguel González Perez and Dolores Figueroa have been steadfast supporters of this work,

and their important scholarship on the complex racial and cultural politics of the region has shaped my thinking profoundly. There are far more people who touched this work than I feel comfortable naming here. I know you know who you are. Keep the faith and never give up the fight.

I want to thank my editor, Kimberly Guinta at Rutgers University Press, for her enthusiasm for this project and her unwavering commitment to seeing it in print. It took longer than either of us anticipated—as I navigated a cross-country move, a new job, and a new baby—but her dedication to the work kept me motivated. Special thanks are also due to my dear friend and copyeditor, Katherine Pace, for her patience and fierce editing skills. I would also like to thank the anonymous reviewers who provided me with thoughtful and comprehensive feedback. The book benefited considerably from their insights. I am grateful to colleagues who invited me to deliver talks and to workshop chapters, especially Amanda Minks in the Department of Anthropology at the University of Oklahoma, Paul Lopez Oro in the Department of African American Studies at Northwestern University, and Damien Sojoyner in the Department of Anthropology at the University of California, Irvine.

Earlier versions of some of the material presented here appeared in three publications: portions of the preface appeared in an article in NACLA (Morris 2018); a short excerpt in chapter 1 was originally published in "Becoming Creole, Becoming Black: Migration, Diasporic Self-Making, and the Many Lives of Madame Maymie Leona Turpeau de Mena," in *Women, Gender, and Families of Color* 4(2): 171-195; and a shorter version of chapter 4 was published in "Towards a Geography of Solidarity: Afro-Nicaraguan Women's Land Activism and Autonomy in the South Caribbean Coast Autonomous Region," *Bulletin of Latin American Research* 35(3): 355-369. My thanks to the publishers for allowing me to reprint this work here.

My colleagues in the Department of Gender and Women's Studies at the University of California, Berkeley, have gone above and beyond in their support of my scholarly and creative work. They, along with our staff, are one of the great parts of my job. My gratitude to my department chair Laura Nelson and my colleagues Paola Bachetta, Barbara Barnes, Mel Chen, Patrice Douglass, Gillian Edgelow, Althea Grannum-Cummings, Minoo Moallem, Sandra Richmond, Leslie Salzinger, Eric Stanley, Trinh Minh-ha, and Lauren Taylor. I also have to give thanks for my intellectual community at Cal that continues to grow: Nadia Ellis, Pablo Gonzalez, Michael Iarocci, Erin Kerrison, Jovan Scott Lewis, Tianna Paschel, Leigh Raiford, Tina Sacks, Debarati Sanyal, and Brandi Summers. Thank you all for making Cal feel like home.

I began the enormous task of rewriting the book in its entirety while I was an assistant professor of African American Studies (AFAM) and Women's, Gender, and Sexuality Studies (WGSS) at Pennsylvania State University. I could not have asked for more brilliant and supportive colleagues who believed in this work and my capacity to complete it. In AFAM I especially would like to thank

Vincent Colapietro, the late Lovalerie King, Anne-Marie Mingo, Paul Taylor, and my extraordinary department head, Cynthia Young. Nan Woodruff opened her home to my partner and me and treated us like family. Thank you, hon. In WGSS, I owe special thanks to Gabeba Baderoon, Ariane Cruz, Alicia Decker, Tracy Rutler, Nancy Tuana, and Melissa Wright. Extra special thanks are due to Lori Ginzberg, who read the entire manuscript when I was convinced it was a hopeless mess and, with a ruthless red pen, revealed the book hidden in the chaos. Thank you, Lori.

Life in the Happy Valley would have been a lot more challenging without the friendship and solidarity of Ebony Coletu, Amira Rose Davis, Hoda El-Shakry, Janelle Edwards, Wilma Julmiste, Abe Khan, Marco Antonio Martínez, Mariana Ortega, Judith Sierra-Rivera, Sarah Stefana Smith, Sam Tenorio, Dara Walker, and Anya Wallace. I am also grateful to my colleagues throughout the campus who championed my scholarly and creative work in ways both large and small: Bill Blair, Michael Bérubé, Hester Blum, Jonathan Eburne, and Janet Lyon.

I was very fortunate to receive the postdoctoral fellowship through the Center for the Study of Women, Gender, and Sexuality at Rice University. I am grateful for the incredible community of scholars and staff whom I had the good fortune to work with; they include Krista Comer, Susan Lurie, Cymene Howe, Brian Riedel, Abigail Rosas, and Angela Wren Wall. I want to extend special thanks to the former director of the center, Rosemary Hennessy, for being so present and supportive throughout the fellowship. Thank you all for your generosity, mentorship, and early support of my work and career.

This book began as an undergraduate research project and then a dissertation in the Graduate Program in African Diaspora Studies in Social Anthropology at the University of Texas at Austin. It has taken a radically different turn from that original work, but the mentorship that I received from my dissertation committee continues to shape my thinking in ways that now feel almost instinctual. Many thanks are due to my committee members: Jafari Allen, Charles Hale, Juliet Hooker, Lok Siu, and Kamala Visweswaran. Edmund T. Gordon served as my committee chair, but he has been so much more in my life. He introduced me to Bluefields and the world of African Diaspora anthropology. My work remains indebted to his scholarship. Thank you, Ted, for taking a chance on me.

At the University of Texas at Austin, I was privileged to be part of a community of scholar-activists whose work and ideas are shifting the discipline of anthropology in new and necessary directions. They remain my most important interlocutors, and this work has been strengthened by their insights, feedback, and love. Many thanks to my UT family: Maya Berry, Mitsy Chanel Blot, Patrick Bouchez, Peggy Brunache, Takkara Brunson, Raquel de Souza, Alex Dodson, Sonia dos Santos, Melissa Forbis, Eunice Garza, Jennifer Goett, Pablo Gonzalez, Bonnie Claudia Harrison, Celeste Henery, Maryam Kashani, Hafeez Jamali, Mónica Jimenez, Jamahn Lee, Nedra Lee, Christopher Loperena, Saikat Maitra, Elvia Mendoza, Mariana Mora, Vivian Newdick, Keisha-Khan Perry, Roger Reeves, Mubbashir

Rizvi, Lynn Selby, Damien Sojoyner, Fernanda Sota Joya, Raja Swamy, Theresa Velasquez, Traci-Ann Wint, and Gabby Yearwood. Special shout-outs are due to Mohan Ambikaipaker, Alix Chapman, Juli Grigsby, and Savannah Shange for the 2016 New Orleans writing retreat that helped me rethink this book at a moment when I was struggling to find my footing. My gratitude also to Adam Mansbach and Jamie Greenwood for the annual Mansbach/Greenwood Writing Retreat in Berkeley, CA. I finished this book at your kitchen table, which somehow feels appropriate.

Let me make it plain: research requires resources. Research for this dissertation was funded through the following fellowships: a Faculty Residence Fellowship from the Humanities Institute at Pennsylvania State University, the Fulbright IIE Fellowship, Ford Foundation Pre-Doctoral Diversity Fellowship, Tinker Foundation Summer Travel Field Research Grant from the Lozano Long Institute of Latin American Studies (LLILAS) at UT-Austin, the Center for Latin American Social Policy (CLASPO) Research Fellowship from LLILAS, a Graduate Student Travel Fellowship from the John Warfield Center for African and African American Studies, and a Dissertation Award from the Center for Women's and Gender Studies.

My family has been a steadfast source of support. I thank my parents Rennick and Cynthia Morris for believing in me and indulging my wildest flights of fancy. To my brother Christopher, thank you for loving me and reminding me who I am when I cannot seem to remember. I also thank my three nieces, Brianna Kathleen, Abigail, and Brielle, for the sweetness you bring into my life. I lost three grandparents in the years that it took to complete this work: Reverend Jean "Gene" Baptiste Freeman (1933–2013), Barbara Venice Freeman (1933–2019), and Kathleen May Morris (1928–2008). But they believed that one day I would write books, and so I did. I will continue to tell our stories—because they matter.

Last, but certainly not least, *mil gracias* to my beloved, Martín Perna. You are patient, beautiful, and wise. Thank you for walking through life with me and being my best teacher. Loving you makes everything possible.

I end at the beginning. I finished this book only a few months after the birth of my daughter, Sequoia Jane. My mighty redwood, you compel me to rethink everything I think I know and to approach each day with a beginner's mind. Thank you for choosing me.

Berkeley, California
MARCH 2022

NOTES

PREFACE

1. It was later revealed that the International Monetary Fund had recommended the INSS reforms as one component in a larger set of preconditions for Nicaragua securing loans and IMF assistance. See "Nicaragua: Staff Concluding Statement of an IMF Staff Visit," February 6, 2018, https://www.imf.org/en/News/Articles/2018/02/06/ms020618-nicaragua-staff-concluding-statement-of-an-imf-staff-visit.

2. Members of the Civic Alliance often pointed out that COSEP and the Catholic Church were both complicit in the Ortega administration's consolidation of power. Before the April 2018 uprising, COSEP and the Catholic Church had both maintained positive relationships with the Ortega administration. Prior to the 2006 elections, Ortega brokered a series of "pragmatic alliances" with COSEP, the Catholic Church, and former Contras that enabled his return to power and later facilitated his growing control over the nation's political institutions. Under this pact, what critics termed the "COSEP model, the Ortega administration maintained the neoliberal economic development that the private sector preferred, and in exchange COSEP did not impede the administration's expansion of powers and dismantling of the nation's democratic institutions (Chamorro 2018c).

3. In August 2018, Slate and Lovo were convicted of murder and sentenced to 23.5 and 12.5 years in prison, respectively. Their sentences were later overturned on appeal in 2019.

4. Costeños typically use the term "the Pacific," to describe the larger mestizo Nicaraguan nation-state. Geographically, the term broadly refers to the western and central regions of the country which includes the departments of Boaco, Jinotepe, Chinandega, Juigalpa, Estelí, Granada, Jintogea, León, Somoto, Managua, Masaya, Matagalpa, Rivas, Ocotal, and San Carlos. In cultural terms, it describes the parts of the country that national and cultural elites have historically represented as mestizo spaces that constitute the nation's traditional imagined community of ideal Nicaraguan citizen-subjects. In political terms, it is also used to describe the center of power occupied by the national political parties, which dominate local and regional politics.

5. I am aware that I run the risk here of reproducing the implicit idea that sex work is shameful and thus to be characterized as a sex worker is, in and of itself, an insult. My point here is not to reify the characterization of sex work and sex workers as shameful but rather to consider the ways in which Black women as a group are often read in this manner in such a way that gives license to their social and sexual exploitation. In other words, the shame is not on sex work/ers but rather on how the consistent devaluation of sex workers as exploitable and disposable is also operationalized in the racial logics that structure how the mestizo nation-state engages with Black women as political subjects.

6. Since the early 2000s, political scientists and analysts have deployed the term "managed democracy" to describe the political system that emerged under the administration of Vladimir Putin in Russia. According to David Mandel (2005, 117) the term describes political systems that "fall somewhere between the poles of liberal (capitalist) democracies, characterized by the (formally) free competition of political interests, democratic freedoms and the rule of law, and dictatorships, which violently suppress organized political opposition and political rights. 'Managed democracies' retain the trappings of democracy and tolerate to varying degrees, political rights, and organized political opposition. However, those in control of the apparatuses of state violence do not hesitate to violate the law and accepted democratic norms to ensure the

continuity of their tenure." As Sheldon Wolin (2008) notes, under a managed democracy state actors need not necessarily resort to coercive violence to maintain their hold on power (although they certainly can); rather they use the mechanisms of liberal democracy to consolidate and concentrate power in the hands of a small corporate and political elite, contain dissent, and limit popular influence on state policy. As I argue throughout this book, prior to the 2018 uprising, Nicaragua under the Ortega administration operated as a managed democracy "in which emphasis is placed on political stability, elections are held but results are more or less foreordained, and serious political challenges to executive power are either absent or muted" or, I would add, contained (Wegren and Konitzer 2007, 1025).

INTRODUCTION

1. For example, Ortega also appointed a Creole *comandante* from Bluefields, Lumberto Campbell, to serve as the president of the Supreme Electoral Council (CSE), and he appointed his brother, Francisco Campbell, to serve as the Nicaraguan ambassador to the United States. The current vice foreign minister, Valdrack Jaentschke, is a well-known Creole politician, and the administration has also appointed Creoles to serve in offices to protect the human rights of women, "sexual minorities," and Black and Indigenous peoples.

2. There has been considerable debate among scholars and activists about the state of the Left in Nicaragua and whether FSLN 2.0 can accurately be described as a leftist party. I would argue that given the FSLN and Daniel Ortega's embrace of a neoliberal development agenda, its repudiation and vilification of feminist politics, its attacks on civil society and the press, its assault on the collective land claims of Black and Indigenous peoples, and its undermining of the nation's democratic institutions, the party and its leader have strayed far from its original founding principles in Marxist thought and liberation theology. Indeed, members of the Autonomous Women's Movement have described Ortega's presidency as "Somocismo disguised as the left" (Lacombe 2014). Although one might reasonably debate the merits of that claim, it does reveal that for many of the social actors who have historically constituted the Left in Nicaragua—feminists, student activists, journalists, cultural workers, and so on—the FSLN no longer represents the Left. For that reason, I use the term "nominal Left" to describe a political organization or ideology that uses the rhetoric and discursive trappings of leftist politics while supporting policies that directly counter or undermine those political values.

3. A word on terminology: before the Sandinista Revolution in 1979, Nicaraguan politics was historically dominated by two political parties, the Conservative Party and the Liberal party. The Liberal–Conservative rivalry defined the landscape of Nicaraguan politics from the early nineteenth to the late twentieth centuries. The Conservative party was founded in the 1830s by wealthy elites in the city of Granada, whereas the Liberal Party had its roots in the rival city of León. The Conservatives were represented by the landowning oligarchy based in Granada; the Liberals, located in the city of León, tended to be more commonly identified with the urban professionals, the petit bourgeoisie, the working class, and the peasantry. Justin Wolfe (2007) notes that Blacks and mulattos were also represented among the ranks of Liberal supporters. Despite the hyperpartisan conflict between Liberals and Conservatives that led to a series of civil wars, coups, and prolonged U.S. intervention in the nation's political affairs, the two parties largely agreed on a range of political issues ranging from the establishment of private property regimes, an export-based agricultural economy, the inheritance law, the reorganization of labor, the forced assimilation of Indigenous peoples, the maintenance of a hierarchical class order, and dismantling the colonial juridical order. Dore (2006) argues that both parties, like Liberals and Conservatives throughout Latin America, drew selectively from European liberalism and often converged in their policy positions on these issues (see Wolfe 2010; Dore 2006; Burns 1991; Gould 1998).

4. The pact protected both Alemán and Ortega from prosecution. Ortega faced a threat to his power from legal accusations of sexual abuse by his stepdaughter Zoilamérica Narváez Murillo. Under the terms of the Alemán-Ortega pact, an outgoing president and the candidate who came in second place would automatically be guaranteed seats in the National Assembly for two consecutive terms, which granted them partial immunity from criminal prosecution (see Morris 2010; Bendaña 2007; Lacombe 2013; Narváez 1998).

5. "Ortega aprovecha discurso del repliegue para criticar racism," *La Prensa*, July 8, 2016, https://www.laprensa.com.ni/2016/07/08/politica/2065550-ortega-aprovecha-discurso-del -repliegue-criticar-racismo.

6. Article II of the Convention on the Prevention and Punishment of the Crime of Genocide. Approved by the United Nations General Assembly Resolution 260 A (III) of 9 December 1948; entry into force 12 January 1951 in accordance with article XII.

CHAPTER 1 GRAND DAMES, GARVEYITES, AND OBEAH WOMEN

1. "Doña Anita Krause v. de Crowdell." *La Información*, February 27, 1944, pp. 1, 5.

2. Crowdell Family Bible, Crowdell Archives, Centro de Investigación de la Costa Atlántica (CIDCA), Bluefields, Nicaragua. See also Anna Crowdell Newspaper Clippings Scrapbook and Photo Album, Crowdell Archives, CIDCA.

3. "Doña Anita Krause v. de Crowdell," p. 5.

4. "Doña Anita Krause v. de Crowdell," p. 5.

5. "Doña Anita Krause v. de Crowdell," p. 5.

6. "Claims of Dr. Thomas and Captain Anderson, report by Capt. D. J. Kendall, Bluefields, 2nd Endorsement," RG 127, Entry 206, US National Archives, July 3, 1928, http://www.sandinorebellion .com/eastcoast/ATL-1928B/ATL-280924A-Kendall-Claims.JPG.

7. "Bluefields: A Retrospect," *The Bluefields Sentinel*, March 31, 1892, p. 1.

8. For additional coverage of tensions between the Nicaraguan government and the Mosquito Reserve, see also "Correspondence" in *The Bluefields Messenger*, January 12, 1894, p. 1.

9. *El Termometro* editorial cited in "Correspondence" in *The Bluefields Messenger*, January 12, 1894, p. 1.

10. See diplomatic correspondence in the Foreign Office, FO 371/17.

11. "Doña Anita Krause v. de Crowdell."

12. British National Archives, Further Correspondence Respecting the Mosquito Reserve, Inclosure 2, No. 10, Statement by Mr. H. F. Patterson, February 12, 1901, FO 881/8217; No. 39, Statement by Mr. G. Campbell to the Marquess of Landsowne, October 8, 1901, FO 881/8217.

13. British National Archives, Inclosure 1, No. 45, Mr. H. E. Patterson to Mr. J. O. Thomas, October 23, 1900, FO 881/7493.

14. British National Archives, No. 1, Petition addressed by Mosquito Reserve Indians to the King, July 23, 1906, FO 371/17_25125.

15. British National Archives, Inclosure 2, No. 45, Mr. H. E. Patterson to Mr. J. O Thomas, October 22, 1900, FO 881/6885.

16. Indeed, it is surprising how little mention there is of sex work on the coast at this time. Although popular media accounts tended to narrate Bluefields as a site of vice and criminality, these reports and diplomatic correspondence do not specifically discuss sex work. The specter of racial miscegenation does appear in travel literature, and the reports of foreign observers, particularly North Americans, suggest that the racial heterogeneity of the region reflected the "low morals" of Black and Indigenous women engaged in common-law relationships with white foreigners.

17. British National Archives, Inclosure 2, No. 45.

18. "Doña Anita Krause v. de Crowdell," p. 5.

19. In November, Zelaya forces captured and executed Leonard Groce and Leroy Cannon, two U.S. mercenaries serving in the Conservative forces, giving the U.S. government a plausible pretext to support his removal from office. "Zelaya Broke Faith to Kill Americans," *New York Times*, November 23, 1909, https://timesmachine.nytimes.com/timesmachine/1909/11/23/101905987.pdf.

20. In his memoirs of the Conservative revolution, the Conservative politician and intellectual, Carlos Cuadra Pasos, described meeting Crowdell during a trip to Bluefields to secure support. While in Bluefields he met with Adolfo Díaz, who had participated in a failed uprising against Zelaya in 1899. Diaz was a secretary at the Bluefields office of the La Luz y Los Angeles Mining Company, a U.S. company that controlled the largest gold mines in Nicaragua. In this capacity, he channeled funds to the anti-Zelaya rebel forces. Diaz recommended that Pasos stay at the Crowdell Hotel. Pasos recalled that Crowdell was, even at this time, a "very respected Creole woman" in Bluefields though he failed to mention her standing as an influential, Conservative figure with social and political networks far beyond the coast. See Cuadra Pasos, Carlos, *Obras*, Vol. I, *Managua*, Fondo de Promoción Cultural, Banco de América, 1976.

21. 1912, *New Orleans, Passenger Lists, 1813–1963*, Ancestry.com subscription database, http://www.ancestry.com. De Mena's claiming to be "Nicaraguan by marriage" may have been more than a rhetorical gesture given that, as Bredbenner (1998) notes, prior to 1922 and the passage of the Cable Act, U.S.-born women who married foreign nationals assumed their husband's nationality and forfeited their U.S. citizenship.

22. See David Dewitt Turpeau, *Up from the Canebrakes* (1942).

23. "U.N.I.A. in Bluefields, Nicaragua Forging Ahead," *The Negro World*, February 26, 1921, p. 10; "Unveiling of U.N.I.A. and A.C.L. Charter in Bluefields Nicaragua, Central America," *The Negro World*, March 19, 1921, p. 5; "Chapter Charter, No. 3 U.N.I.A., Bluefields, Nicaragua," *The Negro World*, July 9, 1921, p. 9.

24. "Brown Stirs Bluefields, Nicaragua," *The Negro World*, August 7, 1922; "Bluefields, Nicaragua—Celebrates Aug. 1 the Opening of Third International Convention of Negroes," *The Negro World*, September 16, 1992, p. 8; "Interesting News of Bluefields, Nicaragua—Brilliant Pen Picture of the Celebration of August 31," *The Negro World*, October 7, 1922, p. 8.

25. "Amalgamated Factions of U.N.I.A Nominate Officers to Function," *The Bluefields Weekly*, May 10, 1930, p. 1.

26. Moravian Mission Report 1921; see also Wunderich (1986, 33).

27. "Great River Bar, Nicaragua, Division Unveils Charter," *The Negro World*, June 10, 1922, p. 12; "Great River Bar," *The Negro World*, June 13, 1925, p. 3; "Puerto Cabezas," *The Negro World*, October 5, 1929, p. 3; "Puerto Cabezas Unveiling of Charter," *The Negro World*, October 12, 1929, p. 3; "Puerto Cabezas, Nicaragua, C.A.," *The Negro World*, May 17, 1930, p. 3; "Great River Bar Div., Nicaragua C.A.," *The Negro World*, June 28, 1930, p. 3; "Puerto Cabezas Division 335," *The Negro World*, July 12, 1930, p. 3.

28. "Bluefields, Nic," *The Negro World*, March 9, 1929, p. 6; "Nicaraguan Garveyites Wake up Early to Celebrate Aug. 31," *The Negro World*, October 25, 1930, p. 3.

29. 1922, *New Orleans, Passenger Lists, 1813–1963*, Ancestry.com subscription database, http://www.ancestry.com.

30. Anna Crowdell to Sr. Gral don Bartolomé Viquez, January 22, 1926, Crowdell Archives, CIDCA-UCA.

31. General George Hodgson (1884–1927) was a Creole dentist and a former Conservative who participated in the 1909 Revolution. He led several critical military campaigns throughout the region and became a general in the Liberal revolutionary army. See Gordon (1998) and González (2016).

32. "Written Statement of Dr. John L. Marchand, M.D., Bluefields, referring to Lt. H. M. McGee, to US Consul A. J. McConnico, US National Archives & Records Administration, RG

84/E164/Box 84, December 18, 1926, http://www.sandinorebellion.com/eastcoast/ATL-1927 /ATL-261218D-MARCHAND-01327.JPG

33. High Rate of increase Venereal Diseases in the Guardia Nacional, 9th Company Puerto Cabezas, Department Medial Officer T. Simmer to Commanding Officer, August 19, 1930, http://www.sandinorebellion.com/EastCoast/ATL-1930B/ATL-300819-Simmer.JPG; Record of Events, Eastern Area, Month of April, 1932, Col. L. L. Leech, Bluefields, to Jefe Director GN, Managua, May 4, 1932, p. 3, http://www.sandinorebellion.com/EastCoast/ATL-1932A/ATL -320504c-Leech.JPG; Record of Events, Eastern Area & Department of Southern Bluefields, Col. L. L. Leech, Bluefields, June 7, 1932.

34. Letter from Lord Cushendon to British Foreign Office, August 18, 1928, Crowdell Archive, CIDCA-UCA; Letter to Alice Anna Crowdell to James Douglass Scott, May 18, 1934, Crowdell Archive, CIDCA-UCA; Letter from Anna Crowdell to the British Chargé d'Affaires, November 15, 1934, Crowdell Archive, CIDCA-UCA; Letter from Alice A. Crowdell to K. White, British Chargé d'Affaires, November 30, 1934, Crowdell Archive, CIDCA-UCA; Letter from Alice A. Crowdell to James Douglas, British Chargé d'Affaires, January 9, 1935, Crowdell Archive, CIDCA-UCA.

35. Adjusting for inflation, this would be the equivalent of approximately US$25,700.

36. Letter from Anna Crowdell to the Comisión de Reclamaciones, June 26, 1930, Crowdell Archive, CIDCA-UCA; Letter from Anna Crowdell to the Comisión de Reclamaciones, November 12, 1931, Crowdell Archive, CIDCA-UCA; Letter from Anna Crowdell to the Comisión de Reclamaciones, February 20, 1933; Letter from Anna Crowdell to Presidente Doctor don Juan Bautista Sacasa, November 18, 1934, Crowdell Archive, CIDCA-UCA.

37. Intelligence report by Captain Donald J. Kendall, U.S. Marine Corps.

38. Letter from Capt. Merritt A. Edson, Cristobal, Canal Zone, to Ethel & Austin, p. 6, January 25, 1928, The Sandino Rebellion, http://www.sandinorebellion.com/EastCoast/ATL -1928A/ATL-280125f-Edson.JPG.

39. "More Light on the Bolton-Dorothy Fox Story," The Bluefields Weekly, November 19, 1927, pp. 3, 5; "Murder Will Out: The Doreth Fox Case," The Bluefields Weekly, December 31, 1927, p. 1.

40. Theda Kenyon, "Witches Still Live," The North American Review, November 1, 1929.

41. "Eight Jailed for Murders in Nicaragua," The Gleaner, January 19, 1928, p. 11.

42. There is little archival material about the life of Doreth Fox. Her biography exists only in a handful of newspaper articles, a few travel records, fiction, and regional lore. By comparison, Anna Crowdell left a rich repository of archival material that documents her storied life in regional politics. Yet, Fox remains a much more memorable figure in Creole oral history. She was born in 1898 in Bluefields to Ernest and Evaline Fox. Travel records reveal that, when Fox was still a child, the family was quite mobile and made multiple trips from Bluefields to New Orleans and Veracruz, Mexico, and back to Bluefields. She came from two prominent and wealthy Pearl Lagoon families—the Fox and Pondler families—and became increasingly wealthy herself in the early 1920s when she began farming in Rocky Point. These familial connections made Fox, like Crowdell, a member of the region's mixed-race Creole elite. See New Orleans Passenger Lists, 1813–1963, March 6, 1902, www.ancestry.com; New Orleans Passenger Lists, 1813–1963, June 30, 1904, www.ancestry.com; New Orleans Passenger Lists 1813–1963, May 10, 1905, www .ancestry.com; "Murder Will Out."

43. "The Bolton-Dorothy Fox Case and Its Consequences," The Bluefields Weekly, November 5, 1927, p. 2; "Eight Jailed for Murders in Nicaragua"; "Details of the Retrial of the Alleged Slayers of John Bolton and Doreth Fox," The Bluefields Weekly, January 26, 1929, p. 2.

44. RG 127/Entry 43-A/File 2nd Brigade—B-2 Int. Reports—5 September 1927–19 January 1928, The Sandino Rebellion, http://www.sandinorebellion.com/eastcoast/ATL-1927/ATL-271029b -IR-Bluefields-Kendall.JPG; "Eight Jailed for Murders in Nicaragua."

45. "The Bolton-Dorothy Fox Case and Its Consequences."

46. Letter from Anastasio Somoza García to Anna Crowdell, February 21, 1936, Crowdell Archive, CIDCA-UCA.

47. "How Is This?" *The Bluefields Weekly*, November 19, 1927, p. 1.

48. "The Die Is Cast," *The Bluefields Weekly*, September 29, 1928, p. 1.

49. "Cast thy bread upon the waters ... 'Aunt Levy's' Sweeping Coup," *The Bluefields Weekly*, November 19, 1927, p. 3.

50. For example, Carlos Vilas (1989) notes that between 1950 and 1979, the Somoza regime issued sixty-five decrees and resolutions granting natural resource concessions; forty-seven of these concessions, or 72 percent, were granted to the Somoza family, close family friends, and high-ranking members of the National Guard. Nearly all of the rest were granted to multinational corporations. Additionally, the regime gave away coastal lands to its political supporters; from 1964 to 1973, the Nicaraguan Agrarian Institute gave away more than two million acres of land to mestizo farmers as part of the state's agrarian reform program.

CHAPTER 2 *ENTRE EL ROJO Y NEGRO*

June Beer (1986), "Love Poem," *WANI* 4: 37; June Jordan (1985), *On Call: Political Essays*.

1. In A *Theology of Liberation: History, Politics, and Salvation* (1988 [1972]), the Peruvian priest and theologian, Gustavo Gutiérrez, outlines the theological and philosophical foundations of liberation theology; he argues that the central mission of the church is to demonstrate God's love for humankind by working to eradicate poverty and social inequality.

2. Dorotea was recruited by Henry "Modesto" Ruiz, widely considered a legendary figure in the revolution. Ruiz was born in Jinotepe in 1943 to a poor family. He joined the Socialist Party as a teenager and received a scholarship to pursue his university studies in Moscow in 1966. He had already established ties with the FSLN at this time and officially joined in 1967. He received military training in Cuba in 1968 and then returned to Nicaragua in 1969 to help launch a new stage of guerrilla warfare against the Somoza regime. He subsequently became the head of the guerrilla campaign in the northern mountains and later one of the nine comandantes to serve on the National Directorate. For more about Ruiz see his oral history account of his time serving in the mountains in *Memorias de la Lucha Sandinista*, vol. I by Mónica Baltodano (2010).

3. This is a pseudonym. To protect the activists whom I worked with, I changed their names and altered any personal details (their names, age, hometown, etc.) that might reveal their identities.

4. See Freeland (1999) for a more detailed examination of the ideological tensions between the state and Black and Indigenous communities regarding the design and execution of the literacy campaign on the coast.

5. Hortencia's use of the term *alfabetizar* reflects a common practice in in Mosquito Coast Creole English. Creole speakers will often use Spanish infinitives or to Anglicize Spanish terms to describe terms or concepts for which there are either no clear translations in English or where the standard English term is unknown.

6. Steadman Fagoth Mueller is a complex figure in contemporary costeño politics over the last forty years. He was born in Puerto Cabezas in 1953. He was elected head of MISURASATA in 1981 and then selected to serve as the organization's representative on the Council of State (NACLA) in 1982. Later that year, he was arrested by the FSLN government, along with Brooklyn Rivera and Hazel Law, on charges of orchestrating a separatist movement. While in detention the government accused him of having been a police agent of the Somoza regime. After being released from police custody he fled to Honduras where he began working with disaffected Miskitu people and established relationships with groups of ex-National Guardsmen.

Fagoth became a leading representative of the Contra and, in addition to leading Contra military forces, traveled internationally to mobilize broader support for the movement. He cofounded the Indigenous regional political party, YATAMA, in 1987 with Brooklyn Rivera and was part of the negotiation process to end the conflict between armed Miskitu rebels and the Sandinista government. After the revolution, he served as a concejal in the Regional Council in the RACCN, as a diputado in the National Assembly, and later as the head of the Nicaraguan Instituto for Fishing and Agriculture under the Ortega administration. For more see Hale 1994; NACLA 1982; "Los Caudillos de la Costa," *La Prensa*, 2013, https://www.laprensa.com.ni/2013 /09/15/reportajes-especiales/162469-los-caudillos-del-caribe.

7. The Democratic Revolutionary Alliance (ARDE) was the southern front of the Contra forces. It was founded in 1982 by Eden Pastora, a former Sandinista comandante who led the southern front in the struggle to overthrow the Somoza regime. He became disillusioned with the Sandinista government early on, which led to his creating ARDE; although the organization received arms, funding, and training from the CIA, ARDE leaders initially differentiated the group from other Contra forces, notably the Nicaraguan Democratic Forces (FDN) of the northern front, which was led primarily by former National Guardsmen. Despite Pastora's protests, ARDE later entered an alliance with the FDN under pressure by the CIA.

8. Quince Duncan is an Afro-Costa Rican writer, activist, and educator. He is considered the first Afro-Costa Rican writer to publish in Spanish. He was born in 1940 in San José. For a more detailed discussion of Duncan's life, work, and literary legacy see Mosby (2015).

9. Brooklyn Rivera is a Miskitu activist and politician who has been an important and contradictory figure in costeño politics since the 1970s. He was born in 1953 in Li Dakwra, a small village fifty kilometers north of Puerto Cabezas in the RACCN. After completing his secondary education, he went to Managua to pursue a degree in education. In 1979 he joined ALPROMISU and in 1981 was one of the founding members of MISURASATA. After criticizing the Sandinista government's policies on the coast, he was arrested that year, along with Steadman Fagoth and Hazel Law, and accused of engaging in counterrevolutionary activities. Following his release, he fled to Honduras and met up with Fagoth, but tensions flared between them. Rivera then went to Costa Rica where he organized his own armed group to resist the Sandinistas. In 1985, he agreed to begin peace talks with the FSLN and played a central role in the negotiations between armed Miskito groups and the state and in supporting the development of the regional autonomous governments. In 1987, he cofounded YATAMA, which he still leads today. He has served as a deputy in the National Assembly representing YATAMA and has also taught at the Bluefields Indian and Caribbean University.

10. Karen Buhl is a conservative activist and an active member of the conservative organization, Eagle Forum. She became involved with the Eagle Forum in 1973 and met Phyllis Schlafly when she went to South Dakota to support local efforts to overturn the state's ratification of the Equal Rights Amendment. In 2014 Buhl wrote an essay, "My Heroine Phyllis Schlafly," in which she writes about soliciting Schlafly's support to organize a speaking tour for Hodgson. For more details see http://phyllisschlaflyinstitute.com/index.php?title=Karen_Buhl&oldid=207.

11. *Buena presentación* translates literally to "good presentation." Although the term seems to be neutral, it historically has been used as a tool for discriminating against Black people in the labor market. In her work on Black women's experience of citizenship in Brazil, Kia Caldwell describes how the rhetoric of *boa aparência* works to exclude Afro-Brazilian women from certain professional occupations while locking them into low-paid, precarious, service work where their labor is exploited. She states, "Classified advertisements in Brazilian newspapers frequently list boa aparência as a job requirement. While such advertisements do not openly state that only white or lighter-skinned women are qualified to hold these positions, the implicit message is that women without good or white appearance should not seek employment in certain professions. Popular understandings of what constitutes good appearance are closely correlated with Euro-

pean standards of feminine beauty and dominant constructions of female gender identity. *Phys-ical attributes such as hair texture and skin color are fundamental to the notion of good appearance"* (Caldwell 2007, 65; emphasis added).

12. Historically, one of the primary modes of intraregional travel has been by water because there are no major highways that connect communities on the coast, and until recently there was no direct land route from Bluefields to Managua.

13. Mirna Cunningham is a Miskito/Creole physician, Indigenous rights activist, and former rector of the University of the Autonomous Regions of the Nicaraguan Caribbean Coast. In December 1981, she and Regina Lewis, a nurse, were kidnapped by Indigenous Contra combat-ants outside the hospital in the small village of Bilwaskarma. There were taken across the border into Honduras where they were held for twelve hours and repeatedly beaten, raped, and tor-tured. They were then taken back into Nicaragua and released and ordered to leave the region. In 1982, the Center for Constitutional Rights filed a suit against the U.S. government for its role in sponsoring covert paramilitary activity in Nicaragua. Cunningham served as one of the lead plantiffs in the case, *Sanchez-Espinosa v. Ronald Reagan*. The case was dismissed in federal appeals court in 1986 but brought international attention to the human rights abuses being perpetrated by the Contra in Nicaragua.

14. Ray Ronald Hooker is a Creole educator, university professor, historian, and politician. He was born in Bluefields in 1938 and was raised in the small community of Pearl Lagoon. He received a scholarship to study in the United States and completed a BA in history and an MA in education at the University of Ohio. He taught at the UNAN in the 1970s and was later tapped to serve as the first Black dean of the humanities faculty in 1979. He became involved with the FSLN in the early 1980s after being invited to work for the government. In that capac-ity he served as a presidential delegate to the Zelaya Sur region, FSLN coordinator, and was a *diputado* in the National Assembly from 1985–1996. He played a leading role in the National Autonomy Commission. He later helped create the first regional university on the coast and is the cofounder of the Foundation for the Autonomy and Development of the Atlantic Coast of Nicaragua (FADCANIC). Hazel Law is a Miskito activist, educator, attorney, and politician. She was born in 1958 in Sují, a small Miskito community on the shores of the Río Coco. In 1975, she moved to Managua to study education at the UNAN, where she also joined the FSLN-aligned Revolutionary Student Front, which opposed the Somoza regime. In 1976, she joined ALPROMISU and became involved in the emerging Indigenous struggle. After ALPROMISU changed its name to MISURASATA and became aligned with the FSLN, Law was appointed to coordinate the regional literacy campaign in Indigenous communities, through which she developed strong relationships with Indigenous communities throughout the region. In 1981, Law, along with Brooklyn Rivera, Steadman Fagoth, and other MIS-URASATA activists, was arrested. After being released, Law remained in Nicaragua and con-tinued working to improve relations between the government and Indigenous communities. She played a leading role in the National Autonomy Commission and worked with Indige-nous women to help launch peace talks. She currently serves as a magistrate for the Court of Appeals in the RACCN.

CHAPTER 3 CRUISE SHIPS, CALL CENTERS, AND *CHAMBA*

1. In a 2006 interview, Antonio Lacayo, who served as cabinet chief in Chamorro's administra-tion, admitted as much, stating, "The issue of autonomy never managed to rise to a national priority in our government. . . . On the one hand we were not very clear about what Sandinismo had done there in 1987, but on the other hand we could not oppose it, we had to respect that feeling of autonomy" (qtd. in Frühling et al. 2007, 124).

2. The administration appointed Miskitu leader and former Sandinista turned Contra combatant, Brooklyn Rivera, to serve as the minister of INDERA in exchange for his support of the UNO during the election campaign. Rather than speaking as a community leader and serving as an experienced liaison between costeño communities and the state, Rivera then became the face of centralized state power in the region.

3. As Frühling and coauthors (2007) observe, the Regional Coordinator's office remains the most powerful institution within the regional governments but is also vulnerable because the Autonomy Law grants Regional Council members the right to remove a coordinator from office should they lack confidence in his or her ability to carry out the functions of the office. This can only be done, however, with a quorum. As a result, the coordinator's tenure was largely dependent on his or her ability to remain on good terms with the majority of council members. Regional Coordinators often circumvented this formality by limiting the distribution of funds to the Regional Council and making it impossible for representatives to hold regular sessions where they could potentially oust him or her.

4. Political corruption would prove to be a defining feature of the Alemán administration; in 2004, Alemán was tried and convicted on a wide range of corruption charges, including embezzlement, money laundering, misappropriation of public funds, fraud, criminal association, and electoral crimes (Mora 2004). Scholars argue that the Alemán administration more than any other paved the way for Daniel Ortega's 2006 electoral victory, which was a direct outcome of the "pact" between the two caudillos to push through a series of constitutional reforms that radically reshaped the country's legislative, judicial, and electoral institutions and processes and has had dramatic consequences for the future of Nicaraguan politics. For more see Close et al. (2011); Kampwirth (2003); Martí i Puig (2010, 2013); Morris (2010); and Tellería (2011).

5. In Bluefields, I often encountered the discourse that women are less corrupt and have a higher standard of ethics than men in positions of leadership. This narrative was often tied to the presumed moral integrity that is connected to women's performance of motherhood, caregiving, and community advocacy. Yet throughout my fieldwork, I encountered stories of women in leadership positions who abused their power in ways ranging from embezzlement and corruption to sexual and labor exploitation. These stories reflected what Goetz (2007) terms the "myth of women's incorruptibility," even as feminist scholars highlight the distinct differences between how men and women encounter and experience corruption.

6. This is a pseudonym.

7. The Human Development Index of the UN Development Programme is a "summary measure for assessing long-term progress in three basic dimensions of human development: a long and healthy life, access to knowledge and a decent standard of living." See https://hdr.undp.org/en/content/human-development-index-hdi.

8. This figure not only includes direct costs of war-related damages (approximately $2 billion) but also "losses associated with the embargo ($1.1 billion), extraordinary defense expenditures (estimated at US$1.9 billion), and secondary effects on the gross national product (e.g., reduced consumption, estimated at nearly US$4.1 billion)" (Close 1999, 28).

9. The idea was that the money saved from these cutbacks would then be directed toward paying down Nicaragua's massive foreign debt of US$11 billion, six times the nation's annual GDP (Close 1999, 131).

10. According to the Local System of Comprehensive Health Care (SILAIS in Spanish), from 1991–2011 there were 170 reported HIV/AIDS cases in the RACCS. SILAIS found that the most affected demographic was homemakers, with 44 cases, followed by sailors and fishers with 34. Creoles had the highest number of cases (59) followed by mestizos (57), Miskitu (32), the Garifuna (1), and the Rama (1). See "La Infidelidad está matando a la gente en Bluefields," *El Nuevo Diario*, December 2, 2011, https://www.elnuevodiario.com.ni/nacionales/234914-infidelidad-esta-matando-gente-bluefields/.

11. This treatment was all the more ironic given the fact that Gordon, who worked as an education specialist for the Foundation for Autonomy and Development of the Atlantic Coast (FADCANIC), a local NGO, was returning to Bluefields after completing a trip related to a FADCANIC program, Education for Success; this program's goal is to empower young people throughout the region to pursue education and professional development as an alternative to involvement in criminal activity and outward labor migration.

12. As several scholars have noted, the media's excessive focus on the narcotics trade on the Caribbean Coast is baffling and problematic, precisely because drugs is big business in Nicaragua. Managua remains the largest market for in the national drug economy and by far the vast majority of cocaine that transits through the country is typically routed through the Pacific, which is the preferred land route for local and international traffickers. Nevertheless, the idea that the Coast is the primary source of the "drug scourge" remains a powerful narrative in national debates. For more details see González et al. 2001; IEEPP 2011.

13. Years earlier, I visited Hayman's hometown, Tasbapauni, a Creole/Miskito village located on a small strip of land between the Caribbean Sea and the Pearl Lagoon basin. While there I stopped in a general store to pick up a few personal items and was surprised to find a number of luxury consumer items—popular U.S. name-brand clothing, cosmetics, and electronics—that were all quite difficult to find in Bluefields' urban marketplace. I gathered my things and went to the counter to pay for them. The employees were friendly and—in an ironic twist—all wore matching red polo shirts with the store's name, "Tienda Hayman," and logo, a white lobster, embroidered on the shirt.

CHAPTER 4 DANGEROUS LOCATIONS

1. Law 445 was approved following the landmark 2001 ruling by the Inter-American Court on Human Rights, which set a critical precedent for Black and Indigenous land claims throughout Latin America. The court found that the state of Nicaragua had violated the communal property rights of the Indigenous Mayagna community of Awas Tigni after it granted a logging concession to a multinational corporation without the community's knowledge or consent. The IACHR instructed the Nicaraguan government to formalize the land demarcation and titling process and create institutional mechanisms to allow Indigenous communities to have more participation in the granting of concessions and natural resource exploitation. Law 445 was approved in December 2003. For more about the Awas Tigni case and the IACHR hearing see Hale (2008).

2. The Intendencia de la Propiedad is a special agency that operates under the auspices of the Attorney General's Office. This office oversees and all matters related to the legalization and titling of property nationally.

3. These are pseudonyms.

4. In Nicaragua and most Central American nations, one manzana is equal to 1.74 acres.

5. Oonu is a Mosquito Coast Creole term for plural address in the second person. It generally means "you all."

6. Francisco Sacasa Urcuyo has had a long career in regional politics and is a contentious political figure. He was a member of the right-wing Constitutionalist Liberal Party (PLC), a diputado in the Regional Council, and a former member of the National Guard. He is originally from Rivas but has lived in the community of El Rama—which he represents in the Regional Council—for more than thirty years. Since his election as a diputado, he has been at the center of a string of political scandals involving allegations of corruption, embezzlement, and nepotism, as well as combative power struggles with members of his own party. In 2009 and 2010, Sacasa sent groups of armed men to violently remove mestizo farmers from their lands—burning their homes, setting cattle loose on their crops, and, in one case, shooting and wounding one

farmer—in the community of Caño Negro and seize control of some three thousand hectares of land that he claimed belonged to him. But the national government and the National Police confirmed that Sacasa held no title to the lands, which are part of the Rama and Creole territory that extends south from the municipality of Bluefields to the Costa Rican border. For additional information see "Tribunal de la RAAS reconoce nueva directive," *La Prensa*, October 4, 2002; "Grave denuncia contra diputado Francisco Sacasa," *La Prensa*, January 5, 2009; "Intentan matar a diputado liberal," *La Prensa*, January 6, 2009; "Serios señalados contra diputado Sacasa," *La Prensa*, May 28, 2010; "Abren huaca de diputado Sacasa," *La Prensa*, May 31, 2010; "Continúa pleito entre gobernadora y diputado," *La Prensa*, June 1, 2010; "Armados agreden a campesinos en Bluefields," *La Prensa*, October 28, 2010; "Pretenden desalojar a campesinos," *La Prensa*, October 29, 2010; "Estado no tiene tierra en Caño Negro," *La Prensa*, November 2, 2010; and "Botan y queman casas en Caño Negro," *La Prensa*, November 14, 2010.

7. A *panga* is a speedboat with an outboard motor engine. It has, until fairly recently with the extension of the national highway system to the coast, been the preferred (and often) only form of intra-regional form of transportation available.

8. Law 445 guarantees "the Indigenous peoples and ethnic communities the full recognition of communal property ownership rights, the use, administration and management of traditional lands and their natural resources, through the demarcation and titling of the same" (National Assembly 2003, 76). The law defines an Indigenous community as "the group of families of Amerindian ancestry settled in a territorial area, sharing a sense of identification related to the aboriginal past of their Indigenous peoples, and upholding an identity and values inherent to a traditional culture, as well as communal forms of tenure and use of their lands and having their own social organization." Ethnic communities are clearly defined as "the group of families of Afro-Caribbean ancestry sharing the same ethnic identity inherent to their culture, values, and traditions, related to their cultural roots, natural resources, and forms of land tenure" (78).

CHAPTER 5 "SEE HOW DE BLOOD DEY RUN"

1. There are, of course, exception to every rule. In 2011, controversy erupted in the community of Monkey Point, south of Bluefields, when members of the community pressed charges against naval soldiers for allegedly sexually assaulting a young girl and having improper sexual relationships with teenage girls and young women in the community. The Monkey Point case was exceptional precisely because it involved state actors and played out in a broader struggle over drug war policy and land rights conflicts. In this case, sexualized state violence operated as a powerful metaphor for the political repression and economic inequality that defined the community's relationship to the mestizo state. The case captured the attention of many kinds of political actors—feminists, Indigenous rights attorneys, human rights groups, mestizo journalists—and marked an important turning point in the public conversation on sexual violence in Black communities. For a more detailed account of the Monkey Point case see Jennifer Goett's ethnography, *Black Autonomy: Race, Gender, and Afro-Nicaraguan Activism* (Stanford, 2016).

2. For example, activists with the Red de Mujeres Afro-Latinoamericanas, Afrocaribeñas y de la Diáspora used this discourse in testimony before the Inter-American Commission on Human Rights and argued that this culture of silence requires that Black women not speak their experiences of violence publicly. As one woman reported, "You do not speak about sexual violence. From small, we are taught that you wash dirty laundry at home." Similarly, a 2009 study by the Centro de Estudios y Investigación de la Mujer Multiétnica on the commercial sexual exploitation of girls, boys, and teenagers on the Atlantic Coast reached a similar conclusion: "In the Creole ethnicity, these kinds of cases are connected to the dignity and good name of the family and as such, are not made public" (CEIMM 2009, 11; see IAHCR 2014). For more recent Black

feminist scholarship that complicates discourses of Creole respectability and sexual politics on the coast see Gordon-Ugarte (2022).

3. The study also revealed a close correlation between the likelihood of childhood sexual abuse and the occurrence of violence within the home. Specifically, the ENDESA study found that children who grew up in in a home where the mother experienced intimate partner violence were up to four times more likely to experience rape before the age of fourteen years old.

4. According to Article 168 of the Nicaraguan Penal Code, the legal age of consent is sixteen years old. Thus, a minor under the age of sixteen is not legally able to provide consent, so sexual intercourse with a minor under the age of sixteen is, by definition, rape.

5. For a more thorough discussion of the Zoilamérica Narváez case see Narváez (1998).

6. See "Nicaraguan Women May Have to Negotiate with Their Abusers," Inter Press Service News Agency, May 30, 2013, http://www.ipsnews.net/2013/05/nicaraguan-women-may-have-to-negotiate-with-their-abusers/.

7. This is a pseudonym.

8. Comisarías de la Mujer y la Niñez were special police stations staffed by female police officers and "designed to provide women victims of violence with more specialized attention" (Neumann 2017). A handful of stations were established in 1993 with funding from the Netherlands. They were integrated into the National Police budget, although they were chronically underfunded and short-staffed. By 2015 there were 162 Comisarías in the country. The Ortega administration shut them all down in 2016.

9. This is a pseudonym.

10. This office is the Procuraduría Especial de la Mujer. It operates under the auspices of the Procuradaría General (the national Attorney General's office).

CHAPTER 6 FROM AUTONOMY TO AUTOCRACY

1. The Law 445 established the communal governments as the most local level of government that would directly represent the interests of Indigenous and Afro-descendant communities, manage the demarcation and communal land titling process, and manage the 25 percent of revenue derived from the exploitation of the region's natural resources. Communal authorities are elected during a communal assembly process where representatives of all the region's communal governments elect the regional leadership. In Bluefields, the communal government was divided into a central communal government that was elected by communal governments located in each of the four traditional Creole neighborhoods—Cotton Tree, Beholden, Old Bank, and Pointeen—and representatives from communities throughout the Bluefields Territory (see República de Nicaragua 2003).

2. Campbell established his revolutionary credentials when he joined the FSLN in the 1970s while studying physics and mathematics at the National Autonomous University; he was one of the small number of Creoles who participated in the struggle against the Somoza regime. After its triumph, he served in the Pablo Ubeda Brigade, where he achieved the rank of Guerrilla Commander. From there he quickly rose through the ranks of the FSLN party structure serving as the vice minister, and later minister, of the Nicaraguan Institute of the Atlantic Coast (INNICA). He played an active role in the process of establishing regional autonomy and in 1984 was appointed the Presidential Ministry Delegate for Special Zone II of the Atlantic Coast and the Political Secretary of the FSLN (González 2015). After the Sandinistas' 1990 electoral defeat, he continued working within the party, maintaining its relationship with regional leaders and costeño communities. When Ortega returned to power in 2007, Campbell helped select costeño leaders for government appointments and served as the primary point person carrying out the government's development agenda in the region (González 2015).

3. To this end, Campbell served as the central negotiator brokering an agreement with the regional Indigenous party, YATAMA, led by Brooklyn Rivera, which played a central role in ensuring the FSLN's electoral success in the region until the alliance splintered in 2014 after Rivera accused the FSLN of violating the territorial rights of Indigenous communities in the North Caribbean coast.

4. In February 2009, Bridget Budier and several members of her family were denied entry to El Chaman, a popular nightclub in Managua. Budier then filed a complaint with the government's Ombudsman's Office and the National Assembly's Commission on Ethnic Affairs. The case made national and international headlines as a watershed moment in public debates on racism in Nicaragua. One journalist went so far as to dub Budier the "Nicaraguan Rosa Parks" (Rogers 2009). But many costeños were more ambivalent. While they agreed that Creoles routinely encountered similar individual forms of discrimination in the Pacific, they tended not to identify Budier as a Civil Rights figure and instead read the public debate around the El Chaman case as an empty gesture in the face of entrenched processes of structural racism affecting Black and Indigenous peoples. In an op-ed, one article argued that the debate over whether Black people could enter a night club was a distraction from the state's chronic underfunding of public health, education, infrastructure, and development programs in the region: "Discrimination is not the kind of discrimination done by the owner of a bar or his employee, by not allowing a person to enter his establishment, the real discrimination is perpetrated by the State of our country and I do not mean the current government, I mean the State as an institution, discrimination has been a constant in all governments" (Arellano 2009; "¡No Quiero Fiesta, Quiero Educación y Salud"). See also Morales (2009), Rogers (2009), Univision (2012), and Vázquez Larios (2009).

5. Budier was referring to two key documents that outline the formal development agenda of the Ortega administration: the Plan de Desarollo de la Costa Caribe: En Ruta hacia el Desarrollo Humano and Estrategía de Desarrollo de la Costa Caribe y Alto Wangki Bocay para el Buen Vivir y el Buen Común 2012–2016 (Consejo de Desarrollo de la Costa Caribe 2009, 2012). The regional development plan is managed by the Development Council of the Caribbean Coast, which answers directly to the President's Office.

6. CONADETI was established under Articles 41 and 43 of Law 445 as the interinstitutional agency that regulates and oversees the demarcation and titling process. Its membership comprises representatives from the national, regional, municipal, and communal governments. For more details see "Reglamento Interno de la Comisión Nacional de Demarcación y Titulación" (República de Nicaragua 2003).

7. In addition to the canal, the concession also included multiple sub-projects including an oil pipeline, a dry channel for the construction of a railway line, an airport in Rivas, two free-trade zones, new highways, four touristic resort complexes including a golf retreat, and "whatever infrastructure the investor deems is necessary for the development and operation of one or more sub-projects" (Amnesty International 2015).

8. Reverend Rayfield Hodgson is the pastor of Maranatha who entered politics in the 1970s and has been an influential—and controversial—figure in regional politics. He served as mayor of Bluefields after the Sandinista Revolution, coordinator of the RACCS from 1994–1998, and president of the Board of Directors of the Regional Council and has been an incumbent representative in the Regional Council since 1994. Prior to the current Ortega administration, he had had previously been a member of the right-wing PLC but switched parties after the FSLN returned to power. For more see Miguel González, "'Brother Ray y el Legado de Autonomía Costeña," *Confidencial*, November 5, 2015, https://www.confidencial.com.ni/opinion/brotherray-y-el-legado-de-la-autonomia-costena/; "Hodgson deja al PLC por el FSLN," *La Prensa*, June 3, 2011, https://www.laprensa.com.ni/2011/06/03/politica/62437-hodgson-deja-al-plc-por-el-fsln.

9. Creole activists in both Bluefields and in the Rama-Kriol Territory pointed out that the GTRK, like the BBCIG, had also been co-opted by the FSLN, which then hastily approved an agreement to allow the canal to pass through the territory. Former members of the GTRK Executive Committee also filed a constitutional challenge against the Ortega administration and members of the FSLN-controlled GTRK for approving the concession through a rushed and flawed consultation process. In so doing, the government had flagrantly violated their political and territorial rights while maintaining a veneer of legality and multicultural recognition. Activists alleged that the government had intervened in 90 percent of the region's communal and territorial governments with the express purpose of shifting the center of accountability from these communities to the central government, thus ensuring political conditions that would favor the state's policy directives in the region. For more, see the documentary film by Calpi (2017) *We Do Not Consent/Nosotros No Consentimos*, https://www.facebook.com/calpinicaragua/videos /1346650608686272.

10. Specifically, Miller claimed that Hodgson made a vulgar hand gesture known as "*la guatusa.*" La guatusa is a universally recognized nonverbal insult in Nicaragua. Its usage in everyday discourse is well established, and it also has featured prominently in apocryphal stories about various strongmen in Nicaraguan politics from José Santos Zelaya to Anastasio Somoza. For more about la guatusa see Amalia del Cid, "La Guatusa de Nicaragua," *La Prensa*, January 15, 2018, https:// www.laprensani.com/magazine/reportaje/la-guatusa-de-nicaragua/.

11. The Open Society Foundations found that 40.2 percent of Nicaraguan internet users reported using Facebook while only 0.6 percent used Twitter. Indeed, the most popular social networking sites in Nicaragua have tended to be Facebook, Whatsapp, and Instagram (the latter two are owned by Facebook; see Zuniga and Hopmann 2013). By 2017, more than 80 percent of internet users reported Facebook as their preferred social networking site (iLifebelt 2017). See also CuarteroAgurcia (2017).

CONCLUSION

1. See the original tweet at https://twitter.com/LunaPalacios19/status/1020664367283613697 /photo/1.

2. The image is available at https://twitter.com/search?q=%23yosoykymani&src=typed_query.

3. See the original tweet at https://twitter.com/Cenzontle4/status/1020536968252395520.

4. See https://mobile.twitter.com/BlueEveDiamond/status/1020524805295132672.

5. Born and raised in the community of Corn Island, Jaentschke is among the growing number of Creoles who have been appointed to serve in the Ortega administration since 2007. See "A Conversation with Valdrack Jaentschke," Inter-American Dialogue, https://www.youtube .com/watch?v=oVD865fY9oI, September 24, 2018.

6. See https://www.facebook.com/NotiBluefields/posts/1153549581466656.

REFERENCES

Acosta, María Luisa. 2014. "El Canal y los Pueblos Indígenas." *Confidencial* (Managua), October 12, 2014. http://www.confidencial.com.ni/articulo/19683/el-canal-y-los-pueblos -indigenas.

———. 2016. "El Impacto de la Ley del Gran Canal Interoceánico de Nicaragua sobre Pueblos Indígenas y Afrodescendientes del País." *WANI* 13–22.

———. 2017. "El Título del Territorio de los Creoles de Bluefields y el Gran Canal Intero-ceánico por Nicaragua." *Cuaderno Jurídico y Político* 2, no. 8: 5–24.

Acuña, María de los Angeles. 2004. "Nicaribe Soy: Cómo Viven Mujeres del Caribe el Racismo del Pacífico." *La Boletina*.

Adler, William. 2019. "Here Belongs to Us." *McGraw Center for Business Journalism*. April 18, 2019. http://www.mcgrawcenter.org/stories/here-belongs-to-us/.

Allen, Jafari, and Ryan Cecil Jobson. 2016. "The Decolonizing Generation: (Race and) Theory in Anthropology Since the Eighties." *Current Anthropology* 57, no. 2: 129–148.

Álvarez, Leonor. 2013. "CSJ Ignoró a Caribeños." *La Prensa* (Managua), December 21, 2013. http://www.laprensa.com.ni/2013/12/21/politica/175286-csj-ignoro-a-caribenos.

———. 2016. "Ortega Aprovecha Discurso del Repliegue para Criticar Racismo." *La Prensa* (Managua), July 8, 2016. http://www.laprensa.com.ni/2016/07/08/politica/2065550-ortega -aprovecha-discurso-del-repliegue-criticar-racismo.

Álvarez, Rezaye. 2016. "Estado de Nicaragua Cercena Tierras Creoles." *La Prensa* (Managua), April 9, 2016. http://www.laprensa.com.ni/2016/04/09/nacionales/2015636-estado-de -nicaragua-cercena-tierras-creoles.

Amnesty International. 2016. *Danger: Rights for Sale: The Interoceanic Grand Canal Project in Nicaragua and the Erosion of Human Rights.* London: Amnesty International.

———. 2018a. *Instilling Terror: From Lethal Force to Persecution in Nicaragua.* London: Amnesty International.

———. 2018b. *Shoot to Kill: Nicaragua's Strategy to Repress Protest.* London: Amnesty International.

Ampie, Mauro. 2017. "Criminal Indifference to the Violence of the Caribbean Coast." *Revista Envío*, no. 426. https://www.envio.org.ni/articulo/5315.

Anderson, Jon Lee. 2014. "The Comandante's Canal." *The New Yorker*, March 10, 2014. http:// www.newyorker.com/magazine/2014/03/10/the-comandantes-canal.

———. 2015. "Breaking Ground on the Nicaragua Canal." *The New Yorker*, January 2, 2015. http://www.newyorker.com/news/news-desk/breaking-ground-nicaragua-canal.

———. 2018. "Nicaragua on the Brink, Once Again." *The New Yorker*, April 27, 2018. https:// www.newyorker.com/news/news-desk/nicaragua-on-the-brink-once-again.

Arana, Moisés. 2003. "We Live alongside Drugs in Bluefields." *Revista Envío*, no. 263, August 2003. http://www.envio.org.ni/articulo/2109.

Areas Esquivel, Norely. 2016. "Pueblos Originarios de la Costa Caribe Agradecen al Presidente Daniel el Reconocimiento de su Derecho a la Tierra." *El 19*, October 29, 2016. https://www .el19digital.com/articulos/ver/titulo:48340-pueblos-originarios-de-la-costa-caribe -agradecen-al-presidente-daniel-el-reconocimiento-de-su-derecho-a-la-tie.

Arellano, Jorge Eduardo. 2013. "'La Popó,' Orgullosa de Ser Madre, Negra y Costeña." *El Nuevo Diario* (Managua), May 31, 2013. https://www.elnuevodiario.com.ni/nacionales/287609 -popo-orgullosa-ser-madre-negra-costena/.

————, ed. 2009. *La Costa Caribe Nicaragüense: Desde Sus Orígenes hasta el Siglo XXI.* Managua: Academia de Geografía e Historia de Nicaragua.

Arnove, Robert F. 1981. "The Nicaraguan National Literacy Crusade of 1980." *Comparative Education Review* 25, no. 2: 244–60.

Augé, Marc. 2008. *Non-Places: Introduction to an Anthropology of Supermodernity.* 2nd ed. London: Verso.

Babb, Florence E. 2001. *After Revolution: Mapping Gender and Cultural Politics in Neoliberal Nicaragua.* Austin: University of Texas Press.

Baca, Lucydalia. 2011. "Orteguistas Cierran Programa de Radio en RAAS." *La Prensa* (Managua), February 8, 2011. http://www.laprensa.com.ni/2011/02/08/politica/51496-orteguistas -cierran-programa-de-radio-en-raas.

Baltodano, Mónica. 2010. *Memorias de la Lucha Sandinista.* Managua: Instituto de Historia de Nicaragua y Centroamérica de la Universidad Centroaméricana.

————. 2014a. "Canal Interoceánico: 25 Verdades, 40 Violaciones a La Constitución." *Revista Envío,* no. 382 (2014). http://www.envio.org.ni/articulo/4793.

————. 2014b. "What Mutations Have Turned the FSLN into What It Is Today?" *Revista Envío,* no. 390. https://www.envio.org.ni/articulo/4804.

————. 2018. "La Rebelión del Pueblo de Nicaragua." *Nueva Sociedad.* http://nuso.org/articulo /la-rebelion-del-pueblo-de-nicaragua/imprimir/.

Banet-Weiser, Sarah. 1999. *The Most Beautiful Girl in the World: Beauty Pageants and National Identity.* Berkeley: University of California Press, 1999.

Barbeyto Rodriguez, Arelly, and Dolores Figueroa. 2016. "Restoring Damage or Pursuing Justice? The Dilemma of Communitarian Miskitu Women Seeking a Life Free of Violence." *Bulletin of Latin American Research* 35, no. 3: 370-383.

Barnes, Natasha B. 1994. "Face of the Nation: Race, Nationalisms and Identities in Jamaican Beauty Pageants." *Massachusetts Review* 35, no. 3/4: 471–492.

Bay-Meyer, Kelly. 2013. "Do Ortega's Citizen Power Councils Empower the Poor in Nicaragua? Benefits and Costs of Local Democracy." *Polity* 45, no. 3: 393–421.

Beer, June. 1986. "Love Poem." *WANI* 4: 37.

Behar, Ruth. 1996. *The Vulnerable Observer: Anthropology That Breaks Your Heart.* Boston: Beacon Press.

Bell, C. Napier. (1899) 1989. *Tangweera: Life and Adventures among Gentle Savages.* Austin: University of Texas Press.

Belli, Gioconda. 2016. "Nicaragua Is Drifting towards Dictatorship Once Again." *The Guardian,* August 24. 2016. https://www.theguardian.com/commentisfree/2016/aug/24/nicaragua -dictatorship-sandinista-ortega-murillo.

————. 2018. "How Daniel Ortega Became a Tyrant." *Foreign Affairs,* August 24, 2018. https:// www.foreignaffairs.com/articles/nicaragua/2018-08-24/how-daniel-ortega-became -tyrant.

Belli, Gioconda, and Kristina Cordero. 2003. *The Country Under My Skin: A Memoir of Love and War.* New York: Alfred A. Knopf.

Bendaña, Alejandro. 2007. "The Rise and Fall of the FSLN." *NACLA,* September 25, 2007. https://nacla.org/article/rise-and-fall-fsln.

Bernal, Victoria. 2014. *Nation as Network: Diaspora, Cyberspace, and Citizenship.* Chicago: University of Chicago Press.

Berry, Maya, Claudia Chávez Argüelles, Shanya Cordis, Sarah Ihmoud, and Elizabeth Velásquez Estrada. 2017. "Toward a Fugitive Anthropology: Gender, Race, and Violence in the Field." *Cultural Anthropology* 32, no. 4: 537–565.

Bluefields Black-Creole Indigenous Government (BBCIG). 2013. *Informe de Elección Comunal del Gobierno Comunal Creole de Bluefields.* Bluefields, Nicaragua: BBCIG.

Bolaños Chow, Arely Fung-ying and Darling Armenia Quezada Sandino. 2008. *Contribución de las Remesas en la Economía Familiar de la Ciudad de Bluefields, RAAS, durante el Primer Trimestre del 2007*. Senior thesis. Bluefields, Nicaragua: Bluefields Indian and Caribbean University.

Bonilla, Yarimar, and Jonathan Rosa. 2015. "#Ferguson: Digital Protest, Hashtag Ethnography, and the Racial Politics of Social Media in the United States." *American Ethnologist* 42, no. 1: 4–17.

Bonilla-Silva, Eduardo. 2010. *Racism without Racists: Color-Blind Racism and the Persistence of Racial Inequality in the United States*. 3rd ed. Lanham, MD: Rowman & Littlefield.

Borge, Tomás. 1992. *The Patient Impatience: From Boyhood to Guerilla: A Personal Narrative of Nicaragua's Struggle for Liberation*. East Haven, CT: Curbstone Press, 1992.

Borge, Tomás, Carlos Fonseca Amador, Daniel Ortega, Humberto Ortega, and Jaime Wheelock. 1982. *Sandinistas Speak*. New York: Pathfinder Press.

Bredbenner, Candice Lewis. 1998. *A Nationality of Her Own: Women, Marriage, and the Law of Citizenship*. Berkeley: University of California Press.

Brooks, David Clark. 1998. *Rebellion From Without: Culture and Politics among Nicaragua's Atlantic Coast in the Time of the Sandino Revolt, 1926–1934*. Ph.D. dissertation. University of Connecticut.

Burnett, John. 2004. "Cocaine's Influence on Nicaragua's Miskito Coast." National Public Radio, October 22. https://www.npr.org/2004/10/22/4121711/cocaines-influence-on-nicaraguas-miskito-coast.

Burns, E. Bradford. 1991. *Patriarch and Folk: The Emergence of Nicaragua, 1798–1858*. Cambridge: Harvard University Press.

Cabezas, Omar. 1985. *La Montaña es Algo Más que una Inmensa Estepa Verde*. Colección Nueva Nicaragua. Buenos Aires: Editorial Nueva América.

Caldwell, Kia Lilly. 2007. *Negras in Brazil: Re-Envisioning Black Women, Citizenship, and the Politics of Identity*. New Brunswick, NJ: Rutgers University Press.

Calero, Mabel. 2018. "Movimiento 19 de Abril de la Costa Caribe se Planta frente a El Chipote." *La Prensa* (Managua), May 17, 2018. https://www.laprensa.com.ni/2018/05/17/nacionales/2421051-movimiento-19-de-abril-de-la-costa-del-caribe-se-planta-frente-al-chipote.

CALPI. 2016. "We Do Not Consent/Nosotros No Consentimos." https://www.facebook.com/calpinicaragua/videos/1346650608686272/?v=1346650608686272.

———. 2017. "The Golden Swampo." Edited by Vera Narváez. https://www.youtube.com/watch?v=RBzw4f-iV10.

Cardenal, Fernando. 2015. *Faith & Joy: Memoirs of a Revolutionary Priest*. Maryknoll, NY: Orbis Books.

Carroll, Rory. 2007. "Cocaine Galore! Villagers Live It up on Profits from 'White Lobster.'" *The Guardian*, October 8, 2007. https://www.theguardian.com/world/2007/oct/09/international.mainsection2.

Castillo, Félix. 2010. "Una Mujer que Rompió Esquemas." *La Prensa* (Managua), December 31, 2010.

CEIMM. 2004. *El Papel de las Mujeres en la Construcción de la Autonomía." Memoria, IV Simposio Internacional de Autonomía: Regiones Autónomas de la Costa Caribe Nicaragüense*. Managua: URACCAN.

———. 2007. *Explotación Sexual Comercial de Niñas, Niños y Adolescentes en Cuatro Municipios de las Regiones Autónomas de la Costa Caribe Nicaragüense: Estudio de Línea de Base*. Managua: IPAPE.

CENIDH. 2013. "CENIDH Apoya a Indígenas y Afrodescendientes que Recurren por Inconstitucionalidad contra Ley 840 'Ley de Canal.'" https://www.cenidh.org/noticias/460/.

Centro Dos Generaciones. 2007. *Manual para Operadores del Sistema de Administración de Justicia. Protección Especial en el Acceso para Niños, Niñas y Adolescentes en Situación de Violencia Sexual*. Managua: Centro Dos Generaciones.

Chamorro, Carlos F. 2016. "Daniel Ortega, Murillo y la Memoria de la Dictadura." *El País* (Madrid), November 29, 2016. http://internacional.elpais.com/internacional/2016/08/03/america/1470251277_461412.html.

———. 2018a. "Nicaragua Says No to Repression or Backroom Deals." *Confidencial*, April 22, 2018. https://confidencial.com.ni/nicaragua-says-no-to-repression-or-back-room-deals/.

———. 2018b. "El Asesinato de Ángel Gahona en la Impunidad." *Confidencial* (Managua), September 10, 2018. https://confidencial.com.ni/el-asesinato-de-angel-gahona-en-la-impunidad/.

———. 2018c. "'Modelo Cosep' o el Régimen de Ortega?" *Confidencial*, January 2, 2018. https://www.confidencial.com.ni/opinion/modelo-cosep-regimen-ortega/.

Chamorro, Violeta. 1996. *Dreams of the Heart: The Autobiography of President Violeta Barrios de Chamorro of Nicaragua*. New York: Simon & Schuster.

Chavarría Lezama, Pedro. 2003. "Padres y Madres de la Autonomía."

Chavez Metoyer, Cynthia. 2000. *Women and the State in Post-Sandinista Nicaragua*. Boulder, CO: Lynne Rienner.

Close, David. 1999. *Nicaragua: The Chamorro Years*. Boulder, CO: Lynne Rienner.

Close, David, Salvador Martí i Puig, and Shelley A. McConnell. 2011. *The Sandinistas and Nicaragua Since 1979*. Boulder: Lynne Rienner.

Cobo del Arco, Teresa. 2000. *Políticas de Género durante el Liberalismo: Nicaragua, 1893–1909*. Managua: Colectivo Gaviota.

Collinson, Helen, and Lucinda Broadbent, eds. 1990. *Women and Revolution in Nicaragua*. London: Zed Books.

Comisión Interamericana de Derechos Humanos. 2015a. "Nicaragua: Canal Transoceánico." March 16, 2015. https://www.youtube.com/watch?v=oOxVVwrKnBc.

———. 2015b. "Nicaragua: Indígenas y Afrodescendientes." October 20, 2015. https://www.youtube.com/watch?v=t1tLDq15d4o.

———. 2019. "Nicaragua: Indígenas y Afrodescendientes." https://www.youtube.com/watch?v=dFSTjbiwhfY&list=PLo-so_fgjaJ5Dh2-ZQwE9MEYboo3HKqcV&index=1.

Complejo Judicial Central Managua. 2013. "CSJ Rechaza Recursos contra la ley del Gran Canal." http://www.poderjudicial.gob.ni/prensacjcm/notas_prensa_detalle.asp?id_noticia=4242.

Confidencial. 2017a. "Death Threats in Nicaragua against Indigenous Rights Activist." *Confidencial* (Managua), March 27, 2017. https://confidencial.com.ni/death-threats-in-nicaragua-against-indigenous-rights-activist/.

———. 2017b. "World Bank Confirms: A Third of Nicaraguans Live in Poverty." August 7, 2017. https://confidencial.com.ni/world-bank-confirms-third-of-nicaraguans-live-in-poverty/.

Consejo de Comunicacíon y Ciudadanía. 2016. "Comandante Daniel Entrega Títulos de Propiedad a la Costa Caribe de Nicaragua." *El 19* (Managua). https://www.el19digital.com/articulos/ver/titulo:48353-comandante-daniel-entrega-titulos-de-propiedad-a-la-costa-caribe-de-nicaragua.

Consejo de Desarrollo de la Costa Caribe. 2009. *Plan de Desarrollo de la Costa Caribe: En Ruta hacia el Desarrollo Humano*. Managua: Gobierno de Nicaragua.

———. 2012. *Estrategía de Desarrollo de la Costa Caribe y Alto Wangki Bocay para el Buen Vivir y el Bien Común 2012–2016*. Bluefields, Nicaragua: Gobierno de Nicaragua.

Constantini, Peter. 2016. "Powerful Winds Are Blowing against the Grand Canal." *Revista Envío*, no. 419. http://www.envio.org.ni/articulo/5201.

Córdoba, Matilde. 2010. "Francisco Campbell a Washington." *El Nuevo Diario* (Managua), March 22, 2010. https://www.elnuevodiario.com.ni/politica/70822-francisco-campbell-washington/.

———. 2014. "Bluefields, el Paraíso Perdido." *El Nuevo Diario* (Managua), August 28, 2014. https://www.elnuevodiario.com.ni/nacionales/328482-bluefields-paraiso-perdido/.

Craig, Maxine Leeds. 2002. *Ain't I a Beauty Queen? Black Women, Beauty, and the Politics of Race.* New York: Oxford University Press.

Cuadra Pasos, Carlos. 1976. *Obras.* Serie Ciencias Humanas Nos. 4–5, 2 vols. Managua: Fondo de Promoción Cultural, Banco de América.

CuarteroAgurcia. 2017. *Hábitos de los Usuarios Nicaragüenses en Internet.* CuarteroAgurcia. https://cuarteroagurcia.com/producto/uso-de-internet-en-nicaragua/.

Cunningham Kain, Mirna. 2006. *Racism and Ethnic Discrimination in Nicaragua.* Bilwi, Nicaragua: Centro para la Autonomía y Desarrollo de los Pueblos Indígenas.

Cupples, Julie, and Kevin Glynn. 2018. *Shifting Nicaraguan Mediascapes: Authoritarianism and the Struggle for Social Justice.* Cham, Switzerland: Springer.

Daniel, Patricia. 1998. *No Other Reality: The Life and Times of Nora Astorga.* Oakland, CA: CAM Publishing.

Debusmann, Bernd. "Cocaine Is King on Nicaragua's Caribbean Coast." *Reuters*, 2007. http://www.reuters.com/article/us-nicaragua-cocaine-idUSN2326993620070130.

Deighton, Jane. *Sweet Ramparts: Women in Revolutionary Nicaragua.* London: War on Want, 1983.

del Cid, Amalia. 2019. "El Enorme Poder de la Redes Sociales." *La Prensa* (Managua), January 14, 2019. https://www.laprensani.com/magazine/reportaje/el-enorme-poder-de-las-redes-sociales/.

Dewitt Turpeau, David. 1942. *Up from the Cane-brakes.* Self-published.

Dixon, Neyda. 2012. "Policia Nacional Detienen a Ted Hayman." June 24, 2012. https://www.youtube.com/watch?v=Ynd9urm1-fk.

———. 2013. "Policia Nacional Siguen con el Caso Ted Hayman." January 13, 2013. https://www.youtube.com/watch?v=rRSLxwnw2ko.

Doornbos, Elyne. 2016. *Vanguards of Social and Environmental Justice: Politics "from Below" and the Transformative Potential of Resistance in the Context of Nicaragua's Interoceanic Gran Canal.* Biscay, Spain: Fundación Betiko. http://fundacionbetiko.org/wp-content/uploads/2017/02/06_doornbos_nicaragua.pdf.

Dore, Elizabeth. 2006. *Myths of Modernity: Peonage and Patriarchy in Nicaragua.* Durham, NC: Duke University Press.

Downs, Ray. 2015. "Violent Land Invasions on Nicaragua's Atlantic Coast—'Just Like the Spaniards.'" *Vice*, December 8, 2015. https://www.vice.com/en_us/article/ywjbpv/violent-land-invasions-on-nicaraguas-atlantic-coast-just-like-the-spaniards.

Dozier, Craig L. *Nicaragua's Mosquito Shore: The Years of British and American Presence.* Tuscaloosa: University of Alabama Press, 1985.

El 19. 2014. "La Autonomía es la Revolución en la Costa Caribe." November 1, 2014. https://www.el19digital.com/articulos/ver/titulo:23577-la-autonomia-es-la-revolucion-en-la-costa-caribe.

———. 2016. "Comandante Daniel Entrega Títulos de Propiedad a la Costa Caribe de Nicaragua." October 30, 2016. https://www.el19digital.com/articulos/ver/titulo:48337-comandante-presidente-daniel-entrega-titulos-comunitarios-a-pueblos-originarios-de-la-costa-caribe-de-nicaSalinas.

El Nuevo Diario. 2010a. "Scharllette Allen, Miss Nicaragua 2010." *El Nuevo Diario* (Managua), February 27, 2010. https://www.elnuevodiario.com.ni/nacionales/69220-scharllette-allen-miss-nicaragua-2010/.

———. 2010b. "La Reina Abre Su Corazón." *El Nuevo Diario* (Managua), February 28, 2010. https://www.elnuevodiario.com.ni/variedades/69279-reina-abre-su-corazon/.

———. 2011. "Monja, Guerrillera y Defensora de Mujeres." *El Nuevo Diario* (Managua), October 23, 2011.

———. 2014. "Ortega Critica Racismo en Estados Unidos." *El Nuevo Diario* (Managua), December 9, 2014. http://www.elnuevodiario.com.ni/politica/336834-ortega-critica-racismo-estados-unidos/.

———. 2018a. "Publican Reformas al INSS en La Gaceta." *El Nuevo Diario* (Managua), April 18, 2018. https://www.elnuevodiario.com.ni/nacionales/461471-publican-reformas-inss-gaceta/.

———. 2018b. "Organismos Continúan Registro de Víctimas." *El Nuevo Diario* (Managua), April 29, 2018. https://www.elnuevodiario.com.ni/nacionales/462489-organismos-continuan-registro-victimas/.

El Universo. 2018. "Papa Francisco Pide Poner Fin a Violencia en Nicaragua." April 22, 2018. https://www.eluniverso.com/noticias/2018/04/22/nota/6728055/papa-francisco-pide-poner-fin-violencia-nicaragua.

Enriquez, Octavio. "La Ruta de la Droga." *Confidencial*, June 26, 2012. https://www.confidencial.com.ni/archivos/articulo/7090/especial-la-ruta-de-la-droga.

Envío. 1991. "A Year of UNO Economic Policies: The Rich Get Richer." https://www.envio.org.ni/articulo/2944.

FADCANIC. 1997. *Memoria: III Simposio Internacional Sobre La Autonomía De La Costa Atlántica De Nicaragua*. Bluefields, Nicaragua: Fundación Para la Autonomía y Desarrollo de la Costa Atlántica de Nicaragua.

Farmer, Paul. 1992. *AIDS and Accusation: Haiti and the Geography of Blame*. Berkeley: University of California Press.

Fernandez Poncela, Anna M., and Bill Steiger. 1996. "The Disruptions of Adjustment: Women in Nicaragua." *Latin American Perspectives* 23, no. 1: 49–66.

Flores Valle, Alejandro. 2018. "Juicio por el Periodista Ángel Gahona Es una "Burla," Afirma Viuda del Reportero." *La Prensa* (Managua), August 22, 2018. https://www.laprensa.com.ni/2018/08/22/nacionales/2462681-juicio-por-el-asesinato-del-periodista-angel-gahona-es-una-burla-afirma-viuda-del-reportero.

Fonseca Amador, Carlos. 1985. *Obras: Tomo 1 Bajo la Bandera del Sandinismo*. Managua: Editorial Nueva Nicaragua.

Franklin, Jonathan. 2008. "Catch of the Day: Cocaine." *New Zealand Herald*, February 14, 2008. https://www.nzherald.co.nz/world/news/article.cfm?c_id=2&objectid=10491443.

Freeland, Jane. 1999. "Can the Grass Roots Speak? The Literacy Campaign in English on Nicaragua's Atlantic Coast." *International Journal of Bilingual Education and Bilingualism* 2, no. 3.

Freyre, Gilberto. 1956 [1935]. *The Masters and the Slaves: A Study in the Development of Brazilian Civilization*. New York: Knopf.

Frühling, Pierre, Miguel González Pérez, and H. P. Buvollen. 2007. *Etnicidad y Nación: El Desarrollo de la Autonomía de la Costa Atlántica de Nicaragua (1987–2007)*. Guatemala: F&G Editores.

Galanova, Mira. 2017. "Inside Nicaragua's Bloody Conflict over Indigenous Land." *Al Jazeera*, March 1, 2017. http://www.aljazeera.com/indepth/features/2017/02/nicaragua-bloody-conflict-indigenous-land-170206114438236.html.

García, Ernesto. 2013. "60 Crímenes en 5 Años en Tierras Indígenas." *El Nuevo Diario* (Managua), November 28, 2013. https://www.elnuevodiario.com.ni/nacionales/303383-60-crimenes-5-anos-tierras-indigenas/.

Garth Medina, José, Roberto Mora, Alina Lorío, Sara Ruíz, Saúl Martinez, Ramón Villareal, William Aragón, and Eddy López Hernandez. 2018. "Protestas y Tranques Continúan en Varios Departamentos de Nicaragua." *La Prensa* (Managua), May 13, 2018. https://www.laprensani.com/2018/05/13/departamentales/2418962-continua-jornada-de-protestas-y-tranques-en-varios-departamentos-de-nicaragua.

Gilliam, Angela. 1998. "The Brazilian Mulata: Images in the Global Economy." *Race and Class* 40, no. 1: 57–69.

Gilmore, Ruth Wilson. 2002. "Fatal Couplings of Power and Difference: Notes on Racism and Geography." *Professional Geographer* 54, no. 1: 15–24.

Glenn, Cerise L. 2015. "Activism or 'Slacktivism?': Digital Media and Organizing for Social Change." *Communication Teacher* 29, no. 2 (2015): 81–85.

Global Witness. 2017. *Defender La Tierra: Asesinatos Globales de Defensores/as de la Tierra y el Medio Ambiente en 2016.* London: Global Witness.

Gobat, Michel. 2016. *Confronting the American Dream: Nicaragua Under U.S. Imperial Rule.* Durham, NC: Duke University Press. 2006.

Goett, Jennifer. 2006. *Diasporic Identities, Autochthonous Rights: Race, Gender, and the Cultural Politics of Creole Land Rights in Nicaragua.* Ph.D. dissertation. University of Texas at Austin.

———. 2011. "Citizens or Anticitizens? Afro-Descendants and Counternarcotics Policing in Multicultural Nicaragua." *Journal of Latin American and Caribbean Anthropology* 16, no. 2: 354–379.

———. 2016a. "In Nicaragua, the Latest Zombie Megaproject." *NACLA.* (https://nacla.org/news/2016/05/20/nicaragua-latest-zombie-megaproject.

———. 2016b. *Black Autonomy: Race, Gender, and Afro-Nicaraguan Activism.* Stanford: Stanford University Press, 2017.

———. 2018. "Beyond Left and Right: Grassroots Social Movements and Nicaragua's Civic Insurrection." *Lasa Forum* 49, no, 4: 25-31.

Goetz, Anne Marie. 2007. "Political Cleaners: Women as the New Anti-Corruption Force?" *Development and Change* 38, no. 1: 87-105.

Gomez, Oliver and Flores, Yadira. 2004. "Masacran a Policías." *El Nuevo Diario* (Managua), May 4, 2004. http://archivo.elnuevodiario.com.ni/nacional/159363-masacran-policias/.

González, Aldana, Ericka Etelvina, and Vidal Roman Días Chow. 2001. *Diagnostico del Uso, Consumo y Trafico de Drogas en la RAAS.* Bluefields, Nicaragua: Ministerio de Gobernación Delegación Bluefields RAAS/Consejo Regional de Lucha Contra las Drogas.

González, Miguel. 1997. *Gobiernos Pluriétnicos: La Constitución de Regiones Autónomas en Nicaragua. Estudio Sobre el Estado Nacional y el Proceso de Autonomía en la Costa Atlántica-Caribe.* Mexico D.F.: Plaza y Valdés S.A. de C.V.

———. 2005. "'En la Costa Hemos Demostrado que Sabemos Vivir la Autonomía.'" *Revista Envío*, no. 282. http://www.envio.org.ni/articulo/3039.

———. 2015. "La Costa del Comandante Campbell." *Confidencial* (Managua), August 16, 2015. https://confidencial.com.ni/archivos/articulo/22630/la-costa-del-comandante-campbell.

———. 2016a. "The Unmaking of Self-Determination: Twenty-Five Years of Regional Autonomy in Nicaragua." *Bulletin of Latin American Research* 35, no. 3: 306–321.

———. 2016b. "Hodgson May, George Montgomery." In *Dictionary of Caribbean and Afro-Latin American Biography*, edited by Frankling W. Knight and Henry Louis Gates. Oxford: Oxford University Press.

González, Mauricio. 2017. "Usuarios de Facebook Crecen en Nicaragua." *El Nuevo Diario* (Managua), March 27, 2017. https://www.elnuevodiario.com.ni/nacionales/422947-usuarios-facebook-crecen-nicaragua/.

González, Miguel, Dolores Figueroa, and Arelly Barbeyto Rodriguez. 2006. "Género, Etnia y Partidos en las Elecciones Regionales de la Costa Caribe: Retos de la Diversidad." *Wani: Revista del Caribe Nicaragüense*, no. 44: 10–23.

González-Rivera, Victoria. 2011. *Before the Revolution: Women's Rights and Right-Wing Politics in Nicaragua, 1821–1979.* University Park: Pennsylvania State University Press.

Gordon, Avery. 1997. *Ghostly Matters: Haunting and the Sociological Imagination.* Minneapolis: University of Minnesota Press.

Gordon, Edmund Tayloe. 1998. *Disparate Diasporas: Identity and Politics in an African Nicara-guan Community*. Austin: University of Texas Press.

Gordon-Ugarte, Ishan Elizabeth. 2022. *"She Too 'Omanish'": Young Black Women's Sexuality and Reproductive Justice in Bluefields, Nicaragua*. Ph.D. dissertation. The Graduate Center, City University of New York.

Gould, Jeffrey L. 1998. *To Die in This Way: Nicaraguan Indians and the Myth of Mestizaje, 1880–1965*. Durham, NC: Duke University Press.

Gurdián, Galio, Charles R. Hale, and Edmund T. Gordon. 2003. "Rights, Resources, and the Social Memory of Struggle: Reflections on Black Community Land Rights on Nicaragua's Atlantic Coast." *Human Organization* 62, no. 4: 369–381.

Gutiérrez, Gustavo. 1988. *A Theology of Liberation: History, Politics, and Salvation*. Maryknoll, NY: Orbis Books.

Hale, Charles R. 1994. *Resistance and Contradiction: Miskitu Indians and the Nicaraguan State, 1894-1987*. Stanford: Stanford University Press.

———. 2004. "Rethinking Indigenous Politics in the Era of the 'Indio Permitido.'" *NACLA Report on the Americas* 38, no. 2: 16–21.

———. 2006. *Más Que Un Indio = More Than an Indian: Racial Ambivalence and Neoliberal Multiculturalism in Guatemala*. Santa Fe, NM: School of American Research Press.

———. 2007. "Miskitu in the Revolution." *NACLA*. https://nacla.org/article/miskitu-revolution-revolution.

———. 2008. "Activist Research v. Cultural Critique: Indigenous Land Rights and the Contra-dictions of Politically Engaged Anthropology." *Cultural Anthropology* 21, no. 1: 96–120.

———. 2017. "What Went Wrong? Rethinking the Sandinista Revolution in Light of Its Second Coming." *Latin American Research Review* 52, no. 4: 720–727.

Hammonds, Evelyn. 1994. "Black (W)holes and the Geometry of Black Female Sexuality." *Dif-ferences: A Journal of Feminist Cultural Studies* 6, no. 2: 126–45.

Hanchard, Michael G. 2000. "Racism, Eroticism, and the Paradoxes of a U.S. Black Researcher in Brazil." In *Racing Research, Researching Race: Methodological Dilemmas in Critical Race Studies*, edited by Frances Winddance Twine and Jonathan W. Warren, 165–186. New York: New York University Press, 2000.

Haraway, Donna J. 1988. "Situated Knowledges: The Science Question in Feminism and the Privilege of Partial Perspective." *Feminist Studies* 14, no. 3: 575–599.

Harcourt, Wendy and Arturo Escobar. 2005. *Women and the Politics of Place*. Bloomfield: Kumar-ian Press.

Harpelle, Ronald. 2003. "Cross Currents in the Western Caribbean: Marcus Garvey and the UNIA in Central America." *Caribbean Studies* 31, no. 1: 35–73.

Harris-Perry, Melissa V. *Sister Citizen: Shame, Stereotypes, and Black Women in America*. New Haven, CT: Yale University Press, 2011.

Harrison, Faye Venetia. 1997. *Decolonizing Anthropology: Moving Further toward an Anthropol-ogy of Liberation*. 2nd ed. Arlington, VA: Association of Black Anthropologists, American Anthropological Association.

Hartman, Saidiya V. 1997. *Scenes of Subjection: Terror, Slavery, and Self-Making in Nineteenth-Century America*. New York Oxford University Press.

Henriquez Cayasso, George. 2017. "¿Cómo Se Realiza el Genocidio Étnico en Nicaragua?" *La Prensa* (Managua), November 21, 2017. https://www.laprensa.com.ni/2017/11/21/opinion/2334248-se-realiza-genocidio-etnico-nicaragua.

Herrera Vallejos, Carmen. 2018. "How Nicaragua's Good Guys Turned Bad." *New International-ist*, August 1, 2018. https://newint.org/taxonomy/term/14266.

Hill Collins, Patricia. 2000. *Black Feminist Thought: Knowledge, Consciousness, and the Politics of Empowerment*. Rev. 10th anniversary ed. New York: Routledge.

Hine, Darlene Clark. 1989. "Rape and the Inner Lives of Black Women in the Middle West," *Signs* 14, no. 4: 912–920.

Hobson Herlihy, Laura. 2016. "The New Colonization of Nicaragua's Caribbean Coast." *NACLA.* https://nacla.org/print/111.

Hobson Herlihy, Laura and Brett Spencer. 2016. "Indigenous Resistance in Nicaragua's Elections." *NACLA.* https://nacla.org/news/2016/12/09/indigenous-resistance-nicaragua%E2%80%99s-elections.

Hooker, Alta. 2006. "'We Want Respect from the National Government.'" *Revista Envío*, no. 296. http://www.envio.org.ni/articulo/3223.

Hooker, Juliet. 2005a. "'Beloved Enemies': Race and Official Mestizo Nationalism in Nicaragua." *Latin American Research Review* 40, no. 3 (October): 14–39.

———. 2005b. "Indigenous Inclusion/Black Exclusion: Race, Ethnicity and Multicultural Citizenship in Latin America." *Journal of Latin American Studies* 37: 285–310.

———. 2009. *Race and the Politics of Solidarity.* New York: Oxford University Press.

———. 2010. "Race and the Space of Citizenship: The Mosquito Coast and the Place of Blackness and Indigeneity in Nicaragua." In *Blacks and Blackness in Central America: Between Race and Place,* edited by Lowell Gudmundson and Justin Wolfe, 246–277. Durham, NC: Duke University Press.

hooks, bell. 1981. *Ain't I a Woman: Black Women and Feminism.* Boston: South End Press.

———. 2003. *Teaching Community: A Pedagogy of Hope.* New York: Routledge.

Humboldt, Centro. 2016. "We're Facing the Worst Environmental Crisis in Recent History." *Revista Envío*, no. 418 (2016). http://www.envio.org.ni/articulo/5186.

IEEPP. 2011. *Delitos y Drogas en Bluefields.* Managua: Instituto de Estudios Estratégicos y Políticas Públicas.

iLifebelt. 2017. *7mo Estudio de Uso de Redes Sociales en Centroamérica y el Caribe.* Mexico City: iLifebelt.

INIDE. 2005. *Caracterización Sociodemográfica de la Región Autónoma Atlántico Sur.* Managua: Instituto Nacional de Información de Desarrollo.

Inter-American Commission on Human Rights. 2014. "Centroamérica: Poblaciones Creole y Garífuna." https://www.youtube.com/watch?v=3jtMA6_ZAT8.

———. 2015a. "Nicaragua: Canal Transoceánico." March 16, 2015. https://www.youtube.com/watch?v=oOxVVwrKnBc.

———. 2015b. "Nicaragua: Indígenas y Afrodescendientes." October 20, 2015. https://www.youtube.com/watch?v=t1tLDq15d4o.

———. 2018. *Gross Human Rights Violations in the Context of Social Protests in Nicaragua.* Washington, DC: Organization of American States.

———. 2019. "Nicaragua: Indígenas y Afrodescendientes en Costa Caribe." May 8, 2019. https://www.youtube.com/watch?v=dFSTjbiwhfY&list=PLo-so_fgjaJ5Dh2-ZQwE9MEYbo03HKqcV&index=1.

Inter-American Dialogue. 2018. "A Conversation with Valdrack Jaentschke." September 24, 2018. https://www.youtube.com/watch?v=oVD865fY9oI.

IPAS. 2014. "La Maternidad Impuesta por Violacíon Tiene Rostro de Niña." *Envío.* September 2014. http://www.envio.org.ni/articulo/4890.

IPAS Centroamérica and Grupo Estratégico por la Despenalización del Aborto Terapéutico. 2016. *Embarazo Impuesto por Violación: Niñas-Madres Menores de 14 Años.* Managua: IPAS Centroamérica.

Isbester, Katherine. 2001. *Still Fighting: The Nicaraguan Women's Movement, 1977–2000.* Pitt Latin American Series. Pittsburgh: University of Pittsburgh Press.

IXCHEN. 2006. *No Más Vidas Truncadas! Documentando Delitos de Violencia Sexual contra Niñas y Adolescentes en Cinco Departamentos de Nicaragua.* Managua: Centro de Mujeres IXCHEN.

James, Joy. 2009. "The Dead Zone: Stumbling at the Crossroads of Party Politics, Genocide, and Postracial Racism." *South Atlantic Quarterly* 108, no. 3: 459-481.

Jarquín, Edmundo, Elvira Cuadra, Julio Icaza Gallard, José Antonio Peraza Collado, Uriel Pineda, Guillermo Rothschuh Villanueva, and Enrique Sáenz, eds. 2016. *El Régimen de Ortega: ¿Una Nueva Dictadura Familiar en el Continente?* Managua: PAVSA.

Jarquín, Heberto. 2010a. "Bluefields Celebra a la 'Perla de Ébano.'" *El Nuevo Diario* (Managua), February 28, 2010. https://www.elnuevodiario.com.ni/nacionales/69286-bluefields-celebra-perla-ebano/#comentario.

———. 2010b. "Bluefields Rendido ante su Reina." *El Nuevo Diario* (Managua), March 21, 2010. https://www.elnuevodiario.com.ni/variedades/70776-bluefields-rendido-su-reina/.

Jordan, June. 1985. *On Call: Political Essays*. Boston: South End Press.

Jubb, Nadine. 2014. "Love, Family Values and Reconciliation for All, but What about Rights, Justice and Citizenship for Women? The FSLN, the Women's Movement, and Violence against Women in Nicaragua." *Bulletin of Latin American Research* 33, no. 3: 289–304.

Kalb, Courtenay de. 1893. "Nicaragua: Studies on the Mosquito Shore in 1892." *Journal of the American Geographical Society of New York* 25, no. 1: 236–288.

Kampwirth, Karen. 1996. "The Mother of the Nicaraguans: Doña Violeta and the UNO's Gender Agenda." *Latin American Perspectives* 88, no. 3: 67–86.

———. 2002. *Women & Guerrilla Movements: Nicaragua, El Salvador, Chiapas, Cuba*. University Park: Pennsylvania State University Press.

———. 2003. "Arnoldo Alemán Takes on the NGOs: Antifeminism and the New Populism in Nicaragua." *Latin American Politics and Society* 45, no. 2: 133–158.

———. 2004. *Feminism and the Legacy of Revolution: Nicaragua, El Salvador, Chiapas*. Ohio University Research in International Studies Latin America Series. Athens: Ohio University Press.

———. 2008a. "Neither Left nor Right: Sandinismo in the Anti-Feminist Era." *NACLA*. https://nacla.org/article/neither-left-nor-right-sandinismo-anti-feminist-era.

———. 2008b. "Abortion, Antifeminism and the Return of Daniel Ortega: In Nicaragua, Leftist Politics?" *Latin American Perspectives* 35, no. 6: 122-136.

Kelley, Robin D. G. 1994. *Yo' Mama's Dysfunktional! Fighting the Culture Wars in Urban America*. Boston: Beacon Press.

———. 2002. *Freedom Dreams: The Black Radical Imagination*. Boston: Beacon Press.

Kinzer, Stephen. 1986. "In the Other Nicaragua: Reggae and Resentment." *New York Times*, October 15, 1986.

Kulick, Don, and Margaret Wilson, eds. 1995. *Taboo: Sex, Identity, and Erotic Subjectivity in Fieldwork*. London: Routledge.

Lacayo Ortiz, Ileana. 2016. "Afrodescendientes Protestan durante Acto de Conmemoración en Bluefields." *La Prensa* (Managua), August 11, 2016. http://www.laprensa.com.ni/2016/08/11/departamentales/2081724-afrodescendientes-protestan-durante-acto-de-conmemoracion-en-bluefields.

Lacayo Oyanguren, Antonio. 2006 *La Difícil Transición Nicaragüense: En el Gobierno con Doña Violeta*. Managua: Fundación UNO.

Lacombe, Delphine. 2013. "Struggling against the 'Worst-Case Scenario'? Strategic Conflicts and Realignments of the Feminist Movement in the Context of the 2006 Nicaraguan Elections." *Bulletin of Latin American Research* 33, no. 3: 274–288.

LaDuke, Betty. 1985a. *Compañeras: Women, Art, & Social Change in Latin America*. San Francisco: City Lights Books, 1985.

———. 1985b. "June Beer's Story." *Heresies: A Feminist Publication*, no. 20: 54–57.

———. 1986. "June Beer, Nicaraguan Artist." *Sage* 3, no. 2: 35–39.

La Gaceta. 1987. *Ley No. 28. Estatuto de Autonomía de las Dos Regiones de la Costa Atlántica de Nicaragua*. Edited by Asamblea Nacional. Managua: Republica de Nicaragua.

———. 2003. *Ley No. 445 Ley del Régimen de Propriedad Comunal de los Pueblos Indígenas Y Comunidades Étnicas de las Regiones Autonomas de la Costa Atlántica de Nicaragua y de los Ríos Bocay. Coco, Indio, Maíz.* Managua: Republica de Nicaragua.

———. 2013. *Ley No. 840. Ley Especial para el Desarrollo de Infraestructura y Transporte Nicaragüense Atingente al Canal, Zonas de Libre Comercio e Infraestructuras Asociadas.* Managua: Republica de Nicaragua.

Lancaster, Roger N. 1992. *Life Is Hard: Machismo, Danger, and the Intimacy of Power in Nicaragua.* Berkeley: University of California Press.

Lao-Montes, Agustín. 2009. "Cartografías del Campo Político Afrodescendiente en América Latina." *Universitas Humanística*, no. 68: 207–245.

La Prensa. 2007a. "Concejales Mestizos Piden Reformas a la Ley 445." March 15, 2007. http://www.laprensa.com.ni/2007/03/15/departamentales/1295771-concejales-mestizos-piden-reformas-a-la-ley-445.

———. 2007b. "'El Pueblo Presidente' o 'El Estado Soy Yo.'" May 9, 2007. https://www.laprensa.com.ni/2007/05/09/editorial/1299900-el-pueblo-presidente-o-el-estado-soy-yo.

———. 2015. "Nueva Marcha Contra el Canal." September 24, 2015.

La Semana. 2016. "Daniel Ortega: De Guerrillero a Dictador." June 8, 2016. https://www.semana.com/mundo/articulo/nicaragua-daniel-ortega-dictador/484816.

Le Lous, Fabrice. 2016. "Sergio Ramírez: 'Francisca Ramírez es la Única Líder de Nicaragua.'" *La Prensa* (Managua), September 11, 2016. https://www.laprensani.com/2016/09/11/suplemento/la-prensa-domingo/2097735-sergio-ramirez-francisca-ramirez-es-unica.

León, Kimberly. 2017. "Persiste Conflicto por Gobierno Comunal Creole." *La Costeñísima* (Bluefields), February 4, 2017. http://lacostenisima.com/2017/02/04/persiste-conflicto-gobierno-comunal-creole/.

León, Sergio. 2003. "'Ship-out Mantienen Economía de Bluefields." *La Prensa* (Managua), December 15, 2003. https://www.laprensani.com/2003/12/15/departamentales/905264-ship-out-mantienen-economa-de-bluefields.

———. 2009a. "Negros se Alzan en Bluefields contra el Gobierno (Blacks in Bluefields Rise up against the Government)." *La Prensa* (Managua), November 27, 2009. http://www.laprensa.com.ni/2009/11/27/departamentos/8865-negros-se-alzan-bluefields.

———. 2009b. "Invaden Tierras de Bluefields (Invading Lands in Bluefields)." *La Prensa* (Managua), November 28, 2009. http://www.laprensa.com.ni/2009/11/28/departamentos/8972-invaden-tierras-bluefields.

———. 2010. "Conflicto por Tierras en la RAAS." *La Prensa* (Managua), January 14, 2010. http://www.laprensa.com.ni/2010/01/14/departamentos/13072.

———. 2012a. "Capturan a Supuesto Narco en Bluefields." *La Prensa* (Managua), June 23, 2012. https://www.laprensa.com.ni/2012/06/23/departamentales/106041-capturan-a-supuesto-narco-en-bluefields.

———. 2012b. "Narco 'Aliado' de FSLN." *La Prensa* (Managua), July 1, 2012. https://www.laprensa.com.ni/2012/07/01/nacionales/106904-narco-aliado-de-fsln.

———. 2013. "Humillante Trato." *La Prensa* (Managua), February 27, 2013. http://www.laprensa.com.ni/2013/02/27/departamentales/136210-humillante-trato.

———. 2014. "FSLN Controla Gobierno Comunal Creole." *La Prensa* (Managua), October 11, 2014.

———. 2015a. "Droga 'Avanza' y 'Carcome' Bluefields." *La Prensa* (Managua), May 6, 2015. https://www.laprensa.com.ni/2015/05/06/departamentales/1826998-droga-avanza-y-carcome-bluefields.

———. 2015b. "Nueva Marcha contra el Canal." *La Prensa* (Managua), September 24, 2015. http://www.laprensa.com.ni/2015/09/24/departamentales/1907412-nueva-marcha-contra-el-canal?fb_action_ids=10206362241989302&fb_action_types=og.likes.

———. 2015c. "Molestos por Nueva Solicitud de Demarcación en Bluefields." *La Prensa* (Managua), December 15, 2015. http://www.laprensa.com.ni/2015/12/15/departamentales /1954579-1954579.

Lipsitz, George. 2006. *The Possessive Investment in Whiteness: How White People Profit from Identity Politics*. Philadelphia: Temple University Press.

———. 2011. *How Racism Takes Place*. Philadelphia: Temple University Press.

Logan, Samuel. 2006. "Nicaragua's Curse of the White Treasure." Zurich: International Relations and Security Network. http://www.samuellogan.com/articles/nicaraguas-curse-of -the-treasure.html.

López Vigil, Maria. 2003. "The Names of the Rose." *Revista Envío*. https://www.envio.org.ni /articulo/2075.

Lorde, Audre. 1985. *Sister Outsider*. Berkeley: Crossing Press.

Luna, Yader. 2018a. "Bayardo Arce Admite que Ortega 'Se Equivoco.'" *Confidencial* (Managua), April 25, 2018. https://confidencial.com.ni/bayardo-arce-admite-que-ortega-se-equivoco/.

———. 2018b. "Exigen 'Comision de la Verdad' para Investigar Represión y Asesinatos." *Confidencial* (Managua), April 25, 2018. https://confidencial.com.ni/exigen-comision-de-la-verdad -para-investigar-represion-y-asesinatos/.

Mandel, David. 2005. "'Managed Democracy': Capital and State in Russia." *Debate: Journal of Contemporary Central and Eastern Europe* 13, no. 2: 117–136.

Markey, Eileen. 2016. *A Radical Faith: The Assassination of Sister Maura*. New York: Nation Books.

Martí i Puig, Salvador. 2010. "The Adaptation of the FSLN: Daniel Ortega's Leadership and Democracy in Nicaragua." *Latin American Politics and Society* 52, no. 4: 79–106.

———. 2013. "Nicaragua: La Consolidación de un Régimen Híbrido." *Revista de Ciencia Política* 33, no. 1: 269–286.

Martínez, Óscar. 2011. "Langostas, Pangas, y Cocaína." *FronteraD: Revista Digital*, September 8, 2011. http://www.fronterad.com/index.php?q=langostas-pangas-y-cocaina.

McDermott, Jeremy. 2012. "Bluefields: Nicaragua's Cocaine Hub." *InsightCrime*, July 19, 2012. http://www.insightcrime.org/investigations/bluefields-nicaraguas-cocaine-hub.

McDowell, Linda. 1999. *Gender, Identity, and Place: Understanding Feminist Geographies*. Minneapolis: University of Minnesota Press.

McKittrick, Katherine. 2006. *Demonic Grounds: Black Women and the Cartographies of Struggle*. Minneapolis: University of Minnesota Press.

Medina, Fabián. 2018. "El Preso 198: Un Perfil de Daniel Ortega." *La Prensa* (Managua), September 18, 2018. https://www.laprensani.com/2018/09/18/cultura/2472645-el-preso-198-un-perfil -que-retrata-episodios-impactantes-dolorosos-y-conflictivos-de-la-vida-de-daniel-ortega

Mendoza, Tammy Zoad. 2010. "'Me Robé las Barras de las Otras Muchachas.'" *La Prensa* (Managua), March 1, 2010. https://www.laprensani.com/2010/03/01/espectaculo/17682-me-robe -las-barras-de-las-otras-muchachas.

———. 2015. "Indígenas Viven Reino del Terror en Costa Caribe Norte." *La Prensa* (Managua), December 21, 2015. http://www.laprensa.com.ni/2015/12/21/nacionales/1957861-indigenas -viven-reino-del-terror.

———. 2016. "La Guerra que el Gobierno de Nicaragua Evita Resolver." *La Prensa* (Managua), August 8, 2016. http://www.laprensa.com.ni/2016/08/08/nacionales/2080148-la-guerra -que-el-gobierno-de-nicaragua-evita-resolver.

Miller, Dolene. 2018. "Managua Estalla, y No Son Buenas Noticias para la Costa Caribe de Nicaragua." *Os Istmo*, May 1, 2018. https://oistmo.com/2018/05/01/managua-estalla-y-no-son -buenas-noticias-para-la-costa-caribe-de-nicaragua/.

Mills, Charles W. 1997. *The Racial Contract*. Ithaca: Cornell University Press.

Miranda Aburto, Wilfredo. 2014. "El Narco Contagia a Nicaragua." *Excelsior*. September 8, 2014. https://www.excelsior.com.mx/global/2014/09/08/980549.

———. 2016. "FIDH: 'Grave Impacto de Concesión Canalera.'" *Confidencial* (Managua), October 15, 2016. https://confidencial.com.ni/fidh-grave-impacto-concesion-canalera/.

———. 2018a. "Asesina al Periodista Ángel Gahona en Bluefields." *Confidencial* (Managua), April 22, 2018. https://confidencial.com.ni/asesinan-al-periodista-angel-gahona-en-bluefields/.

———. 2018b. "Nicaragua: University Students at UPOLI Continue Unbowed." *Confidencial* (Managua), April 25, 2018. https://confidencial.com.ni/nicaragua-university-students-at -upoli-continue-unbowed/.

———. 2018c. "El 19 de Julio se Impuso el 'Orteguismo de Daniel Ortega y su Señora.'" *Confidencial* (Managua), July 23, 2018. https://confidencial.com.ni/19-julio-se-impuso-orteguismo -daniel-ortega-senora/.

Mitchell, Rick. 2003. "Caribbean Cruising: Sex, Death, and Memories of (Congo) Darkness." *Atenea* 23, no. 2: 9–24.

Molyneux, Maxine. 1985. "Mobilization without Emancipation? Women's Interests, the State, and Revolution in Nicaragua." *Feminist Studies* 11, no. 2: 227–254.

Moncada, Roy, and Emiliano Chamorro Mendieta. 2018. "Gobierno Sandinista Responde con Turbas a Protestas Ciudadanas por Reformas Al INSS." April 19, 2018. https://www.laprensa .com.ni/2018/04/19/politica/2406137-gobierno-sandinista-responde-con-turbas-a -protestas-ciudadanas-por-reformas-al-inss.

Montenegro, Sofia. 2000. *La Cultura Sexual en Nicaragua*. Managua: Centro de Investigaciones de la Comunicación.

Montes, Laura and Socorro Woods Downs. 2008. *Diagnóstico Sobre Violencia de Género en las Regiones Autonomas del Atlantico Norte y Sur de Nicaragua*. Bluefields, Nicaragua: Agencia Española de Cooperación Internacional para el Desarrollo.

Mora, Jose Eduardo. 2004. "Nicaragua: Ex-President Sentenced." *NACLA* 37, no. 4: 46-47.

Morales, Amalia. 2009. "Reportaje: 'Usted Aquí No Puede Entrar.'" *La Prensa* (Managua), 2009, 11–13.

Morris, Courtney Desiree. 2018. "Unexpected Uprising: The Crisis of Democracy in Nicaragua." *NACLA*. https://nacla.org/print/11567.

Morris, Kenneth Earl. 2010. *Unfinished Revolution: Daniel Ortega and Nicaragua's Struggle for Liberation*. Chicago: Lawrence Hill Books.

Mosby, Dorothy. 2015. *Quince Duncan: Writing Afro-Costa Rican and Caribbean Identity*. Tuscaloosa: University of Alabama Press.

Murillo, Rosario. 2018. "Compañera Rosario en Multinoticias (19 De Abril Del 2018)." *Canal 4*, April 19, 2018. https://www.canal4.com.ni/index.php/discursos/discursos-rosario/40477 -companera-rosario-multinoticias-19-abril-2018.

NACLA. 1982. "Let Us Breathe." *NACLA Report on the Americas* 16(1): 18-45.

Narváez, Zoilamérica. 1998. "Testimonio de Zoilamérica Narváez en contra de su Padre Adoptivo Daniel Ortega Saavedra." Self-published.

Navarro, Francely. 2019. "Connie Taylor Cruza Toda Nicaragua para Abrazar a su Hijo Preso en La Modelo." *Hoy!* (Managua), March 10, 2019. http://www.hoy.com.ni/2019/03/10 /connie-taylor-cruza-toda-nicaragua-para-abrazar-a-su-hijo-preso-en-la-modelo/?fbclid =IwAR14Ms9m5vhYTR8LuHkQVIL9N_I.

Neumann, Pamela J. 2017. "In Nicaragua, a Failure to Address Violence against Women." *NACLA*. https://nacla.org/news/2017/04/28/nicaragua-failure-address-violence-against -women.

Nicaragua Hoy. 2013. "Indígenas Nicaragüenses Demandan la Inconstitucionalidad por Ley del Canal." http://www.nicaraguahoy.net/principal/indigenas-nicaragueenses-demandan -la-inconstitucionalidad-por-ley-del-canal.

Nixon, Rob. 2011. *Slow Violence and the Environmentalism of the Poor*. Cambridge: Harvard University Press.

Noticias de Bluefields. 2016. "Creoles de Bluefields Demandan al Presidente Ortega por Cercenar su Territorio." *Noticias de Bluefields* (Bluefields), November 29, 2016. https://www.facebook.com/NotiBluefields/photos/a.226715890816701.1073741826.226715827483374/718395521648733/?type=3&permPage=1.

———. 2018. "Justicia Luego Paz." April 30, 2018. https://www.facebook.com/NotiBluefields/videos/1050827841738831/.

Offen, Karl. 2002. "The Sambo and Tawira Miskitu: The Colonial Origins and Geography of Intra-Miskitu Differentiation in Eastern Nicaragua and Honduras." *Ethnohistory* 49, no. 2: 319–372.

Okin, Susan Moller. 1999. *Is Multiculturalism Bad for Women?* Princeton: Princeton University Press.

Omi, Michael and Howard Winant. 1994. *Racial Formations in the United States*. New York: Routledge.

Oparah, Julia Chinyere. 1998. *Other Kinds of Dreams: Black Women's Organisations and the Politics of Transformation*. London: Routledge.

Orozco, Roberto. 2011. "Porque Crece la Legitimación Social al Narcotráfico." *El Correo*. http://www.elcorreo.eu.org/NicaraguaPorque-crece-la-legitimacion-social-al-narcotrafico?lang=fr.

———. 2012. "Drug Trafficking Now Has Muscle and Is Generating a Lot of Money." *Revista Envío*, no. 373. https://www.envio.org.ni/articulo/4573.

Ortega Hegg, Manuel. 2013a. "'No Es Aceptable la Idea de Hacer el Canal a Cualquier Costo.'" *Revista Envío*, no. 379. http://www.envio.org.ni/articulo/4754.

———. 2013b. "Will the Canal Help Build the Nation or Only Further Fracture It?" *Revista Envío*, no. 387 (2013). http://www.envio.org.ni/articulo/4762.

Ortega Saavedra, Daniel. 2018. "Mensaje del Presidente-Comandante Daniel." *El 19*, April 21, 2018. https://www.el19digital.com/articulos/ver/titulo:76141-mensaje-del-presidente-comandante-daniel-al-pueblo-.

Oxfam. 2016. "El Riesgo de Defender: La Agudización de la Agresiones hacia Activistas de Derechos Humanos en América Latina." https://oi-files-d8-prod.s3.eu-west-2.amazonaws.com/s3fs-public/bn-el-riesgo-de-defender-251016-es_0.pdf.

Parrales, Elba Cristina. 2009a. "Restituyen a Consejera." *La Prensa* (Managua), December 6, 2009. https://www.laprensa.com.ni/2009/12/06/departamentales/309824-restituyen-a-consejera.

———. 2009b. "Aprobarán Proyecto Tumarín." *La Prensa* (Managua), December 17, 2009. https://www.laprensani.com/2009/12/17/departamentales/10602-aprobaran-proyecto-tumarin.

Partlow, Joshua. 2018. "'They Took My Humanity': Pro-Government Paramilitaries Terrorize Nicaraguan Protestors." *Washington Post*, August 2, 2018. https://www.washingtonpost.com/world/the_americas/they-took-my-humanity-pro-government-paramilitaries-terrorize-nicaraguan-protesters/2018/08/02/349f8914-900a-11e8-ae59-01880eac5f1d_story.html.

Paschel, Tianna S. 2016. *Becoming Black Political Subjects: Movements and Ethno-Racial Rights in Colombia and Brazil*. Princeton: Princeton University Press.

Perry, Keisha-Khan Y. 2013. *Black Women against the Land Grab: The Fight for Racial Justice in Brazil*. Minneapolis: University of Minnesota Press.

Pineda, Baron L. 2006. *Shipwrecked Identities: Navigating Race on Nicaragua's Mosquito Coast*. New Brunswick, NJ: Rutgers University Press.

PNUD: Programa de las Naciones Unidas para el Desarrollo. 2005. *Nicaragua Informe de Desarrollo Humano: Las Regiones Autónomas de la Costa Caribe, Nicaragua Asume su Diversidad?* Managua: PNUD.

Price, Richard. 1983. *First-Time: The Historical Vision of an Afro-American People*. Baltimore: John Hopkins University Press.

PRONicaragua. 2017. *La Costa Caribe de Nicaragua*. Managua: Gobierno de Nicaragua.

Rahier, Jean Muteba. 1998. "Blackness, the Racial/Spatial Order, Migrations, and Miss Ecuador 1995–96." *American Anthropologist* 100, no. 2: 421–430.

———. 2012. *Black Social Movements in Latin America: From Monocultural Mestizaje to Multiculturalism*. New York: Palgrave Macmillan.

Ramírez, Sergio. 2007. *Tambor Olvidado*. San José, Costa Rica: Aguilar.

———. 2012. *Adiós Muchachos: A Memoir of the Sandinista Revolution*. Durham, NC: Duke University Press.

Randall, Margaret. 1994. *Sandino's Daughters Revisited: Feminism in Nicaragua*. New Brunswick, NJ: Rutgers University Press.

Randall, Margaret, and Lynda Yanz. 1981. *Sandino's Daughters: Testimonies of Nicaraguan Women in Struggle*. Vancouver, BC: New Star Books.

Riverstone, Gerald. 2004. *Living in the Land of Our Ancestors: Rama Indian and Creole Territory in Carribbean Nicaragua*. Managua: ASDI.

Robb, Deborah. 2007. "Doreth's Cay." In *Una Narrativa Flotante: Mujeres Cuentistas Nicaragüenses*, edited by C. Midence and M. Urbina. Managua: Amerrisque.

Robinson, William I. 2018. "Capitalist Development in Nicaragua and the Mirage of the Left." *Truthout*, May 18, 2018. https://truthout.org/articles/capitalist-development-in-nicaragua-and-the-mirage-of-the-left/.

Robles, Frances. 2016. "Nicaragua Dispute over Indigenous Land Erupts in Wave of Killings." *New York Times*, October 16, 2016. https://www.nytimes.com/2016/10/17/world/americas/nicaragua-dispute-over-indigenous-land-erupts-in-wave-of-killings.html.

———. 2018. "Daniel Ortega Revoca la Reforma ala Seguridad Social por las Protestas." *New York Times*, April 22, 2018. https://www.nytimes.com/es/2018/04/22/espanol/nicaragua-protestas-pensiones-daniel-ortega.html.

Rocha, José Luis. 2016. "Four Keys to the Volatile Success of the Ortega-Murillo Project." *Revista Envío*, November 2016. https://www.envio.org.ni/articulo/5284.

———. 2009. "The Ship-out Caribbeans Have Left the Coast on Cruise Ships." *Envío*. https://www.envio.org.ni/articulo/4114.

Rodriguez, Dylan. 2006. *Forced Passages: Imprisoned Radical Intellectuals and the U.S. Prison Regime*. Minneapolis: University of Minnesota Press.

Rogers, Tim. 2009. "Disco's Door Policy Sparks Race Debate." *Tico Times* (San Jose), February 27, 2009.

Romero, Elizabeth. 2012. "'Es Un Montaje.'" *La Prensa* (Managua), July 2, 2012. https://www.laprensa.com.ni/2012/07/02/nacionales/107037-es-un-montaje.

———. 2017a. "Estado Ausente en Conflicto entre Indígenas y Colonos." *La Prensa* (Managua), January 12, 2017. http://www.laprensa.com.ni/2017/01/12/nacionales/2164092-estado-ausente-conflicto-indigenas-colonos.

———. 2017b. "Nuevo Ataque de Colonos a Indígenas Miskitos." *La Prensa* (Managua), March 1, 2017. http://www.laprensa.com.ni/2017/03/01/nacionales/2190988-nuevo-ataque-colonos-indigenas-miskitos 1/2.

———. 2017c. "Defensora de Derechos Indígenas Recibe Amenazas de Muerte En Nicaragua." *La Prensa* (Managua), March 8, 2017. https://www.laprensa.com.ni/2017/03/08/nacionales/2194852-defensora-derechos-indigenas-recibe-amenazas-muerte-nicaragua.

———. 2017d. "Población Afrodescendiente de Bluefields No Reconoce Título Emitido por el Gobierno." *La Prensa* (Managua), July 14, 2017. http://www.laprensa.com.ni/2017/07/14/nacionales/2263009-poblacion-afrodescendiente-bluefields.

———. 2017e. "El Peligro que Enfrentan los Defensores de la Tierra en Nicaragua." *La Prensa* (Managua), July 15, 2017. http://www.laprensa.com.ni/2017/07/15/nacionales/2263665-peligro-enfrentan-los-defensores-la-tierra-nicaragua.

———. 2017f. "Otro Líder Comunitario Asesinado por Colonos en Territorio Indígena Miskito." *La Prensa* (Managua), December 1, 2017. https://www.laprensa.com.ni/2017/12/01/nacionales/2340090-otro-lider-comunitario-asesinado-por-colonos-en-territorio-indigena-miskito.

———. 2018. "Migueliut Sandoval, Viuda de Periodista Ángel Gahona: 'Fue un Antimotín Bajito el Asesino.'" *La Prensa* (Managua), August 28, 2018. https://www.laprensa.com.ni/2018/08/28/nacionales/2464688-migueliut-sandoval-viuda-de-periodista-angel-gahona-fue-un-antimotin-bajito-el-asesino.

Romero, Elízabeth, and Sergio León. 2012. "Gran 'Quiebre' de Célula Narco." *La Prensa* (Managua), June 27, 2012. https://www.laprensa.com.ni/2012/06/27/nacionales/106495-gran-quiebrede-celula-narco.

Ruiz, Alfredo. 2013. "'La Tierra Se Está Concentrando en Pocas Manos, La Gran Hacienda Está de Regreso.'" *Revista Envío*, no. 378. http://www.envio.org.ni/articulo/4742.

Ruiz, Henry. 2016. "The Task Right Now Is to Avoid the Consolidation of a Family Dictatorship." *Revista Envío*, no. 422, September 2016. https://www.envio.org.ni/articulo/5250.

Ruiz y Ruiz, Frutos. 1925. *Informe del Doctor Don Frutos Ruiz y Ruiz Comisionado del Poder Ejecutivo en la Costa Atlántica de Nicaragua*. Managua: Tipografía Alemana de Carlos Heusberger.

Salazar, Maynor. 2017. "Mujeres al Frente de la Defensa de la Tierra." *Confidencial*, April 21, 2017. https://confidencial.com.ni/mujeres-al-frente-de-la-defensa-de-la-tierra/.

———. 2018a. "Fire in Nicaragua's Indio Maíz Biological Reserve Could Spread to its Western Border." *Confidencial*, April 11, 2018. https://confidencial.com.ni/fire-in-nicaraguas-indio-maiz-biological-reserve-could-spread-to-its-western-border/.

———. 2018b. "Nicaragua: Trial of Political Prisoners Continues Behind Closed Doors." *Confidencial*, August 18, 2018. https://confidencial.com.ni/nicaragua-trial-of-political-prisoners-continues-behind-closed-doors/.

———. 2018c. "Declaran Culpables a Los Primeros Presos Políticos." *Confidencial* (Managua), August 28, 2018. https://confidencial.com.ni/declaran-culpables-a-los-primeros-presos-politicos/.

Salgado, Jesús. 2014. "Comunidad Kriol Exige Demarcación de Tierras." *El Nuevo Diario*, July 17, 2014. http://www.elnuevodiario.com.ni/nacionales/325024-comunidad-kriol-exige-demarcacion-tierras/.

Salinas Maldonado, Carlos. 2017. "Nicaragua Se Acerca a un 'Sistema Autoritario.'" *Confidencial* (Managua), January 25, 2017. https://confidencial.com.ni/nicaragua-se-acerca-sistema-autoritario/.

———. 2019. "'La Orden Era Eliminar a los Líderes de la Protesta.'" *Confidencial* (Managua), February 11, 2019. https://confidencial.com.ni/la-orden-era-eliminar-a-los-lideres-de-la-protesta/.

Sassen, Saskia. 2000. "Women's Burden: Counter-geographies of Globalization and the Feminization of Survival." *Journal of International Affairs* 53, no. 2: 503–524.

Scott, Kesho. 1991. *The Habit of Surviving: Black Women's Strategies for Life*. New Brunswick, NJ: Rutgers University Press.

Semple, Kirk. 2018. "Nicaragua Roiled by Protests over Social Security Benefits." *New York Times*, April 20, 2018. https://www.nytimes.com/2018/04/20/world/americas/nicaragua-protests-ortega.html.

Serra Vázquez, Luis H. 2016. "El Movimiento Social Nicaragüense por la Defensa de la Tierra, el Agua y la Soberanía." *Encuentro*, no. 104: 38–52.

Silva, Jose Adan and Elizabeth Romero. 2018. "Acusan Formalmente a Supuestos Asesinos de Periodista Ángehl Gahona y les Dictan Prisión Preventiva." *La Prensa* (Managua), May 8, 2018. https://www.laprensani.com/2018/05/08/nacionales/2415972-acusan-formalmente-supuestos-asesinos-de-periodista-angel-gahona.

Simmons, Shakira. 2018. "Grito Por Nicaragua, Un Grito desde la Costa Caribe." *LASA Forum* 49, no. 4: 32–36.

Smith, Andrea. 2005. *Conquest: Sexual Violence and American Indian Genocide*. Durham, NC: Duke University Press.

Smith, Christen. 2016. *Afro-Paradise: Blackness, Violence, and Performance in Brazil*. Urbana: University of Illinois Press.

Solís, Azahálea. 2013. "'La Ley 779 Tiene una Large Historia de Lucha y su Reforma Envía a la Sociedad un Mensaje Muy Negativo." *Envío*. https://www.envio.org.ni/articulo/4770.

Soto, Fernanda. 2017. "Las Historias que Contamos." *Iluminuras* 18, no. 43: 11–28.

Spillers, Hortense J. 1987. "Mama's Baby, Papa's Maybe: An American Grammar Book." *Diacritics* 17, no. 2: 64–81.

Spira, Tamara Lea. 2013. "From the Fringes of Empire: U.S. Third World Feminists in Solidarity with Chile." *NACLA Report on the Americas* 46: 39–43.

Squier, E. G. 1860. *Nicaragua; Its People, Scenery, Monuments, Resources, Condition, and Proposed Canal*. New York: Harper & Brothers.

Stewart, Kathleen. 2007. *Ordinary Affects*. Durham, NC: Duke University Press.

Sujo Wilson, Hugo. 1998. *Oral History of Bluefields = Historia Oral de Bluefields*. Colección Autonomía. Bluefields, Nicaragua: CIDCA-UCA, 1998.

Sutton, Barbara. 2010. *Bodies in Crisis: Culture, Violence, and Women's Resistance in Neoliberal Argentina*. New Brunswick, NJ: Rutgers University Press.

Taylor, Deborah Robb. 2003. *The Times & Life of Bluefields*. Managua: Academia de Geografía e Historia de Nicaragua.

Tellería, Gabriel M. 2011. "A Two-Headed Monster: Bicaudillismo in Nicaragua." *Latin American Policy* 2, no. 1: 32-42.

Téllez, Dora María. 2012. "Confronting the Ortega Regime Requires National Unity." *Revista Envío*, no. 366. http://www.envio.org.ni/articulo/4480.

Thaler, Kai M. 2017. "Nicaragua: A Return to Caudillismo." *Journal of Democracy* 28, no. 2: 157–69.

Thomas, Deborah A. 2004. *Modern Blackness: Nationalism, Globalization, and the Politics of Culture in Jamaica*. Durham, NC: Duke University Press.

Tijerino, Doris, and Margaret Randall. 1978. *Inside the Nicaraguan Revolution*. Vancouver: New Star Books.

Trinchera de la Noticia. 2018. "Exdirectora Denuncia la Corrupción en INAFOR." January 9, 2018.

Trouillot, Michel-Rolph. 1995. *Silencing the Past: Power and the Production of History*. Boston: Beacon Press.

Twine, Frances, and Jonathan W. Warren, eds. 2000. *Racing Research, Researching Race: Methodological Dilemmas in Critical Race Studies*. New York: New York University Press.

United Nations Human Rights. 2018. *Human Rights Violations and Abuses in the Context of Protests in Nicaragua, 18 April–18 August 2018*. Geneva: Office of the United Nations High Commissioner for Human Rights (OHCHR).

Univision. 2012. "Diputada Sufrió Discriminación." http://archivo.univision.com/content/content.jhtml?cid=1841382.

Valencia, Roberto. 2011. "Bluefields, Inexplicablemente Violenta." *Confidencial*, June 21, 2011. http://www.confidencial.com.ni/archivos/articulo/4265/bluefields-inexplicablemente-violenta.

Vargas, João Costa. 2006. *Catching Hell in the City of Angels: Life and Meanings of Blackness in South Central Los Angeles*. Minneapolis: University of Minnesota Press.

———. 2008. *Never Meant to Survive: Genocide and Utopias in Black Diaspora Communities*. Lanham: Rowman & Littlefield Publishers.

———. 2018. *The Denial of Antiblackness: Multiracial Redemption and Black Suffering*. Minneapolis: University of Minnesota Press.

Vásquez, Vladimir. 2017a. "Nicaragua: Canal Opponents Denounce Human Rights Violations." *Confidencial* (Managua), July 29, 2017. https://confidencial.com.ni/nicaragua-canal-opponents-denounce-human-rights-violations/.

———. 2017b. "'Ortega's Gov. Treats Us like Criminals.'" *Confidencial* (Managua), October 21, 2017. https://confidencial.com.ni/ortegas-gov-treats-us-like-criminals/.

Vázquez Larios, Martha. 2009. "Budier Rechaza Disculpas Públicas de Propietarios de El Chamán." *El Nuevo Diario* (Managua), February 17, 2009.

———. 2018a. "Fiscalía insiste en que la Bala que Mató a Ángel Gahona Salió de un Arma Hechiza." *La Prensa* (Managua), July 18, 2018. https://www.laprensani.com/2018/07/18/nacionales/2450438-fiscalia-insiste-en-que-la-bala-que-mato-a-angel-gahona-salio-de-un-arma-hechiza.

———. 2018b. "Más Inconsistencias en el Caso del Periodista Asesinado Ángel Gahona." *La Prensa* (Managua), May 22, 2018. https://www.laprensani.com/2018/05/22/nacionales/2423013-mas-inconsistencias-en-el-caso-del-periodista-asesinado-angel-gahona.

Velasco, Andrés. 2017. "The Sandinista Shell Game." *Confidencial*, August 1, 2017. https://confidencial.com.ni/the-sandinista-shell-game/.

Vilas, Carlos María. 1989. *State, Class, and Ethnicity in Nicaragua: Capitalist Modernization and Revolutionary Change on the Atlantic Coast*. Boulder, CO: Lynne Rienner.

Vilchez, Dánae. 2015. "Gobierno 'Sordo' ante Clamor de Pueblos Indígenas." *Confidencial*, October 21, 2015. https://www.confidencial.com.ni/nacion/gobierno-sordo-ante-clamor-de-pueblos-indigenas/.

Visweswaran, Kamala. 1994. *Fictions of Feminist Ethnography*. Minneapolis: University of Minnesota Press.

Volpp, Leti. 2001. "Feminism versus Multiculturalism." *Columbia Law Review* 101, no. 5: 1181-1218.

Walker, Thomas W., and Christine J. Wade. 2017. *Nicaragua: Emerging from the Shadow of the Eagle*. 6th ed. Boulder, CO: Westview Press.

Walter, Knut. 1993. *The Regime of Anastasio Somoza, 1936–1956*. Chapel Hill: University of North Carolina Press.

Wanzo, Rebecca. 2009. *The Suffering Will Not Be Televised: African American Women and Sentimental Political Storytelling*. Albany: SUNY Press.

Watts, Jonathan. 2015. "Land of Opportunity—and Fear—along Route of Nicaragua's Giant New Canal." *The Guardian*, January 20, 2015. https://www.theguardian.com/world/2015/jan/20/-sp-nicaragua-canal-land-opportunity-fear-route.

Wegren, Stephen K., and Andrew Konitzer. 2007. "Prospects for Managed Democracy in Russia." *Europe-Asia Studies* 59, no. 6: 1025–1047.

White, E. Frances. 2001. *Dark Continent of Our Bodies: Black Feminism and the Politics of Respectability*. Philadelphia: Temple University Press.

Whitten, Norman E. 2007. "The Longue Durée of Racial Fixity and the Transformative Conjunctures of Racial Blending." *The Journal of Latin American and Caribbean Anthropology* 12, no. 2: 356-383.

Wolfe, Justin. 2007. *The Everyday Nation-State: Community & Ethnicity in Nineteenth-Century Nicaragua*. Lincoln: University of Nebraska Press.

———. 2010. "'The Cruel Whip': Race and Place in Nineteenth-Century Nicaragua." In *Blacks and Blackness in Central America: Between Race and Place*, edited by Justin Wolfe and Lowell Gudmundson. Durham, NC: Duke University Press.

Wolin, Sheldon S. 2008. *Democracy Incorporated: Managed Democracy and the Specter of Inverted Totalitarianism*. Princeton: Princeton University Press.

Wood, Robert E. 2000. "Caribbean Cruise Tourism: Globalization at Sea." *Annals of Tourism Research* 27, no. 2: 345–370.

Woods Downs, Socorro. 2005. *"I've Never Shared This with Anybody": Creole Women's Experience of Racial and Sexual Discrimination and Their Need for Self-Recovery.* Bluefields, Nicaragua: CEIMM-URACCAN.

Woods Downs, Socorro, and Courtney Desiree Morris. 2007. *"Land Is Power": Examining Race, Gender and the Struggle for Land Rights on the Caribbean Coast of Nicaragua.* Austin, TX: Caribbean and Central American Research Council.

———. 2010. "Reflections on Struggle, Ambivalence, and Memory: An Oral History of Afro-Nicaraguan Women and the Sandinista Revolution." Paper presented at the Latin American Studies Association Meeting, Toronto, October 6–10, 2010.

Wu, Judy Tzu-Chun. 1997. "'Loveliest Daughter of Our Ancient Cathay!': Representations of Ethnic and Gender Identity in the Miss Chinatown U.S.A. Beauty Pageant." *Journal of Social History* 31, no. 1: 5–31.

Wunderich, Volker. 1986. "Seguidores de Marcus Garvey en Bluefields 1920." *Revista WANI*, no. 4 (July–September): 33–35.

Yarris, Kristin E. 2017. *Care across Generations: Solidarity and Sacrifice in Transnational Families.* Stanford: Stanford University Press.

Zimmermann, Matilde. 2000. *Sandinista: Carlos Fonseca and the Nicaraguan Revolution.* Durham, NC: Duke University Press.

Zuniga, Leonor, and Cornelio Hopmann. 2013. *Mapping Digital Media: Nicaragua.* London: Open Society Foundations.

INDEX

Names of activists are pseudonyms.

Abelardo Mata, Juan (bishop), 159
abortion, 13, 15
Abraham, Judith, 193, 197
abuse, spousal. *See* violence, sexual
activist anthropology, xv–xix; definition of,
 xvi–xvii
African culture, 162
African diaspora, 20, 24, 27, 80, 84, 117, 165, 197,
 205, 208
Afro-descendant people. *See* Creoles
Afro-Descendant Women's Organization of
 Nicaragua (OMAN), 168
Agnes Ana Frederick, princess of Mosquitia, 38
agriculture. *See* banana industry; farming
Aguilar Gibbs, Lourdes Maria, 100–103
Alemán, Arnoldo, 13, 95, 99–100, 225n4, 231n4
Aleman, Carlos, 183
ALPROMISU. *See* Miskitu and Sumu Alliance
 for Progress
Alvarez, Kymani, 212
Amnesty International, xi
anti-canal movement, 15, 91, 182, 190–202
antiracism: and the BBCIG, 191; FSLN
 performance of, 16, 212–213
Arana, Moisés, 118–119
Arce, Bayardo, x
archives: alternative, 25, 26, 27, 36, 62; erasure
 of Black women from, 11; informal, 155, 174
Asian culture, 162
Astorga, Nora, 69
Augé, Marc, 109
austerity measures, 26, 106
authoritarian turn. *See* Sandinista National
 Liberation Front (FSLN): authoritarian turn of
Autonomous Women's Movement, 224n2
autonomy, regional: definitions of, xv, 181,
 183–187, 193, 195; dismantling/undermining of,
 by Nicaraguan state, xii, 3, 16, 17–18, 22, 23,
 122–124; inspiration for, from Marcus Garvey,
 48; as linked to the struggle for land rights,
 125–150; managing, in the neoliberal era,
 95–124; and the 1909 revolution, 46; in the

1980s, 86–89, 90; as outlined in the Mosquito
 Convention, 34, 38, 41; pursued through
 media, 202–208; shift away from, under
 Somoza, 59, 62; weakening of, through
 co-optation and intervention, 181–182, 192–195
Autonomy Law. *See* Law 28
Azote, El (satirical news supplement), 7

Baltodano, Mónica Lopez, 15, 69, 190
banana industry, 34, 39, 50; blight, 59;
 exploitation of, 44–45, 107, 145
Barbeyto Rodriguez, Arelly, 163–164
Barricada (official FSLN publication), 105
BBCIG. *See* Bluefields Black-Creole Indigenous
 Government
Beer, June, 65, 83, 91, 217; poem by, 63
Belli, Gioconda, 15; memoir of, 66
Bernal, Victoria, 205
bisexuality, 159. *See also* LGBT community
Black/Afro-descendant people of the
 Caribbean coast of Nicaragua. *See* Creoles;
 Creole women; Creole women activists
Black Farmers Back to the Land Movement, 132
Black history, 65, 79, 169, 208. *See also* civil
 rights movement; Jim Crow; slavery
Black Women's Organization of Nicaragua, 197
Bluefields, xi, 5; anniversary of emancipation in,
 198–199; as a Black space/Creole city, 2, 6, 37,
 127–129; as a British protectorate, 38–39, 47; as
 the capital of the RACCS, xi, 2, 5; commercial
 and social life of, 39, 47–50, 79, 172; and the
 drug trade, 115–122, 133; international
 immigrants as residents of, 47–48; land
 occupation in and land claims of, 28, 125–127,
 130, 132, 134, 148–149, 181, 183–184, 188–195;
 martial law in, 52–56; the Moravian Church in,
 38–39; political unrest in, x, xii, 213–214;
 poverty in, 104–105; remittances sent by
 ship-outs to, 111–112; and the Reincorporation,
 40–47, 61; sexual violence in, 155, 162, 175; as
 a war zone, 84, 86. *See also* Bluefields
 Black-Creole Indigenous Government

ABOUT THE AUTHOR

COURTNEY DESIREE MORRIS is assistant professor of gender and women's studies at the University of California, Berkeley.